Making Theory

Making Theory/Constructing Art

On the Authority of the Avant-Garde

Daniel Herwitz

The University of Chicago Press / Chicago and London

Daniel Herwitz is associate professor of philosophy at California
State University.

The University of Chicago Press, Chicago 60637
The University of Chicago Press, Ltd., London
© 1993 by The University of Chicago
All rights reserved. Published 1993
Printed in the United States of America

02 01 00 99 98 97 96 95 94 93 1 2 3 4 5

ISBN: 0-226-32891-0 (cloth)

Library of Congress Cataloging-in-Publication Data

Herwitz, Daniel Alan, 1955–
 Making theory/constructing art : on the authority of the
avant-garde / Daniel Herwitz.
 p. cm.
 Includes bibliographical references and index.
 1. Art—Philosophy. 2. Constructivism (Philosophy) 3.
Avant-garde (Aesthetics)—History—20th century. I. Title.
N71.H45 1993
701—dc20 92-43483
 CIP

⊗The paper used in this publication meets the minimum
requirements of the American National Standard for Informa-
tion Sciences—Permanence of Paper for Printed Library Materi-
als, ANSI Z39.48-1984.

To Lucia Saks

When I talk about language (words, sentences, etc.) I must speak the language of every day. Is this language somehow too coarse and material for what we want to say? *Then how is another one to be constructed?*—And how strange that we should be able to do anything with the one we have!

—Ludwig Wittgenstein, *Philosophical Investigations*

Contents

Illustrations

Acknowledgments

The substance of this book was written during the academic year of 1990–91 while I was a Mellon Fellow at the Stanford Humanities Center. That garden of three Victorian buildings, set at the edge of the Stanford campus against the rolling hills of northern California, is an ideal environment in which to apply oneself wholeheartedly to the task of work. The only defect of the Stanford Humanities Center is that it has a termination point for the fellows, unlike life, which has both a termination point and other difficulties. I wish to thank Bliss Carnochan, then director of the center, Charles Junkerman, its associate director, and the staff of the center as a whole for facilitating a stimulating, productive, and most pleasant year. My fellowship was also funded by a grant from the American Council of Learned Societies. I also wish to thank Susan Steiner of the research office of California State University, Los Angeles, for her help in my applications for these grants and California State University for a two-term sabbatical leave during the academic year of 1992–93 in order to complete the final preparations of this book.

My former teachers Ted Cohen and Stephen Toulmin, both of whom I am now fortunate to count as friends, encouraged me to be self-critical and to trust in my inner convictions, to respect the importance of absorbing a discipline and to study the art of conversation between disciplines, to listen carefully to the words of others and to be beholden to no one (especially not to them). The absorption of this education will, I am sure, be a lifelong task. Richard Wollheim, in repeated conversations and through his various books, set for me the example of what Freud called a *visuel,* one whose trust in the evidence of the visual is matched by his sense of how much subtlety, discernment, and time is required to achieve the difficult work of "seeing." For a person like me, writing on the theoretical practices of the avant-garde and their legacies in the present, both a respect for the ineluctable power of the visual in art, and a sense of the mind's being tempered by the eye are crucial. Marjorie Perloff, whose work on the avant-garde manifesto may be thought of as a kind of starting point for my own discussions, has been an enthusiastic critic and an indefatigable friend. Other friends and colleagues who have been especially helpful during the writing of this book are Caro-

line Jones, James Holston, Arnold Davidson, Robert Harrison, Peter Galison, and Michael Steinberg.

My first real exposure to constructivism came during a conference hosted by the Instituto Internacional de Estudios Avanzados in Caracas, Venezuela, in 1984. That magnificent event, which included a trip to the Museo de Arte Moderno Jesús Soto, in Ciudad Bolívar on the Orinoco River, represented a sustained discussion of constructivism, especially in its vibrant Latin American incarnation. It was graciously arranged by Luis Castro Leiva, then director of the Instituto Internacional, and by Gloria Carnivale, then from the museum in Caracas. I also wish to thank the constructivist artist Carlos Cruz-Diez, whose studio was open to the participants and whose participation was welcomed.

Since then, during its process of gestation, I have had occasion to present portions of this book to the MIT School of Design, the American Society for Aesthetics and the College Art Association, the John Cage Symposium at Strathmore Hall (Washington, D.C.), and the roundtable seminars of the Stanford University art history department. At each of these gatherings I received stimulating comments. A special opportunity to lecture on what would become the entire book came in 1989 when I gave a series of lectures in São Paulo, Brazil, to the Museo de Arte Contemporaneo and the University of São Paulo. I wish to thank Ana Maria Barbosa, director of the museum, for inviting me to lecture, and Rejane Cintrão for introducing me to the dense and vivid history of modern Brazilian art. Selections from the book have appeared in *Critical Inquiry, Modern Philology,* and *Modern Painters.*

I wish to thank T. David Brent, my editor at the University of Chicago Press, who has been strategically helpful in the book's planning and persistently encouraging, especially during those moments when I really needed it.

Special debts are due to John Cage and Arthur Danto, both of whom figure centrally in the pages of this book. My concern is to understand the nature of their art and philosophy in terms of what I call the mentality of the avant-garde, a mentality which precisely intends to blur the distinction between art and philosophical theory. While I am critical of that mentality as one that overadulates the role of theory in art (and music), how could I—as a philosopher myself—not also be respectful of the attempts on the part of both these innovators to conceive of art as a form of practice designed to engender the most philosophical questions about art's own place in the world? How could I not admire the daring and incisive character of

Danto's philosophy, his willingness to risk analysis of the contemporary, his original amalgamation of philosophical vision and lightning response to art? How can I avoid recognition of the complexity of Cage's music, of its (avant-garde) insistence on the inculcation of vision, of its belief in the possibility of a life which is more perfect and more human than one which has as yet been dreamed? Cage's vision of the human, a vision in which people open themselves to the play of the world's complexities, in which they allow themselves to acknowledge the fact of each other, in which their receptive listening takes precedence over their politics of domination and their intellectual cleverness, is a vision as decent as Cage was himself human. Writing these acknowledgments the day after hearing of John Cage's death seems a chance operation of the highest order, and an unfortunate one, since for myself and for many others his spirit will be deeply missed.

This book is dedicated to Lucia Saks, former art student of Richard Hamilton's, ex-advertising designer, and currently student of critical studies. She is also my wife. The book I would have written would not have been *this* book without her help and attention, nor would my life have been the same. I can only hope that when she writes the books that she will write, I can give to her something of what she has given to me.

<div align="right">

Los Angeles, California
Summer 1992

</div>

Introduction: What We Have Inherited

This is a book about avant-garde art and the close relations it has formed with philosophy and theory in this century. It is well known that the art of this century, and especially the art of the avant-garde, has been obsessed with its own theoretical self-formulation. The art movement De Stijl immediately started a journal in its revolutionary year of formation (1917, that great year for revolutions): the journal *De Stijl,* for to take on its artistic identity required, in De Stijl's view, announcing itself, getting its rhetoric straight, explaining itself, and philosophizing its paintings, sculptures, and buildings into existence. The Bauhaus formed close relations with Marxist philosophy, biological theory, and logical positivism,[1] and reserved a crucial place for theory of design in its curriculum. Marcel Duchamp, who played his artworks like theoretical accordions, put the point nicely in remarking about his own art: "Everything [in my art] was becoming conceptual, that is, it depended on things other than the retina."[2] Evidently, the retinal values and visual pleasures associated with past art were no longer adequate for the thought-provoking and rhetorically confrontational art of the avant-garde, as if only in the context of a philosophical theory could the work of art now have meaning, integrity, and purpose.

Not all of the avant-garde, much less of the rest of twentieth-century art, conformed to the theoretically minded style of artistic production shared by Piet Mondrian and Duchamp in their different ways. But important regions of twentieth-century art have conformed to it, and it is my own view that equally important regions of both contemporary art and contemporary art criticism are the inheritors of that theoretically minded approach to art. We are the inheritors of the avant-garde's theoretical norms. Paintings are made nowadays whose flirtations with philosophical seriousness are meant to engender perspectives about the relations between art, real estate, investment banking, television, gender, ethnicity, and the power of past art while at the same time lambasting the modernist urge toward high-concept philosophical seriousness. On the side of criticism, paintings are approached today not as the bearers of innocent retinal values but as complex semiological codes whose visual effects are to be glossed as information requiring deep theoretical analysis—as if each painting were a psychological or historical subject

with an unruly psychological or historical unconscious demanding to be stripped bare in the manner of Duchamp by a hermeneutics of suspicion backed by extreme theoretical firepower.

If the profusion of such theoretical stances taken in and toward art is more than a mere example of current overproduction (by the art industry), then the suggestion is that our times seem to require such theorizing from the artist, from the critic, and from the philosopher. There is great benefit in using theory to unmask the canons of art history as the complex cultural armaments that they are, to unmask the ideological stances and the voluptuously possessive gazes which the canons of art cast with such security into the burning and voracious eyes of the viewer. Indeed, the idea that paintings have meaning purely on some retinal basis, that their visual character is not partly structured by a culture whose conceptual schemes, social attitudes, and specific requirements impose norms of production and visual reception, is at best a fabrication—currently under correction—of the eighteenth century. As Michael Baxandall has shown, the Renaissance painting was made, commissioned, and interpreted partly on the basis of socially trained visual skills, and it was produced to satisfy the norm of religious devotion (and, one would add, to serve in the harmonization of the city with the church).[3] What current theory has done is to return our eyes and minds from the abstracted formalism and self-absorbed connoisseurship of the eighteenth and nineteenth centuries to the robust world in which "art" is set. In so doing, it has returned artworks from being mere sights in a museum to the sites of their making, reception, and enmeshment.

Yet if the tendency nowadays is to mistrust the visual effects a painting sets forth, we unfortunately have no equally strong suspicions about the *theories* we use in decoding such effects. Insofar as these are times of what Jean-François Lyotard calls "incredulity towards meta-narratives," we are left with suspicions about the projects of art present and art past. Yet we are not at all suspicious about the theories we use to frame our suspicions about "metanarratives." We find it crucial to contextualize artistic styles, to grasp who the princely recipients of such styles were, and whom such styles helped to marginalize. And indeed art, like everything else in culture, did its share of marginalizing, excluding, and humiliating—ironically, under the veil of beauty. Yet if we are rightly mistrustful of the veil of beauty, we are not equivalently mistrustful about the ease with which our theories explain what lies under the veil. In fact it is precisely our metanarratives about artistic explanation in which we have complete faith; what we are incredu-

lous about are the narratives with which past art and past art criticism have supplied us.

The use of theory by artists and critics can be thought of as a kind of game, a language game, if you will, played with words over art objects. Then what are the terms of this game? What authorizes it? What are its uses, what its benefits, and what its illusions? We trace with utter confidence the genealogy of artistic styles, yet we in no way trace the genealogy of our own theoretical interventions. Nor do we attempt to otherwise contextualize them. Rather, we seem to believe that theory can transparently explain any painting if one simply learns how to use it well enough. The key word is *transparency.* Art history and art criticism have become all too spectacular, with the historians or critics writing two sentences about what a painting looks like and ten pages about some essay by Freud, upon which they are sure that they have said everything important about what a painting means. Does such a mode of reading do justice even to the highly conceptual artworks of Duchamp? I would be the last person to deny that Freud is deeply relevant to the explanation of paintings,[4] but sometimes a painting is just a painting. When is that? Such questions demand recognition by the theorist. How did we get to a point where artists or critics can transparently rely on theory to empower their artwork or their reading with meaning, power, and integrity? And conversely, if theory can hurt, it can also help, and why do our times require the intricacies of theory in both art and criticism? How did our tendency toward reliance on theory come about?

Naturally, it would take the grandest narrative, the grandest *theory* in the world, to answer all of these questions at once. Indeed, the very thought that one could answer them in one great blow of words is itself a product of the theoretical mentality I wish to explore in this book. Only a Hegel, a Mondrian, or a Tarzan could think that a single narrative would answer such a locus of pestilential questions. What I wish to do in this book is to explore the avant-garde theoretical norms which I believe have possessed large regions of contemporary philosophy of art, cultural studies, and art criticism. I wish to trace out a mentality that could be called especially theoretical, which can be found in both avant-garde art and in contemporary philosophy. I wish to show the philosophers and critics who exhibit this mentality are formed (in part) by the norms of avant-garde art itself. Thus I wish to provide us with part of the story of our genealogy, call it the story of our inheritance of a *mentality* (with many variations).

The belief that there exists a transparent relationship between theory and

the visual object it defines or explains is an avant-garde hallmark. Mondrian is sure that the Platonist philosophical theory he articulates in his many essays serves to define the meaning and power of his paintings. By contrast, we think of postmodernism as being predicated on the rejection of such avant-garde illusions of transparency as Mondrian's, but is this entirely true? Since Robert Venturi's book, *Learning From Las Vegas,*[5] accused the impetuses of modern architecture—to impose utopian changes on the lives of everybody through an architecture whose purist principles could be elaborated prior to all building contexts—of being almost totally wrong, in contrast to the blooming, buzzing palazzi of Las Vegas, which were "almost all right," postmodernism in the visual arts has dedicated itself to the rejection of modernism's utopian narratives. The pristine abstractions of Naum Gabo and the idealized world of Mondrian can seem very distant from us when considered from the position of hot-rodding at sixty-five miles per hour down the main drag of Las Vegas (or when hot-reading through the pages of *Learning From Las Vegas*). Yet in spite of a great deal of ironizing, patronizing, and cauterizing, in spite of enormous distances traveled from modernist times at breakneck speeds, we have still not ironed the wrinkle of modernism out of our post-1960s minimalist black Soho clothing (worn mostly by white people). By which I mean that the avant-garde mentality which adulates a transparent relationship between theory and the art object is still with us. It still carries authority. Then this mentality must be explored, teased out of avant-garde art, and understood. Why did the avant-garde come to theorize in the way that it did? How important was theory for it in the end and why? What kind of game did the avant-garde play with theory? What purposes did theory serve? And how clear an answer can one have to any or all of these questions? What, in short, is the nature of our inheritance from the avant-garde?

It is this set of questions that will structure my book. That is to say, my book explores the avant-garde mentality and tests its authority. A word about it is therefore in order. This mentality, this alliance between avant-garde art, philosophical thinking, and art criticism in this century has its well-known sources in a shared history, a shared critical perspective on culture, a shared commitment to politics, and a shared conversation. But the depth of the alliance, the depth of the conversation, the depth of the shared perspective on politics must be construed as flowing from a deeper agreement between avant-garde artists and philosophers about what a work of art is. The agreement amounts to a pair of assumptions about art which avant-garde artists and philosophers in this terrain hold: first, the assumption that

an artwork is, in a very strong sense, a theoretically defined entity and, second, the related assumption that a unique art example can be found that will perfectly illustrate this essential fact about art. These assumptions may, as a pair, be considered basic (although not definitive) avant-garde features since they lie deep in the menu of the avant-garde, serving to characterize it as a *mentality:* a style of thinking shared by art, philosophy, and cultural theory.

Both the segment of avant-garde art and the segment of philosophy I will discuss are, I intend to show, committed to the idea that what makes an artwork an artwork is the rigorous character of the theory behind it.[6] The avant-garde is dedicated to the idea of prefiguring its artworks by a philosophical theory, while such thinkers as Arthur Danto are dedicated to claiming that it is the property of theory which inherently makes an artwork what it is. The second assumption, that a favored art example can be found that will illustrate perfectly the theoretical structure of art, flows from the first. Avant-garde artists of the sort I will be concerned with aim to create an art object that is illustrative of the capacity of art to conform to the dictates of a philosophical theory.[7] I will refer to this avant-garde aim as the aim of embodiment: the artwork should be designed so as to embody philosophical truth in its formal structure. In a similar vein, modernist philosophers and cultural theorists claim to articulate their theories of art by finding some art example which will uniquely reveal the structure of art pellucidly and from the roots. The philosopher-theorist and the artist-theorist converge because *both* claim to find their favored art example in the domain of avant-garde art. The avant-garde artist aims to make such a perfectly revealing work; the philosopher claims to have found it there. Indeed, the philosopher, in the spirit of Hegel's famous owl of Minerva, comes just after the fact. He or she claims to have learned the lesson about what art is from the avant-garde art example itself. He or she is the interpreter of its legacy and part of its dialectic.

I will discuss this mentality by example. Indeed, the only way to carve out the terrain of this mentality from the rest of art and philosophy is by example, for there are a number of ways in which art, including the art of the avant-garde, is theoretical and philosophical. Works of art stimulate philosophy by being deep enough to raise existential questions or exhibit existential conditions (Dostoyevsky, Shakespeare). Works of art occasion philosophy by being deep enough to make one think about the nature of life (or of art). They are made on the bases of philosophies of life and culture. They state philosophy or suggest it, aim to end it, are in competition with

it, need or desire it. They admire it, try to drink deep of it, succeed or fail in this endeavor, and in general enter into a myriad of relationships with philosophy. Some of these relationships are quite intense, others more superficial. For this reason alone, one cannot provide a general and systematic account of philosophy and art. Just as it used to be thought that language had one principal relationship to the world—that of stating the truth—there is still the idea that art has one relationship to philosophy—that of stating it in some implicit form. The old picture of language and the world, dispelled so thoroughly by Wittgenstein (cf. the opening quotation from *Philosophical Investigations,* sec. 120 [New York: Macmillan, 1968]), Heidegger, and various others, is now a picture of a pattern of interrelated ways in which language exists in relationship to the world. Similarly, one can speak of a pattern of relationships (fulfilled and unfulfilled, fulfilling and unfulfilling) between art and philosophy. It is the same with theory. Artworks can be theoretical in the weak sense that they are prefigured by complex beliefs of all kinds, ranging from religious beliefs to beliefs about science, theory of color, method, craft, and social welfare. They can be theoretical simply because they are designed to make the viewer think about what a work of art is, because they are designed to engender thought about the concepts, expectations, and desires a viewer inevitably brings to the art encounter. Thus to say that certain avant-garde artists have a uniquely theoretical mentality is to say nothing until we see what is unique about its specific reliance on philosophical theory. Indeed, even within that capacious category called the "avant-garde," there is room for many avant-gardes, each with a different quantity and character of theory. Similarly, even the most cursory glance at philosophical writing about art in this century will reveal a number of different approaches based on an equal number of different assumptions about the nature of art.

I have chosen three specific moments in avant-garde art and discourse which paradigmatically illustrate the mentality in question: the constructivist movement (mostly but not entirely Russian); De Stijl, especially the artwork and writing of Mondrian beginning in 1917; and the performance music and texts of John Cage. The choice of examples may strike one as odd, because these three moments, when viewed from other perspectives, appear as unrelated as they appear related. Constructivism and De Stijl share a conversation, a time, and to some extent, a style. But John Cage is a full generation younger than either of these movements, and if he is a movement at all it is in the nature of an American one-man band. Cage's discourse does not specifically address either constructivism or De Stijl, although Cage's

skepticism about an art of structural clarity addresses in more general terms the kind of modernism constructivism and De Stijl represent. Moreover, Cage is our contemporary; his art has a complexity, diffuseness, and naturalness which is in tune with very contemporary art in a way that the grand, pristine gestures of constructivism and Mondrian are not. Cage's style is a bricolage of performance, writing, and sound which is among the primary sources of performance art. Nevertheless, I choose these three avant-garde moments because if any art illustrates the attempt to prefigure an artwork by a philosophical theory, it is these artists and art movements.[8] When viewed from my perspective, these artists and art movements form a genre.

Furthermore, constructivist, De Stijlian, and Cagean art should be viewed together because together the discourses of these artists illustrate the *opposing* directions in which theory has been taken by the avant-garde in this century. These opposing positions taken about the artwork by art theory, moreover, bear such striking affinities with opposing positions philosophical epistemologies of the past have taken regarding their object, human knowledge, that one cannot help but feel that Cage, constructivism, and company are transferring philosophical debates which have been going on for centuries to the sphere of the artwork. How this transfer occurs will be a central point of my readings of the artists' works. Suffice it to say here that I take constructivism, Mondrian, and John Cage to exemplify, within the ranks of the avant-garde, both sides of the equivalent of a long-standing epistemological debate within philosophy: the debate between skepticism and Cartesianism regarding our knowledge of the world. The discourse of constructivism, and De Stijl, together with Cage's discourse, represent a similar debate posed over the question of artistic structure. On the one hand, John Cage (along with the surrealists to a lesser extent) represents skepticism about all claims to perceptual knowledge of structure in art. Cage is the purest example of this skepticism. Like texts of the classical skeptics, John Cage's performances aim to dislodge us from our obsessional imposition of structure onto sound. By contrast, the constructivists (and to a degree the Bauhaus) represent Cartesianism by requiring of artworks heightened criteria of total perceptual clarity in which form is transparent to the eye and perceptual knowledge indubitable. Constructivist (and other) Cartesian artists aim to produce geometrically abstract artworks designed from utterly simple shapes and colors in self-evidently transparent ways—like Cartesian proofs. Closely related to the constructivist impulse is Mondrian's purist Platonism.[9]

I want to understand the reasons for the level of theory in the discourse

of the examples I choose to study. These reasons are multiplex, but a central reason for the level of theory is the utopian concerns of these artists. My readings will detail a precise sense in which long-standing debates in the history of philosophy have reemerged over the structure and role of the art example. In my studies of constructivism, Mondrian, and Cage (chaps. 2–5), I connect their utopianism, their essential optimism, to the philosophical theory in their works, for the avant-garde is utopian because it is meant to demonstrate to the world through its formal perfection the fact that extreme and ancient philosophical truths can and will be embodied in the world.

I read these artists as philosophers in art. The constructivist project is one of social, spiritual, and philosophical renewal; Cage's project is one of naturalizing our spirit and our ears. Utopian concerns with an art whose structure (or lack thereof) will bring about a new possibility of life overall by exemplifying the form of that new life, introduce the idea of a theory, for the theory is required to tell us what the new age should be like and how the work of art must be structured so as to exemplify it. The artwork is, in the hands of these artists, a new arena in which the prospects of human knowledge and human life can be played out. We are meant to be stimulated by the avant-garde's divinely formulated artistic example, to take the cue of its philosophical perfection and extend its structure to life as a whole. Theory turns the avant-garde artwork into an *example,* an example of a future whose form is nothing less than the embodiment of the dictates of philosophy.

The degree of security with which these artists articulated their philosophical views should not be overstated. All were supremely confident in their commitment to the idea of a theoretically prefigured art example that would represent the utopian future. Yet with the exception of Mondrian, who held every one of his views with certainty, these artists exhibit constant theoretical shift and revision. Constructivism is a laboratory for the creation of the new in which the free play of theoretical experimentation is as dramatic as any experimentation with new technologies, new materials, and new styles of abstraction. Constructivists moved effortlessly in their theoretical identifications from engineering models through mathematical models, identifications with the scientist and the biological theorist, and on to mysticism. Most of these theoretical shifts retained some sort of Cartesian tinge or other, but all were elaborated in a quasi-experimental (read "tentative") vein.

Such free play of theorizing was required in this laboratory by the insu-

perable difficulty of actually imagining utopia. The avant-garde wished to pave the way to the utopian future through its own art examples; it was in the business of developing a clear picture of the new life and of the new person who would live that life (such a new person was mostly, it must be said, thought of as a "new man," not as a new, gender-free human being). Yet nobody can envision this future, granted its radical character, granted how much of ordinary life would have to change in order for it to happen. It defeats the imagination. Marx, that arch utopian, referred to the transition to a classless society as a "vague immensity," by which he meant an event of enormous proportions which neither he nor anybody else could envision except in some burning dream. Thus the utopian was required to approach a future which demands to be imagined (for it must be planned), yet which cannot be imagined (so the avant-garde, including that political "avant-garde" called the Party, had to experiment with a variety of images of it, including theoretical images, in order to make it, and the route to it, comprehensible).

This paradox led to a restless shifting between the poles of theoretical assertions of absolute confidence by avant-gardists and constant shifts and revision in the theories they asserted. Theory was an experimental element, a way of imagining from various perspectives the utopian future, not simply a way of planning that future. When tracing the avant-garde aim of theoretical prefigurement, we will have to take account of these shifts in theoretical voice.

Artworks are complicated, and we will have to take account of more shifts in voice than the above when reading the avant-garde. My concern is, in fact, to take these apparently pure examples of artworks prefigured by theoretical discourses and then to probe the artworks to determine (insofar as one can do this) how purely philosophical even they are. Is philosophy, however shifting in character, the master voice of constructivism, or is there another dimension to the art, another set of intentions in it or ways of receiving the art which resist, ignore, overcome, or call into question the philosophical voice in constructivism or Cagean music? In every case, even in the case of Mondrian's art, I argue that this is so. The avant-garde is a mosaic of voices which exist in tension and partial contradiction. It is the specific configuration of voices, rather than any one, which defines the richness, difficulty, intensity, and character of an avant-garde work. Thus one will never understand the role of philosophy in this (or any) art without answering the critical question, just how important is the philosophical voice really in the work? And how do you decide?[10]

An aside: philosophy has, from time to time, claimed that a person (or a culture) is at bottom to be understood in terms of the nature of his, her, or its belief scheme, in terms of the intersecting pattern of the moral, natural, scientific, personal, and so forth beliefs she (it) holds. And this kind of philosophy has claimed that the most basic regulating principle of a person's or a culture's beliefs is that of consistency. The idea that if you dig down deep enough you will find consistency is evinced in claims of both Kant and Mill to articulate in their ethical theories *the* underlying moral position of the Judeo-Christian tradition. That each came up with an opposite account suggests that there is no one moral position underlying Western culture as such. This is exactly what Bernard Williams has said.[11] Williams claims that underneath Western culture is a set of partially conflicting principles, maxims, and moral attitudes through which human life steers itself with, one hopes, the highest possible integrity. While consistency is obviously important as a regulating principle of belief (without it the very idea of a belief would be attenuated), Williams (and others) have then questioned the scope of consistency as a regulating principle on human belief and human life. There are, indeed, principles other than consistency which are equally central in regulating belief. The obvious ones among them are principles of empirical sensitivity, of flexibility, adaptation, decency, and integrity (Williams's favored principle). All of these principles represent aspects of the complete human being (who is never fully complete). Emerson speaks aptly when he says that consistency is the "hob-goblin of little minds." You diminish your humanity, make yourself little, when you fail to take cognizance of the total arena of feelings, thoughts, and conflicting principles impelling you, when you attenuate your openness to things or absorption in them in order to live in service of order. I think it is similar with the avant-garde. What impels it is a confluence of various, partly contradictory voices plastered together into the total art gesture, not any one principle or rationale. It is the specific configuration of voices that defines the meaning of the avant-garde and supplies its power.[12]

*

On the side of professional philosophy, the avant-garde mentality I probe in this book is exemplified by the writing of the philosopher and art critic Arthur Danto, who says, "It would today require a special kind of effort at times to distinguish art from its own philosophy. It has seemed almost the case that the entirety of the artwork has been condensed to that portion of the artwork which has always been of philosophical interest, so that little if

anything is left over for the pleasure of artlovers. Art virtually exemplifies Hegel's teaching about history, according to which spirit is destined to become conscious of itself." [13]

Danto will be a major player in this book, because of the inherent interest in his claims, because of his well-earned prominence in parts of today's artworld,[14] but above all because of the supreme sense in which he holds to the avant-garde assumptions I have outlined.[15] Just as I choose to study in this book the purest cases of this mentality in art, I choose to study its purest inheritances in philosophy, and Danto is uniquely representative of this style of thinking in the 1990s. Should any readers fail to share my own interest in Danto's philosophy, I would be happy if they found Danto's work more appealing on closer inspection. But, even if not, I would urge those readers to consider the broader issue at stake, namely, the significance, both philosophical and cultural, of the turn toward a theoretical conception of art, a turn represented by Danto's philosophy.

In this dystopian age of despair over the future, dyspepsia over the present, and disbelief in everything, Danto's confident application of his grand narrative to the objects of the present can appear to be a semimodernist anachronism, far removed from the tenor of the times. Yet I assign to him a representative place in our inheritance from the avant-garde, for he exemplifies—in an exaggerated, highly developed, and therefore exceptionally clear form—the theoretical tendencies, assumptions, and practices of theorizing that are, in various forms and to various degrees, cultural practices today. This must, of course, be defended, and I take the entire book to constitute its defense.

Danto is both the recipient of the theoretical mentality I attribute to the avant-garde and its interpreter, which makes him of special interest to my story. As recipient, he shares the idea that theory, specifically a historically evolving theory held by the artworld, defines art. This evolving property of theory is the essential defining source of art.[16] As interpreter of the avant-garde's history, Danto has a very specific idea about what the avant-garde's own theoretical game was—about why it turned to theory and what it accomplished by its theorizing. According to Danto, avant-garde art was in the same business he is in, namely, the business of philosophizing about art for the sake of self-recognition. Danto's idea is Hegelian: the history of avant-garde art has had a Hegelian shape, a destiny of self-discovery. Avant-garde art has been impelled by the urge to become self-conscious of its own theoretical nature, with, as we shall see, the most unlikely artwork in the world serving as the perfected culmination of this project, namely Andy

Warhol's *Brillo Boxes*. (Danto's assertion that the avant-garde is crowned by Warhol's work has an audacity and confidence worthy of any avant-garde artist's.) Avant-garde art has endeavored to become its own philosophy, according to Danto, thus blurring the very distinction between philosophy and art (leaving "little leftover for . . . artlovers").[17] It has succeeded in this project, according to Arthur Danto, with the philosophical help of Danto himself. Danto has done no less than complete art history by making the avant-garde's philosophical adventure of discovery explicit. That is, Danto has, by his own lights, become part of art history, his work rides the cusp of art history, thus blurring the distinction between philosophy and art.

Danto holds to both the modernist assumption that theory prefigures art and to the further assumption that an art example can be found which perfectly illustrates (or demonstrates) that fact. And he also considers his own philosophy to be an integral part of the avant-garde's history, a culminating feature of its dialectic.[18] I will use avant-garde art (its assumptions and its example) as a way of understanding the character of Danto's philosophical mentality.[19]

There is already a growing literature on Danto within the field of aesthetics, and I intend my work to be a contribution to that literature, but I also intend to focus on what previous discussions of Danto within aesthetics have left out or skirted, namely, the cultural context of avant-garde art from which Danto, originally an artist, grows and of which he is a part. American aesthetics, when it addresses its practitioners, tends to apply its energies to the sport of unpacking, analytically reconstructing, and arguing with the content of their ideas. This is a worthy task, one required for philosophical interpretation; and I will myself, in chapters 6 and 7, be concerned to philosophically unpack (and argue with) Danto's theory of theory, for it is not obvious what he means by a theory. But the game of mere reconstruction and argument falls short of full philosophical engagement with Danto (or with any philosopher, for that matter) on two grounds. First, aesthetics tends to be unconcerned with asking about the requisite range of contexts into which a philosopher like Danto must be placed in order for us to understand him (this in spite of Danto's own claim to be part of avant-garde art history). The discipline of aesthetics has not adequately taken the cue from other disciplines about how to read philosophy in context. (Is that because the very discipline of aesthetics, with its allegiance to professional philosophy over and above art history and cultural studies, would then be challenged?) I have said I aim to place Danto somewhere on the map of the avant-garde. This way of placing Danto's style of thinking is assumed by

many aestheticians to be noncentral to the philosophical understanding of his ideas and thus to be the business of someone, say, a cultural historian, from some other department.[20] Aestheticians will locate Danto on the map of traditional philosophy; they will speak of his Hegelian influences, of the importance of the philosophy of science for his work (even that has not been adequately discussed in the literature), and so on. All of which is true and important.[21] But Danto's context, the context which illuminates the shape of his philosophy, is also to be found elsewhere, namely, in the terrain of avant-garde, modernist thinking itself. (Or does this, rather, show that terrain to be also philosophical turf, for to locate Danto in the terrain of the avant-garde is to locate him in some potent but obscure region of life where philosophy, theory, and painting either converge or conflict?)

Second, aesthetics leaves insufficient time and energy for the arduous philosophical task of deciding how best to read and draw significance from the art examples about which a philosopher of art philosophizes. Most aestheticians acknowledge the importance of the avant-garde for Danto's work while failing to explore how Danto's thinking arises out of his reading of this art. Aestheticians do not ask how the avant-garde ought to be read, from which prismatic positions it is best interpreted, or why.[22]

In general, questions about how to read art, about what counts as a complete reading, or even an appropriate one are left inadequately discussed by aesthetics or are discussed at a great distance from the trenches where readings of artworks take place. Such questions about the parameters of reading tend to be as central, as hard, and as furiously indecisive as any others in philosophy (or art history or cultural studies). They are context-bound questions in an obvious way: such questions can only be asked and answered in the throes of reading: you cannot watch the parade of art from the outside and expect to decide how to read it. There can, of course, be division of labor, a corporate adventure into art and art theory with aesthetics, in the manner of a Hegel, waiting in the wings for the news from others in other departments of art about the results of reading. We all rely on others in our work, but reliance on others without the requisite experience of reading the material ourselves will neither allow aestheticians to test their questions about reading nor frame their criticisms of the readings of others. Danto does not wait for the news, he invents it. He learns his putative lessons about art from close study and total absorption of the avant-garde.

As an example of what I am talking about, take Danto's inspiration, which comes especially from his favored example, Andy Warhol. Yet Danto's reading of Warhol has been neither challenged nor reinforced by others in

aesthetics (this is not true of art criticism and art history, which have challenged his views). Little has been said by Danto or by others in aesthetics about how Warhol's other voices might or might not cohere with his reputedly philosophical voice in spite of obvious controversy surrounding the very idea that Warhol, that archstylist, mannequin, art director, and wearer of dark glasses, is philosophical to begin with. Danto assumes Warhol is an avant-garde philosopher in art, whose work has engendered Danto's own. The question must be whether the alliance between Danto and Warhol is one of fellow philosopher-artists who are doing the same thing, or whether it is simply a case of Danto's modernist projection of a reading and a theory onto Warhol. (If the latter, then what is it about Warhol's art which makes it into a screen that encourages and accommodates Danto's projection?)

A typical response from the wings of philosophy to my charge about lack of attention to the art example (here, Warhol) will run as follows. The truth of Danto's philosophical claim that art is theoretical should be assessed independently from his historical claim that Warhol was the artist who showed him this truth. Theory might define art, but who cares if Warhol was the man who demonstrated it? On this line of reasoning, whether Danto's reading of Warhol is correct or not is a matter for art history and art criticism; whether Danto's philosophical claims about art in general are true is a matter for philosophy.

This response is misleading on two counts. First, in a specific instance, a philosopher might, of course, give a bad reading of an artist but still make a good general point about art (Kant is a notable example; his tastes were dismal while his philosophy of art was brilliant and reflective.) But in the present instance (as in most), how can we even determine whether Danto's discourse about theory in art is true without developing questions about how to ascertain the level of theory in a full range of art examples? And what art could Danto be right about if not that obviously theoretical art which is his starting point, the avant-garde? Second, it has not occurred to such persons that Danto's reading might not betray the structure of his philosophy in gel, that his style of reading might reveal his philosophical approach, and that his choice of favored examples might explain much of the substance of his philosophical thoughts.

As an interpreter of the avant-garde, I believe Danto does to the avant-garde exactly what it does to itself when it claims to prefigure its artworks by a theory. Danto's reading, like the avant-garde's own self-explanation, assumes a transparent relationship between art theory and art practice where there is none to be found. His reading of the avant-garde falls short

in exactly the same ways the avant-garde's own reading of itself falls short: by repressing the complexities of the art example in the interest of a utopian theory of art and of art history. Danto's reading of the avant-garde must be tested in ways similar to the ways by means of which we will test the scope and truth in the avant-garde's own theories about its art.

Specifically, to assess Danto's work is to do three things. First, and most obvious, it is to test his theories in terms of the art examples they aim to explain. Danto claims the avant-garde is essentially impelled by the urge to philosophical theory. How far does the philosophy in avant-garde art go? Where does the philosophical voice in avant-garde art stop? What other voices are there in the art? At what points do the visual features of a con-structivist object or a Mondrian abstraction resist the master voice of theory which aims to rule the work? Or to put it more strongly, how true is it that avant-garde art really has a master voice of philosophical theory at all? Just because an artist such as Mondrian claims that his artworks exemplify facts of political harmony or platonic order does not mean that they even begin to do this. People talk a lot; that doesn't mean they do what they say. And what do they really want to be? Some people and some artists claim that their art does such and such, but when they turn from talking to making, there is a subtle shift in their intentions. Then how does one interpret these intentions, theoretical or otherwise? Such interpretive intricacies call for philosophical speculation but also for skepticism abut interpretive certainty and for sensitivity to the many voices, theoretical or otherwise, a work of art might sound when reflected in the prism of its various contexts. Only when these voices are explored can we be in a position to decide just how philosophical the avant-garde is, and just how correct Danto's reading of the avant-garde is.

Second, we must ask whether Danto's notion of theory is the same as the avant-garde's. Both share a commitment to the transparent relationship be-tween theory and the art object, but do they mean the same thing by "theory"? Danto offers his own theory as on a par with, indeed as the cul-mination of, the avant-garde's own project, thus suggesting they are the same. But we have no way of knowing whether Danto's notion of theory *is* the same as the avant-garde's until we determine what constructivism or Mondrian mean by theory, and then what Danto means. We therefore have no clear picture of how Danto's notion of a theory intersects with art and its notions of theory until a dialogue over the notion of theory is set up be-tween the two. Without a sustained discussion of avant-garde art, we will have no way of fully understanding *Danto's* idea of theory, not just con-

structivism's. A dialogue between philosophy *in* the art and philosophy *of* the art is in order.

Third (and related), we must explore avant-garde art in sufficient detail to be able to position Danto's inheritance of its mentality more clearly. We must trace Danto's assumptions about theoretical prefigurement, about the art example, even about the utopian role of theory to their avant-garde roots (as well as to their other roots in Hegel and the philosophy of science). We cannot define these as part of an avant-garde mentality until we get a clear idea of how they emerge from avant-garde thinking and discourse.

A reading of the avant-garde is therefore required not simply to test the avant-garde's own claims about the nature of its artworks but also to understand and test Danto's philosophy. My readings set the stage for a more general and philosophical dialogue between Danto, avant-garde art and theory, and me about what it means to say that theory defines art. This dialogue takes place in chapters 6 and 7. My stress in the readings of constructivism, Mondrian, and Cage will have been on the myriad ways in which theory does and does not inform the painting or music it claims to structure. If by theory Danto means the kind of theories one finds in one's favored avant-garde examples, then theory cannot be the one essential condition of art, for the artworks of the constructivist, of Mondrian, and of John Cage all resist or even ignore their theoretical voices; the visual (or in Cage's case, sonorous), spiritual, and political aspects of their works are partially independent of their theories. We will, however, see that Danto is never quite clear about what he means by a theory, and I will discuss various things Danto might mean by a theory.

My own approach to theory is to view the theoretical element in art, however it is construed, as one of numerous elements (visual, spiritual, historical), none of which completely rules the others, and all of which together define the art object. Mine is an organicist approach which attempts to draw a philosophical moral from my readings of the avant-garde art example about the kind of marriage with the visual features of an artwork that is required in order for the artist's theory to succeed in even partially structuring her artwork.

It is especially important to me to show how Warhol's work resists Danto's explanation of it. In my own reading of Warhol (chap. 8), I discuss Warhol's ambivalent place in the legacy of the avant-garde, along with his complacent, anti-utopian indifference to theory. If the general question in my avant-garde studies is, "Why is theory called on by art to play a role? the

specific question in the reading of Warhol is, Why and to what extent does Warhol, an artist interested in Duchamp, abdicate any clear interest in theory? What does that show about his work?

My reading of Warhol concerns not simply Danto but also our contemporary inheritance of the avant-garde's theoretical game and theoretical assumptions, about which we of the present period are quite ambivalent. On the one hand, we, the contemporary artworld, are the inheritors of Warhol's legacy of gaming whose ever-so-cool detachment resists the game of theoretical self-definition and theoretical exploration. Warhol prefers to live in the phosphorescent glow of the Pop soul. On the other hand, we are the inheritors of the avant-garde's commitments to theoretical empowerment. In spite of our rejection—in one voice—of all commitments, theoretical and otherwise, in another voice we still believe in a transparent definition and explanation of the art object by theory. And our commitment to the role of theory in art is politicized, if not utopian. Finally, in chapter 9, I explore aspects of our ambivalence to the project of theory; I explore it by raising the question of how one can provide a theoretical explanation of it. My aim is to trace our inherited belief in theoretical empowerment to its source in avant-garde norms (it can be traced to other sources as well). But how much can I say? In general, how stringent a theoretical explanation of contemporary uses of theory will suffice?

Regions of contemporary art and theory assert that a strong explanatory scheme, a grand narrative, can be found which will give shape to the schisms of the times. Specifically, this mentality expresses itself in contemporary philosophy and cultural studies through the assumption that a shape can be found to the current "postmodern" age, a shape perfectly illustrated by certain unique art examples. According to this mentality, the concept of the postmodern is characterized in terms of the imposition (in the manner of Hegel) of a univocal shape onto the diverse cultural examples and trends comprising the current age. The theories of Arthur Danto, Jean-François Lyotard, and others exhibit such a mentality (in spite of the power in each one's view). These philosophers articulate the shape of the times by relying on some favored art example or category of art that is taken to be uniquely illustrative of the structure of the age. Thus each holds to the second assumption of the modernist mentality I have discussed in addition to the first, the assumption that an art example can be found which uniquely illustrates the theory. Needless to say, the example is culled from the domain of the avant-garde.

I make no modernist claim to generalize from these two philosophers to philosophical thinking in general today, or even to provide the only perspective from which these two thinkers can be understood. I merely claim to trace their mentality to avant-garde sources. Others in the rich and growing industry of postmodern studies do not theorize postmodernism in this synoptic way. Others will speak instead of the elusiveness of the age, an age which, like any other, reveals significant trends, ongoing conversations, shared beliefs and styles of reasoning, shared commitments and disappointments, shared causal sources, common concerns, and ongoing arguments. I myself am highly skeptical that there is an age called "the postmodern" which can be defined by a theory which gives the postmodern a clear shape. Yet even those who favor my view, even those who do not believe one can find a clear shape to the age, are all too often committed to the assumption that their theories transparently explain the art they address, and they discover in such art—or invest it with—political if not utopian power. Conspicuous is a lack of skepticism about the applicability and scope of the theorist's own metanarratives; all too often, theory is simply used, it is not scrutinized. Thus, in my view, the traces of the avant-garde's attitude toward theory can be found in regions of the artworld which do not subscribe to the strong concepts of explanation found in Danto, Lyotard, and other philosophers.

This mentality can also be found in the regions of art making itself. In this regard, I explore two things. First, I explore the reception of theory by a number of younger artists and critics. Chapter 9 considers a variety of ways in which contemporary art receives theory. In its extreme form, the subordination of the visual aspects of an artwork to a theory becomes a living illustration of Danto's picture of what an artwork is but with results which are far different from anything Danto would have expected. For what is evidenced is the attenuation of the artwork, its loss of interest, and its subsumption under a hyperbolic set of references to the written word (then why not simply dispense with the artwork and read the books?). Art lives when its visual aspects resist its master theory or when its visual aspects contribute to the formation of the theory or when they force the theory to conform to the power in the image. It is a basic concern of this book to bring home the meaning and force of these basic facts about art by *showing* them in my readings of the artworks themselves. To merely *state* them is as yet to have done nothing.

I therefore subject the norms of theory to the same skepticism to which theory subjects the artwork. I do not do this to deny the forces of theory—

in a way, the last avant-garde activity there is. I am respectful of theory's attempt to continue the discourses of the avant-garde, to help the fly out of the bottle of cultural atrophy. James Holston, in an excellent book on utopian architecture, speaks of the "alternative futures" dreamed by avant-garde architecture.[23] I, too, respect the avant-garde commitment, however delirious, to envisioning powerful, alternative realities. And I respect the traces of this commitment in the contemporary scene: in art theory and in theoretical art. Nor do I want, like some intellectual Luddite, to turn the clock of art making and art history back to the days of purple prose, purple orientalism, and self-satisfied connoisseurship. I simply wish to reactivate the eye and refine the mind by making both skeptical of the claims of theoretical transparency, such that we might do theory better by doing it more reflectively. Thus it is crucial to the design of the final chapter that I have no theory of theory, but rather that I urgently search for how to voice a set of remarks about the role of theory in the art world of the present time. I am frankly suspicious of all generalization in the face of the richness of the examples. I think the best shard in the fractured legacy of the theoretical wing of the avant-garde is that part of contemporary art (exemplified, I believe, by Jenny Holzer) which speaks in a voice of theoretical urgency while remaining suspicious of the theory behind it.

What ties this book together is its exploration of a mentality which I refer to as avant-garde. I find variants and traces of this mentality in the writings of artists, in their artworks, in philosophy, and in cultural studies. I illustrate it by example. My probing of this style of thinking forces the raising of many questions about the intricacies of reading the artwork, about its intricacies of voice, about how an artist's words do and do not spell out a theory, about how much the artist really holds to that theory in practice, about how to weigh the evidence of one's eyes against the evidence of the artist's words.[24] What are at stake are the synoptic claims of a mentality that adulates the suprapositive role of theory in the avant-garde and in all art. And what is more generally at stake is the epistemological confidence by which the modernists, be they avant-garde artists or professional philosophers, can claim to know what makes art art, and furthermore, can claim to know how this defining property generates a luminous, utopian shape to art history (if not to the history of the world).

My readings are meant to undercut this confidence by stressing the complexity of the art example over all simplified claims about what prefigures it. My aim of showing that avant-garde art can exist as art only by resisting

its theories can be loosely thought of as "poststructuralist"; it owes even more to the ideas of the later Wittgenstein. Since it is my intention to stress the complexity and partial undecidability of the art example against claims about its essential simplicity and theoretical clarity, my readings must proceed slowly. I wish to avoid at all cost quick judgments and quick slogans. The length of my readings is, I hope, offset by the level of detail and thought I am to bring to the artwork and to the artist's discourse.

It is also my intention to use my detailed scrutiny of the art example as a way of bringing out philosophical issues concerning the nature of theory in art, to speak to the question of what visual conditions must obtain for a theory to actually inform an artwork; this does not happen automatically. This task is philosophical, I find, concerned as it is with the exploration of a mentality. Others may call my work merely a chapter in the history of culture. Then what do terms like "philosophy" and "cultural studies" mean, what should they come to mean, according to what post-avant-garde style of thinking?

The structure of my book is interdisciplinary by requirement, not simply by design. Any interdisciplinary work of this kind invites difficulties of reception. I am trained in philosophy, yet this is not merely, or even primarily, a book in philosophy. Rather, it is a book that renders problematical the very distinction between a philosophical book and a book in art history, in music history, in intellectual history, or in cultural studies. Readers from any or all of these disciplines will find questions, artworks, or texts of importance to them that I have either omitted or, to their minds, have inadequately discussed. Parts of the book may fatigue or bore one kind of reader or another. Simple descriptions of philosophers or artists must be given to ensure that everyone can follow the narrative thread, and I urge the reader who tires of what looks obvious (some description of Mondrian's cubist period or of Descartes's idea of proof) to tentatively skip a few pages. I have made every attempt to familiarize myself with and cite avant-garde studies from a variety of disciplines, but no one can know or cite everything, except at the risk of total boredom for everyone. Moreover, styles of procedure and of citation, of what counts with respect to an earlier study by another writer, of how much time and energy ought to be spent on a topic, differ from, say, art history (where a litany of previous writings on a subject is expected and a very slow mode of procedure from artist to artist is the rule) to philosophy (where the expectation is that you engage a topic by moving succinctly into the argument with relatively little reference to past writings). I have chosen a middle ground which, as such, cannot satisfy everyone. I hope it satisfies

some. If I am even close to being right, my study must proceed in a fundamentally interdisciplinary way, and I have cut a path through the byways of the various disciplines in keeping with the exigency of my subject. Others are free to cut different paths, so long as they don't end up destroying the terrain altogether and building huge edifices in its place, something theories and even academic disciples have unfortunately often ended up doing.

Part 1 / Studies in Avant-Garde Art

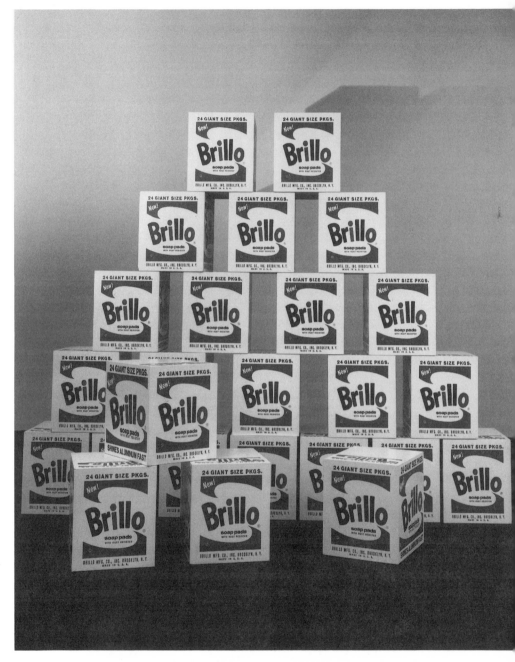

Andy Warhol, *100 Brillo Boxes,* 1969 version of the 1964 original. Acrylic silkscreen on wood, 20 × 20 × 17 in. Norton Simon Museum, Pasadena, CA.

1 / *Setting the Stage: Arthur Danto's Reading of the Avant-Garde*

Let us begin by sketching Danto's reading of the avant-garde, for it will serve as a challenge to our own reading. We will return to the substance of Danto's claims in the second half of this book. Arthur Danto is nearly unique among American philosophers in the seriousness and imaginativeness of his response to twentieth-century art.[1] Like Collingwood and Hegel before him, Danto believes that aesthetic theory must, above all, be responsible to the challenges of the new, for in the originality of the new resides a potential antidote to embalmed habits of philosophizing about art. For Danto, quintessential New Yorker and former painter, the new is the avant-garde and the postmodern. We all know that avant-garde art has raised innumerable questions for intellectuals of all kinds. According to Danto, the question avant-garde art has raised for twentieth-century aesthetics is that of art's theoretical and philosophical character. The conceptual character of avant-garde art, the rigor of its interpretive requirements, its flirtation with incomprehensibility, and its critical and philosophical stances have all conjoined to thematize for the aesthetician the crucial element of theory in defining and interpreting art.

The avant-garde, having delivered this topic of theory to Danto on a large silver platter (on which sits, as we shall see, oversized Brillo boxes), has set Danto to work. The synoptic reading Danto has, in turn, delivered back to avant-garde art about itself is a reading which claims that the avant-garde and Danto share a sensibility and a project: both are philosophers jointly investigating what art is. Danto's Hegelian reading of the history of art claims that art history has been impelled in this century by the search for philosophical truth about what art is. Hegel had already argued in the *Philosophy of Fine Art* that great art is philosophical in the dual sense of being a revelation of the nature of its specific medium and a revelation of the background cultural shape defining its zeitgeist.[2] According to Danto, avant-garde movements have been obsessed with both of these aspects of self-revelation. On the side of the medium, avant-garde movements have produced innovations in art which have attempted to reveal the nature of the art medium transparently.[3] On the side of the zeitgeist, our most materialist and most self-reflective times have demanded of the avant-garde that

25

it take cognizance of the difference between works of art and ordinary material objects. The avant-garde has responded to this challenge of the times by attempting to construct visual objects which would reveal their own place in the world of materials, commodities, and things while also showing themselves to be more than mere things, which is to say, objects transfigured by the art world and its theory.

It took, according to Danto's narrative, exactly the artist one would have least expected to culminate this magnificently abstract task of self-demonstration, namely, Andy Warhol. If Danto is right, behind those dark glasses and that pasty skin lay a mind of powerful philosophical preoccupation. (Then the glasses were some joke, no?) The task was brought off in Danto's own presence, at Eleanor Ward Stable's Gallery in 1964, where Warhol placed on exhibition his *Brillo Boxes* construction. Warhol's *Brillo Boxes,* if Danto is right, finally revealed to us the nature of art. Starting from the conviction that Warhol's *Brillo Boxes* is a work of art while its ordinary counterparts are not, Danto reasons that Warhol demonstrated that, since there is basically nothing in *Brillo Boxes* which is meant to distinguish it from ordinary Brillo boxes that you could find in the supermarket, what makes Warhol's boxes artworks and not mere Brillo boxes must reside in a property outside the work itself. In Danto's words,

A great deal more was achieved through the Brillo Boxes than this, to be sure, but what was most striking about them was that they looked sufficiently like their counterparts in supermarket stockrooms that the differences between them could hardly be of a kind to explain why they were art and their counterparts merely cheap containers for scouring pads. It was not necessary to fool anyone. It was altogether easy to tell those boxes turned out by Warhol's Factory from those manufactured by whatever factory it was that turned out corrugated cardboard cartons. Warhol did not himself make the boxes, not did he paint them. But when they were displayed, stacked up in the back room of the gallery, two questions were inevitable: What was it in the history of art that made this gesture not only possible at this time but inevitable? And, closely connected with this, Why were these boxes art when their originals were just boxes?[4]

This property outside *Brillo Boxes,* which makes it art and not merely another supermarket cleanser, Danto identifies as an interpretive theory of art held by the artworld. Warhol's box demonstrated to him and demonstrates to us that what turns ordinary objects into artworks is a theory. Note the philosophical scope Danto gleans in Warhol's demonstration. Warhol's artwork is not simply about what defines it; it is about what defines *all* art. Warhol's boxes crown the avant-garde project of philosophizing about art by demonstrating a general claim about all art (not simply about the art of

the avant-garde). Further embroidered by Danto, the claim is that it is a historically evolving theory of art held by the artworld which defines and interprets art. The immediate question is, What kind of theory is this? How is it related to the avant-garde's own style of theorizing? Since avant-garde artists, including Warhol, are themselves surely part of the artworld, a reading of the avant-garde's own style of theorizing is required before we can further decide what the nature of this theory is that Warhol discovered defines all art.

Danto claims that the avant-garde is impelled by the project of philosophical self-discovery and by the *avant-garde,* he means everyone from the Picasso of 1911 to the Warhol of 1964. The avant-garde's innovations in the art medium are developed with an eye to philosophical self-revelation. But as for the revelation of the zeitgeist by art, one would have thought, had one listened to the ferment in the studios of the avant-garde itself, that the avant-garde had its own ideas about its place in the zeitgeist. One would have thought it considered its place in the zeitgeist to be one of transforming the world and not simply interpreting it. While such avant-garde artists as Gabo, Gino Severini, and Mondrian themselves claimed to have envisioned a utopian future in the ringing rhetoric of their newly articulated artworks, Danto claims that the project which the avant-garde really developed and brought to fruition (as opposed to dreamed and failed) was instead the philosophical one of mere self-revelation contemplated by Warhol. On Danto's reading, in spite of its own assertions to the contrary, the avant-garde's deepest intention and greatest success was its philosophical project, not its revolutionary one.

This claim that the revolutionary project of the avant-garde is different from its philosophical project would have shocked an avant-garde artist such as Gabo, for whom, I will argue, there was little point in making art into philosophy if the goal was not to transform culture and politics. Even a brief look at the writings of the avant-garde will reveal how consistently it merges philosophy and revolutionary rhetoric in its writings. Mondrian continuously slides from Platonist pronouncements about art and reality to the place of art in envisioning the world of the future, for the new world he envisions is a platonic transformation of the old world. Then for Mondrian, art's philosophical search and its revolutionary practice are not distinguished.

Danto is, of course, right to have noticed how central philosophy is for (a segment of) the avant-garde. The question is, how central? He is right to have responded to the philosophical urge in the avant-garde for a newly

innovated medium which will reveal its own nature transparently. There the question is, how successfully was this carried off? And he is right to have connected the avant-garde's search for a new medium with its philosophical character. There the question is, how and why? My aim in the readings which follow is to show that Danto has oversimplified the reason for these avant-garde developments. In my readings of constructivism, Mondrian, and Cage, I will stress that the reasons for these developments, while multiplex, revolve around the avant-garde's utopian, world-transforming commitments. I stated in the Introduction that the game of theory and the aim of utopianism go hand in hand in the avant-garde. Danto's reading fails to appreciate the depth of this point. Bringing this point home will be a central task of my subsequent readings of the avant-garde. In a word, the constructivist, like Marx, does not seek merely to interpret the world as a philosopher, he or she seeks to change it. The question is how the artwork is supposed to accomplish this feat. The answer, while again multiplex, has to do with how the artwork is meant to be turned into a perfectly prefigured embodiment of philosophy, an object whose form will exemplify and call forth the revolutionary future of life turned into philosophical truth.

And if I am right, it is also from the perspective of world transformation (although not only from this perspective) that the urge away from philosophy in the same segment of avant-garde art must be understood. I also stated in the Introduction that a central question will be how far the philosophical voice goes in defining avant-garde art. It will be my thesis that the utopian character of constructivist art is brought out by the way philosophical clarity converges in the artwork with voices that are neither philosophical nor clear but which are, rather, voices of risk, action, and revolt. Only when philosophy is melded to these other voices does the full utopian force of the art make its presence felt.

Then I will test Danto's thesis that the avant-garde's game of play with theory, its explicitly theoretical turn, is caused by its aim of philosophically revealing its own difference from ordinary objects. And I will test his conclusion that what those avant-garde philosophers demonstrated was the defining role of theory in making ordinary objects into works of art.

Why does Danto pinpoint the factor of theory? To say that something outside a work of art makes it what it is is not yet to conclude that the relevant property must be a theory. A variety of contextual factors such as history, society, the art market, taste, and the artist's education, all of which reside, in some sense, outside the artwork (as well as "in it"), might also serve to define the artwork. That Danto pinpoints without argument the

factor of theory must be an expression of assumptions he brings to the act of deciphering the avant-garde, assumptions substantiated in his mind by his encounter with it.

Such assumptions demand exploration. I will understand Danto's assumption that theory transparently defines Warhol's art object to be an inheritance from the avant-garde's own theoretical mentality. Not only does Danto focus on the property of theory, he does so to the exclusion of potentially significant visual differences between Warhol's *Brillo Boxes* and actual ones, differences he acknowledges and then immediately elides without argument. Danto assumes that Warhol's point was to demonstrate, I repeat, that (1) since there is no difference between a Warhol box and an ordinary one, yet (2) the Warhol box is art and the ordinary one is not, then (3) it must be a property outside the visual scope of the object that makes the one box art and the other not. But we cannot decide if this was Warhol's point (or was even among his goals) until we take note of the visual differences as well as the visual similarities between his box and ordinary ones. Only then can we decide (and how do you decide this?) whether the visual differences should be ignored. Warhol's boxes are oversize and made of plywood. They are closed, empty, painted, and silkscreened.[5] They look useless, ironic, and playful, even absurd. Are these visual facts significant or not? We need some discussion from Danto about why Warhol would have bothered to make his boxes look so different from ordinary ones if he invested no significance in their visually unique features. If Warhol's primary reason in making these boxes was to stimulate the thought that they are (really) identical to ordinary ones, differing only by their presence in the gallery and a theory to back them up, why did he make them oversize, why do they look both painted and mass produced, what is the reason for their comedy?

Duchamp, an artist well loved by Warhol, did exhibit art objects which really were visually indistinguishable from ordinary objects; in fact, they were ordinary objects. I refer to Duchamp's *Ready-Mades*. The point in Duchamp's *Ready-Mades* is itself complicated. Exhibiting them is Duchamp's way of raising, *but not answering,* the question of how ordinary things relate to art objects—by extension, the question of what art is. His artworks are philosophical stimulants, not philosophical demonstrations of anything more than the fact (itself monumental) that in some circumstances (art-historical, cultural, and theoretical) ordinary things can become art objects. But what makes even Duchamp's *Ready Mades* artworks and not just the ordinary objects they also are cannot be answered until we have a reading of the visual qualities and connotations in the objects Duchamp chose, and of

Marcel Duchamp, *Ready-Made, Why Not Sneeze Rrose Selavy?* 1921. Marble, blocks in shape of lump sugar, thermometer, wood, and cuttlebone on small bone cage, 4 ½ × 8 ⅝ × 6 ⅜ in. Philadelphia Museum of Art. Louise and Walter Arensberg Collection.

how such qualities are exploited in Duchamp's gesture of exhibition. Duchamp's choices of objects are quite specific. He searches not only to parody the auric splendor of artworks by choosing ordinary and intimate objects such as combs, but he also searches for the erotic, poetic, and comical resonances in the objects he chooses. His choices tease out of the viewer strings of free association and trains of thought, for Duchamp is a surrealist poet of objects.[6] A comb, in the right circumstances, can remind one of the hair of women, of Degas's paintings of nude women just out the bath, of coiffure, stroking, and manipulation. Anyone who understands the role of expression, correspondence, and free association in the experience of art knows Duchamp's play to be about the attitudes and capacities we bring to art as well as to ordinary objects. In this sense artworks *are* ordinary objects; both are defined by patterns of association and response. Duchamp's is a theater of exhibition which exposes, analyzes, defamiliarizes, toys with, but also, in some erotically liberated way, celebrates our most constructed—our most naturalized—ways of seeing.

Warhol's boxes partake of some of Duchamp's questioning about art. They stimulate trains of thought about art, mass production, and a lot of other things to be discussed in chapter 8. Warhol's boxes are indeed philosophical stimulants, although I doubt whether they supply any sort of answer or "demonstration." But if Duchamp's poetic gaining is a matter of qualities in and associations to the objects he chooses, Warhol's game is played over those features of his *Brillo Boxes,* which are unlike the features of ordinary Brillo boxes; it is not simply played out over features which are (more or less) the same. The oversize character of Warhol's boxes makes a comedy of art and exhibition. It inflates commodities to their true scope and true size (their size in advertisements, on TV, and splashed across the billboards of the strips of America). Warhol's boxes parody as much as they mimic. In this game of pleasure and parody lies Warhol's ambivalent relation to commerce, to America, and to a lot of other things on the agenda for discussion.

Warhol's game is, then, to do far more than theorize; indeed, the role of theory in his game is far from clear. Since Warhol is crucial to our contemporary inheritance of art practices, to establish the terms of theory in his game will be important. Only then will we be able to decide if Warhol is the culmination of the avant-garde in Danto's sense or, rather, an example of its fragmented legacy.

Our stage setting is not yet finished, for there is more of Danto's grand narrative to introduce. Its final, Hegelian, phase brings us right into the 1970s and 1980s, concluding with a reading of postmodernism. Warhol, having offered to art his most philosophical *Brillo Boxes,* succeeded in bringing art history to a close. It may not have brought about the utopia dreamed of by the avant-garde, but it has succeeded in liberating art itself into a utopian artistic (if not political and spiritual) space. Danto announces with all possible enthusiasm that, with Warhol's *Brillo Boxes,* "a century of deflected philosophical investigation came to an end, and artists were liberated to enter the post-philosophical phase of modernism free from the obligation of self-scrutiny."[7] He goes on to describe the postphilosophical phase in these marvelous terms:

Warhol was, appropriately, the first to set foot in this free moral space. There followed a period of giddy self-indulgence and absolute pluralism in which pretty much anything went. In an interview in 1963, Warhol said, "How can you say one style is better than another? You ought to be able to be an Abstract Expressionist next week, or a Pop artist, or a realist, without feeling you've given up something." Who can fail to believe that, in art at least, the stage had been attained that Marx

forecast for history as a whole, in which we can "do one thing today and another tomorrow, to hunt in the morning, fish in the afternoon, rear cattle in the evening, criticize after dinner, just as I have a mind, without ever becoming hunter, fisherman, shepherd or critic." Its social correlate was the Yellow Submarine of Warhol's silverlined loft, where one could be straight in the morning, gay in the afternoon, a transsexual superstar in the evening and a polymorphic rock singer after taking drugs.[8]

This utopian space in which art can now happen has been produced by art's self-revelation of its own theoretical nature. Danto's narrative demands a reading of the polymorphic, postmodernist position of contemporary art which Warhol's theoretical genius supposedly engendered. Since in this book I am interested in our inheritance of the avant-garde's theoretical stance, Danto's synoptic reading of twentieth-century art (and, by extension, of art in general) provides a convenient narrative frame. I intend to show that the history of art, including and especially the art of Warhol, resists Danto's claims about art's theoretical prefigurement. I intend to show that the reasons for the search for a transparent medium of art in this century are different and more multiplex than Danto's reading acknowledges. I also intend to make it clear that Danto's reading is an avant-garde reading of the avant-garde. Danto's reading goes wrong, paradoxically, because it shares the very pair of assumptions about art which the avant-garde itself holds to, assumptions about (1) the role of theory in transparently defining art and (2) the uniquely revealing art example which allows his reading to be synoptic. The avant-garde is as right—and as wrong—about itself as Danto is about it. Then if Danto's narrative is a convenient frame for this book, supplying us with a synoptic reading of the avant-garde's project, my own reading of the avant-garde's mentality must be a frame for the reading of Danto. Only by understanding what the avant-garde's mentality consists of can we understand that Danto's reading of the avant-garde is an avant-garde reading, a reading motivated by variants of the same mentality, which represents in extreme form our avant-garde inheritance.

2 / *Constructivism's Descartes*

This is the first of my three studies of the philosophical character of avant-garde art. I stated in the introduction that I have a theory to present about the game of philosophical theory avant-garde art is engaged in, specifically, about how the avant-garde intends to prefigure the form of its artworks in accord with philosophical theory. I will understand the reason for the avant-garde's desire to prefigure its works by philosophy in terms of the avant-garde's world-blossoming, utopian concerns. Danto and other writers have called attention to the philosophy in avant-garde art (although few have tried to work out its nature precisely). Nearly everyone has called attention to the utopian character of avant-garde art (and how could one not, when "utopia" is stamped across every page of every avant-garde manifesto, pronouncement, periodical, letter, and debate?). What has not been worked out in detail is how the formal innovations in the art medium, so important to these artists, are called on to make the artwork philosophical, much less how the perfected philosophical artwork is meant to exemplify the utopian or perfected future announced by it.

That modernist movements and schools such as constructivism, the Bauhaus, De Stijl, and others were highly theoretical is well known. The avant-garde position of such movements, their utopian desires to bring about a new and perfected world order by erasing the excrescences of the European past, by defamiliarizing the European person from his (or her) received attitudes toward everything, by starting from scratch and building this new future, all of this demanded the search for a theory of what the new, utopian world would be like and how the artwork or architectural project would play a crucial role in stimulating the prospect of this new world order. The turn to philosophy, to science, to Marxism, to mathematical models on which artworks were based, all of these relentless appropriations of concepts and models into art by the avant-garde were at the service of theory construction, of finding a way to articulate these most obscure relations between the artwork, the world, and the future. Such artists tended to slide from one theoretical model to the next with ease or to blend various theoretical models into a kind of montage which can only be called modernist, as if their theories were themselves as disruptive, as shocking, and as intox-

icating as their experiments with form and materials. An El Lissitzky pronouncement is as audacious, as clever, and as shocking to the mind as an El Lissitzky Proun is to the eye (see text at n. 3 below), making one think that the modernist assault is not simply on the eye but on the mind as well; making one think that theory is, in the hands of an El Lissitzky, not simply a way of articulating the terms for the new art and its relation to the new world order but is itself a kind of weapon, poised alongside Lissitzky's visual art as part of his avant-garde assault on the present in the name of the future.

This is a way of saying that theory and practice have no ultimately clear boundaries in the field of the avant-garde, a point made in a somewhat different way by Peter Bürger in *The Theory of the Avant-Garde*.[1] Theory is brought into art in the spirit of praxis, not simply in the spirit of philosophical contemplation about the nature of art for its own sake. Thus if we wish to understand the nature of an avant-gardist's reliance on theory, we must look to his or her mode of engagement with the world. It is only from this perspective that the avant-garde's actual historical relations with theory will make sense. It is only from this perspective that the avant-garde's restless shifting from one theory to the next, its admixture of supreme confidence with which it states a theory at a given time and its willingness to forgo that theory in the next moment only to take up another with equal intoxication, that its development of what Marjorie Perloff, in her book *The Futurist Moment* (Intro., n. 24), calls the "art of the manifesto"—it is only from this perspective that its appropriation of philosophy into a utopian framework, in the end also makes sense. Experimentation with theory is as important a feature of avant-garde activity as experimentation with new art forms and new materials. Gabo, the master of both, goes through genres of theory just as he goes through genres of sculpture (his perspex "heads," his open cubes, etc.). Yet Gabo's movement from theory to theory is not random; all of the theories are related, just as all of the sculptures are. Gabo's theories all tend to have a sort of Cartesian ring: they all rely on some central notion of an artwork's construction from clear and evident simple elements into a lucid whole by a clear method of construction. It is the related pattern of theories which, as a whole, tell us what Gabo's project was, just as it is the whole pattern of artworks he created in his lifetime which tells us about the vicissitudes of his avant-garde life.

In this chapter I will understand the constructivist aim, and especially Gabo's, of producing a transparently constructed art object to represent a

Cartesian wish, which is to say, a Cartesian theory: the wish and the theoretical attempt to make the artwork as reflectively clear about its mode of construction from simple formal elements as a Cartesian proof. And I will develop the utopian reasons for the constructivist commitment to transparency through the idea of the artwork as a perfected example, an example of philosophy embodied in the world. In the work of art's construction from simple elements is a starting from scratch which rejects all things past, all bourgeois encumbrances, all outmoded and outdated forms of social and political life, all merely aesthetic pleasures, all things reactionary. In its clear mode of construction resides the example, the metaphor, the possibility of a future designed and brought about with total clarity of mind and purpose. The clarity of form evidenced in the art object exemplifies the embodiment of new social, political, and spiritual values which will make the world over, bring it to recovery, and revitalize it. The material force of the constructed art object contains an intense energy which will empower such revolutionary building with the confidence, indeed with the certainty, by means of which an engine pushes a train toward a destination whose route is well marked.

But if my aim is to outline this majestic constructivist intention, my concern is also to be suspicious of my own theory of avant-garde intentions, which, like so many other intentions, are difficult to fathom. I will be suspicious of the scope of my theory. I wish to search for the place, and therefore the limits, of the philosophical voice in constructivist art. How far does philosophy go in structuring constructivist art? How far do constructivists intend it to go—really? In answering these questions about how to read, I will claim to find a configuration of voices in constructivist art which jointly define the art and lend it its power and complexity. Moreover, a chief purpose of this study (and the studies of Mondrian and Cage which follow) will be to ask why the specific configuration of voices, philosophical and otherwise, jointly comprising the artwork, are as they are. In the case of constructivism, it is my view that the ultimate utopian (and spiritual) force in the art derives from the pattern of different voices which the art, in a sublime act of transubstantiation, mysteriously causes to converge in its formal simplicities. Utopia does not merely derive from the single Cartesian voice in constructivist art; it derives from the way the artwork seems to unify opposing voices.

In this investigation we will proceed slowly. It is among my concerns to refer to the broad history of the constructivist movement. Since constructiv-

ist voices come and go in various weights and measures throughout the history of the movement, some history is required to allow us to ask the questions we need to ask about how to read the art.

I

From its Russian and revolutionary beginnings through its relations with the Bauhaus, to its resonances in the De Stijl movement of Theo Van Doesburg and Mondrian, to its more recent incarnations in England, Italy, and the United States—not to mention much of Latin America—the constructivist project of art and design has been of central importance in twentieth-century art and culture. It has given us artwork and design of power, genius, and originality. Its emphasis on art as a process of abstract construction from basic design materials and forms has engendered major stylistic achievements, including some of the first composed sculptures (as opposed to sculptures modeled or carved) and some of the first abstract paintings. Its approach has set an example of clarity of vision and formal purity in art; constructivist writers and teachers from Vladimir Tatlin, El Lissitzky, and Naum Gabo to László Moholy-Nagy and Jesús Soto, have taught generations to appreciate the aim of exploring how far and with what degree of lucidity a plastic medium can be articulated. These internal commitments in art have been matched by the scope of constructivism's utopian aspirations for art in the larger social world. If its utopian aspirations have not been fulfilled, its legacy has extended to the fabric of the present world, from our concepts to our doorknobs, teapots, or art murals, buildings, and cities.

Central to constructivism is the idea that artworks are designed to actively and explicitly exhibit their mode of construction from simple geometrical elements, materials, or colors. The finished constructivist artwork is one which thrusts its mode of composition before your eyes.

Constructivism's utopian politics have been much discussed. From its Russian birth as a movement complete with style, ideology, and a polemical conception of the role of art in society, the constructivist approach has been much recast and much interwoven with the dialogue of twentieth-century artists and art movements. There has also been excellent historical writing on its formal innovations and its history, including the history of its interactions with the Bauhaus, De Stijl, futurism, cubism and other art movements. Its theories have been mentioned by everybody (how could they not be?), but little interpretive thought has been given to the question of how and with what degree of centrality its words and artworks should be taken

to define its theories. And insofar as one takes constructivist words to spell out a theory of art, little discussion has been concerned with how constructivist theory actually does, or fails to, inform the constructivist art object. Rosalind Krauss's work is an exception to which we will turn shortly.

Whatever complexities of theory pertain to the constructivist movement, it is clear that constructivism was brought into being with a slam and a bang. Vladimir Mayakovsky, the poet laureate of the movement, proclaimed in 1915, "We consider the first part of our program of destruction to be concluded. And do not be surprised if in our hands you no longer see the jester's rattle, but rather the architect's plan; do not be surprised if the voice of futurism, yesterday still soft with sentimental fancies, today rings out in the metal of sermons." [2]

This proclamation of death and gestation, of a Daedalus, compass in hand, who would arise from the dead ashes of whatever, is that of an art aiming to eradicate much of its past, to start from scratch and scratch out of its materials something as yet unfathomed. The ring of revolution in Mayakovsky's statement is obvious; constructivism will lead the way toward the Russian future, playing a role inseparable from the (Russian) Revolution itself. All emphasis is toward a new future. Mayakovsky tells us that even futurism is not futurist enough, being too much caught up in the delicacies of some painterly and aestheticized nineteenth centuryness currently under replacement by the metallic, material hardness of constructivism.

This announcement of a revolutionary art to proclaim and bring in the future is, of course, a proclamation of an art in stylistic revolt. As El Lissitzky writes, "Yes, we hail the bold one who hurled himself into the abyss in order to rise from the dead in a new form. Yes, if the painterly line used to descend as . . . 6, 5, 4, 3, 2, 1 until 0, then on the far side begins a new line 0, 1, 2, 3, 4 . . . and we realized that the new painting which grows out of us is no longer a picture. It describes nothing, but it constructs extensions, planes, lines for the purpose of creating a system of new composition of the real world. To this edifice we give a new name: Proun." [3]

El Lissitzky's Prouns (often translated as "projects for the establishment of the new") do not describe anything (they have neither figurative nor iconographic features), yet in their projected abstractions they contain, it seems, everything; they compose, shape, or articulate not only the world of the artwork but apparently the whole domain of the real world as such. As El Lissitzky will put it in other places, "The point of art is not to decorate but to organize life." [4] This strong claim, a utopian claim for an art doing nothing less than playing a fundamental role in structuring the future, bears a

direct connection to Mayakovsky's notion that in the constructivist work a metal of sermons is to be heard. We should both see the constructivist work as doing something—organizing life—and take its organizational dynamism as a sermonizing example of how to live generally. The artwork is then meant not only to compose the world but also to exemplify how it might (ought to) be.

Constructivism is an example of an art with a sermon voiced in its metallic hues. The sermon is supplied by the raw force of the object but also by the words behind it. Hence the need for a movement with a journal called *LEF*. For one is meant to take from the art example a sermon about how to live, an example of a life whose form is exemplified by the new design of this new art. The artwork cannot by itself show its form without a background of words (of theory) to explicate its lines, shapes, and colors, to help us to see and didactically explain how the shape of the artwork is a mirror of the future. It is, by itself, dumb. Indeed, although the constructivist call is not for sermons in words alone but rather for sermons in more concrete metals, "acids which bite into everything they touch,"[5] no group of artists has used more words in explaining, discussing, articulating, arguing for, and lauding its art. There are, in short, lots of words which go into the metal or help one understand it.

It is well known that constructivism is an avant-garde movement of a highly intellectual character. Its participants were trained in science and engineering; they had read philosophy, biological theory, and, of course, Marx. They were part of a Russian world in which spiritualism, philosophy, the theory of praxis, the distrust of theory by those committed to praxis, the conceptualization of connections between theory and praxis were issues explicitly under debate as the society reeled toward an uncertain destination. Constructivism's orientation toward the revolutionary Russian (or world) future is perhaps its central focus. Yet what that future was thought to be, how spiritual or how material, and how the combination of background words and material objects should exemplify the future and serve as a rhetorical thrust toward it are questions as complex as the plethora of movements, debates, discussions, and rethinkings that were the daily bread of that land without bread called Russia.

One can place constructivism in this setting, with its need for theory, its visual rhetoric, its thrust toward the future. That is to begin, but it is not to have solved, the relations between constructivist discourse and constructivist art objects which must now arise. Our concern must be to understand how, in the ferment of constructivism, its words inform, insinuate, or oth-

erwise inhabit its artworks. How do constructivist words figure in the metal of sermons one hears when one looks at a Tatlin wood construction, a Gabo quartet of transparent rods, or a Lissitzky *Proun*? And how important are the words for the artworks, for what one sees in their visual shapes and feels about those shapes? The answer, it is the point of this study to show, is multiplex. There is no one way to take constructivist words, or constructivist art objects. Rather, word and object form a mosaic of partially inconsistent voices, philosophical, theoretical, and otherwise. And it is the pattern of these voices which gives the movement its utopian force, its meaning, and its complexity.

One obvious thing about how words and artworks work together is worth remarking at the outset. It is something so obvious that it will serve as a kind of theme for the book, recurring when we return to Danto's philosophical receptions of the avant-garde. It is not as if one can first decide the question of what the words of an artist amount to and then figure out how (and to what degree) they insinuate the art. Rather, an artist's words only become fully comprehensible in the context of the visual experience of her work. Theory cannot entirely prefigure an artwork for the reason that it is partly in terms of the artwork that the theory itself becomes interpreted. This is a general feature of interpretation. The term *sonata* or the theory of style is only made fully clear in the context of the art examples the term or theory intends to capture.[6] We then need to explore constructivist words not only against other constructivist words but also against our evolving experience of constructivist artworks. Only then is the theory made fully determinate. In this dialectical interplay of word and artwork, a tricky question about what the work is can also arise. One reason for this is that the words might end up being in some sense part of the art; the capaciousness of the artwork might extend not only to the rhetoric in the visual gesture but also to the rhetorical twists of the words themselves, as if word and object are in alliance.

If this is so, then how could it ever be that theory defines art since the theory is only fully made determinate in the context of one's visual experience of the artwork? This point will be a theme to which I return over and over from various points of view.[7] There is a further point. Whether or not the words apply to the object—and in what degree of centrality—can only be told when one's educated eyes receive the visual force of the art object. Art can stand in resistance to its theory, to its words generally. Words, like an artist's intention, do not always make it into the finished project (so the words are *partly* interpretable independent of the finished product). Simi-

larly, the finished product can qualify what the artist's intention or the artist's words really mean. The relationship between constructivist discourse and the constructivist art object is dialectical.

There is, indeed, a question about what exactly one wishes in the end to call the artwork amid this play of signs and the visual (or tactile or sensual generally). The question should be raised of constructivism. One should be clear that constructivism is in some sense tied to a clear distinction between the artwork—the visual object you see—and the words which inform it. This is the case if only because the visual object is meant to speak in a metal that is more than words, in a currency as materialist as bread, technology, war, peace, and work. Nevertheless, the words might be part of the art not only by informing it but also by sharing in its gestures of construction and revolution. No one and certainly no constructivist said that words cannot be, in their own right, materialist, the material of acid which burns through sentimental and sedimented concepts of art and announces the metallic hues of revolution. Call those Mayakovsky's words. And he is a poet/editor, suggesting that Marjorie Perloff's claim that the avant-garde turns the manifesto into an art form is to be taken seriously.[8] The avant-garde consists of total art practices, in which the painting or sculpture is favored but is also only one element in an overall picture and proclamation of the new that includes the words. Constructivism reduces its art objects to the simplicity of an "architect's plan," but in this simplification less definitely means more.

II

Consider Gabo, the most crystalline of the constructivists and possibly the most articulate. Gabo, unlike Tatlin, Alexander Rodchenko, or Moholy-Nagy was never really a painter, hence, unlike those others, he was never faced with questions of abstraction in painting. Gabo was a sculptor from beginning to end; his innovations lay in making sculpture abstract, in freeing it from depiction and reliance on weight of materials as a basis of sculptural expression—something he commenced to do around 1920. By the 1920s Picasso had already brought the world of found objects, wire materials, old iron castings, wood, and paint to sculpture in the interest of deepening the physical and anthropomorphic resonances in the sculptural form itself, making his wire horses and wooden heads of women sing with the erotic modulations of such rough, ready, and tactile materials. By 1915 Tatlin had removed sculpture from the realm of depiction. Tatlin's wood constructions (under the influence of Picasso's pictorial collages from 1912

to 1913) bring a range of found materials to the sculptural arena, but for Tatlin this is not to enlarge the possible depictive resonances of such materials. Rather, Tatlin aims in his wood constructions for an abstract organization of elements in which an architecture is felt to evolve which derives from the densities and sizes of the materials.[9] Tatlin constructs his complex shapes like an engineer, integrating the specific gravities and stresses of his materials into an overall plan.

Tatlin's sculptural constructions fundamentally rely on the strong downward gravitational pull in their heavy materials for their power and force. His corner constructions in wood and metal, placed in the corners of rooms, seem at once to acknowledge and to actively defy the force of gravity, as if they are hard at work in their fight against that determining force. The Tatlin artwork seems to force its own labor of existence onto one. One feels its labor—a difficult, exuberant, and determined labor—just as one feels its "pictorial" clarity, as if it is a painting which has jumped into three dimensionality off the wall. Gabo's use of materials is quite different. Gabo chooses materials for their potential transparency rather than for their gravity or resistance to gravity, thus dispensing with a sculptural tradition as old as Archaic bronzes (and as famous as the work of Bernini and Rodin), which forges sculptural expression from the musical and dramatic interplay between sculptural materials and the downward-pulling force of gravity. Gabo favors plastic, perspex, and metals which can be employed with the lightness of a Miesian steel and glass curtain wall. (In this, Gabo is closer to Moholy-Nagy, who will use glass in a series of constructions done in the 1920s.) Gabo aims for a kind of floating transparency of form which negates all roles for the pull of gravity in sculptural expression. The sculptures are not weightless in the way an astronaut is weightless (i.e., unhinged), rather, the pull of gravity is no longer the fundamental organizational force of the works. Various commentators have referred to the manner in which Gabo's sculptures radiate outward, kinetically embracing the space around them. The kinetic element in Gabo replaces the elements of anthropomorphism and weight central to traditional sculpture. The sculpture becomes a field of dynamic forces which define and articulate space within and without; his is sculpture as space and the rhythmical articulation of space.

Gabo conceives of the rhythmical, kinetic element in his art as the bearer of time. When Gabo announces in the "Realist Manifesto" that "space and time are re-born in us today,"[10] he means that his artwork exemplifies the construction of life in both space and in time. In its radiant, lucid pas de deux with space, Gabo's sculptural forms mirror change, growth, action and

reaction. As we will see, Gabo's introduction of time into sculpture is really his introduction of the claims of the future into the present; his introduction of process into sculpture is his way of representing sculptural movement toward that future.

What is remarkable about a Gabo sculpture is its capacity at once to claim a dynamic or musical relation with the space it inhabits and to seem as self-transparent as a nineteenth-century bridge or a geodesic dome. It is the conjunction of dynamism with transparency which is fundamental to the experience of a Gabo. For Gabo, transparency is achieved through materials and their spacing, which make visible the simplified inner structure of the object that is constructed. Rosalind Krauss puts it thus, following Gabo's own famous discussion of how to show the inner structure of a represented cube:

Cube II . . . [the one of importance for us] is constructed differently. Its four side walls have been removed, and in their place, two diagonal planes knife through the interior of the form, intersecting at right angles at its very center. These two intersecting planes serve the purpose of simultaneously structuring a cubic volume— serving as an armature or support for the top and bottom plane of the figure—and permitting visual access to the interior of the form. What the second, opened cube revealed for Gabo was not merely the space ordinarily displaced by closed volumes but the core of the geometric object, laid as bare as the principle of intersection itself, making the figure comprehensible much the way a geometric theorem isolates and makes available essential propositions about solid objects.[11]

Krauss goes on to remark that "the thrust of Gabo's work was thus towards the conceptual penetration of form."[12] The cube should present with utter visual clarity the inner core and path of its own construction. Krauss's analogy with a geometrical proof is striking. Gabo's represented object seems designed to demonstrate something essential not only about how it is made but also about how all objects of its type are made.

The analogy between Gabo's cube and a geometrical proof seems to me deeply suggestive. Krauss mentions it and goes on; it is itself worthy of conceptual penetration. The constructivist work is one whose finished product is designed to thrust its mode of construction onto the viewer in a relatively explicit way. Here the suggestion is that the completed constructivist shape or form is meant to exhibit its underlying and essential mode of construction in a *more* than relatively explicit way. The idea that a work has an essential mode of construction is itself a presumption of its theory, for by an essential mode of construction one means a clear route to making it what it is, a defining mode of construction without which it would not be what it

Naum Gabo, *Two Cubes (Demonstrating the Stereometric Method)*, 1930. Painted plywood, 30.5 × 30.5 × 30.5 cm each cube. Tate Gallery, London. Presented by the artist, 1977. © Nina Williams.

is. That rings of philosophy, of the assumption of an art aspiring to the condition of an essential definition and demonstration.

Such a suggestion is borne out in one's visual experience of Gabo's sculptures. When one looks at Gabo's sculptures—at a lot of them—one cannot help but feel that (amid their kinetic embracing of the space around them) they call forth the sense that they are showing one, with some kind of total clarity, how they are constructed to be what they are. They invite the feel of certainty, the senses of transparency and of demonstration. That feel of resonant clarity in the work invites thought, thought about just how transparent the sculpture really is and is, in fact, intended to be.

To take an example, consider Gabo's 1937 *Model for Construction in Space: Crystal* (Tate Gallery, London). Made of transparent celluloid, this small model can be viewed as a cube or rectangular form whose front and back have been removed and whose sides have been tapered into irregular curves. (The tapered curves also suggest to the eye a set of larger circular forms which would have been present, were the sculpture extended.) Gabo thus allows vision into the center of the object. The work's center, its heartbeat, is a weightless point around which Gabo's sculptural arcs spiral. Everything is dynamized in this construction: the arc of movement is picked

up by the work's tapered sides, which present the illusion of arcs of movement running from front to back and around the top. Then the static quality of the rectangle is at once opened up to vision by deletion of forms and defeated by the running arcs of movement which turn the rectangle into a flat, spiraling shape, rather like a pinwheel. Gravity is replaced in this sculpture by kinesis. From the work's visually available center to its spiraling gesture out into the space beyond it, every twist in the sculpture is open to vision.

I will think of this feel of transparency in Gabo's work as embodying a Cartesian wish, the wish for an art of objects whose core elements and mode of construction are completely self-evident to perception (vision), as if seeing into the object is completely seeing into it. This way of thinking about Gabo's work, already suggested partly by the visual feel of his sculptures and partly by his words about how to represent a cube, would provide one with a sense in which one could think of his sculptures as informed by philosophical theory (a theory of explicit representation). But even more than being informed by theory, Gabo's sculptures would themselves be philosophical; they would be like philosophy by aspiring to its Cartesian condition of proof.

It is the shared commitment to visual demonstration, to a pellucid, indubitable perception of structure, which binds constructivism to Descartes. This idea naturally needs explication. Among other things, we will need to know how explicitly Gabo's philosophical theory of (his) art is Cartesian. When I discuss Mondrian, the case will be simpler. Mondrian, a lifelong reader of Plato and of philosophers who read Plato, makes it clear in his essays that his paintings are to be thought of in Platonistic terms (what those terms are will be less clear). There is, by contrast, no explicit reference to Descartes in any of the constructivist writings I have read. Cartesianism is, rather, a style of philosophizing and art constructing to be reconstructed from Gabo's and El Lissitzky's words, diagrams, and artworks. Constructivists are explicitly philosophical. In the course of this chapter I will discuss their writings on art, science, truth, the biological bases of vision and creation, and a further range of philosophical topics. From their familiarity with science, architecture, and engineering, from their reading, and from the ferment of their Marxist times, constructivists are well versed, and actively engaged, in conceptual debate about relations between art, science, philosophy, and praxis. But let it be clearly said that my Cartesian imputations to constructivism are matters of reconstruction. Mine is a reconstruction of the style of reasoning constructivism has about its artworks. I do not think

Naum Gabo, *Model for Construction in Space: Crystal,* 1937. Celluloid, 7.6 × 7.6 × 3.8 cm. Tate Gallery, London. © Nina Williams.

my reconstruction is purely speculative, either, for some sense must be made of the degree to which Gabo, El Lissitzky, and others articulate the aim of reflexively clear construction in art; some sense must be made of both their discourse and their artworks—of the way Gabo opens his sculpture to view on the model of his visual representation of the cube, for example. If one resists Cartesian language in the reconstruction of constructivist thinking and practice, then some other language must be brought in to account for the words and the objects.

In reconstructing the Cartesian wish for clarity in art, we will also need to ask how far that wish goes in explaining the art and words as a whole. Wishes, whether personal or Cartesian, may be left at a vague, half-recognized, and inchoate level, or they may be articulate. They may linger at the periphery of one's actions and plans, cropping up only in dreams and slips, or they may play a fundamental and explicit organizing role in a per-

son's character and action. If we think of artworks as embodying, express-
ing, or being structured by a wish, we need to ask the similar question of
how explicit, detailed, and fundamental the wish is.

My idea is to understand the Cartesian wish as directly generated by the
utopianism of constructivist art. It would be bizarre if constructivist ser-
mons in metal, if those acids which burn into time and history, turned out
to be nothing other than sermons in the idealist, logical currency of a Des-
cartes, unless the Cartesian currency were more material than one expected,
say, as material as a work of art is material, or a society is material, or the
construction of the future according to Cartesian principles of clarity would
be material. If I am right, constructivism is the putting of Descartes to work,
the claim that the future can and will be structured along lines that have
been previously thought to be only philosophical and not material. Thus
theory enters in the spirit of praxis, the question being how.

To begin with the reconstruction, notice how far Gabo's words articulate
an urge for total transparency in art. In describing his method of artistic
work, Gabo asserts, "As a quality of the plastic element of our constructive
art we have chosen the elementary, accurate and primary shapes long ago
handed over to us by psychological experience as symbols of a perfected
plastic expression. These elementary shapes are universal and available to
our general human psychology. In general, there cannot be different opin-
ions as to the psychological effect on a man of a circle, of square or a straight
line . . . just as there cannot be different opinions as to the psychological
effect of the tonic sol-fa in music." [13] Gabo asserts in the "Realist Manifesto,"
"The plumb line in our hand, eyes as precise as rulers, in a spirit as taut as
a compass . . . we construct our work as the universe constructs its own, as
the engineer constructs his bridges, as the mathematician his formula of the
orbits." [14] And in a letter to Herbert Read he writes, "Where . . . do I get my
forms from? . . . I don't take them as they come; the image of my perception
needs an order, and this order is my construction. I claim the right to do it
because this is what . . . science does, what philosophy does, what life
does." [15]

Such alliances of sculpture with science, philosophy, and mathematics
might be taken as the illusions of a man drunk on a conglomeration of
human activities which are not even so much alike. Let us not take them to
be mere ravings from an artist who devoted his life to the positioning of art
within such realms. Let us, rather, take them as expressions of the urge for
conceptual or linguistic transparency. [16] One finds a similar claim voiced by
El Lissitzky: "We have set the proun in motion and so we obtain a number

of axes of projection; we stand between them and push them apart. Standing on this scaffolding in the space we must begin to mark it out. Emptiness, chaos, the unnatural, become space, that is: order, certainty, plastic form, when we introduce markers of a specific kind and in a specific relationship to each other." [17] El Lissitzky's call is for an art in which complex shapes ("markers in specific . . . relationship") exhibit form with certainty. Art, like the new social order, like the new life, is to be built from scratch—from the primordial space of "emptiness and chaos." The question is how strictly to take Gabo and Lissitzky at their philosophical word. Since the ring of philosophical foundationalism is strong in their words, I will reconstruct this foundationalist ring. (I will then wonder how far that voice really goes in constructivist art and discourse.) My reconstruction will be very straightforward, which is what is needed.

Foundationalism has had various incarnations in philosophy: one could call it a running theme or philosophical tendency. It begins from the philosophical claim that our ideas, language, or perceptions are built on a foundation of elementary, lucid, and indubitable perceptions, intuitions, or linguistic bits. The classical empiricism of John Locke, George Berkeley, and David Hume claims that our ordinary, complex ideas are built from absolutely simple perceptions of the world, perceptions which are self-evident to the mind and available to all who share our mind (nature).[18] Twentieth-century logical atomism and logical empiricism conceives of language as a logical construction from simple names which do nothing but refer to the correspondingly elementary world. For the logical atomist (especially for Bertrand Russell and the early Wittgenstein), simple names (linked to the simple world) are assumed to be psychologically available to everybody.

The second feature of foundationalism is its commitment to a formation principle. Complex ideas, language, or perceptions are formed from elementary ones according to clear and relatively simple rules of formation. That is to say, foundationalism assumes transparency. To understand a complex thing of its kind is to have certain knowledge of the simple elements from which it is formed and equally clear possession of the principles which build the complex bit from its simple ingredients. The complex bit is an epistemologically open mirror, showing its core and mode of construction to the conceptualizing mind. For the empiricist, complex ideas are formed from simple perceptions of the mind according to clear principles of association, custom, and convention. Logical atomism holds that the correspondence between language and the world obtains through the analogous, indeed isomorphic, construction of both.

From the elementary linkage between (1) the simple names of language (or simple perceptions or intuitions in the mind) and (2) the simple objects in the world, on the one side, the edifice of the world is built up, as it were, chemically, through combination of such simple objects into complex states of affairs (the human body, a tree, a broom or sunset or grand piano). On the other side, and in absolute correspondence to the world, the language which refers to it (or the complex perceptual scheme) is built up from its simple names according to logical rules of construction. It, too, is an edifice.[19]

Such foundationalism resounds in Gabo's statements that the constructivist artwork is to be built from simple artistic elements which are psychologically available to everybody, and that there can be no interpretive disagreement about the meaning of such elements. No more disagreement ought to arise about the meaning or force of the red line with which a constructivist begins his or her work than ought arise for a classical empiricist about the simple bits of sense data which impinge on the empiricist's eye or ear.[20]

Gabo is committed to the first foundationalist assumption about simple elements. His discussion of how to represent a cube suggests that he is equally committed to some sculptural analogue of the second foundationalist assumption that the transparency of a complex object is insured by the fact that the complex one is built from elementary ones according to clear and simple formation rules. Gabo's cube makes visually available its mode of construction from simple lines in the manner of a geometrical proof (Krauss). Gabo's object (cube) is transparently represented if you can see into it in a way that is clearly and indubitably a seeing into its basic compositional shape. The mark of such demonstrability is, it appears, visual certainty itself: there simply is no room to doubt the conviction of your eyes. And a further mark of visual demonstrability is the test of repetition. The basic compositional shape your eye so certainly descries must be repeatable; you must be able to take the visual knowledge of structure you get from the one cube and construct another cube or sculpture in a way that tells perception these are exactly (essentially) the same (or at least you must be able to recognize sameness of structure in other cubes).

Two aspects of Gabo's notion of sculptural transparency place it closer to Descartes's than to other foundationalist styles of philosophy: its method and its essentially perceptual criterion of demonstrative certainty. Descartes's well-known method begins by placing his received beliefs about almost everything in doubt and rebuilding them on a better (i.e., more cer-

tain) foundation. Having doubted almost everything, the crucial moment in the *Meditations* occurs at the famous beginning of *Meditation II* when Descartes proves that he cannot doubt that he is a thinking thing. This idea of himself as a thinking thing, now shown to be cast in iron certainty, will be the foundation of his intellectual self-reconstruction. So excited is he to find it, that he asserts, with a utopian largesse worthy of any pronouncement El Lissitzky or Mayakovsky ever made, that with this one certain idea as an Archimedean fixed starting point, he should be able to move the earth with all the glory of which Archimedes dreamt. Descartes then begins his grand reconstruction by proving, one after the next, most of the large-scale ideas he doubted (that God is not a deceiver, that his body exists, that the world is more or less as he thinks it is, etc.).

It is Descartes's procedural focus on the actual finding of simple ideas that allies the constructivist with him. Other foundationalists conceptualize the idea of a simple perception, name, or idea from which complex things are built but leave it vague—indeed, impossibly vague—as to what exactly these simple elements are. Russell found himself in "On Denoting" required to claim that names one ordinarily thought simple ("the king of France, Louis XIV") cannot be so, on account of paradoxes of reference which he thinks ensue if one believes them to be simple.[21] However, after telling us that those names we thought to be elementary are not so (my name, your name, the king of France's name), Russell leaves the thorny, impossible question of what the simple names are to empirical psychology. Similarly, empiricists assume that the starting point of philosophy is a person thrown, tabula rasa, into the impinging perceptual world; yet the basic and simple sense patches such a person experiences, from which she builds up the ideas of ordinary objects such as tables and chairs and verandas, are themselves equally mysterious.

Thus neither Russell nor the classical empiricists are in a position to place the foundational elements of our language or our ideas in plain view; such primordials are for them more in the nature of an assumption. But for Descartes, the crucial philosophical task is to find the foundational idea and get it in plain and certain view. Mathematician that he is, Descartes must exhibit his starting point so that everybody may see it and be compelled by it. In this, Descartes's mode of procedure is like that of the constructivist for whom the simple, elemental core of an object must be pellucid. The constructivist object is a thing constructed from something, and the something from which it is made must be evident to all.[22] Otherwise the very idea of a visual proof of the complex object's mode of construction is attenuated.

The next point of alliance between Gabo and Descartes has to do with their shared perceptual notion of demonstrative certainty. (Classical empiricism also shares this notion with Descartes.) Following the example of the cube, Gabo's sculptures set up a condition of transparency in the following way: a sculpture satisfies the condition of transparency if your eyes cannot doubt how the self-evidently received simple elements are combined into the complex shape at hand. A further mark of transparency is, as I said, visual repeatability. You must be able either to construct another instance of the same shape or to recognize sameness of construction when someone else presents you with an example of such. The criterion of clear and distinct revelation (proof) of structure is visual—seeing is believing.

This perceptual criterion of constructive adequacy (transparency) is Cartesian in spirit. Descartes's concepts of an idea, of a proof, and of certainty, are perceptual. He speaks of ideas and proofs as "perceptions in the mind." Thinking out an idea is for him a matter of attaining a clear and distinct perception of it in the mind "all of whose parts are clear." Descartes's proofs are also elaborated visually; he speaks of the mind's being compelled to see the indubitable fact of proof with complete clarity. Furthermore, Descartes relies on what he calls the "light of reason" to provide him with principles of reasoning. These principles (some of which are nothing other than received forms of scholastic reasoning and as such are eminently open to doubt) are not relied on for some merely pragmatic intellectual utility they might have; rather, they are taken to be so introspectively compelling as to be indubitable.

Descartes's epistemology, his goal of making the mind transparent to itself by building up knowledge about it step by step, is thus an epistemology which relies crucially on visual metaphors of knowledge. Add to this the foundationalist notion of knowledge as a construction, and we can take a cue from Descartes's own perceptual language and speak of (1) his idea of the mind as a kind of building or shape (a sensorium), and (2) Descartes's text of the *Meditations* as a clarification by the mind of itself which proceeds by starting from scratch and building up its ideas of itself step by step until the shape of the mind is demonstrably clear itself.[23]

Then Descartes's philosophical text has a structure which is already close to that of the avant-garde artwork as theorized by the constructivist. It has been important to note the central place of visual metaphors in foundationalist philosophy, for we can then understand constructivism's desire to build a visually transparent artwork (one whose shape the viewer can see/know clearly and distinctly) as an outgrowth of the more abstract Cartesian phil-

osophical commitment to building an edifice of knowledge which is itself conceived of in terms of the metaphor of visual introspection. Indeed, we can understand constructivism's aim of transparent construction as a direct contribution to the history of the visual in philosophy. What Gabo adds to this history of the visual is the idea of building an object, not metaphorically but in reality, which will satisfy the stringent criterion of perceptual transparency. Gabo wishes to make an art object, in effect, all of whose parts are clear, as if it is the outward embodiment of Descartes's world of inner, perceptual certainty. The Gabo cube is a Cartesian philosophical proof in a visual medium, the medium of the actual world.

One often thinks of an artwork's philosophical character as a product of the depth and suggestiveness of its message; this is especially true of such literary texts as a Dostoyevsky novel or a Shakespeare play. The constructivist artwork does have a message in its sermons of metal worthy of the name "philosophical"—a message about how to take the artwork as an exemplar of a live lived with clarity of purpose, and especially about how to construct a society from material resources and technological means of production and people of all kinds with the conceptual control of a transparent cube. But this message flows from the prior philosophical character to the artwork itself. The constructivist artwork is philosophical in that it is like a (Cartesian) philosophical proof (or text): it establishes and is subject to a (Cartesian-styled) criterion of perceptual adequacy or transparency. Put another way, we can think of constructivist works and constructivist discourse as jointly delivering a theory, a philosophical theory, of what an adequately represented artistic shape is. A shape is adequately represented if its form or structure is transparent to perception.

Yet this theory, while it can be considered purely as a philosophical proposition about form in art, is not articulated by the constructivist as a proposition alone but rather as a method of praxis. For it demands the creation of an object from scratch, which will be a transparent, perfected edifice whose *example* of construction will stand as a metaphor and stimulant for the revolutionary future. The object (artwork) will be a sermon about how future life may, in general, be constructed and a material proof of humanity's constructive possibilities. In the philosophy of pure construction—a construction which, in Descartes's own terms, begins by putting aside all received encumbrances of past belief ("everything that nature taught me") in order to built a new foundation in the sciences capable of moving mountains with clarity alone—the constructivists obviously found their image of the Soviet future.

Constructivism really claims that philosophically self-evident clarity can and will be embodied in the world, that the world is up to it, up to receiving the terms of clarity and certainty and making itself over accordingly. Where foundationalist structures of knowledge were abstract, built from mere visual metaphors of knowledge ("perceptions in the mind," "introspections"), constructivism will build an edifice of perceptual truth that is real, whose criterion of truth is actual vision, not mere introspection. The constructivist object will rescue certainty and proof from their solipsistic entrapments in Descartes's inner sensorium of the mind and deliver proof to the material world for all to witness, that is, to see. Under the spell of vision's conviction and in the name of Marx, the spiritual values and clarities of philosophical abstraction will now be set to work in the world, with the art object leading the way (in the avant-garde). The sermon in the constructivist work is the material; it is about how philosophy can and will be embodied in the world.

In this, constructivism ends up outphilosophizing philosophy. Descartes's idea of philosophical proof is inward—in the nature of an introspective deduction from intuitions in the mind. The constructivist proof from intuition is outward—the seeing of how a shape in the world is made from its simple elements. Descartes emphatically denied that outward vision can ever carry the certainty required by the constructivist wish. Clear and distinct ideas remained for Descartes just that: ideas in the mind which can never be adequately embodied in our perceptual states, our visual objects, or the material of the everyday. To embody Cartesian clarity in the world, to construct the world according to Cartesian dictates is what constructivism, in alliance with revolutionary vanguards in science and politics, aims to do and claims to be able to accomplish. The constructivist art object shares in the claim of Cartesian method, but its method will be real and material, not abstract and internal. Philosophers have merely attempted to interpret the world (as it were, internally); the point is to build the world in conformity with philosophical truth, thus simultaneously perfecting the world and proving the case for philosophy. What news! What a transformation of the order of things! What optimism about the capacity of visual objects to be arranged to perfection!

The constructivist work of art, then, requires prefigurement by philosophical theory for two related reasons: first, to turn it into an example of the planned and perfected future, for one then needs a story of what that future will look like and why the form of art, in this case its self-transparent structure, exemplifies that future;[24] second, because its very mode of oper-

ation is to take philosophical truth and materialize it, making it nonabstract and building the world in accord with it.

Again, I am not saying that constructivists actually went back and read the pages of Descartes; rather, that Cartesian styles of reasoning were, in broad terms, part of their lives (from Marx, engineering, science, etc.), and moreover that philosophical styles of reasoning can, in fact, be found to underlie culture generally, not simply the pages of what are ordinarily called philosophy books.[25] That constructivism perhaps partly reinvented Cartesian thought from this salient bricolage shows that the question of where a philosophical text is to be found, of its range and domain, is precisely raised by the constructivist work. You don't need to live in a philosophy department or be exclusively a writer to invent it. (Descartes did not live in a philosophy department nor was he exclusively a writer.) One needs Descartes in order to understand constructivism because he helps us make sense of the use to which it puts philosophical theory via Marx. How much and how explicitly constructivism is derived from Descartes is a further story, the story of explicit influence.

Gabo's call for a revitalized life in future Russia is less explicitly political than the call of other constructivists (e.g., of Tatlin). Gabo's call is deeply spiritual; he believes clarity of construction is a spiritually heightening event which will perfect the material of human life. His idea of perfectionism is one which calls for the unity of art, philosophy, and science in a perfected humanity. Then Gabo's vision of the future is also that of a philosopher. His art and writing is a philosophical search for truth, a restless desire for connection with science, mathematics, and God (traditional philosophical desires). So we should not conclude that the only reason why constructivism calls on philosophy is for its immediate, world-historical purposes; constructivists are also philosophical and spiritual searchers in sculpture and paint. Josef Albers is an example, although the complete absence in his work of political commitment is one reason why he is at the margins of the movement. (He is, rather, its interpreter and the one who subjects it to philosophical critique.) Then there is a family of reasons for philosophical foundationalism in the constructivist movement, and these reasons are shared in various weights and measures by various constructivists. Yet the central constellation around which these foundationalist concerns formulate themselves is that of art as a theoretically prefigured example of a perfected future. Theirs is theory used to turn the artwork into an example of, an exploration of, and a call toward the perfected future.[26]

II

Having reconstructed the Cartesian impulse in Gabo, I ask, how far does it go? With what other voices does it compete or ally? It will be my thesis that constructivism is the convergence of two voices, one philosophical and the other emphatically not. Its philosophical voice is the voice of transparency. But constructivist art is also art with a tendency toward opacity, and that tendency will also, paradoxically, turn out to be part of what gives the work its utopian character.

To take the point about opacity from Gabo, consider again Gabo's 1937 *Model for Construction in Space: Crystal.* That work can, in one sense, be seen as an attempt at clear construction from a set of lines and curves. These conceptually begin from the idea of a rectangle, then delete parts of the rectangle, opening up the form into a center from whose core a set of arcs are projected. These dynamize the whole into a nearly complete spiral. The work is a play between the idea of a rectangle and the idea of a spiral. This play is a clear effect created from the fact of deletion; how it is constructed is clear to the eye. But the opacity in the effect is a matter of what else happens in this formal play between geometrical shapes, namely, the work's play with stillness on the one hand and with spirals of motion on the other, which taper into nothingness while at the same time radiating out into space. Gabo's sculpture is a gesture, a pas de deux with the space which flows in and around it. Its form takes wings, flowing serenely and harmoniously into space while also seeming to rest in space as a still form. Gabo's sculptural model is a dancer caught in the moment of a leap while also leaping outward. There are two poles in the experience of this work: one, the pole of self-reflexive clarity in construction, of visual transparency and geometrical lucidity, the other, of opacity, of the simplified construction of a form which *feels whole and wholly alive* in its movement in and out of ambient space.

This freedom of movement in a Gabo sculpture, which outruns clear conceptualization, defines the individuality of a Gabo work. No two are quite alike, although they run in obvious genres (the rectangles, the triangular forms, the constructed bodies and heads). This fact alone should make us wonder whether the art in a Gabo resists its Cartesian formulation.

If Gabo were, at bottom, only concerned to elaborate structures as clear as his cube, then he would have tried to work out the geometry of his sculptures far more consistently and thoroughly than he does. For according to the demonstrative example set by Gabo's *Cube,* the eye is offered access to geometrical form. Our eye and mind converge in the visual proof of the

cube's construction because we know or can directly see the geometry behind the representation that builds the shape—the cube—up. Demonstration of geometrical form is, I have said, a principle of construction which must be visually repeatable. Geometrical form is the form of a *type* of object, and seeing the form clearly means competence in being able to see sameness of form in all other objects of that type (assuming our eyes are strong enough or the object is not too big etc.).

Seeing a form transparently is seeing a geometrical *type* in an individual. Gabo's example of the cube implies that he will be committed to making sculptures which will exhibit their types of form to the viewer; but when he switches from theory to practice, the situation is not so clear. Up to a point, the 1937 *Model* is intended to be a type of construction, an object composed of lines and curves in the shape of a (partially deleted) rectangle and turned into a kinetic set of spirals and counterspirals. And Gabo's work does run in genres (the constructed bodies, the heads, the spirals, etc.). Yet Gabo's sculptural series are less matters of conceptual investigation into sameness of form and more matters of finding expressive variety within a strict genre. The eye of the viewer is not focused primarily on discerning geometrical shape in his sculptures. In my experience of a Gabo, I find myself quickly passing from the geometrical perspective into a visual study of the expressive inflections of the individual Gabo object itself. I quickly focus on its individual inflections of gesture and dance, on its nuances of open and closed space, on its suggestion of complexity and diffusion by simple means. These moods of beauty are the points at which Gabo's theory fades away and his art blossoms, for these features of the sculpture, while connected to the object's clear geometrical form (insofar as it has a clear, geometrical form), are features that cannot be explained in terms of the object as a clear type. There could be no question of a visual proof for these features other than one's convictions formed from one's experience of the individual object, for there is no clear structure to hang onto in seeing the object which would prove satisfactorily how it blossoms as art.

This remark about the art in Gabo should be developed. In order to claim that essential structure is there for visual representation in an object, one has to distinguish the essential from the inessential, that is to say, there have to be some other visual features of the object (its size, its color, its materials, or its decoration) which are not essential to making it the type of thing it is. Part of what it is to see the Gabo cube as a demonstration of inner cubic structure is to see that certain of a given cube's features—its actual size, its lack of color, the fact that it is drawn in black ink—are not essential to its

form. The illustration could have been bigger or smaller or in blue ink or in bolder, wider lines. Yet one does not look at a Gabo sculpture quite as one looks at the cube, that is, in a way that detaches the form from the specific object. A Gabo sculpture quickly becomes more than an illustration of a principle of construction; its point, its art, resides in its singularity, in the fact that it is a living, breathing, unique thing which has been constructed from pellucid elements—one whose overall effect is not repeatable. One feels there is nothing to essentially zero in on—no essential structural elements—simply because Gabo's sublimely spare capacity as a sculptor is precisely to make everything in the particular sculpture count. Everything, every twist of metal, every punctuation of material by space, every prismatic opening into the object's core, every reduction of color or modulation of harmonic weight and intensity seems essential, as if these configure a total formal balance and strange effect whose grace, elegance, and feel of clarity derive from the fact that they could not be done in any other way. This is sculpture in accord with Kant's famous dictum that an artwork is the symbolic moment in which freedom and necessity converge. The artwork is imaginatively free and made in the absence of general rules while at the same time it is made with a tautness and concentration that inspires the feel of total necessity, as if every inflection of every curve in the work is required by the evolving and dynamic sculptural whole: if but a single placement of an ingredient were altered, the total effect would be attenuated or lost. Since the effect of a Gabo seems to depend on everything's being exactly as it is, no question of repetition—of making the sculpture bigger or in a different color or of different materials—can enter. (One can at best make another which is like it. But there can be no criterion of exact repetition to be gleaned from a visual perusal of the object.) Clarity is in Gabo's art a matter of everything remaining exactly as it is, not of the revelation of an essential form which can be in full clarity detached and repeated—like the cube.

What we have in Gabo is the feel of transparency, a dramatic artistic effect achieved through his simplified use of materials in which every gesture matters, and through a sculptural form in which the work at once opens to engage the space around it, and opens to reveal what one feels to be its inner core. The Gabo feels transparent in roughly the same way that a Miesian office building or Bauhaus factory feels cleanly functional. For both, the art is to make the building look functional, to make it celebrate the functional with complete modernist audacity, as if the functional were an expressive requirement. The question so often put to these architects—whether amid this functional look the buildings really are functional and, if so, in what

Naum Gabo. *Linear No. 2, Variation,* 1962–65. Stainless steel coil on plastic, 46 × 16 × 25 in. Albright-Knox Art Gallery, Buffalo, N.Y. Gift of the Seymour H. Knox Foundation, 1965.

respects—can be similarly put to Gabo. Amid this feel of transparency, are the artworks, in fact, transparent? By extension, does the theory transparently apply to the object? Insofar as the criterion of transparency is the Cartesian one that has been set out, insofar as one's instincts are correct that Gabo's sublime art is the art of making everything matter in a holistic interplay of elements that precludes repetition, and because one would not know how to start to isolate the artistic moves comprising a Gabo sculpture so as to demonstrate their structural repeatability, the answer must be, "No, the sculptures are not transparent (in this sense). The theory does not transparently apply to the sculptures."

What then does one make of the contrast—call it the apparent inconsistency—between the kind of transparency claimed in the example of the cube and one's experience of the art in an actual Gabo sculpture itself? On the one hand, Gabo's intense concern with clarity in his sculpture and with the unity of art, science, and philosophy in his writings allows us to attribute to Gabo a Cartesianism according to which he aims to make his works satisfy the condition of clarity presented by his cube (why would he bother to write about the cube if it did not matter for his art?). Insofar as we attribute this to him, we must also say his works fail to live up to the Cartesian goal (a goal of idealized transparency which is equally unachieved in foundationalist philosophy, be it Descartes's, Locke's, or Russell's). To speak in the words of Foucault, where there is power there is resistance, and here theory is empowered with transparent application, but the object resists it.

One can, in other moods, say that Gabo's sculptures are even indifferent to his Cartesian aspirations. Multiple readings are possible. Then Gabo the sculptor defeats Gabo the thinker, which is part of what allows us to speak of his as marvelous art and not simply the art of a philosophical mission. His sculptures do, however, express the feel of his Cartesian goal, the feel of a perfected, sublime self-transparency, and they go a long way toward the act of visual penetration and simplification of form. In the light of Gabo's art, an art which, like the best of most art, makes everything count in it, one might say that the works aim to unite two opposing visual aims: the aim of structural clarity, of the presentation of an essential form of construction, and the aim of an opaque sculptural gesture in space achieved through an individual form whose parts cohere with a simplicity in which everything is put to use and everything matters. Together, these make beauty. For me, the most promising way to read these sculptures is to consider how the distinct sculptural voices in his work might as a whole be required by his art. When one looks at a Gabo it feels as though it is two things, not one: on the one

hand, a construction from a transparent core; on the other, a pas de deux emanating from its center to embrace space in a geometrical dance. That latter quality is not the expression of transparency but rather the expression of a marvelously opaque and energetic union with the space around it, as if in this movement of art in space is the activity of present and future time, the time in which immersion, risk, reformulation, and revolution can and will occur with serene and vibrant assurance.

A Gabo is expressive of more than transparency, and its various voices stand together in a pattern which is difficult to discern but of importance for the total power in the art. I will develop this restless union of voices in the work of other constructivists, seeking to understand it.

El Lissitzky, *Die plastische Gestaltung der elektro-mechanischen Schau: Sieg über die Sonne* (The plastic formation of electro-mechanical images: Victory over the sun), plate 3, lithograph. Collection of James and Barbara Herwitz, Muir Beach, CA. Photo by Daniele Filippetto.

3 / Constructivism's Utopian Game with Theory

I

If Gabo's art object is restless and resistant to theory, Gabo's experimentation with theory is as important a feature of his avant-garde activity as is his experimentation with new art forms and new materials. Gabo goes through genres of theory just as he goes through genres of sculpture. Yet Gabo's movement from theory to theory is not random; all of his theories are related, just as all of his sculptures are. Gabo's theories all tend to have a Cartesian ring: they all rely on some central notion of an artwork's construction from clear and evident simple elements into a lucid whole by a clear method of construction. It is the related pattern of his theories which, as a whole, tell us what Gabo's project was, just as the whole pattern of the artworks he created informs us as to the vicissitudes of his avant-garde life.

I said that theory is brought in by the avant-garde in the spirit of utopian praxis. To make a work of art conform to the requirements of transparent construction was to make it materialize (embody) the principle of clear construction, thus turning it into an example and stimulus for the future. The key was to set Descartes to work, to cast his currency of abstract thought and inner vision into the currency of materials and deeds of construction for all to see. In this regard, it is useful to consider how El Lissitzky and Moholy-Nagy in their own experimentation seek to find a theory which will ground a suitably materialist conception of the work of art.

El Lissitzky and Moholy-Nagy develop an explicitly materialist notion of the idea of clarity-in-construction by (1) identifying art making and art viewing as a kind of work, (2) in the spirit of Marx, celebrating work as a basic human requirement, and (3) giving that kind of work called "artwork" a material basis in human biology. Lissitzky and Moholy, each in his own way, speak of our organismic needs for constructive work, which their art is meant to satisfy. Science enters the picture because biology also declares that the human organism has environmental needs (for functional and pleasing cities, housing, etc.) which it is the task of art to discover and elaborate. Just as Lenin will aim to build a social order on the needs for bread, land, and peace, the constructivist will build his or her artwork on the discovery and appropriation of universal facts of visual and "aesthetic" biology.

El Lissitzky looks to biologically inspired theory to empower and justify

his claim that, like the revolution in general, an artistic revolution is in order. He relies on Oswald Spengler's extension of biological discourse to the topic of social formations—specifically on Spengler's characterization of social formations as morphological forms—to buttress his revolutionary claims. Using Spenglerian extensions of biological concepts to culture, Lissitzky thinks of bourgeois art as a species with a morphology, a set of goals, and a life span, naturally, a species which has played out its adaptive and productive life. Bourgeois art can play no functional role in the new, biologically grounded, cultural and political person. In his appropriation of biological concepts for the interpretation of social forms, Lissitzky is in accord with the Marxism of the Third International, in which constructivism played a well-known part.[1] The Third International's Marxism conceives of the world-historical movement toward socialism in Darwinian, evolutionary terms, with past and present social formations no longer fit to survive the changes in humanity which would be required to bring humanity into revolutionary accord with its true biological needs and technological capacities.

This biological language, rampant in the late nineteenth and early twentieth centuries as a style of reasoning,[2] supplied both El Lissitzky and the ideologues of the Third International with scientific firepower and conceptual certainty. Biological theory serves to buttress Marx's materialist conceptions of humanity with the authority of science. In terms of the historical future, it serves as a master narrative connecting the Third International to its grand historical future. Lissitzky turns to biological theory on account of his anxiety that art, too, should satisfy the mandate of authentic work, that it, too, should contribute to a revelation and understanding of the new, biological person. For if art cannot be shown to play its part in the joint forging of the full-flowering biological human being that is the job of revolution, then it is nothing but fluff, superstructure, and art history as grand, bourgeois farce.

For Lissitzky, the very existence of art is justified because and only because art is a form of work. Lissitzky puts it thus toward the end of his 1920 essay, "Suprematism in World Reconstruction": "Therefore the idea of 'artistic work' must be abolished as a counter-revolutionary concept of what is creative and work must be accepted as one of the functions of the living human organism in the same way as the beating of the heart or the activity of the nerve centers so that it will be afforded the same protection."[3]

According to Lissitzky, the artistic work—that old bourgeois excrescence decorating the eating and sleeping spaces of the well heeled with the well

oiled in various and sundry styles of taste and passion—must be replaced by an authentic, revolutionary kind of work (as if the history of art should be read in such sardonically crushing terms, the terms of Mayakovsky's "jester's rattle.") This belief that art as a concept is fundamentally in doubt, that art must be pressed to justify its existence as labor or die, caused a whole element within the constructivist movement led by as gifted a painter as Tatlin not only to give up painting (which just about every constructivist other than Lissitzky and Popova did) but also to give up much of what one thinks of as fine art generally in favor of directly utilitarian furniture production, clothing, and theater design. Tatlin turned to graphic design, architecture, and engineering—he designed a stove—these being thought by him to have more social utility than painting or sculpture. In effect, Tatlin retained the old eighteenth-century distinction between the fine arts and the useful or functional arts but reversed the evaluation of the pair: useful arts were to be the more valued of the two.[4]

Lissitzky, Gabo, Antoine Pevsner, and others did not follow this low road with Tatlin; however, they felt the need to stress a thousand ways in which plastic arts (painting, sculpture, and design) could satisfy the mandate of revolutionary work. Their aim was to make the unfolding of a constructivist work more labor intensive, labor explicit and labor celebratory than any art of the past—as if the visual, imaginative, and emotional work you go through when you work out the subtle twists of expression in a Vermeer, the harmonic balance and fragmented structure of a Beethoven quartet, or the humanism in the brown light of a Rembrandt is not work enough or is work of the wrong kind (say, too individual and too aesthetic). El Lissitzky's art responded to this suspicion about the sybaritic laziness and self-indulgence of past art by taking on the feel of a piece of material labor—by making explicit and central the visually constructive element which is dormant in *all* art, that is, by becoming constructivist. El Lissitzky believed the art of the past was decadent.

Lissitzky's artwork became an exemplifying exercise in labor, a sermonizing about our biological need for authentic and productive work.[5] Lissitzky goes so far as to seek justification for his own constructivist style in biological theory, specifically in the French biologist Raoul Heinrich Francé's claim that "every form is only the frozen snapshot of a process."[6] According to Francé, any slice of life—of people or plants or unicellular organisms—you look at is simply a frozen piece of a life process. The dog you look at asleep by the sofa is a frozen picture of its own morphological development. Lissitzky took this rather odd morphological conception to

justify, and indeed to interpret, his own constructionist Prouns, which, unlike Gabo's, are less visually kinetic and feel like pieces of geometry frozen in the process of formulating a shape. El Lissitzky's Prouns are thrusts toward geometrical organization out of artistic simples. In his Prouns, lines, rectangles, other simple shapes, and primary colors are arranged at tilted, oblique angles so as to provide the feeling of a shape in the process of its formulation. Francé's concept of morphological shapes which are freeze-frame pictures of their life processes (in the manner of sports photographs or stop-action film cuts), is then *interpretively* apt for Lissitzky's own style. Lissitzky's artworks feel like freeze frames picturing their struggles of self-formulation, except that El Lissitzky means Francé's theory to be more than a metaphor for his style. Francé's theory is supposed to prove the worth in Lissitzky's work by proving that the Lissitzky Proun is an apt picture of the way life is. Since people do not ordinarily look at still life in this charged way, the constructivist object is called upon to make you see things as they really are. It is a scientific diagram of life.

László Moholy-Nagy, who also gave up painting in favor of sculptural and photographic experiments in the 1920s, extends the relevance of biological theory for constructivist art in two ways. He develops two experimentalist conceptions of artworks, each of which justifies the role of an artwork by its contribution to the biological demands on vision. These conceptions are distinct, even contradictory, and it thus becomes important to understand Moholy's embracing of them both. Understanding that will tell us something about the practical position from which Moholy's avant-garde interest in theoretical experimentation arises. It will speak to how the game of theory is played in the avant-garde, what its requirements, and what its purposes are.

Consider Moholy's two experimentalist conceptions of vision. First, Moholy views art as one way in which human biological capacities are trained, exercised, and developed. In "Production-Reproduction," Moholy states, "Man as construct is the synthesis of all his functional apparatuses, i.e. man will be most perfection if the functional apparatuses of which he is composed . . . are conscious and trained to the limit of their capacity."[7] He goes on to say that

art actually performs such a training—and this is one of its most important tasks—by trying to bring out the most far-reaching new contacts between the familiar and the as yet unknown optical, acoustical and other functional phenomena and by forcing the functional apparatuses to receive them. It is a specifically human characteristic that man's functional apparatuses can never be saturated; they crave ever new

El (Lasar Markovitch) Lissitzky, *Proun 12E,* 1923. Oil on canvas, 57.1 × 42.5 cm. Busch-Reisinger Museum, Cambridge, MA. Courtesy Busch-Reisinger Association Fund.

impressions following each new reception. This accounts for the permanent necessity for new experiments. From this perspective, creative activities are useful only if they produce new, so far unknown, relations.[8]

Moholy's writings contain an essentialist (biological) concept of what a person is. In Moholy's terms, a person is a conglomeration of "functional apparatuses" whose extension and satisfaction are the goals of art and life. Art trains the mind by stretching it to embrace new configurations and connections, and thereby makes us functionally more capacious and acute, that is, more human. Moholy's theory is offered as a defense of the avant-garde, a rationale for the new and experimental, in art. (The essentialism aside, let it be noted that his is not a bad theory of the reasons for art education, not to mention for cultural exposure, wide reading, and travel, which also broaden the functioning mind. Indeed, past art also broadens the mind.)

As to his second conception of vision, Moholy, central teacher and theoretician at the Bauhaus that he is, is deeply concerned about the place of art in the search for principles on which to built a (better) world. For him, art experiments should not only stretch the mind's capacities but also serve in the discovery of biological universals, which, if followed in cultural, social, and political practice, will help to make life better. In "Education and the Bauhaus," Moholy writes:

Here the word "biological" stands generally for laws of life which guarantee an organic development. If the meaning of "biological" would be a conscious procession, it would prevent many people from activities of damaging influence. Children vividly act in accordance with the biological laws. They refuse food when ill, fall asleep when tired, they don't show courtesy when uninterested, etc. If today's society would allow more time to follow the biological rhythms, lives would be less hysterical and less often stranded. . . . In reality the basic biological needs are very simple. They may change and be deformed through social and technical processes. The oncoming generation has to create a culture which strengthens genuine biological functions.[9]

Moholy goes on to conclude that "we are faced today with nothing less than the reconquest of the biological bases of human life."[10]

This search for fundamental biological determinants on which to build a better life is a central Bauhaus preoccupation. It is a commitment which turns art into a branch of experimental, biological science. Moholy goes the farthest of any constructivist in the appropriation of biological discourse because for him art is a contribution to the search for the biological determinants of society.

Moholy construes his search as visual. He asserts, "This should not mean that the present form of abstract i.e. non-representational painting will be

proclaimed binding for all time. At present it is far from being so, amounting only to an intensive search for biologically founded elements of pure visual expression in which we are mirrored more unambiguously and more frankly than in outworn forms of appearance which have been used to satiety." [11] Art is a partner with science in its goal of uncovering general (universal) laws of visual biology, including cognitive and perceptual psychology. But art is also a mode of construction, not simply a search for principles. As such, art aims to design its objects, office spaces, and houses in accord with the visual laws it also discovers. An artwork is, then, both a search and a mirror built on what it finds.

What kinds of visual laws is art meant to discover and build upon? Moholy expects art to discover laws about its new materials, about their plasticity, their tensile forces, and their aesthetic characters. Art should discover laws of color combinations (which calm you down or energize you); laws about living spaces (which facilitate the flow of life or deter it); about the amount of architectural complexity the eyes can bear; about our visual capacities to make transparent complex structures; and especially about the contribution of new materials and technologies to these determinants. These laws should have complete generality. They should be context free and universally true of all persons. In this respect Moholy's is a Bauhaus aim shared by Gropius and others.

When Walter Gropius, the first director of the Bauhaus and the one who is most identified with the image of the school, designed his Fagus Factory in 1911 (more or less while, in Tom Lehrer's famous words, working late at the Bauhaus and only coming home now and then), what he aimed for was visual transparency in his designs. Gropius wanted his glass partitions and open spaces to exhibit structure rather than to obfuscate it (in the manner, say, of a Victorian house whose rooms feel mysteriously disconnected from each other, as if each is the entrance into a great secret). Since for Gropius a building's structure should be designed so that all of the parts of the building are defined by their function, what Gropius was after was transparent self-presentation of structure by his buildings and, in turn, function which could be read from that transparent structure, if not directly *seen* in it, by the viewer. Hence the viewer was meant to have transparent conceptual access to the Fagus Factory's mode of construction. It is right to attribute to Gropius a kind of foundationalist approach, in which a building is a construct whose parts are composed into a greater whole by means of a clear notion of function, which can, in turn, be discerned by the viewer through the viewer's combination of clear vision and clear thinking.

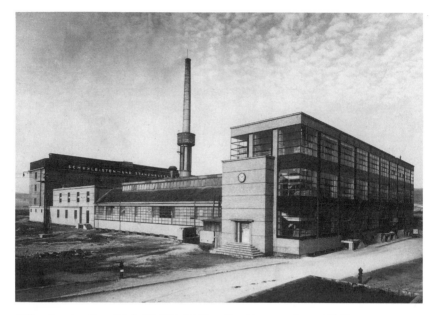

Walter Gropius, *Fagus-Werk,* 1913/14–25. View from Hannover Street, Alfeld, Germany. Reproduction from the original photograph courtesy Bauhaus-Archiv, Museum für Gestaltung, Berlin.

Furthermore, Gropius was interested, like every member of the Bauhaus, in designing prototypes: types of buildings which can be built anywhere. He is thus committed to the search for universal relations between form and function, relations which are not inhibited by the specifics of location or architectural context.[12] The worker's house, the airport, the factory, the government office—these should be transposable on demand to any location. These building types should, moreover, be as similar as possible to one another, thus reducing the number of types to a limited repertoire of basic forms of maximum functional power. And so the international style came about from the ideas of the Bauhaus. Its results can be viewed, for better or worse, at your local airport, in the blank and congested suburbs of Rome, in the reconstruction of Germany, in inner-city housing, and across the faceless map of most large Latin American cities.

It would, indeed, be fine to finally possess a science of visual aesthetics, to be in a position to construct cities, towns, houses, in its wake, to stylize office spaces and modulate light sources for workers and design better work spaces so as to really improve the quality of the functioning human organisms's daily routines. The seriousness of the Bauhaus/constructivist aim is

as unquestionable now (in the light of our urban megalopolises, our inchoate visual spaces, and our unbridled architectural celebration of the fast and the expensive) as it was in the then-overcrowded cities and turbulent politics of the 1920s, 1930s, and 1940s. How many such simple laws there are to find about vision and perceptual aesthetics, how the art itself is supposed to demonstrate the biological universality of these laws (their generalizability from the specific context in which they seem convincing), is another question—call it a postmodernist question. We have here a utopian project of scientific construction, formulated in terms of biological needs and capacities. Moholy is aware (especially as a Marxist) of the historically changing character of visual aesthetics, for he admits the possibility that human biological needs and biological laws may be subject to social and technological change or deformation (then what makes them biological?). Yet he is nevertheless committed to the idea of an art which would discover universal relations and construct the future in the manner of Gropius's dreams.[13]

These, then, are Moholy's two theoretical conceptions of how an artwork or design object relates to vision. On the one hand, the work of art is meant to stretch and extend our flexible biological capacities. Moholy's experimentation with new media and materials (photograms, perspex, glass, etc.) reflects his desire to extend the human eye and the human organism by making us see in new ways. On the other hand, Moholy's goal is not to create new forms of vision in us but to scientifically discover universal and stable laws of vision and visual aesthetics to which we all, as human beings, conform. The first conception points the way toward the creation of a new person, of what the modernist will call, in his gendered way, the "new man," by extending his biological apparatuses and changing his life. The other conception points the way not toward the creation of a new person but toward the discovery of stable laws about the old and conservative person, laws which will then be used to make the environment conform to the man, or the man's social life conform to his own nature rather than deform him. Why then does Moholy believe both of these conceptions?

First, note that, taken in the right way, both these conceptions have degrees of truth about what a person is and how he or she sees. The human being is a partially stable entity and a highly constructed one at the same time. There are a number of general laws to be discovered about the eye; at the same time, the search for such laws immediately reveals how flexible and plastic the eye is, how it can be stimulated to see in new ways. It was precisely Albers's task to illustrate both of these facts about vision. In this

regard Albers was the most philosophical of all of the modernists, for his search was for recognition of the stability of perception and of the limits of this stability. Thus Moholy is right to believe both of his conceptions of vision, the one stressing vision's plasticity and art's capacity to create new eyes (does not all art in some degree do this?), the other stressing the law-like stability of the eye and universality of vision (does all art in some degree hope for this?). But it is the fact that Moholy held such extreme versions of both of these conceptions that is unique to his modernism and of interest here. One cannot believe in the Bauhaus project of developing an elaborate science of visual aesthetics—as if the eye were largely stable and mostly lawlike in its behavior—and also believe that the eye is largely plastic and capable of radical extension. That is to believe two contradictory ideas about vision and, by extension, about the capacities of the human organism to grow and change. Yet Moholy seems to believe both. He is committed to both the universal stability of human life (and thus to a science of discover-ing the basic principles of human life) and to the possibility for the radical creation of the new person, as if people are as plastic as clay, as if people can be formed and reformed like modernist works of art. This dual commitment to a scientific conception of the person and to a conception of the person which apprehends him as art is the crux of Moholy's contradictory belief.

Moholy was notoriously experimental in his relation to theory, even more so than Gabo. Moholy's search for new conceptual lenses in terms of which to view the human being and for new concepts of the relation of art to this person was as pronounced as his practical search for new art materi-als and new art forms. As I said, this was not unique to Moholy; it was true of all constructivists and of many in the utopian wings of the avant-garde. But what is unique to him is the degree to which he explicitly holds two opposite ideas about art and vision. Other constructivists vacillate between these poles of theory as well, but Moholy expresses the vacillation most clearly. Thus we are left with the questions, Why these poles? Why Moholy's two ideas about vision? What does his belief show about the constructivist position in general?

There are surely a variety of perspectives from which these questions can be addressed. I choose one, for it is my belief that the commitment to both a stable conception of the person which makes him the object of visual science and a conception of the person which views him as experimentally malleable derives from the requirements of avant-garde, utopian art as such. On the one hand, Moholy's commitment to constructing a new world order

according to a utopian plan of construction required him to believe that the human being embodies universal and stable laws which would make such planning possible. This commitment to the design of the future pushed the Bauhaus generally in the direction of a scientific theory of design. On the other, Moholy's position as an artist who desired to bring about a utopian future which was as yet unimaginable to him in any detail, pushed him, as it had to push any such artist, in the direction of wishing to create a new and as yet unenvisioned person, the new man who would inhabit this dreamlike, dimly felt utopian world. From this perspective, the new man was a subject to be experimentally created in the laboratory of the modern, to be imagined only in experimental gestation. Hence Moholy was required to believe in, to trust in, a conception of vision which stressed the malleability of vision and of human identity as such, the capacity of a new person and a new world to arise through cultural experimentation itself.

The tension between these two conceptions of the person derived from the utopian character of avant-garde art, from its claim of building a new and perfected world from scratch. The utopian character of socialism branded it with exactly the same tension. Socialism is in this sense modernist. Marx, that archutopian, was himself of two minds when he turned to envision the future classless society (the USSR, which, as the saying goes, was the USSR and is now the USSWAS). On the one hand, Marx envisioned a lucid dialectical route by which the party (that avant-garde political entity) would construct the new world according to a clear plan, rooted in facts of human biology and in the history of technology. On the other hand, Marx spoke of the need for experimentation (shall we say, of art?) in revolutionary practice. In the latter frame of mind, Marx referred to the transition to a classless society as a "vague immensity," an event of enormous proportions which he could not as yet envision. Marx might have been confident that the path would, in the end, lead to the grand finale of a revolutionary cadenza (the USSR-to-be of those sweet 1917 days,[14] but he had no detailed idea of its routing, nor could he. Nobody can envision it, granted its radical character, granted how much of ordinary life would have to change in order for the revamped world of the revolution to happen. It deafens and defeats the imagination. Thus the utopian must approach a future which demands to be imagined (for it must be planned and exemplified), yet which cannot be imagined but is, at best, felt like the luminous light of a distant planet ("Ich fühle Luft der anderen Planeten," says the poet Stefan George in his invitational poem to the twentieth century called *Entrückung*.

So the avant-gardist experiments with a variety of images of the future including theoretical images, in order to make it, and the route to it, comprehensible.

This paradox leads to a restless shifting between the poles of planning and of free experimentation, between revolutionary "science" and the free play of dialectical self-criticism and self-creation, between theory held with utter confidence and clarity and theory taken up and abandoned in a flush of imaginative experimentation. These poles are reflected in Moholy's two theories of vision, which stress discovery of laws about vision on the basis of which to plan the world and the free play of the eyes, which, if radically stimulated, will allow a new person to arise who will see, define, and inhabit that as yet unknown planet called "earth."

It is precisely this dialectic between transparency and experimentation which is reflected in Moholy's art practices as well. (We have already found variants of the dialectic in Gabo's sculptures.) We need to look to Moholy's art, which is supposed to discover and reflect these visual laws, in order to begin to address these questions. His glass architectural series of highly simplified lines and colors bespeak a concern with transparency of construction. They give one the feel of a shape emerging from its source according to a clear visual pattern. However, the source from which the construction visually emerges in Moholy does not feel like simple lines and colors; although the colors are often primary, the lines clear-cut, and the shape of exemplary simplicity. Rather, the source feels like light itself. From his paintings to his photographic experiments, Moholy betrays a consistent fascination with the articulation of light. One feels that in his paintings and architectural sculpture the light is being presented with the clarity of a gothic stained glass. But Moholy's art does not filter in light from without as a stained glass would; rather, his art is a window of light which originates in some invisible nowhere, deep in the medium and the color itself, and is dispersed toward the viewer like a patterned rainbow. A Moholy artwork is a modernist cathedral in miniature. Its mysteriousness has to do with the simplicity with which light is dispersed.

Moholy patterns or formulates light through a set of clear visual twists: a figure/ground maneuver which has been made transparent, a moment in which a grey line has transversed a red one with a blending of color that also makes one feel that depth has been partially suggested, the angular dispersal of lines into and out of the canvas or sculptural object by means of their intersection. The conceptual element in Moholy, the element suggesting a general law, has to do with the specific visual effect in the work.

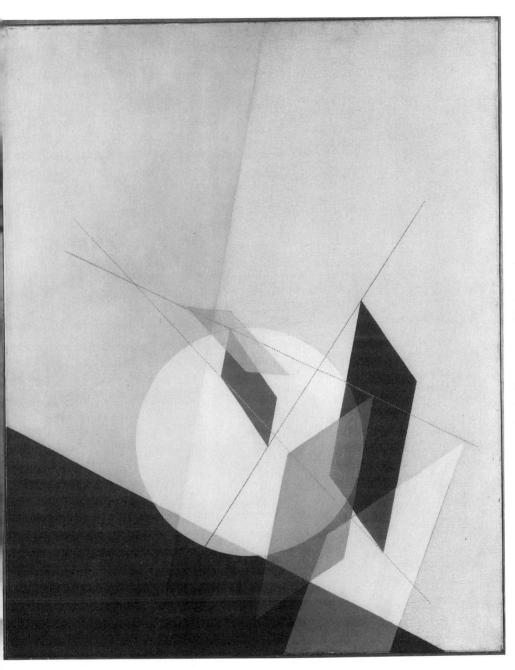

László Moholy-Nagy, *A 18*, 1927. Oil on canvas, 95.9 × 75.2 cm.
Busch-Reisinger Museum, Cambridge, MA. Museum purchase.

Whether any of Moholy's visual effects can be generalized into laws, whether any are maneuvers that can be generalized independently of elements in the singular work at hand (and if so, to what degree) seems to me as unresolved as it is in Gabo.[15] Like Gabo, were Moholy primarily concerned to explore in his art the generalizability of effects into laws, I believe he would have more systematically gone about establishing generalizability by experiments with the same effects in different sizes, colors, and so forth. That by and large he did not, suggests his is a theory about his art which is half-applied in practice. If he only half-follows in practice his theoretical aspiration for an art discovering and mirroring general laws, then what other voices are present in his artworks? What other things does it do or does it express? It is impossible to answer this question without noting the continuous concern for overall movement in his work.

Whereas El Lissitzky's Prouns are shapes frozen in the act of self-formulation, Moholy's shapes are like crystals or prisms, tilted as a whole at oblique angles to cast their shapes of light with the speed of light. This tilted placement contributes to the movement by dynamizing the viewer, for the viewer feels as if he is seeing the shape while momentarily twisting to his side or while falling toward it from a curved height. Moholy's synoptic, wide-angle perspective is most explicit in his photographs of people, squares, and buildings. These masterful executions from above and from oblique angles at once turn what they show into a kind of pure form, as if one could take the photo of the piazza with its pigeons and people and recast it as a complete abstraction while leaving every visual detail in. They dynamize the scene by presenting it from an angle that one can take up only by feeling oneself move toward or away from what is shown. The kinesthetic relation one must assume toward his photographed event makes one intensely aware that one *has* a position—which could change, indeed, which must change, were one to follow it through, for one could no more remain in the position of falling toward what is shown than one could remain suspended in the middle of a cathedral of light after jumping from its flying buttresses. The viewer is then taught the lesson that perception is plastic, that it exists in the process of continuous construction and reformulation. This lesson is, in one respect, the teaching of a general perceptual fact about how the eye and receiving, perceptual mind works and in another is meant to show that perception is *not* lawlike and stable but fluid and amorphous. It is a lesson with its converse in the world. Moholy represents the world from an impossibly unstable perspective in order to dematerialize it, to disorient us from it, to show it to be flying from moment to moment toward

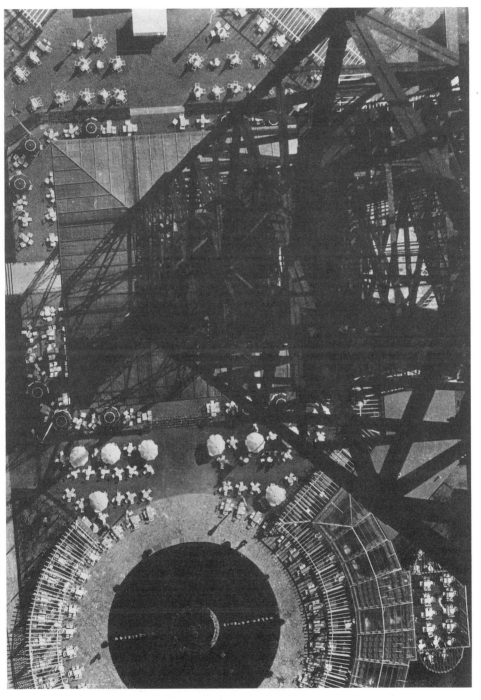

László Moholy-Nagy, *Untitled* (view looking down from Berlin radio tower onto chairs and tables), no date. Photograph, 36 × 25.5 cm. Julien Levy Collection. ©1992 The Art Institute of Chicago.

the prismatic tropics of an as-yet-unconstructed future. Indeed, Moholy's real lesson is that there is no world without us to take up an oblique relation to it any more than there is an us without a scene to occulate. The eye of the camera and the world it sees are caught in an endless, ecstatic dance whose potential rearrangement is unknown. Moholy makes us want to be there in this working dance with the world because its potentialities are so fascinating.

If the enthrallment with movement and potentiality in Moholy's experiments is as deep as this, then he cannot merely be making art into a kind of science; rather, his art objects have the goal of scientific/Cartesian demonstration of the visual effects of construction in, at most, one of their voices. What is wonderful is how these art objects can exist in the partly simplified, conceptual state in which they exist while at the same time suggesting such plasticity and synoptic flux. In one voice these artworks aim for the scientific clarity and self-transparency of a world that is stable and lawlike while in another they celebrate the vague immensities of constructive interaction with a changing world. Their unification of these voices may be as contradictory as Moholy's unification of his two theories of vision, yet the artworks unify these voices with an exuberance and beauty which itself betrays utopian confidence. If there is more richness than consistency to the voices at play in the art, it is worth noting that neither voice is out of sync with the world (any more than either theory is). In this sense, Moholy's art and his theory are of a piece. They are expressions of the same game with the same requirements.

II

I continue with some remarks about more recent brands of constructivism in Latin America. The idea of an educational mission in which art functions as a branch of science is given its most utopian statement by more recent brands of constructivism, most notably by the group of Latin Americans centered around the Venezuelan artist Jesús Soto. For the Latin American, constructivism arrives with a history, and the history demands appropriation. The constructivist modernism to which these painters lay claim is grasped in a panoramic sweep. These painters see themselves as the heirs to a grand twentieth-century tendency in art and culture, one arising in the Russian sermons of the future and embracing the more geometrical aspects of cubism, the Rayonnistic color poems of the Delauneys, the abstractions of Mondrian and De Stijl, the educational concepts and devotion to clar-

ity of the Bauhaus, and moving on into the later work of Albers, the sculptures of Max Bill, and Italian constructivism of the 1940s and 1950s. This panoramic view of a segment of twentieth-century art devoted in various ways to abstraction, construction, and clarity while yoked to the picture of a grand march is not without merit. Soto and his group have erected museums of constructivism which give voice to the panorama; one can find huge quantities of El Lissitzky, Albers, Liubov Popova, Tatlin, and Bill in museums in Caracas and other places.[16] Indeed, Soto, who grew up in a languid colonial town on the Orinoco river deep in the savannahs of Venezuela and found modernity all at once in the slam and bang of constructivist rhetoric while sojourning in the Paris of the 1950s, has established a museum of constructivism in Ciudad Bolívar, his town. There the museum sits unfinished, like a great quixotic dream, its concrete pillars, framed doorways, and open modernist spaces half-windswept and half-undone, its sermons in metal whispering sotto voce to the endless flow of the twisting river which passes nearby and hears nothing. That monument to the messianic power of structure is a structure incomplete. It *has* a messianic mission, similarly uncompleted: to become the exemplary icon of a Latin American future which will end the fact of Latin America as such by absorbing this tattered, colonial place—a place filled with a magic blended of many cultures and much magic, a place tuned to the strings of García Márquez, a place with a spirit played out in the slow rhythm of endless coffees drunk over local news in cafes bowing to the streets, a place whose streets bow to waves of looming cumulus clouds whose silent threads of filtered light connect it to nowhere—by absorbing this place into a univocal and universal modernity often called the international style.

Venezuelan constructivists demand of themselves that they realize the dream contained in their museum of constructivist history. They think in terms of that history because for the first time they are constructivists in a position to *have* a history (constructivism having had by this time enough of a life to become historical). They also think in terms of history because they need a history, that is, they need to feel in the center of things, in the wake of a movement which will embrace the globe in its erasure of difference. The thought that they are the heirs of the history of the International serves to centralize them.

The Venezuelan constructivist painter or sculptor will make every effort to erase everything Latin American and personal from his art in the interest of discovering visual universals. Thus Soto adamantly denies that his magnificent constructions, in which strings are built out from a canvas support

in luscious color and kinetic frenzy, bear any stamp of his ethnic origin or personal expression. "A work of art must be capable of moving the beholder, but this does not mean that it must be born of an emotive situation. If the work of art has an origin it is in the reflection, the strictness and the logic of artistic research. Art is not expression, it is knowledge." [17]

His works, according to him, are inquiries into visual problems which produce visual results of demonstrative character and universal scope: "Yes, repetition possesses a universal character, revealing pure structure: that . . . was a fundamental concept." [18] Indeed, Soto thinks of art as a science in much the same way that Moholy does. In Soto's words, "this is a highly positivist view, but I believe that art should be positivist, that it should contribute to the education of society on a very professional level; since as artists we have been formed by western culture, our art should evolve with the same seriousness as philosophy, math, and scientific research. For me, art is valuable when rationally justified." [19] He goes on to say, "I believe art is a science or a form of science." [20] Soto's own "positivism" bears the explicitly social stance of Moholy and the Bauhaus[21] but also of the proselytizing positivism of August Comte churches with their religion of science and social construction. These one can still find scattered in Brazil and in other places on the eastern side of South America. The kind of education Soto requires has a slightly different emphasis than Moholy's, befitting Soto's Latin American context. For Soto, modernization ("professionalization") is the issue, while for Moholy, who writes from the perspective of an already deranged, industrialized Europe, the issue is reconstruction according to the dictates of a truly rational form of modernization. Both share the idea of education through an art which is scientific research. Both share, along with Gabo and El Lissitzky, the idea of an art whose self-definition in terms of mathematics and philosophy is socially exemplary. Cruz-Diez, one of Soto's teachers, also living and working half-time in Paris, concurs with Soto in describing his work as a "physics." [22]

Having already considered the relations between Gabo's theory and his art objects, we do not need to ask in detail whether the artworks of Soto and Cruz-Diez fully conform to their positivistic physics other than to say that an experience of a Soto kinetic piece or of a Cruz-Diez reveals the same complexity of voices that an experience of a Gabo or a Moholy does. The works of Soto and Cruz-Diez are meant to be viewed as complex constructions from simple elements, but their moving and boisterous effects, along with their sinewy patterns of construction, far outrun the positivistic demonstration of structure their theories require. Some structure is demon-

Jesús Rafael Soto, *Oliva y Negro* (*Olive and Black*), 1966. Flexible mobile, metal strips suspended in front of two plywood panels painted with synthetic polymer paint and mounted on composition board, 156 × 170 cm. Collection, The Museum of Modern Art, New York. Inter-American Fund. Photo ©1992 The Museum of Modern Art, New York.

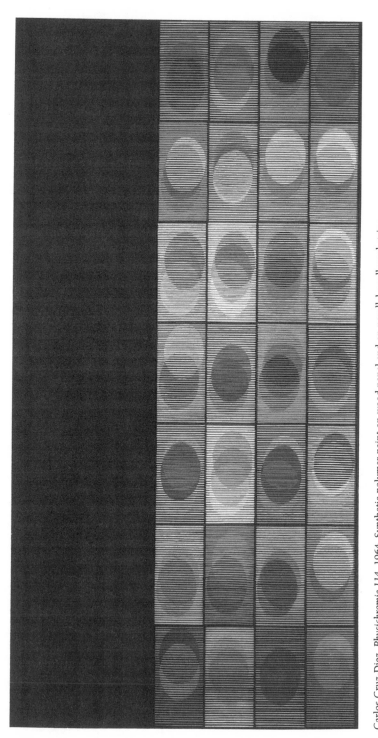

Carlos Cruz-Diez, *Physichromie 114*, 1964. Synthetic polymer paint on wood panel and on parallel cardboard strips interleaved with projecting plastic strips (or blades), 28 × 56 ¼ in. Museum of Modern Art, New York. Inter-American Fund. Photo ©1992 The Museum of Modern Art, New York.

strated, but it is of an overall and general form (as in Gabo). Cruz-Diez's long horizontal picture supports, built of three-dimensional verticals placed onto the picture support in patterns of repeating colors, are demonstrations—of how to make something surprising, beautiful, pointillist, elegant, and endlessly shifting in perspective as you animate the work by walking along it from side to side. Indeed my own view of Cruz-Diez's work is that it demonstrates how to make the rich patina of Venezuelan colors, filtered through the primary colors of De Stijl, international in style by subjecting color to a technique not unlike that of Seurat and exploring the idea of constructive repetition. Cruz-Diez does not erase his origin, he extends it and glorifies it. Let us say he modernizes it.

Then there is modernization here but not of the philosophical form demanded by the theory. It is worth noting that Cruz-Diez is also a practical artist with practical, piecemeal ideas about the way that art and aesthetic theory can help a society. His studio is at the edge of a barrio in the center of Caracas, where he is known as "the painter" because of his frequent forays into that community. There he works with the people to make their houses better organized and more aesthetic, to make street signs more legible and colorful, to make playgrounds more playable and fun, to construct things which are simple, safe, and beautiful. He is among the few in the history of constructivism who have taken the practical value of constructivist design off its messianic horse and put it into the streets. Even Tatlin, the leader of that segment of constructivism which abandoned "high" art in favor of explicitly utilitarian artistic production, worked mostly in the rarified arenas of theater, book design, and the like (perhaps this was not entirely his fault in the Russia of the twenties, with no money and many restrictions).[23] Cruz-Diez has succeeded in designing on the streets.

III

Like Moholy, Gabo in one voice allows a space for the opacity, spontaneity, and art in art. In such a theoretical voice Gabo describes his art as "sensuous . . . intuitive . . . spontaneous . . . irrational . . . [and] creative,"[24] and these are not the words of a man who believes his art is only Cartesian. Speaking in a voice which celebrates spontaneity over certainty, Gabo asserts:

The way in which art perceives the world is sensuous (you may call it intuitive); the way it acts in response to this perception is spontaneous, irrational and factual (you may call it creative), and this is the way of life itself. This way alone brings to us ultimate results, makes history, and moulds life in the form we know it.

Unless and until we adopt this way of reacting to the world in all our spiritual activities (science above all included) all our achievements will rest on sand.

To this end we have to construct these activities on the foundation and in the spirit of art.[25]

Gabo stresses the values of flexibility, sensitivity, and attentiveness to the shape of the new in ways which outrun the rational, the systematic, and the eternal. These words are anti-Cartesian. They are cosmopolitan in their desire to connect art, science, philosophy with the spiritual values of human flourishing. While Gabo does not speak of art as the wild stretching of the human sensorium in the manner of Moholy, he nevertheless goes so far as to reconstrue science in terms of art. Gabo's interest is how persons can mould a world that exists in flux, that outruns the systematic, that demands continual reconstruction. Science, "science above all," must base itself on the perceptual openness, quickness of response, and creativity of art. The eye of the scientist, when at its best, begins as the eye of an artist. The theory constructions of the scientist, while passing beyond the sphere of art into that of explanation, must share in the creativity of sculptural construction to be adequate to the flux of the world.

Conversely, science's dependence on art must entail an art that is stable enough to deliver some kind of truth to science. What kind of truth is art—and, by extension, the artistic eye of the scientist/theorist—in a position to deliver?

Gabo believes truth is itself a construction: "There is no place in a constructive philosophy for eternal and absolute truths. All truths and values are our own constructions, subject to the changes of time and space as well as to the deliberate choice of life in its striving towards perfection." [26]

The very idea of truth is the idea of something we have set up on the basis of experience, reflection, and the pressures of geography, city and society, psychology, and whatever else. Gabo's conception of truth smacks of idealism, of the thought that there are no truths in the world to be found out, truth being instead an imposition of the human mind onto its conceptually inchoate environment. Or perhaps more to the point, it also smacks of pragmatism. Gabo stresses the idea that truth finding is a mode of interaction with the world to be proved worthy or defective in terms of its uses—in terms of the quality of the truth construction for our lives. If Gabo's is a pragmatic position, it is not simplistic; his notion has no trace of commitment to the precise quantification of utility values as a way of ranking degrees of truth. The art in science is to gain a sense, somehow or other, of the overall way a truth construction helps us or not. What Gabo stresses is the

flexibility of truth. With the eye of an artist, we sense that the world has outrun a given truth, or that it is in need of repair, reconvening, or reconstruction. We sense that life has changed, and a new kind of construction is required. Then we get a recasting, or at its most dramatic, a revolution in art, science, or life.

Gabo's own art is, he thinks, such a revolution, with art as the beacon of the very recognition of what truth is. Gabo's sermon in art is one about flexibility, sensitivity, close scrutiny, and, above all, about the nature of truth itself, the lesson being that truth is a construction, and one had better understand the nature of one's power and possibility as a constructor of it.

Gabo's notion of the need for regeneration of the total order of life along the lines of clarity, openness, and flexibility is a compelling one. Penned in the dark days of the 1930s and 1940s, one can appreciate Gabo's urgent appeal to culture, an appeal which is less confident in its utopianism than the earlier Gabo might have been (this is no longer the 1920s, and we are no longer in the days of Lenin and glory). But even here his pen is committed to the need for and the possibility of a nearly total renewal of values. Like any other initially compelling notion of truth, philosophy is bound to raise a host of questions about Gabo's notion. Indeed, it already has. Much of the history of philosophical debate from Plato to Kant to Wittgenstein and to the present could be brought to bear on Gabo's piece of philosophizing. The question of the degree to which truth is a construction as opposed to a reception of the world, the question of how you figure out the difference between these things, these are, in effect, nothing other than the deepest questions about realism and skepticism, questions which have occupied the pages of many a philosophy book.[27]

For Gabo, the role of art is to show by example that truth making *is* an art—one founded on the qualities of art. Then not only science but also philosophy must be founded on art, attenuating the distinction between these. Does art itself, therefore, present truths, elaborations of structure, visual demonstrations, or the like for science (and for philosophy) to grab up and explain? Or does it, rather, content itself with presenting to science and philosophy a visual *style* (of flexibility, openness, and creativity conjoined with clarity in construction) which, according to art, science had better use? Gabo's notion of truth founded on art seems to reverse the wager about what an artwork can demonstrate; art would appear to demonstrate a flexible act of construction, not an act of transparent self-demonstration. ("There is no place in a constructive philosophy for eternal and absolute truths.")

Then what of Gabo's cube? How well does Gabo's placement of thinking (both scientific and philosophical) on the footing of art square with Gabo's own Cartesian philosophizing in art? We are here in a different voice, a modulated theory which doubts an object's capacity to have, much less reveal, essential structure (essential beyond the construction of the moment) and which must perforce doubt the Cartesianism Gabo in another voice appears to believe. Then in one voice Gabo intends to raise art to the status of mathematics and philosophy while in another he intends to found science and philosophy on *art*. In the latter voice, he also intends to found *art* on art, thereby calling into question his Cartesian hopes for it.

This latter voice is reinforced by the following words about the character of shapes (including his own sculptural shapes): "Shapes exalt us or depress, they elate and make desperate; they order and confuse, they are able to harmonize our psychical forces or disturb them. They possess a constructive faculty or a destructive danger." [28] This is not the talk of a man who claims reflective certainty for his works, unless one is prepared to believe that the exaltation, elation, or disturbance in a shape are as clearly produced properties of it as the fact that it is a square or a cube. There is something to be said for that idea, and it would not be an absurd constructivist task to try to show as clearly as possible how, from simple artistic elements, emotional effects (elation, depression) are produced. The task seems to be part of what Moholy has in mind. One could call such an investigation a branch of the psychology of art (it has been attempted in music, where questions of the emotional character of intervals, chords, and the like are not out of place).

Gabo may well have taken himself to be engaged in such a piece of demonstrative research; however, research and demonstration do not seem to be implicated by his words here. When Gabo speaks of a shape's "constructive faculty" or its "destructive danger," he focuses on how the shape will affect people rather than on how it is made. It is the rhetorical character of a shape which everything hangs on, the capacity of a shape to make one feel ecstasies of constructive possibility and thrills of clarity. And conversely, it is the indignity of a badly made shape, of work less than thought out, of the strident, the showy, the overdone, or the typical which distress, deflate, or calcify the viewer. Gabo the sculptor is himself a master harmonizer of his shapes, which are serene and vibrant, modest and bold, lucid and free-flowing.

There is something of a psychology of art in Gabo's words, a belief that the psychological effects of shapes are profound and must be taken seriously. Moholy will concur in this belief, for his work at the Bauhaus is ded-

icated to discovering what shapes will cause what effects—aesthetic, psychological, and whatever—or so he describes his work in one voice. But Gabo's words also suggest a morality of forms, a view about the capacity of forms to affect our consciousness and shape our character. This belief that art plays a direct, causal role in stimulating people to live in a certain way through its moral fiber has been deeply held by Schiller and mis-held by fascism and totalitarianism. Schiller is keen to write plays whose form is magnificently crafted and whose high ideals shine through, for both these qualities of drama—call them a play's form and its content—preach by example.[29] The fascist is keen to impugn modernism as "entartete Kunst" or "narcissistic self-absorption" because the fascist (correctly) fears the liberating powers in modernist freedom of form, modernist irony, and modernist clarity.[30]

I hear Gabo's talk about the constructive faculty or destructive danger in a shape ring with a similarly moral concern for the exemplary power of a shape to shape the moral character of its viewers.[31] What, then, is the example Gabo feels he must set in his art? Art should contribute to the development of a new style of cultural thinking through its own investigation into the place of art in science and philosophy. The philosophical search by art for its own place in the thinking of the future is a search whose domain is the artist's pen. Again, theory is called forth in the service of imagining the perfected world of the future. But it is also a search carried out in the domain of his plastic, self-discovering art objects. The psychological force in the artist's sculptural shapes, his exemplary treatment of form, his mood of inquiry and discovery, of reception and action, of finding and imposing will serve as examples of how to live more perfectly. Art will become philosophy by showing thinking (including new philosophical styles of thinking) wherein its own art lies. Then there will be no clear distinction between art and philosophy in this new style of searching and finding, of clarifying and opening; philosophy and art will be porous parts of a new style of thinking overall.

Gabo is still committed to the capacity of his art objects to transparently (and eloquently) express what the culture needs expressed. He does not doubt the capacity of his sculptures to speak in a clear philosophical voice to the world. That is, he does not doubt the transparency of the relation between this his theory and these his art objects. Yet in this his modulated theory of art, the artwork is not defined by Cartesian requirements. One could take the liberty of reconstructing Gabo's position as one leaving room for Cartesianism not as a theoretical requirement placed squarely on sculp-

tural structure, but as an ideal pole of experience, a moral ideal of how to live. The artwork will no more attain it than we will, but it is in the artwork's high-minded striving for this ideal of clarity that one finds the artwork's capacity to make us more high-minded. The closer our activities approximate the ideal of self-transparency, the better they are.

Even if Cartesianism is taken as a regulative ideal, it is in tension with the voice (in both Gabo's artworks and his words) which stresses the power of forms to psychologically excite, embrace, engender, and kinetically interact with the space of the world in free, flexible, and opaque ways. When the two poles of thinking are put together, it is as if Gabo's theories, like Gabo's artworks, abandon you to the joys of interaction in space while at the same time holding you back and placing you in the position of reflective (Cartesian) thinker or observer. In a similar vein, perhaps a Gabo sculpture is not to be read as a bundle of contradictions but rather as a reflection of tensions inherent in the actual experience of life: tensions between involvement and observation. If one thinks of life itself as a complex pattern of interactions interweaving (1) abandonment—the sense of being thrown into the world in a dance whose beginning and ending is not clear but whose movements must be constructed amid the continuous onslaught of everything— and (2) reflection—the capacity to stand back and see into the inner core of the dance itself—then Gabo's artworks reflect and acknowledge the power of this tension, showing you a way of working to simplify the conundrum. If one thinks of life itself as a spiritual possibility, then Gabo's art of simplification—of gaining control over the power of a sculptural form so that the smallest gesture carries the strongest weight, the most beautiful innuendo, the most freedom and autonomy, and the highest possible clarity—is a spiritual art setting a spiritual example.

Gabo's philosophical art is a good working image of what productive thinking is. Then his sculpture, rather than being wildly utopian in its optimism about the future absolutely to come, can be read as a gesture toward a better life, toward the way Gabo believes life must be lived if European culture is to survive. It is a gesture toward the recovery, renewal, and perfection of thinking. Similarly, Gabo's words are about survival, about how to guide the world out of its chaos. The very idea that art is in a prime position to bring about a perfected, spiritual age by setting a fine example is itself utopian enough, as is the idea that there is one and only one route to the perfected life. Nevertheless, the claim of an art aspiring to the unity of clarity and opacity is a livable one and a good description of what Gabo's own art accomplishes.

Therefore there are philosophical moments in which constructivism theorizes its art into the status of an example from which we can truly learn (this is also true of Moholy's theories about art's relation to vision). They are moments of constructivist philosophy which slide in and out of its more wildly optimistic, revolutionary speech and design. The revolutionary birth of the movement was in inflammatory words and hard-hitting artworks, and that voice never dies; it shades in and out, making the movement's history into a tapestry of voices. An overview of the enormous number of manifestos, articles, attacks, proclamations, descriptions, and criticisms constructivists have produced in their time will, I think, show the reader that no constructivist is consistent in his or her level of utopianism. Utopianism rises and falls like the political temperature, the social weather, and the waxing and waning of human optimism. Gabo is more wildly utopian when he writes in the 1920s than when he writes in the 1940s and 1950s. The extreme moment of modernist rhetoric comes to Latin American constructivism later, in the decades of the 1950s, 1960s, and 1970s: that is the moment of their avant-garde coup d'art. Constructivism is a restless search for connections between art, science, and philosophy. The search is not stable; indeed, the level of optimism must be inherently unstable, granted the impossibility of its radical success.

I have found two distinct philosophical voices in constructivism, both in its experimental shifts from theory to theory and the pattern of voices of its art objects. The first is the Cartesian voice, the second is Gabo's commitment to a philosophical search in art for the place of art in thinking; the first is Moholy's conception of art as part of a science which will discover universal visual laws, thus serving in the planning of the future; the second is his conception that art should stretch the visual sensorium, thus serving in the creation of that as yet unknown being called "the new man." The first, Cartesian, voice allows for nothing but transparency and scientific discovery in an artwork. It is resisted or ignored by the artwork's opaque features. These latter features speak in their own voice of risk, openness, beauty, and abandonment as do their requisite theoretical poles. I have provided an explanation of how the requirements of imagining and bringing about utopia forced constructivists into a constant experimental shifting from one theoretical pole to the other (even to the point of inconsistency), but there is more to say about this. What has still been left unanswered is the question of the full power in an art object which in its own right expresses both of these voices. In what follows I will argue that in the constructivist imagination, in its wildest dreams, the artwork does not contain two inconsistent

voices at all. Rather, the artwork is the terrain for their magnificent convergence.

To grasp the point, consider El Lissitzky. Lissitzky, far more utopian than Gabo, and far more overtly political, proclaims, "And we are the steps of our movement, which is just as independent and just as incomprehensible as the path of the lunatic for whom we all step aside in shame." [32] This is by the man who wrote (as we have seen), "We have set the proun in motion and so we obtain a number of axes of projection; we stand between them and push them apart. Standing on this scaffolding in the space we must begin to mark it out. Emptiness, chaos, the unnatural, become space, that is: order, certainty, plastic form, when we introduce markers of a specific kind and in a specific relationship to each other." [33] What are we to make of this contrast? Are we to infer that Lissitzky believes the Proun itself is visually certain, but not the revolutionary movement in which the Proun will play a role (call the revolutionary movement the "vague immensity" [that was what Marx called it] which winds toward Marx's golden future along an immense and uncertain path of progress)? Interpretation of Lissitzky's rhetoric hinges on how one takes the "we" in the first of the two quotes. Does "our movement" whose "steps . . . are independent and incomprehensible" refer to the revolutionary movement as a whole, or does it refer specifically to the constructivist movement? If the latter, then it is the constructivist movement itself which is being described as independent and incomprehensible—including especially, one assumes, its artworks. I take El Lissitzky to be speaking of constructivism and of his own Prouns, to which he intends to impute a wallop as striking, potent, unusual, and incomprehensible as the lunatic's wallop. (What he says probably extends to the revolution as a whole, which he must certainly believe is no less striking, potent, and opaque than its constructivist flank.)

Then how is the Proun to produce visual certainty and incomprehensibility all at once? Lissitzky wants his artwork to contain the confidence and clarity of reflectively and philosophically certain speech, and he wants his artwork to be a shot in the dark, an acid burning into the past estranging the bourgeoise from their complacency, a stimulant for the future which makes history get up and go. Of course, the truth itself burns, so a clear scientific presentation can contain all the rhetoric you want. But Lissitzky's idea of the laboratory for the creation of the new is not that of any ordinary laboratory, for in it

The *Proun* creator concentrates in himself all the elements of modern knowledge and all the systems and methods and with these he forms plastic elements, which

exist just like the elements of nature, such as H.O.S. He amalgamates these elements and obtains acids which bite into everything they touch, that is to say, they have an effect on all spheres of life. Perhaps all this is a piece of laboratory work: but it does not produce any scientific preparations which are only intelligible to a small circle of specialists. It produces living bodies, objects of a specific kind, whose effects cannot be measured with a meter or a manometer.[34]

The mad scientist of the Prouns makes an artwork from simple, pellucid elements (the hydrogens, oxygens, etc.) according to some strange alchemical process which is as incomprehensible as it is potent. This chemist/constructivist relies on all kinds of knowledge to forge a special metal which will bite into the world and stimulate the future. The language of science (read also "measurement and certainty") is brought into the process, but the result is a "living body" whose nature and effects outrun science and certainty: they "cannot be measured with a meter or a manometer." This rhetoric of a Dr. Jekyll, an Edgar Allan Poe, or a medieval alchemist elides the distinctions between truth and power, science and disruption, theory and praxis. Lissitzky draws on the resources of science (including Marxist "science") to invent acids whose power is astronomical to the point of cataclysm.

Lissitzky's image of the laboratory is more dramatic than that of any Bauhaus member's might have been, but certain of its features resonate with, for example, Moholy's image of the Bauhaus as a laboratory where the conception of the "new man" (read "the new person") is brewed in a ferment of theory and experimentation, including experimentation *with* theory. Moholy's is an image of experimentation with new forms, new images of the future, and new kinds of design which will play a role in bringing this future about.

Lissitzky's elision of science and gesture is one that is felt in his artworks themselves, not simply in the force of his rhetoric. His artworks have an expressive power to match his words. They are struggles toward self-formulation in metal for which the important thing is the activity, not the attempt at total clarity. Yet they also have the appearance of clear design, and they arise from simple elements. When Lissitzky's words combine in his laboratory with the forces already felt to exist in his artworks, both are strengthened in a synechodochical chemistry which insures the indomitability of the artwork. For our experience is then of an artwork (empowered by words) whose union of clarity and opacity, of geometry and forceful thrust, is assured through the forces of mad science. Shall we call those the forces of millions of people in revolution, of a violent entrenchment of per-

sons in the capitals of the world who will hurl missiles at all centers of power and launch the world on a trajectory from which it will never recover, a trajectory whose path is incomprehensible in detail yet whose final destiny is as rational (scientific) as it is majestic?

El Lissitzky's elision of the poles of transparency and opacity is not so much a recognition of the need for art and life to situate themselves between these poles as it is a rhetorical gesture which suggests that history is already making these poles converge. Lissitzky speaks as if his art has symbolically resolved the "scientific" pole and the hallucinatory rages of the historical madman, as if all the energy in the world and all the risk in the world has been absorbed by the artwork and silently merged with its clarities of form and its clarities of purpose. In their less moderate speech, constructivists like Lissitzky really mean their works to satisfy the requirement of Cartesian structural transparency, *and* in their other voice they mean their works as Mayakovsky means them—to be defamiliarizing shots in the dark toward a grandiose future which they already celebrate as they bring it about (call that "the 1920s in Russia"), as if both of these voices can converge in the artwork. Like Marx's rhetoric, the constructivist's artwork is a dream, a dream absolutely unifying two (mutually contradictory) poles. The artwork is a vision of the future in which opaque change and logical control will have already converged, as if the future is already in it in complete form. In it, Cartesian clarity and lunacy are the same. This is art as eschatology from these most hard-nosed artists.

Wittgenstein asks how a new language is to be constructed within philosophy. He asks what kind of builders are up to this most modernist task and what kinds of tools they must use. His answer is that no one is up to it, for the requirements of foundationalism can be met only in intoxicated philosophical fantasy. One can also ask how a new form of art or a new form of life are to be constructed from scratch, using the chemical simples and background knowledge of the philosopher/constructor of the Prouns. The answer is, it cannot, if what is required is prefigurement by a Cartesian theory, or what is more, an object in which Cartesian clarity and opacity will mysteriously converge. Wittgenstein also remarks that it is amazing that we can use our ordinary language to begin with. There is something amazing about the constructivist's use of words as well, but he does not use them as they are ordinarily used. His words take on the aura of art, they take on the rhetoric of eschatology. The form by which extreme constructivist discourse assumes power lies in the way its words bring philosophy to bear on art, and the way they slide—as they do in El Lissitzky—between the lan-

guage of science and that of lunacy. The constructivist's words must be unstable, shifting, and half-metaphorical, because that is the only way in which his eschatological image of art can be unfolded. It is a message which preaches the unacknowledged, let us say hidden, convergence of voices as a metaphor for history. Both voices are found in the constructivist's words and in his art objects.

Constructivist art is intoxicated by its quixotic dream of the convergence of two ultimately inconsistent requirements: the Cartesian (or related, the scientific) and the creative, as if it will recast life as a divine union of total clarity and totally unimaginable opacity, as if the future will suddenly loom before you completely accomplished and you don't know how. The convergence of these two voices in the artwork makes it appear as the beacon of transcendence, transcendence not into another world but into the future. In its most concrete sermons of metal, constructivism preaches the most ethereal of substantial unions. In this sense, the constructivist artwork is, in effect, a piece of philosophy, a place in which philosophical voices are given full range of fantasy, as they are in the metaphysics that it was Wittgenstein's desire to confess and bring back to earth. As such, the constructivist artwork is liable to the same transgressions and the same enthrallments as the metaphysical ideas Wittgenstein subjects to critique. Indeed, Kant's picture of a deep human tendency for the mind to try to pass beyond the limits of reason into the field of metaphysical dreams, extends beyond the province of philosophy departments into culture as such, for the constructivist artwork is, in effect, a union of philosophical requirements no less metaphysically conceived than the union of foundationalism, the world, and the human mind.

Whether this illusion making is ever justified is a complex question. There are situations in which it is more important to let the imagination run wild toward its utopian conclusions than to sit down and measure everything out. There may be certain moments in history in which this kind of utopian dreaming is a gamble that pays off. Nietzsche will call that the use of illusion in history. Here the illusion is noble but quixotic in the spirit of the times. My point is that the use of philosophical theory by constructivist art must be understood in terms of the dynamics of this illusion.

As for the ultimate belief in a transparent (if not eschatological) relation between theory, the art object, and the flow of history, it has been addressed by the youngest of the Venezuelan constructivists, Victor Luceña. Luceña designs artworks which construct situations in which the viewer is the ironized butt of the joke. He will make a set of four objects that look like iron

weights (*Cuatro elementos*). These range from a small one which looks very light to a large one which looks very heavy. Needless to say, the joke is on the viewer who is invited to pick up these objects and finds the smallest is much heavier than the largest (which is made out of Styrofoam painted to look like metal). These are sermons about metal, not in it. They preach skepticism about what one might find when one expects to find something; they preach the divergence of one's plan or narrative or explanation of the world and the world itself; they preach the instability of materials and shapes. They acknowledge the recalcitrance of the example for the theory. Luceña's ironizing suspicion about the connection between people and the world is a final suspicion of constructivism as such. Let us call it postmodernism.

4/ Mondrian's Plato

Banding together in 1917 with the painter and architect Theo Van Does-
burg, the sculptor and designer George Vantongerloo, the architects Gerrit
Rietveld and J. J. P. Oud, and with other, primarily Dutch artists, into the
famed De Stijl movement, Piet Mondrian aimed to erase the figurative, the
colorful, the picturesque, the sensual, and the particular from art, to erase
art's past altogether in the service of a crystalline, simplified abstraction
capable of bringing about the new. Almost at the same moment when con-
structivism began its act of destruction, Mondrian and his compatriots
started their own task of burying the past with their words and artworks,
with their journal *De Stijl* and with their canvases, sculptures, buildings,
and furniture designs. Such a grand mortality would, they knew, take some
doing. Van Doesburg, writing in the voice of all, stated that "The old cul-
ture, the culture of Jean Jacques Rousseau, the culture of the heart, the un-
cluttered vulture of a petit bourgeois intelligentsia and its hairy apostles,
Morris and Ruskin; the concentric culture, the culture of 'I' and 'mine' is not
yet completely a corpse."[1]

De Stijl's intention was to make it a corpse, to ensure that no shred of
past style remained in their own art. Thus liberated from its past, Mondri-
an's art and that of his compatriots would be in a position to usher in the
new age from scratch through its pristine example. Mondrian's essay "The
Liberation from Oppression in Art and Life" shows how much the painter
believed changes in the fabric of art would effect changes in that of life. He
began his essay, written in the dark days of 1942, with a description of what
changes were needed in the political world in order for a new, harmonious
life to emerge from the ashes of oppression. But he quickly shifts in that
essay to the topic of how past art has enchained painting in a maze of figu-
rations from which the art of the future must liberate itself. It is as if past
art, not economic chaos, war, and fascism, is the real enemy, an enemy one
can feel capable of dominating by a swift kick of the pen and the brush. The
subtext of this text lies in its optimism, in its sense that, were art to free
itself from its past, forging clear abstraction and pictorial harmonization
and completely banishing figuration, somehow the rest of life—political,
economic and social—would be in a position to follow.

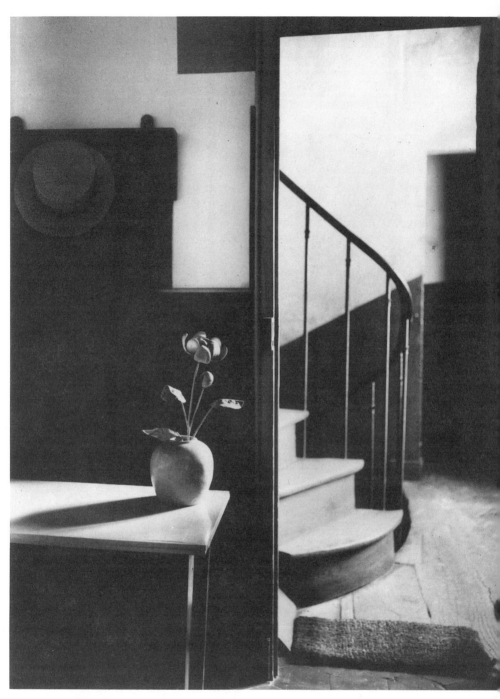

André Kertèsz, *Chez Mondrian*. Photograph. Collection of James and Barbara Herwitz, Muir Beach, CA. Photo by Daniele Filippetto.

Mondrian's level of optimism, his level of belief in just how far art could go in recasting and rejuvenating the world, passes beyond the optimism of Russian constructivism, which was quite clear on the point that art by itself, in the absence of a more general revolution in material conditions, cannot be expected to succeed in its purpose. Constructivism is materialist, Mondrian, idealist. In spite of his belief in the importance of technology for human development, Mondrian is, in the end, a Platonist who stresses the ethical force of abstract theory and abstract structures in perfecting the world, rather than a materialist revolutionary who relies on the transformation of art and ideas into the hard currency of work.

The question of how to take Mondrian's optimistic discourse, of how to decide the kind of relevance it has for his paintings, is to our point. It is a question at the core of Mondrian interpretation. Mondrian's optimism is extreme to the point of spearheading a complete change in the world. In proportion, his theory, the place where he articulates this spearheading, is all-encompassing. One needs to come to grips with Mondrian's level of idealist optimism, with the extent to which he claims his paintings exemplify an enormous idea. It is tempting and easy to write it off as nutty, thus dispensing with many of Mondrian's many words altogether when approaching his paintings. Mondrian's writings are inflammatory, they are a wilderness of adjectives, interjections, interconnections, associations, and raving appropriations of philosophy, while his paintings are serene, contemplative, rational, and simplified. Strange that his style of writing should differ so dramatically from his style of painting! It is easy to take this division of labor or of personality as insuperable, to view Mondrian as two relatively disconnected persons: an original, even wonderful, painter on the one hand, and a crazy writer on the other, a writer whose words don't, in the end, touch whatever powers and values his paintings have. Or if one decides that the gap between word and painting is not insuperable, then perhaps the words show us that Mondrian's paintings are more animated, more obsessed, more wildly symphonic than their quiet harmonies would lead us to suspect by visual inspection alone. Perhaps this is a case of a painter who walks softly but carries a big stick.

These questions about how to decide how much Mondrian's words are actually imprinted in his art have not been adequately addressed by Mondrian studies, however excellent such studies might be in other respects. They either begin and end with Mondrian's pictorial innovations (his achievement of abstract two-dimensionality, his use of primary colors), or they begin and end with his words. In either case, they dispense with the

question of whether and how Mondrian's words, that is, his stated philo-sophical theories, succeed in making a connection to his paintings. On the side of the words, there has been considerable writing on Mondrian's phil-osophical background, most notably by Mondrian himself (who may rank as the painter who wrote the most words of any painter), but also by Hans Jaffé and others.[2] Mondrian's Platonism, his belief that the identity, integrity, and reality of a painting is a matter of how transparently it unfolds abstract, universal forms, has been made a topic of discussion. The influences of He-gel (through Gerardus J. P. J. Bolland) and of theosophy (through Rudolph Steiner) on Mondrian have also been well documented.[3] However, these dis-cussions have either uncritically assumed that Mondrian's paintings have the power to express all the philosophy he says they do or they have avoided the question of Mondrian the theorist versus Mondrian the painter alto-gether. Jaffé, for example, begins and ends his magisterial study from within Mondrian's universe of discourse, uncritically concluding his book by as-serting, "Mondrian was indeed capable of universal vision. He has ex-pressed it in his works, his essays, and in his imaginings of the future" as if this has been proved or is an assumption about the expressive capacity and nature of Mondrian's paintings which is not in doubt.[4]

Mondrian has read Plato and Hegel; he is a spiritualist thinker who in-tends his art to reflect platonic ideas and thereby exemplify the new platonic world order and bring it about. Mondrian is a philosophical painter par excellence. My study of Mondrian, like the constructivist study which pre-ceded it, will be a study of Mondrian's philosophical voice. That means ask-ing hard, philosophical questions about how to read his art. The questions which run through my study are (1) how far the philosophical theories culled from Mondrian's words actually do work in structuring his artworks; (2) what other voices there are in the artworks, how his paintings might resist the rule of his master intentions; and (3) for what reasons Mondrian calls on theory and philosophy to prefigure its artworks. As for the third, Mondrian is not one to slide from theory to theory in an experimental fash-ion. He claims no difficulty in imagining utopia to perfection. But that is because, on account of his Platonism, he feels no need to imagine utopia in any detail. For him the world is an abstract, harmonious entity, known in complete philosophical abstraction. He is no planner of utopia; for him, it will come about by the compelling force of abstract thought itself as if, were everybody to think hard enough, the world would automatically change. Thus Mondrian's use of theory does not take place in the cultural trenches of trying to plan utopia; he is not in the concrete position of Moholy and

the Bauhaus, or even in the didactic and educational position of Gabo. Yet for Mondrian, the turn to philosophical theory takes place in the context of his vision of utopia and of his perfect certainty that his artworks with their Platonistic form will bring utopia about by exemplifying it. His use of theory is then itself practical—once praxis is understood to exist at the highest level of intellectualization and abstraction.

This chapter will work out the terms of Mondrian's Platonism, of his attempt to philosophically prefigure his art in Platonist terms while also bringing out alternative voices in Mondrian's art. I will focus on how Mondrian goes about marrying theory and painting into a grand and harmonious gesture. But marriage of two things in a gesture of art does not imply the rule of the one by the other. Mondrian intends to autocratically define and rule every inch of his simplified abstractions by his Platonistic theory. My reconstruction of Mondrian's attempt to do this will be the reconstruction of a serious attempt on Mondrian's part. It is not, needless to say, the reconstruction of a success story. To my mind the difficulty in reading and reconstructing Mondrian has to do with deciding just how far his philosophical theories about art should be taken to actually define the meaning of his paintings. That is, contra Jaffé, I find it very hard to decide just how far Mondrian's paintings *do* express his Platonist/Hegelian/theosophical words, much less how much these words, either in tandem with the paintings or not, add up to a universal vision. I find it hard to decide just how philosophical his paintings actually are.

This is obviously a sore point for any investigation into the philosophical character of avant-garde art which would desire clear and conclusive results. One way of achieving a clear result about the philosophical character of Mondrian's art would be to say that Mondrian's total artistic gesture—including his paintings, his theories, and his manifestos—is philosophical simply because part of that package (the manifestos and writings) spells out philosophy. The total art of an avant-garde artist goes beyond the *art object* (the painting). So it could be said that Mondrian's total art is philosophical, not because his paintings are defined by his inflated, philosophical words, but because (1) his words are philosophical, and (2) they are one ingredient in his total art.

That approach would avoid the harder issue of deciding whether Mondrian's words invest his paintings with philosophy or not. It would not be a reading to satisfy Mondrian himself. It is important to Mondrian that his theory is embodied transparently in his paintings whose abstract crosses are, so to speak, the crux of his total art. Otherwise, his artworks lose their

powers of philosophical exemplification. Yet it does seem to me that at the core of one's engagement with Mondrian, doubt must arise about whether the paintings are, in fact, very philosophical at all. I have been told by art historians who teach Mondrian that they often flinch at the confident insanity of this serene painter's discourse, as if to say, "Should I really believe this? Should I really think that these paintings are explained by this woolly wilderness of words?"

I take such reactions seriously—philosophically seriously. Better put, it seems to me that a doubt should arise about the extent to which Mondrian's paintings express the *amount* of philosophy he claims they contain, namely, a world of it. When Mondrian asserts about the simplified abstract paintings in primary colors he began to paint in 1917 and continued to paint until his death in 1944, "The rectangular planes of different dimensions and different colors demonstrate to satisfaction that internationalism involves no chaos at all . . . but a unity that is well-ordered and sharply divided,"[5] should we take his paintings to mean, much less demonstrate, that fact (if it is a fact) or not?

Mondrian's art raises the question of the capacity of a visually abstract object to be the transparent bearer of ideas. This question was, in effect, already raised about Gabo, but less forcefully. In chapter 2, I asked whether Gabo's abstract sculptural forms (1) succeed in conforming to his philosophical intentions, and (2) even carry the Cartesian intentions he says they do (as opposed to, say, merely being beautiful objects or shots in the dark or having some other meaning and intention). But Mondrian aims to go further than Gabo in making his art objects the bearer of philosophical ideas. He aims to turn every inch of his paintings into abstract signifiers, so that, like the signs or words of a divine language or philosophical code, they can be invested with maximum semantic value. His paintings should describe the world in detail, they should express and demonstrate highly specific facts about the world. Mondrian is an artist of extreme theoretical *putsch*. He intends to make his canvas speak like a philosophy book. Those Mondrian paintings which look to the naked eye so naked in their profound balance, are meant to carry demonstrative power and linguistic articulation—if we take his theory about them to be the key to his intentions. So, for example, the cross in a Mondrian painting should declare the interdependence of all values: masculine/feminine, space/time, self/other, internal/external, nature/artifice. The abstract cross form is supposed to be nearly as articulate as a word in language, the Mondrian painting as articulate as a sentence of language.

It will be a task of this study to reconstruct how the demonstrative character of Mondrian's paintings is supposed to be achieved. That will involve understanding how Mondrian aims to make his paintings into platonic forms which "speak" or "demonstrate" the truths of the world. My reconstruction will be somewhat elaborate, befitting its theosopher/philosopher subject. Nevertheless, it is required if we wish to ask in a perspicuous fashion how much semantic (philosophical) control Mondrian succeeds in achieving over his canvases. Mondrian's interpretive codes for what his paintings signify and describe about the world are surely a road map of what the paintings *might* mean.[6] But is it right to say that his intention to make his abstractions into philosophical codes actually succeeds? Do his paintings resist the requirement (perhaps in accord with his deeper, unconscious intention)? Can they, as abstract paintings, fulfill it?[7]

The extraordinary thing about abstract painting is how flexible its conditions of meaning are and how constrained they are. Without an interpretive code shared by a culture, without a specific context of events to which a painting responds, without a title or a narrative supplied by the painter, an abstract painting will not have much chance of depicting or describing anything. Then it is worth remarking how an abstract painting is made into a narrative or otherwise turned into a sign of some kind. This typically happens through a marriage between word and paint.

Consider as an example of such a marriage the role of the title in Barnett Newman's well-known series of canvases, the *Stations of the Cross.*[8] Newman's paintings are oil and acrylic abstractions consisting simply of modulating sequences of vertical lines or areas on unprimed canvas or white fields of "color."[9] I am sure they would look a little different were they named differently or left untitled. As it is, their look is redolent of their title. In this acrylic series, Newman pushes his black and white (with traces of brown) to the expressive limits of color, but with a spareness that intensifies the Christ story. In Newman's spare tones of black and white one sees the seriousness of that story; in his brilliant whites one sees a blinding severity and blinding brightness, as if the stations of the cross are being reduced to their existential and expressive core, to a modulation of moods of little articulation but vast expressive depth. For one is invited to play off Newman's abstract, hence unarticulated, set of pictures against what one knows of the story, and in the spare reductionisms of Newman's abstractions each station is turned into a pictorial mood of the most basic dramatic and existential elements. Newman's repetition of the edge in his pictorial verticals (the only pictorial element in his paintings other than mere black and white) sets the

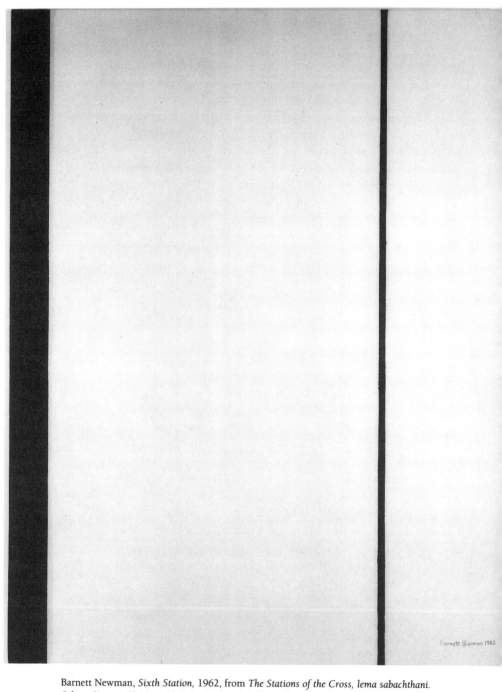

Barnett Newman, *Sixth Station,* 1962, from *The Stations of the Cross, lema sabachthani.*
Oil on Canvas, 78 ⅛ × 59 ⅞ in. National Gallery of Art, Washington. Robert and Jane
Meyerhoff Collection.

internal drama played out in these pictures as one concerned with the very limits and definition of painting as such. This calling forth of essential elements of abstract painting (the edge, the filling of space with black and white) becomes Newman's way of interpreting the Christ story in terms of its existential core—in terms of questions of limits and of the limitless, of definition and form—both pictorial and existential. It is in this interplay of abstraction and articulation, of mood and drama, of the limited and the limitless (the edgeless, the nonarticulate), that the resources of abstract painting are called on by Newman to show the uncontained mystery contained in these biblical events. In short, Newman's painting is religious.

Newman's work is a powerful marriage of title and paint. It is certainly true that, were Newman's title different, the overall experience of Newman's work would emerge differently. In this sense, the expression and signification in its paint has a plasticity capable of various ways of completion. The title finds its relation to the work because of visual features (absence of color, spareness of composition, the sequence of works, the repetition of the edge in the verticals) which (1) could survive the absence of the title and (2) give the title a visual path through which to inform the paintings.

This dialectic, this marriage of the visual features of the work with the story provided by the title, is what makes Newman's paintings signify (what makes them deeply significant). Mondrian's art is also an attempt to marry the theory behind the painting with the painting's visual features. However, unlike Newman, Mondrian aims for more than a correspondence of art and idea; he supplies a further semantic interpretation of his abstractions which is assigned by fiat and in astounding detail to his visual forms. Mondrian, seldom one to rest content with the natural element in things, treats his visual abstractions as wholly arbitrary signs in an interpretive code. And he goes further—not merely saying that his paintings signify something about internationalism or the male/female relation, but saying that the paintings *demonstrate* those truths. Not only are the things signified by a Mondrian (internationalism and gender) true, but furthermore, his artworks prove or show their truth. The idea that an artwork can demonstrate a truth about its own construction is at the center of constructivist thinking. It is likewise part of the conceptual character of Mondrian's art that the art should have demonstrative power not simply about its own construction but about the world as a whole.

The line between art as demonstration and art as mere signification sometimes becomes blurred in Mondrian's writing, a fact itself worthy of exploration; indeed, a fact leaving us unsure about just what Mondrian

means by the term "demonstration" or how seriously he really means it. One shouldn't dismiss his belief in the demonstrative character of art too quickly, however, any more than one should dismiss his claim that his abstract oils are elaborately conceived signs. Mondrian is not only a Platonist but also a theosophist, and it is perhaps the epistemological definition of a theosophy that it makes grandiose claims about just how much of the hidden world is available for knowledge, subterranean insight, or demonstration.

I aim to show that Mondrian's theosophy and his modernist optimism converge at the point of demonstrative epistemology. The artwork's form and semantics are meant to prove that Plato's truths are applicable to all areas of the world.[10] But a leading theme of this chapter is that Mondrian's abstract paintings bear an essential ambivalence toward the theories which Mondrian so confidently claims interpret and explain his paintings. In one voice Mondrian's post-1917 abstractions are like blank logical grids, waiting for the words to flesh out their meanings, while in another, Mondrian's paintings are abstractions perfectly balanced between the forces of dynamism and stillness, hard and soft colors, space and line: they are abstractions whose spirituality is a matter of their complete indifference to any and all of the words Mondrian intends to interpret them with. The paintings open to and resist the words. Hence one perspective on Mondrian's paintings is that their very spirituality is predicated upon the way they banish or ignore all theory. Does this mean that the paintings speak in their own voice, call it the voice of Mondrian the painter rather than Mondrian the theorist? The issue is further complicated by the fact that Mondrian's is a use of theory which turns theory into a spiritualistic gesture which itself contributes to making the paintings into spiritual *art*. In Mondrian we will find a porous exchange between philosophy and art, with philosophy used to make the art philosophical, but also philosophy made into a kind of spiritualistic, theosophical art.

I

In order to introduce Mondrian's Platonism, let us briefly recall the opening phases of Mondrian's history. Mondrian achieved a breakthrough into completely abstract painting in 1917. He continued to make, and at the end, jazzify, abstract paintings, until his death in 1944 (see *Victory Boogie-Woogie* on this book's cover). Before moving to Paris from his native Holland in 1911, Mondrian had already felt the impact of modernism and had

painted Fauvist-inspired landscapes (whose vivid reds and blues were also heavily layered in impasto in the manner of his countryman Van Gogh). By 1912 Mondrian had embraced cubism. His well-known oval composition of 1913–1914 contains the letters "KUB," an obvious acknowledgment of the picture's style and derivation. But Mondrian's cubist style is quite different from Picasso's or even Braque's. Mondrian's cubist work is already abstract. He never aims for the solidity of Picasso's cubes and planes, or for Braque's harmonizations of nature. Mondrian is less interested in the capacity of lines and color to engrave a canvas with the potency of anthropomorphized forms and more interested in the balance of relations between lines, paint, and cubes on a two-dimensional surface. Mondrian's cubist work is about blocks and lines in a mostly two-dimensional space. His cubist composition of 1914 relies on an interlocking pattern of small straight lines, mostly horizontally and vertically placed (suggesting that his overriding concern with the cross was already implicitly in place). These lines delineate a maze of small geometrical cubes in a complex figure/ground pattern. Some of the lines are surrounded by washes of background color as if thematized, while others are clearly used to descry cubes. The mazelike effect of Mondrian's composition in cubes traces neither a figure nor an ordinary object as in Picasso or Braque, but, rather, the line and the cube are themselves the explicit pictorial elements.

Cubism, according to Mondrian, had not gone far enough in following through its own "abstract" principles. "Gradually I became aware that cubism did not accept the logical consequences of its own discoveries; it was not developing abstraction towards its ultimate goal: the expression of pure reality." [11] It is debatable whether Mondrian's interpretation of "the Cubist discovery" is correct. Are Picasso's geometrized canvases the presentation of an a priori principle of idealized representation or is his hard-edged, multi-perspectival geometry less the expression of a theoretical principle and more the expression of other things, things personal, intimate, and sexual? [12] At any rate, Mondrian believes that Picasso's "discovery" was an abstract one, and he aims to complete the cubist task as he sees it: following through the "logical consequences" of cubism, developing it into a fully abstract style of painting capable of presenting an idealized reality. Returning to Holland, Mondrian is caught by the outbreak of war and isolated from Paris. In Holland he commences on his project of pictorial clarification, his plan of recasting nature according to a completely abstract plan of composition, a plan capable of showing the real underneath things.

This necessitates further pictorial innovations on the part of Mondrian.

His cubist works, while more abstract than Picasso's or Braque's, had nevertheless retained the underlying suggestion of figuration through their oval figure/ground arrangement. Those pictures may be about lines and cubes, but their mazelike interlocking of lines and planes, set ovally against the backdrop of grey or color in the manner of Picasso's work of 1910 and 1911, cannot help but make the oval itself figural. By 1917–18 Mondrian had removed this trace of portraiture, freeing his pictures into the realm of complete abstraction. His compositional plan is no longer oval but square; his lines and boxes are no longer placed figurally in the middle of the canvas, surrounded by background color space at the borders of the picture frame. Rather, Mondrian composes his squares and lines so that no surrounding space which could be construed as "ground" is left. No trace of figuration remains, all is a matter of internal harmonization or calibration of the inner parts of the composition into a single whole. These works, poised as they are between the forces of stillness and vibrancy, are works in which the whole dominates over the parts, as if it were a single chord in music whose elements have just been tuned, whose tuning is beautiful because so subtle (a single shade of difference would be enough to throw the entire compositional chord into disarray). Yet the whole is paradoxically tuned through the intensely asymmetrical interplay between the parts (the individual squares), whose asymmetries of color and placement force the eye to oscillate between focus on one and focus on the other, as if each part is asserting its visual centrality. In the vibrato of the eye's oscillation from part to part, each part's relationship to the whole is visually reinforced (put another way, each part's placement in the overall pictorial arrangement is visually clarified). Mondrian's pictures are also animated through the fields of energy generated where his thick, varnished lines meet areas in the canvas of unvarnished oil pigment.[13] Thus harmony or balance is achieved through the fact of vibrato, not simply at a glance, with the effect that Mondrian's paintings are chords which perpetually sing their notes in alternating emphasis. Mondrian's compositions, tuned by his perfect ear, possess an originality of arrangement and calibration which signals perfection. In his reduced world of the cross, the cube, and soon only primary colors, equilibriation of form into an intense, vibrant, but also serene harmony is everything.

It is against the mood and feel of Mondrian's pictures—highly sublimated pictures drained of all chaos, all inchoate emotion, and all romanticized, unbalanced play of parts—that Mondrian's writings take on whatever conviction they have. One feels, when looking at a Mondrian, that it is the attunement of the whole which is the only real value, indeed, the only real

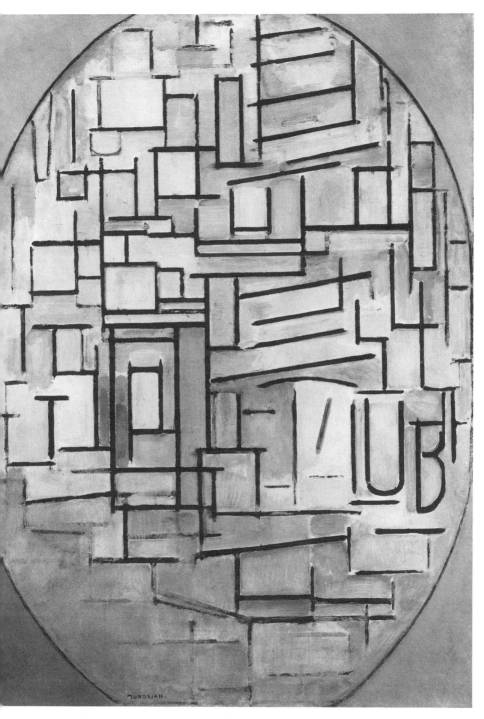

Piet Mondrian, *Oval Composition,* 1913–14. Haags Gemeentemuseum, The Hague.

thing or quality in the painting. One feels that without the whole the parts would disintegrate entirely into a kind of nothingness, that without the whole the parts would have neither meaning, integrity, nor identity.

Mondrian eliminates the fact of particularity in his paintings by eliminating all elaboration of differentials of meaning between the parts of his pictorial wholes. Painting normally accepts the details of particulars, explores these, and makes them shine through. It studies the individualities of things in paint (Delacroix's animals, Cézanne's fruit, Daumier's faces), it explores differentials of meaning between particulars (landscape vs. sky, figure vs. ground, Madonna and child), it projects peculiarities and intensities of mood. Mondrian removes all presentation of individual vicissitude from his pictures: "The appearance of natural forms changes but reality remains constant. To create pure reality plastically, it is necessary to reduce natural forms to the constant elements of form and primary color." [14] The pure reality of things is a matter of their balance into the harmonized whole, and Mondrian believes that the mere assertion of any particular vicissitude of a thing inherently deranges and unbalances the whole: "If anyone should advance that art has always given proof of 'harmony,' we may perceive . . . that the art of the past bore a balanced expression, yet always there was something dominating in the range of the forms and in that of the relations. Suffice it to mention the predominance of the figures or things as to paintings, or the predominant expression of the Height in Gothic Art, etc." [15] Past art, while not unbalanced overall, did not achieve the complete balance Mondrian's abstractions present, a balance in which no aspect of the picture predominates other than balance itself. Then balance or harmony is everything for Mondrian. Reality—his pictures tell us if we are to believe the evidence of our eyes in tandem with his discourse—is nothing other than and nothing beyond the balance of things as such, a balance repressing individual assertion of difference or the preponderance of any element (Gothic height, Fauvis color, the figure).

What is left of particularity in paint is nothing other than shape, position, and color. Shape is reduced to rectangularity, color to primary colors. Only dimension and position are allowed to be asymmetrical in the service of overall balance: "Plastic art shows that real form is not mutual equality but mutual equivalence. In art, forms and colors have different dimension and position, but are equal in value." [16] The concept of equivalence allows for the assertion of particularity (through the visual fact of asymmetry), but particularity defined only as size and color and interpreted only in terms of the whole arrangement in which it inheres. One is therefore uncomfortable

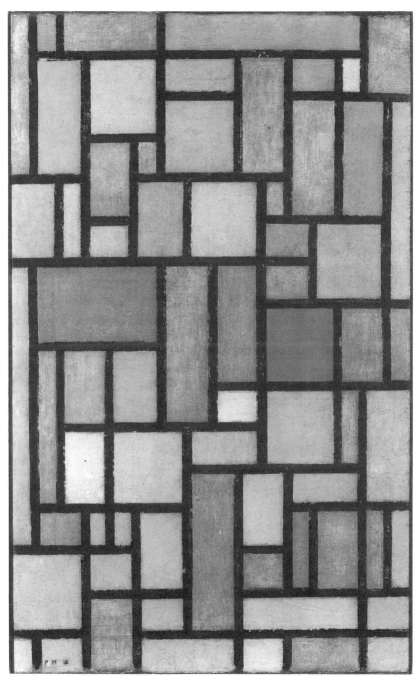

Piet Mondrian, *Composition with Gray and Light Brown,* 1918. Oil on canvas,
31 ¾ × 19 ½ in. The Museum of Fine Arts, Houston, TX. Gift of Mr. and Mrs. Pierre
Schlumberger.

with calling the parts of a Mondrian abstraction "objects" or "things" in any but the most abstract sense.

Nineteen seventeen was, as I said, the year that Mondrian both achieved abstraction and banded together with his compatriots to form the De Stijl movement. It was at this time that Mondrian began to write in quantity. Mondrian wrote almost entirely for *De Stijl* while the journal was in existence. Mondrian's words are required to explain the exemplifying powers of his art. Words are required to get the audience to take the sermon in the art, for Mondrian's paint does not wear its sermon on its face. Just looking at a Mondrian, you might receive anything or nothing in the way of a sermon from it. Your eyes would tell you something of its nature: that its harmonies are idealized, that it is pristine and simplified. If the paintings are to speak at all, one must gather at least this from them purely visually. However, Mondrian's paintings appear so placid, so divinely silent in their grace, that there is no reason, independent of Mondrian's words, to take from their harmonies any message about the world generally. On the contrary, one might assume on visual grounds alone that Mondrian is a spiritualist whose paintings exist for their own sake and indifferently to all else, or one might assume nothing and simply enjoy them.

For Mondrian, a painting's abstract, harmonized form exemplifies the hidden, inner form of life, its true reality. Mondrian's art is Platonist in conception. the platonic form in the work is meant to raise one's consciousness and serve as an example of how to find the form in all other things. Since Mondrian's theory is Platonistic, let us recall the character of Platonism for a moment. Platonism is the belief that the reality of things is not a matter of their robust concreteness but rather of the abstract forms behind them. Things are to be distrusted as unclear, inchoate, and uncontrolled. To possess the reality of the world, to hold the integrity of the world in one's hand, is to conceptualize it, to know it, to stand in a knowing relation to the inner forms of things which lie behind or outside of things. A tree is nothing until given identity by its abstract, ideal form. Its particularities of shape and size, its twisted branches bearing out the endurance of slow years of wind and hurricane, its cedary aroma, these things particular to its appearance are to be counted as not counting. This is no romanticism, no interest in all the things about that tree which make it special, which make it ring with its own site and time and history and ecology and aromatic wine. This is the idea that the reality of the tree, its essence, is precisely the ideal shape which it, at most, approximates: let us say a shape straight as a Mondrian arrow. Platonism claims it is the erasure of all differences between trees which mat-

ters for their reality, not the assertion of what is particular to each, as does De Stijl. (Why one can't have it both ways, opting for commonalities and differences as together defining the nature of things, is another story, an empiricist's story.) The Platonist goal of life is to bridge the gap between appearances and their ideal forms through knowledge of forms. Knowledge of a form will make the world better by placing the knower in the position of making the world conform to the form's dictates. The world will then be better.

Socrates demands of Euthyphro in the *Euthyphro,* that he describe what piety is, neither by giving examples (a picture of the paradigms, varieties, and complexities of pious action and feeling is not enough) nor by pointing to what he sees and does, but rather by producing a definition: "Bear in mind then [Socrates says to Euthyphro] that I did not bid you tell me one or two of the many pious actions but that form itself that makes all pious actions pious, for you agreed that all . . . pious actions [are] pious through one form." [17]

The definition Socrates so valiantly looks for and never gets would tell him what properties of action make piety piety (or, by extension, what properties make a tree a tree, a person a person, or an artwork an artwork).[18] It would tell him what the essence of piety (or a tree, person, or artwork) is. The form of piety, like a standard meter bar or an architect's blueprint, is so precise that for any putative example of piety (or a person, etc.) we will be able to tell, with it in hand, if the particular action (or being) measures up to the form or not. We will be further empowered by the aura of the form to embody the truth of that form (piety) in our lives. The form preaches its own convincing sermon about self-embodiment. If we possess the form of piety, we will be so overwhelmed that we will not be able to do otherwise than act piously. If we possess the forms of nature we will know nature and know the place of nature in the scheme of life. Its place will be harmonized with that of life generally. Life will be recast according to the real and the good; the gap between appearance and form, between the ordinary and the ideal, will be removed. Life will become perfect.

According to the plan, anyway. Socrates was skeptical, if not despairing, about just how far human beings can go toward knowing real forms and thus recasting their lives for the better according to the form of the forms. Plato, writing later in the *Republic,* speaks of the vision of a form as so blinding that no one can hold on to it; it burns one's eyes. But Mondrian is not skeptical about our capacity to embody platonic form in the world, to make the world conform to the powers of philosophical perfection. Mondri-

an's avant-garde optimism is an optimism about the possibilities of making the world conform to the dictates of platonic philosophy. His art intends to out-Plato Plato's philosophy, by claiming (against the intense resistance of Plato) that the platonic ideal can and will be embodied in the world. Using the artwork as his avant-garde example, Mondrian intends to demonstrate the case for the world, to prove that the world is up to the task of embodying platonic law or, what is the same, platonic form.

The demonstration will be visual. Similar to the way Descartes's ideas are seen clearly and distinctly in the mind, Socrates conceives of forms in visual terms. A form is—it is important to put it in this way—like a Mondrian artwork. We are supposed to be able to see it directly (its brilliance would blind us like the sun), but in fact the dialogues of Socrates make clear that our only access to it is through the medium of words (of definitions which will reveal form to the mind). A form empowers us, yet its auric character consists in its eternal, immutable indifference to us. The forms exist in a realm of silent harmonic perfection. Mondrian will exploit all these aspects of the Platonic notion of the forms when he intends to turn his paintings into embodiments of the forms. He will rely on the visual metaphor of seeing the forms. He will rely on the fact that we approach forms through the medium of words, yet words are meant to evaporate in the overwhelming immediacy of seeing them. And he will rely on the auric character of their indifference to us. Like the constructivist's appropriation of Descartes, Mondrian's attempt to embody philosophical truth in a visual object hinges on the fact that the philosophy he aims to embody is already articulated in terms of visual metaphors. It is a philosophy which thus can be transformed from metaphor to reality, from the netherworld to the here and now, from philosopher's dream of seeing to actual vision.

Van Doesburg speaks for Mondrian when he says that the new age is already proclaiming its platonic embodiment: "The new culture is revealed by a few [heralds] . . . appearance is replaced by essence. Vagueness becomes distinctness, . . . illusionary space becomes space. Illusionary depth, real depth. Emotion becomes consciousness. War becomes law. Nature becomes style." [19] This conception of life emergent in the modern age, is a conception of things becoming what they really are, of things being realized or revealed according to their true identity, of things free of vagueness, free of the opacities of appearance, free of the pixilated vicissitudes of emotion, of things exact, lawlike, and immaculately stylized.

Van Doesburg's words provide a good working map for what Mondrian believes is required of art, if it is to be raised to a level where it can embody

platonic truth. First, art must find and express its essence. Second, we must have a clear idea of what the universal law is that painting (and all other real things) expresses. Mondrian believes his first task as a painter is to clarify the essence of his own medium, to discover universal truths about painting. Third, emotion in art must be sublated or sublimated into a kind of universal knowledge free of all personal interests. Fourth, all traces of nature must be cleared from painting. His paintings will then be able to stand as the visual embodiments of the forms, as the bearers of demonstrative and world-historical powers for all those whose gaze they touch.

I wish to elaborate on each of these four of Mondrian's conceptual requirements, and I wish to consider how Mondrian tries to make his crystalline abstractions in paint conform to them. I will then turn to the topic of how Mondrian believes his paintings wrested from nature and turned into the embodiments of form, carry further semiotic and demonstrative powers. First, consider what Mondrian means by painting's finding its own essence. He says: "Neo-plasticism has found the new reality in painting, by abstracting the outward appearance and only expressing (crystalizing) the inward essence. . . . This universal means of expression makes it possible to give the exact expression of a great, eternal lawfulness in relation to which the objects and all existence are only its indistinct embodiments. Neo-plasticism gives expression to this lawfulness, to this 'unchangeable' by an exact, distinct, i.e., a rectangular relation." [20] Neoplasticism has bridged the gap between appearance and essence in the medium of painting by replacing the illusions of the pictorial medium (representational and expressive) with a space simplified of everything except the bare-bones essence of painting as such—real two-dimensional space. Like the formalist critic Clement Greenberg, Mondrian believes paint on a two-dimensional surface in two-dimensional space is the essence of painting because it is what is unique to painting. No other art is built from these features. (Of course, printed language is also built from a physical stuff applied to a two-dimensional surface, so painting would have to be distinguished from language by other means, say, by a theory of language, but let us elide this point.) Note, however, that Mondrian's own art, while visually simplified, is a lot more than mere paint on a two-dimensional surface, for its visual surface is apparently ruled by his theories. Thus Mondrian's formalism is not easily squared with his Platonist requirement that art signify realms of theosophy and demonstrate realms of philosophical truth. Are these semantic powers part of its two-dimensional essence?[21] Indeed the very claim that art has an essence is itself dubious, but let us elide that point as well.[22]

Concerning the second requirement, let us think about what Mondrian means when he claims that De Stijl's canvases, sculptures, and buildings have the capacity to express not only the essential laws of painting but also the universal laws of all things. Socrates did not claim in the *Euthyphro* that the discovery of the form of piety was the discovery of the form of all things, merely that it was the discovery of the form of one thing—piety. Mondrian claims more; he claims that the abstract equivalences of elements in his canvases express the laws of all things—the universal law "in relation to which the objects and all existence are only its indistinct embodiments." A Mondrian canvas is meant to express the one law which shows itself in everything, in every embodiment, and every harmonization. How shall we understand this law ("law" and "form" are interchangeable terms for him)?

For Mondrian, the one law underlying all things must be the law of harmonization as such. (There is nothing else it could be; no other law is general enough.) The identity and integrity of any thing is given through the one law of harmonization. This formal law of harmonization can be taken in two ways. First, it can be taken to mean that there is one superform of harmonization which applies across the board to all things—whether to trees, paintings, rectangles, persons, or societies. The rule of harmonization is a universal rule specifying the correct formulation of every relation in the universe. But the last must also do more. It cannot merely provide the one form of relations between things, it is a Platonistic rule which must also spell out the natures of the things it harmonize or calibrates. Mondrian's law must show us the essential composition of a tree, or of a painting, or of a society. It must then be a law which proposes essential differences between things, yet it must also remain one law for all.

That is a hard task, for, since one assumes each thing has a different nature from all other things, how can one law of harmonization succeed in spelling out these differences? To understand Mondrian's response to this problem, we can take a clue from his discussion about the essence of painting. He says the essence of painting consists in nothing other than its specific formal elements: two-dimensionality, real space, and real depth. He has stripped the particular thing at hand—painting—down to its absolutely minimal essential elements. These minimal elements, relieved of all further individuality, provide, to his mind, enough content to distinguish painting from all other things (they are painting's essential elements, the things that make a painting a painting and not another thing). So one starts from the specific elements of a thing and applies the law of harmonization to those unique elements in order to arrive at the unique thing. It is the bare-bones

elements of a thing plus its form of calibration which show us what a thing really is. On this line of essentialist reasoning, what makes music music is time and tone (its essential elements) in the correct form of composition (harmonization); what makes a person a person are her basic elements (body and mind?) in the correct form of harmonization; what makes a nation a nation are its basic elements (people, geography?), again in the correct form of harmonization. And so on.

Apparently it did not occur to Mondrian that each of these modes of harmonization might be different, thus precluding a single kind of harmonization which could apply to all. This shows how abstract his approach to things is, or how much he disdains their individual vicissitudes. We will return to this point, for it shows how little need Mondrian feels in imagining the specific form that utopia will take. Since all things have the same form, there is nothing unique to utopia other than its complete success at harmonizing all relations as such. This is true even of the second way one can reconstruct what Mondrian means by the law of universal harmonization. On this second interpretation, Mondrian's law is more holistic and Hegelian. The one law is a superrelation, the relation of the harmonization of everything. It harmonizes everything together into a whole. One begins by specifying the essential ingredients of all things. Then one points to the one law relating all things into one fully interrelated, harmonious world, as if the world were an enormous chord composed of a universe of tones.

However one wishes to interpret Mondrian's conception, the point is to see that, for Mondrian, there is in the end only one law—that of equilibration. Mondrian is not a precise philosopher, he leaves vague which of the alternatives he prefers. Perhaps he believes a bit of both. It is important to realize that this law applies to ideal things, say, to utopian things, not to ordinary, real things. Mondrian's Platonism is not a description of the essence of painting as we know it but, rather, a modernist statement about what painting ought really to be. Mondrian replaces the *is* of painting by its *ought,* and then speaks as if what painting ought to be is what it is (really). This tendency resides deep in Platonism, whose universe is idealized, containing a power which, once known, can recast the world into what it really is; Platonism identifies true reality with the world which ought to be. Ordinary things are but the pale shades of this incandescent reality.

Mondrian's theory of the one form of harmonization is a theory which, if adopted, could institute the harmonization of things by remaking things according to their essences, thus liberating the *real* behind their appearances. His works of art contain a perfected harmonization which exempli-

fies the inner harmony of all things. Recognition of its perfected shape, like knowledge of a platonic form, will enlighten the world, make it conscious and ready to discover harmony everywhere, and embody the ideal harmonic form of things in the things of the world generally: in the modern age, in its societies, buildings, nations, intimacies, and its relations with nature. Like platonic forms themselves, Mondrian's paintings will stimulate you to find the form in everything else, to harmonize everything else. In this dialectic, finding harmony within things amounts to recasting things according to their real form: *realizing* them.

Mondrian's third requirement on painting is that in it, emotion be overcome, transposed into consciousness or knowledge. He believes that painting must become a kind of contemplation of the form of things, a way of replacing the chaos of our individual, emotional lives by a consciousness of universal form which can be shared by all. The painter and the viewer must use painting as the occasion for occupying the position of Plato's philosopher.

Basic to the Platonist position is adulation of a heightened kind of knowledge purified of all ordinary emotions. Plato's call for a state of high sublimation, the sublimation of the body into the act of knowing, is at the core of the idea of platonic love, love of knowledge.[23] Mondrian followed Plato's rejection of the emotions. "Emotion becomes consciousness," Mondrian says in a statement applying to his paintings. Mondrian's highly sublimated paintings intend to replace the emotionalities of Raphael's softly caressing eroticism, of Michelangelo's struggles, of Munch's exorcistic, self-aggrandizing anxieties, and even of Rembrandt's biblically deep sympathies with a feeling only for purity and the mysterious beauty of formal tuning and balance.[24] People will be better persons and art more beautiful the more sublimated the emotions of people and those expressed in art are, the more emotion is transmuted into consciousness and directed toward universal form. Plato's idea of human perfection is Mondrian's. Again, as Mondrian puts it, "The truly modern artist consciously perceives the abstractness of the emotion of beauty: he consciously recognizes aesthetic emotion as cosmic, universal. This conscious recognition results in an abstract creation, directs him towards the purely universal."[25] And, further, "The fact that people generally prefer figurative art . . . can be explained by the dominating force of the individual inclination in human nature."[26] Emotion becomes universal when freed from particular interests in particular figures and from specific inclinations (to get rich, to possess someone, to see Europe in spring, to finish college). Thus purified of individuality, emotion

can be universally directed at the form of things rather than at things themselves. Emotion then becomes the surrogate of knowledge, for it is turned into a form of contemplation (the abstract contemplation of form). The position of the knower is the position of one freed from all particular interests, desires, and subject matters and thus of one able to contemplate those universal relations comprising life and humanity. An artwork which resists the expression of all particulars is one which will raise each of us from our individual concerns (or the artists') into this position of universal knower. Each of us will then occupy the same position, since it is, by definition, a position devoid of all individuality and difference. Each will—qua universal seer—see and know with the eyes of all humanity, for each, by definition, will see in the universal position just what everyone else will see in that position: the universal relations defining us all. The individual will then be raised from his or her individuality by dint of pictorial abstraction.[27] Of course, whether Mondrian abstractions are really free of all interests is another story; they are certainly not free of Mondrian's interests, his modernist optimism, his theories, and his moods. (Indeed what suprasublated "emotion" could possibly be left in a person to feel once her repertoire of interests, feelings, desires, and patterns of fantasy are removed?) Moreover, the very identification of universality with abstraction is questionable. What makes abstraction in painting more universal in form and subject than the themes adumbrated in the tonalities of Rembrandt's *Self-Portraits* or Michelangelo's *Moses?* In what sense are any of these universal? The claim to speak in a universal voice runs the risk of being nothing other than an imposition of one's own interests and feel for the world onto others, however abstract one's own interests, however pristine one's feelings may be. What, then, substantiates a painter's claim to universality? This Kantian conundrum about claims to speak for all humanity in art or philosophy or culture or politics so totally obsessed Jean-Paul Sartre that he fell into skepticism about our ever finding a common ground called *humanity* in the light of which we are entitled to use the universal voice. For Sartre, such skepticism ushers in despair, despair of ever accepting oneself as at one with others since, for Sartre, one is never entitled to belief but only to hope that others are in deep ways at one with oneself.

Mondrian believes universal emotion is attained by the shedding of the body and its interests. Rather, it might be thought that one is precisely bound to others and recognized as human by taking possession of the full nature and range of one's bodily feelings. It might be thought that all the universality there is resides in one's capacity to claim the contours of one's

life, a life whose need for attachment, whose need for imagination, whose memories, reveries, aging, and decay are shared by others and not shared (quite) by them. (Is this enough for universality? According to whom?) Seneca's humanism, which preaches that "nothing human is foreign to me" and means that everything foreign is human to me, preaches connection to the foreign through shared routes of feeling and thinking, through the capacity to imagine what it is to feel what one has not lived, through a community of interaction and training, through fascination with human difference and the refusal of its repulsion, through shared styles of action and shared tendencies of thought and feeling—all of which happens in the absence of any further universality, universality being the hope of connection amid all of this.

There is then a question to be asked not only about the degree to which a universal position is, in some further sense, possible but also about the degree to which it is desirable. The idea that the only way to share in the dictates of humanity is to spiritually abstract oneself from one's body (as opposed to extending it in its robust totality) is an inheritance from Plato that has found its way to Mondrian through medieval Christianity, the Enlightenment, Spinoza, and theosophy. Mondrian the voracious reader recurs to all of these sources; he sees himself as the heir to this philosophical culture who will now bring its teachings about.

The castigating force of Plato's ideas on the life of the bodily self is powerful and strict, some would say mortifying and sadistic.[28] But its visions of human unity and perfection are enthralling. Mondrian's universal voice allows one to stand aside from one's own interests (self) and assume feelings of pure harmony, to shed one's own skin. It is as if the ideal of humanity resides above one in the sky and one can enter it by an act of discipline, abstraction, harmonization, and purification, ultimately to emerge remade and purified under the shelter of the forms above. The new person who emerges is one who is less animal, more universal, and more humane, for he (this is gendered) has cast off nature entirely only to become part of what human nature really is: Dante sitting on a rose and contemplating the divine light.

He becomes an individual remade. The assumption of a universal, sublimated position on things is at the core of Mondrian's idea of individuality transformed: "The new culture will be that of the mature individual; once matured, the individual will be open to the universal and will tend more and more to unite with it."[29]

This recasting of the individual is conceived of by Mondrian to be the

overcoming of his nature (its "combating"). Nature is a leading term for Mondrian. It is a more capacious term for him than "emotion," although emotion is part of the natural. The natural encompasses all types of particularity, individuality, and desire. Everything natural is bad, chaotic, and lacking in perfection. Subjective vision is thus nothing but nature in people; it prevents happiness. Mondrian hates nature as Plato hates the natural part (noncognitive, read, "irrational part") of the human soul. The natural part of people is to be supervened by their sublimated contemplative feelings; the natural part of the rest of nature is to be overcome by the achievement of universal knowledge, informed design, and enhanced technology. This triumph will bring happiness, it will make people less animal and more human: "A less animal physical constitution and a stronger mentality is making man more human." [30]

Mondrian's conception of human perfection is then predicated on a highly overdetermined rejection of things natural and of nature itself.[31] He dislikes nature as a modernist city dweller and lover of technology hates the forest with its confusion, mythology, and its bugs; he hates it as certain people hate their own natural vicissitudes. Some of these reasons are personal, others are of the spirit of the age. All contribute to Mondrian's Platonist position.

Mondrian's first task, as he conceives it, is to purify his art of all traces of nature; to make his art abstract by abstracting from natural forms colors, moods, and everything else those hairy apostles like Ruskin thought was the ground of beauty: "The first thing to change in my painting was the color. I forsook natural color for pure color."[32] And "the more neutral the plastic means are, the more the unchangeable expression of reality can be established. We can consider all forms relatively neutral that do not show any relationship with the natural aspect of things."[33] He even goes so far as to banish curves from his abstractions on the grounds that they are too natural: "If we take the ground of a purely aesthetical analysis . . . , we are entitled to state that the rhythm of the cadence of straight lines in rectangular opposition is a purely plastic expression and that the rhythm of the undulation of curves is more 'natural.' For in nature these undulations manifest themselves; e.g. we detect them after having thrown a stone in a pond, in the transverse section of a tree trunk, etc. . . . The cadence of straight lines in rectangular opposition, however; has to be created by man."[34] It is hard to know what to make of this. In virtue of what does Mondrian decide that cadences of straight lines are not found in nature, for example, in the perpendicular columns of redwoods which sway in Northern California

winds and disperse California's clear yellow light in absolutely straight rays, in the white cliffs of Dover dropping dramatically to the sea, in desert oases, in reeds, bamboo shoots, or the legs of storks? It is not clear to me that straight lines are any less common in nature than curves, nor is it clear to me how one decides the question.[35] Indeed, if we broaden the concept of nature to include the naturalized landscapes of ancient cities set against plains, monuments in context, and the like, then nothing is more straight, perpendicular, and flat than Mondrian's own countryside, a countryside Hans Jaffé suggests is "naturally" internalized by the De Stijl artists and recapitulated in their pristine rectangularities.[36]

Mondrian believes art and life can be cleansed of the natural. This new-age crystal called the life of the future will be so far from nature as to be perfect. Even crystals are facts of nature, as any proponent of the new age knows, and we need some explanation for Mondrian's insane optimism about how far from nature toward perfection human life can be brought. Why should we want to divorce ourselves so completely from all of nature anyway?

Nature is an obsession for Mondrian, and like all obsessions, its sources must be interpreted. One source is to be found in Mondrian's philosophical and theosophical perfectionism. In order to conceptualize the perfect in terms of the category of purity, something must correspondingly be conceptualized to be impure; otherwise the very idea of bringing about purity by removing the impure agent cannot make sense. To clarify a stock—or an idea—there must be something impure to remove from it through the process of clarification. A Platonist must find some locus or loci of impurity, some philosophically inspired fall guy or bad thing whose removal signals the coming of the age. Philosophical concern with something or other's removal is conceptually required by the level of perfectionist Platonism Mondrian invokes, and Mondrian chooses the idea of the natural as the impure agent. Some other painter/thinker might have chosen another obsession, say, the idea of vagueness (or of sex). While Mondrian does discuss vagueness (though not explicitly sex), it is not his main focus.

Why does Mondrian choose nature as the locus of his philosophical obsession rather than some other, albeit related, thing? One reason has to do with his inheritance of the long-standing philosophical and religious tradition of Christian Platonism which opposes the divine light of God and Reason to the natural world. Mondrian's reliance on this intellectual tradition converges with his modernism. His celebration of the socially liberating forces of modern science and technology is on a par with Moholy-Nagy's,

but, unlike Moholy, Mondrian does not subscribe to a biomorphic justifica-
tion for scientific and technological forces. Mondrian's modernist rational-
ism opposes the modern forces of technology, science, and all things man
made to the brute forces of nature, including and especially human nature
(as if science does not work with nature but, rather, dominates it in an act
of conceptual imperialism). Another reason Mondrian attacks nature has to
do with his modernist rejection of romanticism. Mondrian associates the
adulation of nature with nineteenth-century romanticism's barrage of nos-
talgia, love of folk simplicity, and yearning for natural return. He associates
nature with the nineteenth-century's assertion of the particular and its view
of nature as the ground of beauty (Ruskin). In short, Mondrian associates
nature with all the ideas of those hairy apostles which De Stijl (along with
constructivism and the Bauhaus) intends to bury once and for all. Thus a
further reason why Mondrian chooses nature as the fall guy for his Platon-
istic conception of perfectionism is rhetorical, it is a way of distancing his
art and philosophical outlook generally from the romanticism of Ruskin
and all others who love nature's opaque intricacies (and architectural se-
crets) and whose vision reaches back toward a refinding of the past rather
than toward the technical invention of the future.

So we can understand Mondrian's extreme position about nature to be
(1) philosophically required by his superplatonic perfectionism, (2) an
expression of his faith in the modernizing capacities of the nonnatural
(technology), and (3) a rhetoric distancing himself from the nineteenth
century. His extreme position is also, I think, personal, as one would expect
of any obsession. Nina Kandinsky tells the following story about Mondrian:
"I will never forget Piet Mondrian's visit to our apartment. It was on a glo-
rious spring day. The chestnut trees in front of our building were in blossom
and Kandinsky had placed the little tea-table in such a way that Mondrian,
from where he was seated, could look out on all of their flowering splendor.
Mondrian, of course, insisted on taking a different seat, so as to turn his
back on nature." [37] And in a rarely personal voice, Mondrian says something
about nature that is anomalous: "The beauty of nature does not satisfy me
entirely—I cannot enjoy a beautiful summer evening, for instance. Perhaps
then I feel, in a manner of speaking, how everything ought to be, while at
the same time I am aware of my own impotence to make it so in my life." [38]

The strangeness in these words is not a matter of Mondrian's admission
that the beauty of nature makes him feel badly; things wonderful can do
that sometimes—the music of Mozart, the philosophy of Wittgenstein, the
beauty of Garbo, or the suave zaniness of Cary Grant (who once said,

"Everybody wants to be Cary Grant, even I want to be Cary Grant" as if even Grant himself was envious of his own persona). Mondrian goes further; nature, if we believe his words, always fails to satisfy him. Nature is a problem for Mondrian.

Mondrian's words are anomalous and odd because they are the painter's acknowledgment of what he denies everywhere else: that a summer night can be beautiful, that nature is beautiful. Mondrian's acknowledgment of the beauty of nature renders his general view of nature odd, which urges all banishment of nature from art. Indeed, one was hard put to believe that he really believed his view. One wondered why Mondrian could not admit with Kant that the beauty of art and of nature are interconnected, nature being artifacted like art when seen as beautiful, and art being seen as having the form and fluency of nature when seen as beautiful. One wondered why Mondrian refused to bring nature into the harmonizing, humanizing domain of art in the kind of marriage Kant's theory suggests—and any Italian villa confirms. Mondrian ascribes his incapacity to enjoy nature to the sense of being dwarfed by its beauty. Its beauty leaves him out. He feels the imbalance of human things relative to natural perfection (then nature is a form of perfection), and he is aware of how much must be done on the human side of things to bring human life up to the standard of harmony already there in nature. That thought is understandable, many have had it. But why doesn't he, therefore, think of nature as an exemplar—on a par with his own art—of the kind of harmony needed in the world? Something personal is signified in Mondrian's despairing words about his sense of annihilation by the beauty of a thing not made by him (nature) and with which he cannot, in a fundamental sense, compete. The form Mondrian's fear of nature, or envy of it, takes is perhaps a denial through theory of what Mondrian obviously knows and must know: the simple fact that nature can be beautiful, sublimely beautiful. This he never mentions (to my knowledge) in his writings which are consumed with discussions of nature.

Mondrian's rejection of the natural element in art is a form of denial; it is his attempt to banish a potentially dwarfing, annihilating force, thereby securing a kind of control over himself and the world. This denial explains in part Mondrian's too obvious mistake in denying that the perpendicular is to be found in nature, when Mondrian's own landscape is exactly that: he does not want to see nature in himself. Mondrian's aim for universalism through his denaturing of the nature in art is not simply philosophical but also his assertion of personal control through denaturing forces of perfection felt to be more powerful and more perfect than his own self. Reliance on philo-

sophical theory is Mondrian's route to this replacement. Theory replaces the natural element in Mondrian by a reemergent Mondrian, a new person divinely recast under the perfect shelter of the forms. In short, theory is Mondrian's compensating route to perfectionistic empowerment, empowerment with an attendant optimism capable of recasting himself and all persons as perfect.

Mondrian has learned to distrust nature on philosophical and modernist grounds, and this dislike has come to him, as it were, naturally. Mondrian's obsession revolves around the issue of perfection as such, but it is also personal in nature. To say it is personal is not to deny its philosophical character, it is merely to suggest a further reason why the philosophy takes the extreme form that it does. Mondrian's rejection of nature is overdetermined.

II

Have we in our own ways rejected the natural nearly as thoroughly as Mondrian? Have we too pervasively come to mistrust our natural reactions to paintings and to nature and instead made a highly constructed, highly compensatory, and highly empowered turn to theory? To what degree have we done this? Is our radical distrust of our tastes and our sensual interminglings with pictorial form and pictorial impasto a partial displacement from what our bodies naturally know of the world? Is our conception of the body as largely a socially constructed instrument, rather than a being who feels and thinks, a way of avoiding what must be at least the partial authority of the body and its sources of emotion? Have we purchased the powers of theory at the expense of relinquishing even partial trust in the immediacy and the transparency of how we feel in the presence of paintings? Nothing is fully transparent, neither the claims of our senses and desires nor those of our theories. Have we gone too far in the direction of Mondrian? This is a heady question which I will return to (somewhat obliquely) in the final chapter of this book. Instead, let us now turn to Mondrian's paintings, to the question of the fit, the gesture of marriage, between Mondrian's paintings and his theoretical, essentialist discourse.

There are a number of questions to be asked about Mondrian's intended marriage of theory and paint. Note first, that Mondrian's paintings are in resonance with his Platonist dictates, not in the sense that his theories are true or his sermonizing exactly palatable—never mind how much of his or anyone's Platonism you believe—rather, in the sense of a poetic correspondence between what his discourse says a painting should be and how his

paintings strike the eye.[39] The feel of a Mondrian picture resonates with Mondrian's superplatonic thought that there is only one underlying form of everything, the relation of harmonization at the expense of individual assertion of difference. Mondrian's pictures force the feeling on you that the only real thing in them is the relation of form (balance). The primary thing a Mondrian abstraction expresses is its perfected equilibration, poised between dynamic vibration and total stillness of abstract part elements. Such primacy of equilibrium over individual detail is the very thing his theory claims his paintings should exhibit. In Mondrian, then, there is a harmony of theory and painting; each is a kind of mirror of the other, for each shares the structural feature of highlighting *only* harmonization as such. This correspondence between the form and expressive character dictated by Mondrian's theories and the visual feel of his paintings allows us to interpret the paintings partly in the philosophical terms Mondrian desires. We can take seriously his intention to turn his paintings into philosophical objects in the light of this fit. One does not have to believe in Plato's philosophical story in order to see the fit of Mondrian's paint with his words, one simply has to understand it and to understand how the marriage between theory and painting is worked out in this general way.

Second, let us ask how much Mondrian's paintings satisfy his claim that they have overcome the natural. Mondrian intends to turn his paintings into exemplars of the harmony of form as such; thus his artworks must be wholly drained of nature (including all human interest and emotion). In order to satisfy this requirement, Mondrian reduces his palette to only primary colors (which are both simplified and nonnatural in his view). He removes figuration and much ordinary emotion. He deletes the assertion of particulars (which are associated with the natural). He employs the line and the cross which he thinks of as not to be found in nature.

Mondrian's is, no doubt, a highly developed attempt to cleanse nature from art. It is not wholly unsuccessful. Perhaps it is true that his use of only primary colors does distance his work from the colored panoply of nature somewhat. Perhaps his use of only one geometrical form (the rectangle) accomplishes a similar thing (although no more so than a painter who would use only the circle or the octagon). Nature is no more purely rectangular than it is purely circular or purely elliptical. It is not purely anything; nature does not come pure (except the primary colors and simple shapes which are also part of it). That primary colors and shapes can be found in nature and that Mondrian's own choice of perpendicular forms can be traced in part to his naturalized spatial perspective on things shows the

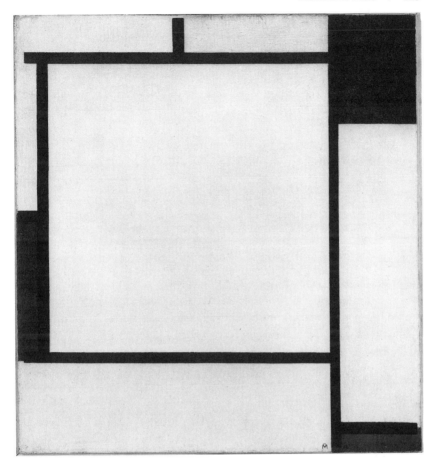

Piet Mondrian, *Composition 2*, 1922. Solomon R. Guggenheim Museum, New York.

inescapability of working from nature, including one's own. One can take the aim of removing art and life from nature as an ideal, an ideal which Mondrian makes a heroic effort to approximate. In this sense, his requirement for painting is related to the currency of constructivism's Cartesian goal of completely self-transparent construction. It is an ideal one aims for and fails to satisfy. Mondrian's pictures do have the feel of removing nature, as if that feel, like the functionalist feel of a Bauhaus building or the transparent feel of a Gabo sculpture, were an expressive requirement, not simply a theoretical one. Nature feels excluded from the taut inner calibration of a Mondrian, simply because nature tends to feel more free, a little more chaotic, a little more admixed than a Mondrian feels. (To some, Mondrian's

expressive quality is a claustrophobic attempt at neatness, to others, a divine simplification.)

Is this really true or am I talking through his words, when I say that Mondrian's paintings have the feel of replacing nature by form? Should I trust my judgment? Suppose someone unfamiliar with Mondrian's words were to explain Mondrian's paintings differently, saying that they are really about the balance of elements in nature. Suppose she were to say that Mondrian loved nature, especially the rectangular Dutch landscape also celebrated by Van Ruisdael. Would Mondrian's pictures look closer to nature then? One could imagine that these paintings, seen freshly by the eyes of a nature lover or biologist, would look and feel a little more natural. One could imagine the naturalist seeing processes of stasis and motion or patterns of interlinked elements like cells in the body or ecosystems in these pictures as if each Mondrian square were a primary reduction of a natural entity or process. One could imagine her seeing in a Mondrian the movement of the stars or the kinetic flow of electricity. All of these natural phenomena would appear highly abstracted and purified, to be sure. Nature would be, in a Mondrian, viewed through its crystallization. But the crystalline character of the paintings would feel closer to, and more in alliance with, existent natural phenomena. If this hypothetical nature-loving viewer is to be called wrong in her interpretations, it is only because we accept the rule of Mondrian's words in coloring what our eyes tell us. Mondrian's intention to purify his art of all natural elements, however unsuccessful in toto, nevertheless has its effect on how the eye sees his canvases. This is because there is enough correspondence between his canvases and his words for the mutual influence of marriage to arise. It takes two to tango, the pair being what the words say and how the paint affects the eye.

A Mondrian abstraction feels to one's eyes as though it is reduced of all admixed and particular things; it feels tuned to the condition of a perfect violin. Yet what do we make of the nature in that? This sense of the tuning in Mondrian's pictures cannot help but tune one's eyes. A Mondrian brings the eye and the mind into sympathetic tuning with the picture; it makes the mind feel its capacities for picking out the core of things and bringing them into creative alignment; it stretches and sharpens the eye. This heightening is at the core of what one brings away from Mondrian's serenely beautiful, vibrant paintings. Man Ray's famous picture of Mondrian's glasses is exactly right as an interpretation of the work. Mondrian's work is about seeing things in focus, it focuses one's eyes. It is an eye training experienced (with the help of his words) as exemplary of the possibilities of conceptual align-

ment generally. It is a training that is meant to make one more human by enlarging one's capacity to pick out the harmony in things, to rearrange them.

Paradoxically, Mondrian's work makes one reconceptualize the very idea of nature to include facts about the capacities of one's cognitive psychology. Mondrian may be said in this sense to work with nature, with our nature, not against it. A constructivist like Moholy-Nagy will speak of his own art's capacity to stretch the sensorium in precisely such biological (natural) terms. This seems to me a good way to think of what a Mondrian actually accomplishes visually, although it is an idea which Mondrian would obviously find uncongenial.

Mondrian's visual marriage between theory and paint stops at the point where his paintings seem indifferent to theory. I have mentioned the feeling one has about their ambivalence to theoretical prefiguration. On the one hand, a Mondrian abstraction seems to open to signification like a logical schema. It stands ready for verbal interpretation and filling in. But a Mondrian painting also resists all prefiguration by words. It feels complete in itself, unreachable and uninterpretable. In its spirituality, a Mondrian painting stands indifferent to everything. This expressive quality, so crucial to a Mondrian, makes the painting feel as if it defeats his words. He tries to place it on a procrustean bed of platonic meanings but the painting remains victoriously complete in itself and victoriously dumb, as if Mondrian's paintings—or Mondrian the painter—defeated Mondrian the philosophical theorist.

Then to say that Mondrian's art is in essence philosophical is to speak too strongly. There is a point at which the philosophy stops and the silence of his paintings speaks eloquently in its own voice. Or does the philosophy stop there? The ultimate paradox is that it is this very indifference on the part of his pictures to theoretical filling in which Mondrian the theorist exploits platonically. The quality of total self-completeness to be found in his pictures is precisely what makes Mondrian's paintings feel even more like platonic forms. For such is also the character of a platonic form. Consider again Plato's forms. They are eternal, immutable, and indifferent to us and our words, yet they can only be reached, known, and interpreted through the verbal act of philosophical dialectic and definition. However, once we arrive in their presence, all words drop out and a magnificent experience of seeing, of divine light, of radiance takes over. The philosopher's presence to the forms is a visual presence, one characterized in terms of visual metaphors, as if such a poetic experience, such an experience of im-

mediacy, such a profound sense of being there can only be described through the language of poetry and metaphor.

Like a platonic form, the Mondrian painting exists complete in itself and indifferent to all discourse, but it also awaits interpretation by Mondrian's words. Mondrian's theory defines his paintings in the same kind of way that a platonic dialogue is meant to arrive at a definition of a form. Theory is Mondrian's and our mode of approach to the painting. But once we reach the painting, theory in hand, the theory drops out and is replaced by the glow of visual experience. We are in the visual presence of a pictorial world whose indifference to our words, whose silent aura, can only give us the illusion that we are seeing the embodiment of an actual platonic form.

To bring off this isomorphism between the experience of a Mondrian painting and the experience of a platonic form is a feat of art on Mondrian's part. But it is a feat of art which relies on the art and spirituality already present in Plato's philosophical picture. If Plato's philosophical account of seeing the forms were not already framed in terms of visual metaphors, Mondrian's own art of making these metaphors real, by making an object which, unlike Plato's forms, you can really see, would not be possible. It is a condition of the possibility of Mondrian's art that philosophy finds that its own dreams of presence to knowledge require the language of visual metaphor, let us say, the language of art. Otherwise the very idea of realizing such metaphors in the flesh of an artwork would make no sense. The line between philosophy and art can be crossed only because it is already blurred.

It is for this reason that the avant-garde mentality which is my subject would have to be rewritten even if it were true. It is an assumption of that mentality that the work of art is theoretically prefigured. But Mondrian's artworks are prefigured by theory only because there is already a poetic art in the metaphors which articulate the theory. Mondrian's art is prefigured by *art,* by white metaphor, in being prefigured by theory.[40] Mondrian's philosophy is already a spiritual art in gel.

Theory and painting are more deeply harmonized in Mondrian than was first noted, because now we can see that the ambivalence to signification in a Mondrian painting is exploited by his Platonist theory to turn a painting into the analogue of a form. A Mondrian abstraction is then not simply the presentation of a form but, in a magnificent act of hubris, a visual analogue of a platonic form itself, which, when seen by the new age, will lead the way out of the cave. Just as the constructivist dreams of an artwork which will have the transparency of a Cartesian proof in the mind's introspective eye, Mondrian dreams of an artwork which will have the status of a platonic

form visually grasped. For both, the artwork exemplifies the new age to come by being the example of philosophical embodiment, the site of philosophical truth in this world. These artists outdo philosophy by making the most abstract and metaphorical philosophy (Platonist, Cartesian) less abstract and less distanced from the world. They substitute real vision of a form for the fantasy of being intellectually blinded by it; they substitute actual visual proof for introspective proof in the mind's eye. A constructivist proof is really out there in the world, in the Gabo cube or sculpture. A Mondrian form really resides in the painting. Plato's truth no longer exists in the third realm but has been brought back into the ordinary realm of things. This bringing of the place of enlightenment back home from the shadowy plane of introspection to the concrete place of ordinary vision sets the world in order, realizes it, and makes it anew.

The transposition is crucial to understanding the optimism of these artist/philosophers. Descartes, I have said, believed that transparent construction could take place in the mind but not in the world of actual perception, the perceptual world being too unclear for any certainty to arrive on the scene. Socrates believed the forms were perfect but did not believe anyone could actually see them. This failure of embodiment is what the avant-garde optimistically denies. The avant-garde locates transparency right here at home; it says we can see the law of harmonization right here in the visual analogue of a form. It turns inner, metaphorical seeing into real seeing. Certainty and conceptual enlightenment are possible right here in this world.

Constructivism and Mondrian in their philosophical voices are thus part of the history of the visual in philosophy. By taking the connection between seeing and the truth literally, these painter/philosophers outdo philosophy. They give the idea of the visual embodiment of truth its philosophical apotheosis. In their abstract, theoretically prefigured paintings, they intend to make philosophy visually concrete. Art has then proven, by Mondrian's example, its case to be truly the beacon, the paradigm, the herald of the world's possibilities. Art has proven is that the platonic *ought* can converge with the world's *is*. The true reality of things (their idealized identity) can be merged with their physical embodiment. Painting has done nothing less than prove the case for the world. It has proved from the Platonist perspective that the actual world of the forms can become instantiated in the ordinary world of paintings and, by extension, things.

Mondrian's art has thus demonstrated by example the capacity of the world to be the bearer of truth. It is from this perspective that we can turn to Mondrian's demonstrative claims about art. These claims will lead to the

hardest questions about Mondrian's marriage of theory and paint, namely, those questions about the capacity of his art objects to signify. Mondrian claims, as I said, that his pictures do not simply exemplify the one law, they demonstrate it. The "rectangular" form of his pictures is supposed to demonstrate "to satisfaction" that "internationalism involves no chaos at all." Art demonstrates the Platonist case for the world in all its essential details.

Let us reconstruct what Mondrian means by art's powers of demonstration. Taken by themselves, his paintings do not demonstrate anything other than a variety of ways of harmonizing rectangles in primary colors. But if one is captivated by Mondrian's total Platonist picture, then his paintings are the proof of the convergence of platonic form and matter(s of fact). First, they prove that ordinary painting can be sublated, brought to the status of embodying platonic form. Second, Mondrian is now ready to believe in sublation as a general possibility. If one piece of the visual world can be converted into truth, then so can every other piece of the world. The good news for modernists has been announced and is in a position to spread through De Stijl, its herald.

What Mondrian's art demonstrates is not a fact but a possibility, an optimistic possibility of generalization from the example of art as an actual locus of platonic form to every other arena of life as a locus for it. Mondrian's statement about internationalism's involving no chaos should be interpreted in the light of this possibility. If art can be proved capable of total abstraction from nature and total harmonization, then the idea of an internationalism without chaos (i.e., totally harmonized) is also possible. Possible how? The concept of an internationalism without chaos is coherent and assured because (1) internationalism is nothing but the harmonization of individual nations into a whole that gives each part (each nation) its true identity; (2) nations are collections of persons who are similarly harmonized and are themselves like persons in this respect; (3) individuals who are harmonized repress their particular desires, beliefs, and interests; they speak in the universal voice, rationally, in conquest of nature and out of the deepest dictates of humanity binding everybody (out of the standpoint of the knower); (5) the case of art has shown both that persons (i.e., Mondrian and his viewers) can achieve this universal voice and that overall harmonization is possible in painting; (6) the field of international politics is that of nations, people, and resources, let us say; (7) if people can be brought to speak in the universal voice in the field of art, they can be brought to speak in a similarly universal way in politics—so can the nations composed of people; (8) art has also shown that the materials of a piece of the visual

world can be platonically arranged into formal perfection. The resources of the political world are not significantly more recalcitrant to harmonization than those of painting. Therefore, (9) the idea of internationalism is coherent and assured. Christ has shown the people of the nations their possibility of emulation.[41] Why not then internationalism, what is to prevent it? The demonstration is here of the form well known to those Yiddish logicians: "So why not *p*? What is to prevent it?"

A lot can prevent it. Mondrian is struck by the overwhelming power of what he believes his art has proved about human possibility. It has instituted form in the visual world, and persons will be struck by the overwhelming fact of the good news as if it is the news of a Messiah. Humanity will generalize the news to all corners of life: personal, national, and international. Having heard and seen, humanity will follow; it must follow the Sermon on the Mount of painting as if by overwhelming necessity, that is, by the necessity deriving from waking up to the good news and being overwhelmed. In the first instance, what proves art's reputed powers of demonstration is the persuasive fact of its example whose news is so profound it will bowl everyone over, make them recognize the essential necessity of internationalism (essential because of the very nature of perfected individualism), and make them recognize it is only they themselves who prevent international peace and harmony. The example of art will ready people for action (as if the scales of sleep have suddenly been shed and one realizes how easy it is to change everything since the only thing that has prevented change has been one's ignorance). Mondrian's, like Plato's and Christ's, is belief in the world-transforming power of ideas: he is a Platonist. Ideas represent the highest currency of praxis.

Of course, Dostoyevsky's Grand Inquisitor knew too well that this miraculous transformation didn't happen even for Christ. Christ's Sermon on the Mount made one ready to believe that soon the meek would inherit the earth, that they must inherit it—because nothing could be more right and nothing could prevent inheritance other than not hearing the news. For to really hear the news would, of necessity, be to believe in the power of the news, and to believe in its power would be to melt, to become meek, and act humanely. And so the meek—and that now means everybody—would inherit the world. And everyone who is human, that is, everyone, would eventually melt into being receptive enough to hear the news. Christ's message is as close as anything one can find to what one imagines the power of a platonic form to consist in. His message hits the truth inside of one in a thunderbolt of recognition (what Plato calls "recollection"), and that rec-

ognition inherently impels one forward to act in the electricity of its thunderbolt. Yet the power of Christ's message was defeated by the difficulty of his example. Chaos and nature are not so easily eradicated, and living like a Christian is harder than the power in the Sermon on the Mount by itself might have led one to think. (In order to take the example of Christ, you have to be prepared. You have to be alone in the desert, you have to resist the most devastating temptations, you must learn to love everybody. How many can do this? Thus how many can be in a position to help themselves and others? That is the Grand Inquisitor's despairing question.)

Mondrian's optimism is even more difficult to institute as a general practice because it is so much less plausible to begin with, its essentialism so much less coherent than Christ's message. In Mondrian's case, we do not even have a paradigmatic example from which to generalize, since painting has not lived up to its own perfectionist claims. (In Christianity, at least one has the paradigmatic example of Christ, even if one cannot live up to him.)

Mondrian does not always speak in such an optimistic voice about the generalization of the perfected example of art to the far corners of life. In a voice more reminiscent of the Socrates of the *Phaedo* than the Christ on the Mount, Mondrian says: "Our subjective vision and experience make it impossible to be happy. But we can escape the tragical oppression through a clear vision of true reality, which exists, but which is veiled. If we cannot free ourselves, we can free our vision." [42] One is glad for this voice, because if Mondrian evinced no doubt about the eventuality demonstrated in his art, one would have to wonder if his eyes were ever really open. However, even in this more Socratic voice, Mondrian is convinced that the true form of perfected internationalism—would that it could occur—is given by the model of the true form of art. That is, even if internationalism cannot be achieved, its essential (perfected) form is demonstrated by the example of art.

Thus he never doubts the example of art itself or its central place as a model of perfected life. Painting demonstrates without a doubt the essential *definition* of internationalism; it demonstrates that the idea of a harmonious, nonchaotic international existence is the correct idea of the essence of political life. It is his super-Platonistic commitment to there being one law of harmonization for everything which conceptually undergirds Mondrian's claims about painting as the model for everything else. If one believes this piece of superphilosophy, if one is captivated by all of Mondrian's Platonism, if one believes that there is exactly one law of harmonization which defines the essence and identity of all things, then one will think of a Mondrian

painting as presenting that law, just as any other thing (a nation, a person, a mathematical equation) might present it. It doesn't matter which thing does the presenting, except that painting has taken the lead and been the first to do it. It is in the avant-garde.

There are, I suggested, two ways to interpret the one law of harmonization. First, all things are subject to the one law by being calibrated in the same way; second, all things are interrelated by one form. This first way to take this means that if one can present in an utterly convincing way the harmonization of one set of things, then that form of relation can be universally generalized to apply in its way to relations comprising all other things. Thus if you can show how pictorial equivalence is achieved, you can assume that the same form of relation relates nation-states together, families, molecules, or anything else. But what is, specifically, that form of relation? Take painting as the example. The relation of harmonization in painting picks a few minimal elements as specifically essential to painting (two-dimensionality, depth), it limits pictorial elements to the rectangle and the primary color, it repressed all assertion of robust differences between the parts of the picture, and makes the fact of equilibrium the primary pictorial thing.

Now when nations are harmonized, then they will be harmonized in the same way. Like the reduced rectangular shapes in primary colors of a Mondrian, the idea of a nation as a perfected (real) entity will be that of a nation equally shorn of individuality and nature, of competing interests, divergent styles of belief, religion, historical consciousness, political taste, taste in everything else, and valuation of resources. A nation will be nothing but a rectangle on the political map, defined, like a Mondrian square, through its color, size, asymmetry of placement, and equivalence in the overall pictorial/political scheme.

It is not hard, therefore, to arrive at the idea that internationalism involves no part of chaos, because the very idea of internationalism is an idea of harmonization at the expense of national assertion of national individuality and difference. Nations will be able to speak to each other with the universal voice shared by each individual nation, for the voice of each nation will be drained of all particularity. It is the idea of nations speaking in the universal voice—as if they were nothing more than geometrical chess pieces with (asymmetrical yet equivalent) locations in primary colors on the pictorial map of the international world—that paintings demonstrate in virtue of belief in the one platonic law of harmonization.[43]

On the second interpretation of the law, there is only one superrelation

which relates all things together. Art shows you this by exemplifying the whole. Then it is easy to see how the only coherent concept of internationalism must be one excluding chaos. With the help of Mondrian's theory, it is made clear that art must be related to all other things—to the total age. And nations also must be related to all other things (to each other, to the whole, to everything). Then internationalism is a trivial entailment from the Hegelian theory: nations are but one example of the things which must be interrelated into a universal whole.

Whatever interpretation one places on the one law, belief in that law has eliminated the conceptual possibility of anything other than harmonious internationalism (or harmonious painting or harmonious anything) by building into the very idea of the essences of things repression of all differences between their parts. Harmony arranges the real, perfected, and essential world into a system of perfectly tuned keys, transposable from one domain to another. Differences between one sphere of life (art) and another (politics) cannot be a conceptual problem for Mondrian because the very idea of harmony precludes that possibility.[44] Demonstration is simply the exemplification in one key of what happens in another.

Note how little has actually been said by Mondrian about what internationalism is, about its historical contexts of possibility, its specific historical shapes, about its problems, prospects, and possible forms of arrangement. Will there be no nation states at all when internationalism occurs, as in the Marxian dream? Or will internationalism exist as a "New World Order"? Will internationalism divide food resources, raw materials, and industrial modes of production equally? Or just fairly? And what is fair? Will it arise violently or through negotiation? None of these questions apparently need be raised, for, from the Platonist point of view, it is knowledge of the general form which will bring about the new age, combined with the help of technology. There is thus no need for Mondrian to imagine utopia in detail. Rather than experiment with theory in the manner of a Moholy (a man who truly understands the need to plan the world from scratch and thus to imagine its shape in detail), Mondrian is sure that its form is abstractly assured. So where we find theoretical experimentation in Moholy, we find theoretical ecstasy in Mondrian. Yet both call on theory in the service of exemplifying and planning utopia.

Mondrian's belief in the unity of all essences is the key to his optimism, for he has assured himself that the world as a whole is univocal. He has not proved that idea; he has not even provided an example of it, in spite of what he thinks his painting has accomplished. Mondrian's idea of knowing the

world is that of grasping an extremely simple principle about the form of the world and applying it to the particular case (as if it is obvious how the complexities of internationalism are of the same sort and therefore amenable to the same kind of harmonization as a painting is). His access to the world is through the essentialist lens of universal abstraction. Thus the world (its essential form) conforms to philosophy.[45]

In general, Mondrian opts for a kind of abstract language when he discusses particular things. Thus he says of disarmament, surely an immensely complex topic, "Though our international relations are anything but balanced or pure, and the various forms, the 'fatherlands'—equally far from approaching somehow the 'neutral' status, yet the question of the possibility of disarmament is now turning up. It goes without saying that, if there were no armament, man's mutual aggression and oppression would not be possible. Be that as it may, any success as to integral disarmament will depend upon the equivalence of the different states that intend to unify themselves."[46] As if this goes without saying. Mondrian not only glosses over all the complexities of the political world, he does so in a very particular way: by speaking about the political in the language of his paintings. He extends terms whose natural home is in their pictorial use to the political arena, employing terms like "neutral" (a word he tends to use to speak of nonnatural pictorial elements), "harmony," "purity," and "form." It is not that these words must originally be taken to be terms about art, it is that Mondrian originally baptizes them as terms of art about art and then simply applies them across the board to other arenas of life. Terms for art are the model for the terms of life. Discourse is ruled by the terms of art, suggesting that Mondrian really believes that art holds a more important place in the order of things than that of one exemplar of the platonic law among others. Art is not simply a route to platonic law (which might be received in another way), art is the source, the model, the foundation of law and harmony. Painting may be said to demonstrate the form of the world indexically by being the visual and conceptual model whose look and whose terms one points to in speaking about what harmony is. If someone asks what international harmony is, Mondrian will simply point to his paintings and answer, "It is that. That is what harmony is like." The terms for painting define the discourse of essences.

Why art should have the privileged status it has in defining the platonic form of everything? What stands behind this empowerment? Mondrian's favoring of painting as the source of the law is the result of a problem inherent in his abstract approach. Mondrian wishes that painting would present

the one law of harmonization, yet he has no access to that one law independent of painting. Indeed, there is no general law of harmonization to be found; the very idea of it confounds the imagination. There is no universal pattern to harmonization in things as diverse as painting, people, and nations. (How often do we even speak of the harmonization of nations anyway? It is a less central metaphor in politics than in art but is especially present in music, where it finds its natural home.) Thus the only way for Mondrian to make the abstraction (the law) coherent is to adopt one example of harmonization and then to generalize from it (illicitly, of course) to all other domains. He has no other conceptual choice, there being no general law to find.

This conceptual predicament becomes for him an occasion to empower painting with paradigmatic status. The idea that painting can present a truth which is a perfect and general truth, idolizes painting. It turns it to the status of an idol. Painting becomes the measure of truth, it is rendered omnipotent in its capacity to replace nature by perfection, to raise Mondrian to the stature of a modernist father whose claim is to do no less than paint the world perfect by painting everything with his own terms.

No natural force can now touch him. Mondrian's art enlists nearly every conceivable modernist force—from the history of philosophy and theosophy to technology, world politics, and the history of art—into his army of truth which will make the world congruent. His is an arsenal in which every force synergizes every other; it is a world-historical armamentarium, yet one whose world-historical forces do not fight the enemy but rather conceptualize it into submission. Utopia need not be imagined because everything in the world is converging to synergize its abstract shape. Nature is struck dumb by the force of the world's perfected arrangement. You cannot fight perfection (you can only challenge its existence).[47]

Mondrian's artwork becomes the premier arena in which the whole world is symbolically played out as if conflicts resolved in an artwork or things achieved there are taken in fantasy to be things resolved or achieved in the world generally. This is the Quixote principle, the idea that you can be the author of your own and everyone else's existence if you only write with enough narrative clarity and narrative gusto. Mondrian aims to write into existence not only himself but also the perfected world. It is not too far off track to say that for him, a work of art slides from the status of a demonstration into the status of a fetish which, if you stick pins in it (or remove them), will change things in distant places (or in the future). Theory is the

place in which the theory of things replaces things, sending them into perfection. It is the place in which human nature is replaced by its perfected double. Mondrian's interest in theosophy is his way of finding a language with which to invest artworks with the status of alchemical objects. By getting the language of a painting right, by getting both the painting harmonized and the words behind the painting written down, Mondrian tunes the entire world. For Mondrian, a painting is not simply a painting, but also a symbol or a Ouija board. It is strange to think that the mathematically precise paintings of Mondrian are so irrational, strange to think that Mondrian's commitments to speak in a dispassionate, objective, and universal voice are precisely the vehicle which projects so much undiluted modernist optimism.

Mondrian's optimism calls out for (it is almost a setup) a Voltaire, a philosopher who would expose Mondrian's gloss on the details of the world as glossed through the glasses of Pangloss. Mondrian, writing in 1942 about a path to liberation through painting, has to strike one as aptly Panglossian. Nineteen forty-two was not a good year for anything (except the liberation of painting). Indeed, Mondrian's politics are Leibnitzian. (In fairness to him, he shares with Leibnitz not simply a penchant for deluding himself into the best of all possible worlds but also a political seriousness born of the enlightenment.)[48]

III

All of this is to assume that Mondrian's words are a road map of his avant-garde wish, the wish that painting demonstrate truth. We now (I hope) understand Mondrian's concept of demonstration in its utopian ramifications. But to return to our original question about the degree of semantic control Mondrian exerts over his pictures, should we take Mondrian's word for what his paintings mean? He wants his paintings to refer to a new world order and, further, to demonstrate its rationality, inevitability, and truth. Do his paintings even signify it? Are they philosophical in this sense? Does the cross in his paintings signify male and female ratios, international collaboration, and a new form of individuality, or does he merely say it does?

I don't think that one can ever really decide exactly how much a Mondrian painting does or does not signify the arcane things he says it signifies. Even if one could decide for oneself, others would have the right to disagree. Some distinction must be drawn between a painter whose paintings depict,

represent, or otherwise refer on well-worn and unproblematical bases and a Mondrian whose intentions to make his paintings signify are wild, problematical, and idiosyncratic. Barnett Newman's intentions to make his abstractions signify (depict, express) the Christ story are less problematical for three reasons. First, the Christ story is so well known, so much part of the stock of culture, with a history of so many styles of representation, that we are more open to the convention of accepting a new way of referring to it. Second, Newman's paintings do not claim to refer to the Christ story with anything like the level of articulation of a Mondrian. If Newman pushed his black, white, and grey lines and color spaces to state a set of truths about the Christ story with the detail and argumentative authority of a text of Thomas Aquinas, we would be forced to ask whether Newman's visual medium is up to the task of this level of semantic articulateness. One can only push a medium so far, and beyond a certain point, the visual medium itself resists your pushing. The third reason is related to the second. Beyond a certain point, there is no visual feature of a painting to back up the semantic claim made for it. Newman's paintings remain at a level of reference to the Christ story in which the viewer is encouraged to think for himself about how much of the story is being signified by the painting. The viewer is encouraged to feel her way into the visual features of the canvas with the story in her mind and make as many connections as she can between what the visual features of the picture feel like to her and what the story tells her. The point at which she stops, at which she can no longer make any more connections, is the point at which the richness of the paintings and their capacity to signify is exhausted. No two people will find this point to be quite the same; it will be a debatable point, a point to converse about. If Mondrian had simply left his paintings to the viewer, saying, "Here are my platonic beliefs, and here is a well-made abstraction, I encourage you to see how much you can connect my platonic ideas to the visual features of the paintings," no one could fault him. But probably no two persons would find in themselves the capacity to accept the same amount of connections between the theory and the visual features of the picture, which means that no two would agree about how far the powers of signification would go in Mondrian's paintings.

There is no other test for how much a painting can signify than what humanity can bring itself to accept. In Mondrian's case, I submit that few would rest easy with Mondrian's own beliefs about how richly his visual medium can signify his philosophical ideas. Mondrian does not leave the

question of how much his paintings can signify up for grabs. He intends to be the perfect arbiter of his paintings; he intends his theory to absolutely dominate the canvas, as if his mind, like the law, imposes a semantic rule onto his work, as if the conviction with which he holds his view, as if the mere *having* of an interpretation, determines meaning. It does not, and the right way to capture the referential insecurity of a Mondrian work is to say that the referential capacity of a Mondrian work is debatable—essentially debatable.

This is as one might expect, for just as the constructivist cannot succeed in imagining utopia in detail, so Mondrian cannot succeed in imposing his abstract and utopian semantics onto the body of his canvases. The theory of utopia, whether imagined or demonstrated, must always remain incomplete.

It is an important lesson about the avant-garde that there already exists in it this desire to impose a semantic rule on a painting above and beyond what the visual medium can bear. On the one hand, as painters who live in a plastic, visual medium, they aim, like Newman, to work out theories in terms of their artworks, to craft their works so that the works will make resonant the theoretical ideas. On the other, as drunken utopian theorists, they begin to speak as if their theoretical interpretation can be imposed onto their plastic objects at will, as if theory transparently imposes meaning. And with the utopian role that theory is meant to play, theory becomes a massive influx of power into art, a mode of inflating it with security, perfection, and force. This is a lesson to note, for it is precisely the same ambivalence about the role of a theory in defining the meaning of a visual object that we will find in Danto's own avant-garde thinking about art. It is an ambivalence (played out over a discourse of power) whose legacy we, the postmoderns, have inherited.

Mondrian's paintings are clearly philosophical; how much they are philosophical is then an essentially debatable point. I do not think it can be resolved. But what cannot be overlooked is Mondrian's avant-garde intention to invest his artworks with Platonism, to produce objects with the crystalline purity and conceptual perfection of platonic forms. What is important is how much he wishes his paintings to demonstrate. Without assigning a crucial role to Mondrian's intentions, intentions expressed in his words but also in his serious (if incomplete) attempt to secure a rule of law between his words and his most harmonized innovations in paint, we will entirely fail to reconstruct the power in his modernist message. We will fail

to understand what makes him avant-garde; indeed, we will fail to grasp what the avant-garde genre under exploration in this book is. We will especially fail to understand how this most serene of painters can also be the wildest, most incorporative, and most optimistic of writers. We will therefore fail to understand one voice—the platonic proselytizing voice—in which Mondrian makes the silent serenity of his paintings speak.

Whether we can decide if the paintings signify every detail he says they do is less important than how much they are constructed under the deep motivation to fulfill this task—and how much they resist it. Resistance to a task is not necessarily successful, it sometimes fails, and other times it leads to a dead heat, a mixed outcome, or an unclear state of affairs. Even when resistance is unsuccessful, it mitigates success—here, the success of signification—casting it in a different light. A marriage of words with paint, of theory and practice, does not entail, after all, the complete rule of the artist's intention over what the painting means. Rather, the marriage called art arises through the conversation betwixt and between these.[49] Marriages may have their running quarrels, their powers and resistances.

And what of the resistance of Mondrian's paintings to his words? We have seen that Mondrian the philosopher exploits this very resistance, appropriating the silent and complete serenity of his paintings to his philosophical purposes, turning his paintings into the analogues of platonic forms. Yet in another voice the paintings resist even that appropriation. In their glorious silence they cast his entire philosophical voice aside as somehow irrelevant. They exist as gestures of spiritual attunement and purity complete and poignant in themselves. This is the Mondrian whose paint preaches nothing more than it feels—a serenity born of vibrant primary colors arranged to perfection. Perhaps that is all the philosophy one needs (which is not much), but it is surely not all the philosophy he wants; it is not all the philosophy that his modernism demands. In his Platonistic, philosophical voice, this attunement in Mondrian's pictures is given metaphysical powers of demonstration; indeed, it is in some sense fetishized.

Yet what exactly is Mondrian's intention? Perhaps, amid the torrent of his words, there is also the silence of a painter who enjoys nothing more than the pure dedication to spirituality in paint. Then the silent spirituality of a Mondrian painting is the victory of Mondrian the painter over Mondrian the painter/philosopher—if only for a moment. Yet in that momentary suspension of language, of the ethical, of the conceptualizing Mondrian, the urge to paint, to do nothing but paint, to paint the sky and hold it in one's hand is given room to be born. I would call such a moment the silent asser-

tion of Mondrian's own nature. Mondrian's art is neither purely of one voice nor purely decidable as to its meaning. Nor does it satisfy his theory of purity, however heroic its attempt. Art, like nature, does not come pure, in spite of what Mondrian desires. Yet strangely, only in the context of its complex nature, which is also his, is art's wish for purity given room to be born.

Art has defeated our own attempt at interpretive certainty, for the level of philosophical theory in Mondrian's paintings is debatable.

5 / *John Cage*

In those rare cases where a composer, such as John Cage in his more extreme moments, . . . allow[s] music to unfold in time totally without restriction, the results seem peculiarly "unmusical." Indeed, in Cage's most consequential experiments in this direction, a performer is simply provided with a unit of time within which anything—or nothing—can be done: musical time then becomes indistinguishable from ordinary time. But if this is so, in what sense can this time be said to be musical at all?

Robert P. Morgan,

I said in the introduction that I had a thesis to articulate and to test about the avant-garde, namely that the three moments of the avant-garde I have chosen to read form a genre: a genre of art whose utopian nature is articulated theoretically. Theory is called on by the genre to turn the avant-garde artwork into an example of the utopian future, and the artwork exemplifies the future by showing itself to be prefigured by philosophical truth. I also said that my choice of examples—constructivism, Mondrian, and Cage—is intended to illustrate the opposing directions in which theory has been taken by this genre. One can find two opposing conceptions of utopia in the avant-garde which are articulated in terms of opposing conceptions of the role of structure in the artwork. On the one hand, there is the commitment broadly shared by constructivism and De Stijl to perfect life through the clarification of forms, through increased lucidity in design, and through a commitment to transparency generally. This commitment expresses itself through the concern to articulate a structurally transparent art example. On the other hand, there is the tendency, represented in its most extreme form by John Cage, which adulates the dissolution of structure in life and art, the dismantling of the idea of the edifice in life and art, and the return to the fresh, the anarchic, and the natural as a way out of the bottleneck of life. Cage's commitment is expressed by his desire to make musical works which are drained of most of the basic elements comprising ordinary musical structure.

I described both of these commitments to theoretically prefigure art as playing out over the artwork a debate which has been long standing in epis-

140

temology: the debate between Cartesianism (and its ally, Platonism) and skepticism about the world. While the Cartesian and the Platonist share the aim of conceptual clarity, definition, and proof, the classical skeptic aims to prove that we cannot know the world and, further, to show that life will be better the less we are obsessed with the urge for knowledge. These differing epistemological positions are, of course, developed through different styles of philosophical text. The Cartesian text aims to prove every one of its conclusions from a certain foundation; the skeptic's text is an admixture of argument and revelation designed to pry us away from our obsessions with knowledge and to open us to the flow of our bodies. My thesis is that in their philosophical voices, constructivism, Mondrian, and Cage play out a similar set of opposing positions (and engage in a similar debate) over the issue of structure (form) in art or music. Their artworks exhibit the same stylistic differences as those that can be found in the philosophical texts of the epistemologist. The constructivist art object is like the Cartesian text. Constructivism intends to make its sculptures into essentially Cartesian proofs of their formal construction. Mondrian intends to make his paintings into essentially platonic forms. Now we must turn to John Cage's musical attempt to make performance in sound into an essentially skeptical text.

John Cage's music and poetry are an extreme example of that hitherto unmentioned tendency in the avant-garde, the tendency aiming for disturbance, dislocation, and the breakdown of structure. His art of disturbance has as its goal liberation from structure in music and life rather than construction of a new and pristine structure. Its goal is freshness or the natural, not the composed and the designed. Cage's art arises out of a quarrel with the hard-edged modernists whom he opposes—above all Arnold Schoenberg, one of Cage's teachers.[1] Cage's response to Arnold Schoenberg is a response to Schoenberg's modernist attempt at musical restructuring. It is a response to Schoenberg's attempt to set modern culture on a new footing by imposing upon it a new twelve-tone musical structure. Never mind that Schoenberg was himself a paradigm of complexity, one who claimed that his technical discoveries meant nothing independent of the total compositional hand. The Schoenberg who interests Cage is the one who, in a moment of fantastic self-irony (the irony of which eluded Schoenberg at the time), claims of his invention of twelve-tone composition that it will insure the supremacy of German music for the next hundred years (couldn't he have opted for a thousand?). Males will be males, structures will replace structures, and certain Americans will naturally revolt at such grandiose European utterances as Schoenberg's or constructivism's or those of De

Stijl. That is to say, we can understand Cage's skepticism to be a radicalism directed against its avant-garde opposite. Cage's is a different and equally extreme form of response to the seared, fragmented, and overdone world to which the rest of the avant-garde also responds.

Cage's art is thus representative of the tendency in the avant-garde to reject the idea of an art prefigured by a theoretical plan of construction in the manner of constructivism's, Mondrian's, the Bauhaus's, and Schoenberg's. Cage's art sits on the avant-garde map in opposition to constructivism, Mondrian, and the Bauhaus and in partial alliance with such art activities as Duchampian play, surrealist bricolage, and dadaist anarchism. But none of these other art movements, I think, go as far, nor do they develop in an equally philosophical manner, Cage's aim of radical improvement in the quality of everything through the dissolution of all structure. Undergirding Cage's music is a skeptical philosophy as epistemologically extreme as that of the philosophical art it opposes. Cage's experiments in form are experiments in this utopian disruption; they are attempts to break through form or to dispense with it so as to allow us to get down to the business of an unmediated reception of the world.

Like the rest of the avant-garde, Cage's writings and his music aim to clear away the rubble of past music; his practice aims to get one's ears to hear from scratch. Only Cage does not aim to construct a new way of hearing but to so totally destroy the old that our ears will be reborn. Thus reborn, our ears will interact with sound without any mediation of structure and interpretation whatsoever, thus being open to, in Cage's favorite formulation, "whatever happens to happen."

The source of Cage's theory lies in both his sounds and his writings, but the very distinction between these is at best porous. Cage's many writings on music are the result of a keen, reflective intelligence that speaks to the nature of music and by extension to the place of music in the restoration of life to its own free play of sound and humanity. But it would be strange if Cage's words were primarily there to articulate a theory of music. Many of his most theoretical texts are written in rhythm and counterpoint; they are meant to be performed on stage or in the reader/listener's mind. Central to Cage's practice is his blurring in his own performances of the distinction between music and words. His books are composed of fragments of story, anecdote, recipe, and theory with a freshness that turns them into wake-up calls to stop obsessing and start living. Their bricolage makes them part of the art, not simply its theoretical description or explanation.

Word and sound are intricately allied in Cage's practice, thus defeating

the idea that his is a single voice, philosophical or otherwise. In this he is Duchamp's heir. Since my topic is to probe the mentality held by avant-garde artists and by philosophers of the avant-garde, my point in reading Cage is twofold: first, to develop a picture of the practical motivations underlying his theoretical skepticism, and then to see how far this philosophical voice goes in his art, for no one is more theoretically restless, or theoretically inventive, than Cage—not even Moholy. How far, then, does Cage's philosophical voice go? For example, how closely is it connected with his Zen voice? to his unabated love of nature? The goal is to develop a picture of the mosaic of voices in which Cage speaks.

I

There is no doubt that John Cage is one of the most important figures in twentieth-century music. His intelligence, humanity, and above all his compositional inventiveness have made him perhaps the most influential and eloquent spokesperson for the musical avant-garde. As a writer and maker of sounds he has in many ways defined what the musical avant-garde is. His contributions to music have included the vast extension of percussive means (most notably the invention of the prepared piano as we know it today), the development of new rhythmic configurations in composition, the early use of electronically processed sounds, and the early use of aleatoric (or chance) elements. He has reworked the dadaist event into an occasion specifically for and about music, which produced the musical happening. In a century in which many composers have written a lot of music as if they were about to die—even if they were under the age of 25 at the time of writing—Cage's music is warm and wonderful. He is the inventor of the mesostic music/poem, a form which, at its best, can be compared to the literature of James Joyce and Ezra Pound.[2] His writings combine everything from technical discussions of electronic instruments to disquisitions on Schoenberg and Satie, Indian philosophy, mushrooms, abstract painters, Zen monks, and Southern California. They are incisive, devastating, and charming.

Cage has given music (and life) a lot of things to use. Yet if Cage is one of the most important figures in twentieth-century music, he is also one of the least understood and perhaps one of the hardest to understand. His work matches the difficulty of his teacher and friend, Marcel Duchamp. Part of its difficulty lies in its complexity. Cage is at once musician, destroyer of music, rhetorician, theorist, and sage. His juxtaposition of snippets from

Thoreau and *Finnegans Wake* with newspaper clippings and discourses on information theory, politics, and ecology (the recent Norton Lectures)[3]— all arranged according to chance operations—creates a complex space whose continuous suggestion and defeat of meanings in an ambient forest of signs can only be called contemporary. But his aim of achieving a calm state of openness to whatever happens to occur in the world without interference can only be called ancient. Like the constructivist, Cage is a person of many voices, some of which are radical while others are not. Sometimes he is set to revamp everything we think of as music, while at other times he confines his attack to the high modernism of Schoenberg and Anton von Webern. Sometimes he seems to be saying utterly ordinary things, while other times his voice is as mysterious and incomprehensible as that of a Zen master. These voices both conform and contradict, leaving one unsure as to what one is hearing and thus how one should respond. Furthermore, Cage isn't simply a man of many selves; he specifically intends to conflate and confuse. Like his compatriot Duchamp, he aims to speak in a plethora of voices so as to produce in us, his audience, an overall response that fails to cohere in ways that we want it to, thus throwing into relief or undercutting some pattern of our ordinary beliefs and responses to works of art. Duchamp's placement of a urinal before the Parisian world was both an outrageous assault on the self-image of art viewers as civilized and clean and a way of forcing thought about what art is through the uncanny resemblance (and lack of resemblance) this object had with sculpture.

That Cage's challenge to our musical beliefs, attitudes, and practices is posed from the difficult perspective of a Zen master has often been discussed, and I will have things to say about that most silent of his voices. However, what has been neglected by both Cage himself and others is the equally potent challenge to the ordinary which Cage formulates in the related but distinct voice of the philosopher. Through his relentless inquiry into new music, Cage has defined certain radical possibilities for musical change. He has defined them in order to realize them in his practices, not simply as a matter for abstract consideration. Yet what is, in effect, his skepticism about music as we know it contains a cogent analysis of our musical concepts and practices, of what it is for us to believe ordinarily that something is music (as opposed to not being music), and of how those beliefs about music connect with styles of feeling and treating what we hear when we hear it as music. Indeed, it is Cage's genius to have established the topic of skepticism about music as an issue for philosophy and cultural criticism. Cage's radical perspective on our musical beliefs allows us to consider both

what those beliefs are and whether and how they might be justified. This invitation to philosophical response through disturbance is an important feature of the avant-garde which Cage shares with Duchamp in plastic art, Gordon Matta-Clarke in architecture, Joseph Kosuth in painting (not to mention El Lissitzky), and conceptual art generally. I wish to give it its due by outlining and addressing Cage's skepticism about music.

Cage's avant-garde challenge is addressed to the very core of our concepts of music, namely, to our commitment to the idea of drawing distinctions between musical and nonmusical sound concatenations, distinctions rooted in our most basic styles of hearing. It aims to completely disturb these distinctions. Distinctions we draw between music and nonmusic may be less than precise, but they lie so much at the foundation of our musical practices that it strikes one as bizarre that someone might care to challenge them. Given reasonably normal listening conditions, reasonably normal listeners, and reasonably nondefective performances, it is our cultural tendency to believe that everything from *Three Blind Mice* to *I Want To Hold Your Hand* to the "Finale" of *Swan Lake* can be heard as music, whereas the sounds of airplanes taking off from runways or the scraping of plastic forks in certain fast food restaurants, however intriguing and revelatory of the contemporary world, are not, in any ordinary sense, music.[4] We acknowledge that many such concatenations of sound, which we do not, in any straightforward sense, call *music,* have musical aspects: from the sounds of birds and the howling of the wind on late October nights to the sounds of rush hour New York when, for example, the wailing of a passing train synchronizes with the soft murmuring of pedestrians highlighted by a blurring of motorcycles to strange effect. However, the criteria we rely on in deciding not to call these various sound concatenations *music* is that they lack either the kind of overall coherence, development, closure, and elaboration characteristic of works of music or the element of human intention—the compositional hand—that distinguishes art from nature or from the purely fortuitous.

Cage impugns with gentle audacity our commitments to such criteria and such distinctions, having this to say to those of us for whom it is obvious that the sounds of elevators, however pleasing or profound, fail to constitute music: "For instance, people getting in and out of elevators and the elevators moving from one floor to another: this 'information' can activate circuits that bring to our ears a concatenation of sounds (music). Perhaps you wouldn't agree that what you heard was music. But in that case another transformation had intervened: what you heard had set your mind

to repeating the definitions of art and music found in out-of-date dictionaries." [5]

Cage might appear to be saying merely that old fogies should open up their ears so that a world of contemporary sounds can strike them with interest—a kind of irresistible plea for openness in hearing. However, he is emphatically stating something much stronger. He is saying that any concatenation of sounds is music, already dispensing with both the musical criterion of composition (elevator sounds are not composed, they simply happen to happen) and our ordinary notions of musical form—of coherence, closure, development, and the like. Indeed, Cage goes further. His is really the claim that it is the mediation of dictionaries per se that we should do without, and by dictionaries he does not merely have in mind the kind of excessively rigid musical categories one found in post-Webern libraries of the forties and fifties. We do not need a more up-to-date, more relaxed and fluid dictionary; we need to do away with dictionaries entirely. We need neither a new language for talking about music nor a new set of distinctions between what is and is not music, nor do we need a new set of criteria for drawing such distinctions. What we must learn to do is to approach sound concatenations in ways unmediated by anything like our criteria or concepts. This is Cage in his radical, as opposed to his more moderate, voice.

Cage believes that when we approach sound with ears informed by our concepts we are precluding a deep and immediate acknowledgment of both sound and the world, opting instead for a kind of distorted attempt at control. Indeed, he believes that the very attempt to order sound in the mind's ear as coherent, complete, resolving, elaborative, formal is an act of manipulation or possession. In projecting through the ear our criteria of the musical, we are doing to sound what we do to other people when we try to remake them in our own image as opposed to letting them freely be themselves. To acknowledge sound, like acknowledging people, is for Cage to just let it be. Such a view goes beyond any mere plea for tolerance in music (or in ethics), for it identifies respect with noninterference. So long as we don't interfere, sound and life are fine. Cage says, "This play [music], however, is an affirmation of life—not an attempt to bring order out of chaos nor to suggest improvements in creation, but simply to wake up to the very life we're living which is so excellent once one gets one's mind and one's desires out of the way and lets it act of its own accord." [6]

Why the mere act of organizing sound or the mere interference with life constitutes an act of distortion—how one is supposed to get one's mind and desires out of the way and why life is so excellent when one does—are

things to be explained. The rosiness of such remarks might appear outrageous in the light of everything we know of the terrors of music, much less of life, in this our painful twentieth century. But Cage means his remarks to be as serious as he means them to be outrageous because for Cage the liberation from one's mind and desires is the invocation of an attitude toward sound and the world in which the discovery of the world's beauty is revealed. Cage states, "To accept whatever comes, regardless of the consequences is to be full of that love which comes from a sense of at-oneness with whatever."[7] Cage is not unlike Saint Francis of Assisi, for whom the entire natural world is an occasion for interest, profundity, and gentleness. Such "at-oneness" is marked by the sense that nothing about any particular thing will cause us to treat it differently from any other thing. Each piece of the acoustical world is then equally an occasion for immersion and equally a piece of the rest of the world. Music is at peace with life, and one is free to feel that at every moment the entire world resonates with the same capacities—as if the world were but one enormous chord or family.

Projecting our musical categories onto sound inherently spells out differences in how we treat sounds (just as projecting our beliefs, attitudes, and expectations onto people inherently involves treating some people differently from others). When, for example, we projectively hear through a sound concatenation in such a way that we end up describing it as a performance of a work by Beethoven, we are identifying that sound concatenation in a way that makes it matter differently to us than noise, bird calls, or silence matter to us (however wonderful these might be in their way). Cage believes that, because our projective identifications of sounds involve us in such evaluative differentiations between sounds, they should be castigated.

For Cage, all there is to identify in sound is whatever makes us treat it no differently from any other sound. That can only be sound apart from our entire mode of projection, identification, and treatment of it—call it a thing in itself, a thing divorced from mind, desires, dictionaries, and whatever else distorts the issue of at-oneness. This idea that sound is a thing identifiable independently from our projective ears, a thing which is miraculously acknowledgeable through the state of at-oneness, brands Cage's as a skeptical claim about our projective modes of knowing music. To twist Kant, Cage's skepticism is about whether the world of sound conforms to our projection of it. The first question to be raised by this invitation to philosophy concerns in what he construes our modes of projection onto sound (our conception) to consist. This he encapsulates into his slogan that sounds are sounds and not people. He observes in his famous Julliard lecture that

before studying music, men are men and sounds are sounds. While studying music things aren't clear. After studying music men are men and sounds are sounds. That is to say: at the beginning, one can hear a sound and tell immediately that it isn't a human being or something to look at. . . . While studying music things get a little confused. Sounds are no longer just sounds, but are letters. . . . Sharps and flats. . . . The privileged tones that remain are arranged in modes or scales or nowadays [twelve tone] rows, and an abstract process begins called composition. That is, a composer uses the sounds to express an idea or feeling or an integration of these. In the case of a musical idea, one is told that the sounds themselves are no longer of consequence; what "count" are their re-lation-ships. . . . In the case of a musical feeling, a-gain the sounds are unimportant, what counts is expression. . . . If anyone wants to get a feeling of how emotional a composer proved himself to be, he has to . . . imagine that sounds are not sounds at all but are Beethoven).[8]

We pass beyond treating sounds as themselves both when we project formal or structural relationships onto them and when we hear them as expressive of human emotions. When we hear ninth chords as part of a tonal system resonating with the dying, unresolved weariness of the late romantics (who were especially fond of such chords) or with the offbeat whimsy of a Thelonious Monk (who is also fond of them), we are hearing more in them than is there and than we ought to hear.

It is this projection of structure and expression into our hearing that Cage has rightly understood to underlie our distinctions between what is and is not music. When we hear sounds, we listen for structure and emotionality in the sounds, and it is in virtue of what we hear or fail to hear in sounds, along with what we know of their origins as composed or natural, that we decide whether or not to call individual sound concatenations "music." Even if we do not fully conflate music and people (unlike the often-mentioned yokel who actually tries to cheer the music up), it is not so clear where our mode of feeling ends and the music begins. It is this practice of projecting something into sound that for Cage is an act of failing to respect the thing itself. To glean the radical power of Cage's pronouncements it is worth pointing out how profound an analysis he makes of the music he aims to disturb. Cage's is a philosophical analysis at the service of change whose incisiveness hits the core of the nature of its target. In this regard, consider how deep in our practices acts of projective hearing lie, how natural it is for us to associate sounds and people.[9]

We respond to musical structure as expressive, hearing melodies as whimsical or sad, chord patterns as anguished, and counterpoint as intensively driven. Whatever analysis best fits the description, we do find it irre-

sistible to say that the sadness is "in" the music as it is in people. We describe the kinds of affective states music causes in us, using language originally employed to describe causal relations between persons. The music "calms" us (Brahms's lulling melodies), it "seduces" us (Wagner or, even more, Mozart), it "forcefully energizes us" (Schumann). The point is not merely that music causes in us thoughts and feelings similar to the thoughts and feelings people can cause in us (drugs and alcohol can also do that), but that music causes our affective and conceptual states by generating in us the *attitude that it is like a person* in doing what it is doing to us. We see the music gesturing to us as people gesture to us, speaking to us as they speak to us, and generally doing things to or for us as people do—whether good, pleasant, and wonderful or irritating, irresponsible, and bad. Brahms's melodies calm us down through our sense that they gesture gently and sweetly like a mother or friend, Mozart's famous Aria, "Bati, bati o bel Masetto, la tua povera Zerlina," sung by Zerlina to disarm Masetto in the first act of *Don Giovanni,* cannot but melt all listeners with its softly pulsing and caressing cellos, reinforcing a perfectly proportioned melodic line that falls accented on the word *bel* (lovely). It seduces us as much by its causing us to see it as charming, warm, and softly stirring as by its causing us to see it as charming through its already operative powers of sweet seduction.

Related to our perception of music as gestural is our sense of it as resembling human action or human activity. We employ a great variety of action descriptions in speaking about music. Themes return effortlessly or heroically, or fade into sleep; musical counterpoint is dialogue, modulations establish new keys and musical lines move up and down. The very place where all this happens is a kind of musical space—not merely the complex theoretical construct of Heinrich Schenker and other theorists but also the ordinary pretheoretical place where listeners see sounds as happening.[10] Hence the very projection of simple formal and structural qualities into sound concatenations is closely allied with our seeing such sounds as persons since the projection of form and structure involves the projection of a space in which music is seen to unfold and act. And onto whole musical movements or works we impute larger forms of activity. Paradigmatically, Beethoven is heard as setting forth musical goals, modifying these in the course of complex musical elaborations, and finally achieving closure in a compressed and forthright manner. Even works such as late Schubert songs in which chromatic and rhythmic disjunctions fail to fully resolve are heard

as though they were actions—incomplete and inconclusive journeys or acts of gradual disappearance.

Furthermore, compositionality is a mark of the musical because we construe music to be a piece of communication between composer and audience. We do not merely treat music as persons and actions; we treat it as if it is intended by the compositional hand to communicate and invoke that content. We take it that the composer intends for us to treat the work as the product of his or her intention.[11] Music is not merely heard as like persons and actions, it is heard as a human product—as the product of a hand committed to what it has wrought.[12]

Cage is opposed to the hearing of any shred of symbolic content in sound. His radical experiments in musical form in the 1950s can be understood in terms of his desire to completely pry apart our hearing of sounds from our urge to project structure and people into the sounds. In these, Cage uses form as a kind of necessary evil, as a way of simply blocking out a segment of time while trying to impose as little organization on it as possible. He structures the time segment aleatorically (using chance methods) or by simply choosing an obviously artificial pattern such as that found in the *I Ching* as a way of getting started. His performances have gone even further. The most illustrous, *4.33,* first performed by David Tudor in Maverick Hall, Woodstock, New York, in 1952, consists of four minutes and thirty-three seconds of silence. The performer sits down at the piano, opens the "tri-partite score," turns its pages, closes it, and—this is a performer with a flair for the dramatic—bows to the audience. Nothing is played by the performer—no harmonies, no "Tristan chord," nothing. The performer goes through the ritual of performing music without performing anything. This founding example of the *Happening* is meant to challenge us to accept it as music. The challenge is ingenious. If there is no sound, how could the issue of whether music has been performed ever arise? But there are sounds there—random sounds of the pages being turned and the audience giggling and the rustling of the trees outside and of birds. Cage intends that we attend to sounds which are not the product of any compositional intention of his and are by extension not conveyed by the performer. His aim is to obliterate his own expected presence in sound. Freed from our fixation on the composer's hand, mind, and desires, we can wake up to the excellence of that hitherto dormant world of sound which is nothing other than happening to happen. The work is a rhetorical instrument to lead us from the composer's instrumentation to the sounds of the present. And since, according

to Cage, sound is everywhere, this is to lead us from music to the doors of the world. And to the doors of philosophy.

II

Cage's radical exemplar, *4.33,* occasions philosophy through its invitation to hear sounds as liberated from structure and anthropomorphism. "A time that's just time will let sounds be just sounds and if they are folk tunes, unresolved ninth chords, or knives and forks, just folk tunes, unresolved ninth chords, or knives and forks." [13]

What is left for us to hear in a ninth chord or a folk tune once we have given up hearing structure or the resonances of persons? Can we hear a ninth chord as a chord without hearing it as part of a structural system called tonality or perhaps some other system in some other context? It seems easier to imagine this when one imagines simply hearing the chord by itself and harder when one imagines hearing it as part of some clearly tonal or other work. Can we hear a folk tune without imagining hearing in it some sort of human statement or feeling? What then does it mean to call these "ninth chord" or "folk tune"? What is a folk tune, after all, but some concatenation of sounds conceptualized as that human sort of thing produced in a certain sort of community by a certain sort of person in a certain sort of style? The very use of language scrapes here. The term *ninth chord* and *folk tune* are reduced to simple indexical markers by Cagean nonconceptualizing ears—indices marking *that* and *that* where what *that* is is what our ears tell us, and our ears are supposed to impute no ordinary structure to either of these things. Cage's invitation is, as I have said, for us to hear sounds as what Kant would call *things in themselves,* things apart from any projections of our categories—here, our modes of imputing to sounds structure and anthropomorphism. Cage wants to abolish all dictionaries because he wants to abolish all modes of mediation between us and sound, as if sound is there for us to coherently hear apart from our projections of structure and the rest onto it. Cage's is a transcendental claim: we can relate to sound itself. As such, it invites a Kantian kind of question about whether sound is coherently available to us apart from our ear's projective schemes.

Put another way, Cage is skeptical about the necessity of our hearing sounds in a structured (mediated) way, and since our concepts of music depend on such styles of hearing, his skepticism is about our ways of conceptualizing music, of knowing what music is. His challenge is addressed to

the security of what we take as obvious—our musical practices. Cage is, to my knowledge, the first to have occasioned such a Kantian, skeptical question in the sphere of music. And he has done so in a way that makes that question one of direct cultural relevance for contemporary music. That in itself seems to me to represent a philosophical contribution. Nor ought one write it off as hopelessly trivial, even if one's initial response is that there is, of course, no such thing as sound for us to hear independently of our modes of projection and that therefore Cage is crazy and wasting our time. His point is precisely to cause us to explore the power in such remarks, to cause us to doubt their power, and thus to take seriously that we don't know ourselves (our own ears). Such doubts can lead us, if nothing else, to understand how and whether we can prove or otherwise know that we do know ourselves as music makers and listeners.

Cage introduces his skeptical theory to dislocate us from our convictions about what sound is and to open our minds to radical alternatives to our musical practices. Cage's philosophical radicalism is practical, a radical skepticism with a beautifully Buddhist flavor. As a philosophical position, it defines the meaning of 4.33, turning that work into an exemplary occasion for the kind of structureless hearing Cage would have us have. Although Cage's sources are explicitly in Zen Buddhism (it was D. Suzuki's lectures at Columbia University in the 1940s which introduced him to Buddhism), I wish to reconstruct Cage in terms of classical skepticism, specifically in terms of the skepticism of Pyrrho of Elis. My reason for the reconstruction is that it is Pyrrho's style of reasoning which most closely approximates the mixture of philosophical claims and art practices that one finds in Cage the philosophical avant-gardist. Cage the Zen master is not the Cage who makes radical philosophical claims about music. And here we are interested in Cage's use of theory, in the way his theory structures his performances. We will turn to Cage the Zen master later.

My philosophical reconstruction of Cage as a classical skeptic thus plays a role similar to my Cartesian reconstruction of constructivism. It is a tool for understanding, to the best of one's capacity, the element of theory in a philosophical art. Cage is not, to my knowledge, conversant with classical skepticism. Whether Cage has actually read the classical skeptics or read only related sources, whether he has acquired classical skepticism as a general style of reasoning in the fabric of culture (as Cartesianism was probably in the fabric of Soviet Russia through the inheritance of philosophy and of Marxian dialectical clarity), or whether he has approximated it in his creative appropriation of Suzuki's Zen, are important but not decisive questions

for my reconstruction of the philosophical voice in (Cage's) art. (As in the constructivist case, if one wishes to challenge my use of the interpretive tool of classical skepticism, one must arrive at a better way than mine of bringing together Cage's philosophical theory with his performance practices.)

Let us briefly consider the idea of Cage as a classical skeptic.[14] For Pyrrho of Elis, the locus classicus of classical skepticism, the goal of skepticism is to achieve contentment. Contentment means relief from obsessional anxiety and a sense of openness to the flow of life, that is, to the flow of one's own body. (Nothing can be further from Mondrian's position than this.) These features of contentment can only be achieved at the price of relinquishing a claim, the claim to know—and thus have conceptual control over—the perceptual world. This claim is identified by Pyrrho as the source of the urge to philosophize. Pyrrho believes that knowledge (and thus control over the flow of perception) is impossible to achieve; one will never really know what the perceptual world is like. The very attempt to secure such knowledge will make one forever miserable. Pyrrho has seen the misery of those schools of philosophy which argue endlessly about how to know the world, and he has had enough. The whole project reeks to him of obsession.[15]

Plato, along with Mondrian, believes knowledge of the forms will make one's life harmonious. Pyrrho believes that Plato's belief is exactly what deforms life. Pyrrho, speaking to the twentieth century, would say that Mondrian's Platonism is also a fetishization of theory over the flow of nature. It is only when one relinquishes the claim to perceptually know and conceptually control the world, according to Pyrrho, that one will be at peace with oneself, with one's sensuous reception of things. The philosopher must give up his obsession to grasp the music of the world in his hand, as if the world were a pure object of certain knowledge. He must let it be. And so his disillusionment at his own incapacity to control the world by making it stop will dissolve, or it becomes, in his case, more manageable. Cage will call this opening oneself to the play of "whatever happens to happen."

Pyrrho's skepticism is itself an extreme position about knowledge. It is one thing to say that highly stringent conceptions of knowledge are reflections of the human being displaced from herself; it is another to conclude that nothing at all can be known about things and that life is better lived without any knowledge at all (as if it could be lived without knowledge, as if the skeptic could, in Miles Burnyeat's words, live his skepticism.[16] Pyrrho's rejection of the role of knowledge in life is as extreme as Plato's adulation of the forms. Pyrrho's philosophy would end all urges toward philosophizing. What shape does this philosophizing to end all philosophizing

take? Pyrrho aims to pry us away from our obsession with the attainment of knowledge of the form and nature of things (1) through a set of arguments that such knowledge is impossible (these are the famous skeptical arguments that we can never know reality, only our sensuous reception of it), and (2) by getting us to see that we do not *need* such knowledge and will be a lot better off without it.[17] Baldly put, Pyrrho introduces a style of reasoning which is a hybrid that combines arguing people out of something and showing people that somehow they don't require that thing anyway and, furthermore, they will be a lot happier without it.[18]

Cage's art practices, his musical events, writings, and mesostics are similarly hybrid, played out for a similar purpose. His amalgamation of texts, poems, music, and performance aims to dislodge us from our obsession with imposing structure onto sound. Their point is to give us peace and to make us more joyous. Cage calls this restoring us to the natural (Pyrrho calls it restoration to the flow of the body). Cage lambastes modern music, tells stories about gathering mushrooms, opens our ears to whatever happens to happen, quotes from information theory, Buckminster Fuller, Duchamp, and Satie, in the interest of this (in effect) Pyrrhonic practice of relinquishment and openness to the flow of perception. Cage's total art practice is then like a philosophical text—the text of a classical skeptic in form and purpose. It is prefigured by the goal of skepticism and, Cage hopes, by a skeptical theory of how sound is heard. Indeed, Cage does to and for music what the history of classical skepticism has done to and for philosophy: through his skeptical practice he challenges music, stimulates it, and humanizes its excesses.

If we understand Cage's skepticism to be motivated by the moral picture of life found in Pyrrho, then we find two parts to Cage's art: (1) a set of skeptical arguments of a philosophical character addressed to our concepts of music and (2) a practice aiming to pry our ears away from their fixations and furthermore to show us that life will be better without those fixations. While their practical import is clear, the philosophical claims behind Cage's moral picture demand philosophical reckoning, for at their basis is the idea that we can know sound in itself, independent of all conceptualization in terms of structure and expression. And since 'ought' implies 'can,' if we cannot do without conceptualization, if we find in our ears no possibility of hearing sound in an unmediated way, then there is no issue for us about whether we would be happier otherwise. If utopia cannot be imagined or lived, then there is no issue of our being happier in it.

Cage's skepticism demands a philosophical discussion of its possibility.

First, let me note that *4.33* is successful in its raising of another, related philosophical question. What Cage has done by that performance is to have succeeded in producing an object about which we cannot simply say, without further explanation, either that it is or that it is not music. ("The Situation must be Yes-and-no not either-or. *Avoid a polar situation*.").[19] Such an object invites skepticism through the sense that it has undercut our concepts of music by dislodging the clearly felt borders between what is and what is not music. It is as if we can no longer tell where music ends and the rest of the world begins, with the result that we no longer know what music is. The importance of borderline or otherwise exceptional cases for testing and revealing our concepts is something philosophers in this century, especially the later Wittgenstein, have focused on. Wittgenstein says in the *Philosophical Investigations*, "A main source of our failure to understand is that we do not *command a clear view* of the use of our words.—Our grammar is lacking in this sort of perspicuity. A perspicuous representation produces just that understanding which consists in 'seeing connections.' Hence the importance of finding and inventing *intermediate cases*." [20]

Wittgenstein's concern with intermediate cases is related to his antiessentialist themes. He impugns the traditional philosophical search for essences as hopeless, replacing that search with a conception of things as being known and defined by the families of complex, related roles they play in the web of our language games and form of life. Philosophers of art have often stressed this Wittgensteinian perspective in approaching art. They have been captivated by the notion that there exist at most only strands of similarities or family resemblances between the various objects we call works of art. I myself hold such a bias about music (and about painting and sculpture and the arts generally). My own view is that there exists no non-normative, non-question-begging way to establish once and for all which features of musical (or artistic) works are essential and which are not. There is no essence to music; rather, there is a family of related things we call *music* and a family of related ways of treating such objects in terms of which we call them that. Nor is there any way to settle similarly the question of which objects are music and which are not.[21]

The recognition that within and between music communities listeners irrevocably diverge in mind and ear can engender the disturbing thought that there is nothing to prevent such irresolvable divergences from extending to the core of music—to the core of what we claim to know and feel music is. It is this thought, that there is nothing solid to our concepts of music, that is occasioned by both Cagean skepticism and the antiessentialist

position of Wittgenstein. Indeed, Michael Dummett and others have ascribed to Wittgenstein a kind of radical conventionalist position tailor-made to substantiate this doubt.[22] On their reading of Wittgenstein our concepts are radically arbitrary in the sense of resting on nothing further than convention (as opposed to nature, necessity, or some other fact or modality). Since neither nature nor necessity backs up our ears, there is nothing in principle to prevent us from radically disagreeing about the basic facts and criteria of music or of radically altering our concepts—or our mind's ear— if we want to. Cagean utopian skepticism is a legitimate possibility, to be accepted or refused simply on the basis of its desirability. We can do nothing further to prove or otherwise establish the legitimacy of our styles of hearing and our musical concepts.

III

A theme running through the preceding chapters shows that the utopian aim of turning an artwork into an exemplar (or planning agent) of utopian possibilities requires a detailed conception of utopia. Theory is used experimentally by the avant-garde in a fashion similar to its experimentation with new media and materials. Theory is the avant-garde's way of attaining some imaginative perspective on utopia. Mondrian believes he needs no such imaginative perspective; for him, utopia will follow from the abstract laws of harmony like a grand cadential formula. And so Mondrian does not engage in the continuous theoretical shifts one finds in Moholy. Cage's shifts in voice, tenor, and degree of radicalism, his art of theoretical and artistic disturbance make it clear that he, too, understands the needs and difficulties of imagining his ideal state of totally structureless hearing. Yet his radically skeptical voice belies what the shifts in his montage of other voices exhibits. And it is this voice with which we are now concerned.

In order for a skeptical claim such as Cage's to be coherent, he must— and we must—be able to imagine or convincingly elaborate a context in which people enough like ourselves to be coherently called people at all might actually live that skepticism.[23] To see this, a brief excursus into the more Kantian critical reading of Wittgenstein—my preference over Dummett's conventional reading—is in order. Wittgenstein says that our concepts and language inextricably depend on what he refers to as our form of life (an elusive but crucial notion) and that our form of life is not merely conventional; he links our form of life to what he calls "facts of nature" and these to what he calls our "natural history" (*PI,* pt. 2, p. 230). Our natural

history is not independent of convention since everything from our language to our social life is part of that history, yet it also outruns mere convention, involving everything from our biology and psychology to our environment. Our form of life is the web of our attitudes, beliefs, desires, interests, behavior, reactions, and practices. The notion is an organicist one, a way of getting us to see that we cannot ultimately pry apart how we conceptualize and mean a language from how we are disposed to feel and respond—and these from our physical and psychic needs as well as from how we are socialized, civilized, and otherwise trained into a community. Our form of life is what Wittgenstein would call "bedrock." As Stanley Cavell remarks: "Nothing insures that . . . we will make, and understand the same projections. . . . [other than] all the whirl of organism Wittgenstein calls 'forms of life.' Human speech and activity, sanity and community, rest on nothing more, but nothing less, than this." [24]

Whatever resources one can muster in addressing skepticism are, for Wittgenstein, to be marshaled through appeal to our form of life. The tenor of Wittgenstein's appeal has to do with his claim that language is only meaningful against the background of a form of life which the words are somehow about and in which they play a role. He states, "And to imagine a language means to imagine a form of life." (*PI*, pt. 1, no. 19). The words "I am in pain" or "slab" are comprehensible to us only if we can imagine a context in which certain beings with certain conceptual and emotional resources employ them for certain ends in certain practices. Just how much of the context must be seen or imagined in order to find the words comprehensible is unclear and probably as debatable as the notion of comprehensibility itself, but if little or nothing of context is gleaned by the speaker, then the words will mean little to that speaker, and if we cannot similarly glean the relevant contextual factors, the words will strike us as intellectually defective, pointless, or incoherent.

For Cage's claim that our ears ought to project neither structure nor anthropomorphic qualities into sound to be comprehensible to us, we must be able to imagine in sufficiently robust detail what it would be for a person to live with ears like that. Cage has of course invited such a context, but in order to pursue his skeptical doubts we need to have a reason to believe that beings sufficiently like ourselves to be called *persons* could hear sound transcendentally (and with what degree of likeliness if they could), which means we need to understand what such perception would be like.

Cage's claim seems hard enough to imagine, but one might worry about how much our powers of imagination really tell us about anything. History

is replete with examples of things that no one seemed to be able to imagine yet which happened, hence were clearly human possibilities—possibilities for beings we call *persons* (if not for every person at every time). Hence it might be thought that what we can or cannot imagine proves nothing about what people can and cannot do.[25] In fact, what we can or cannot imagine fails to *prove* anything about what is or is not possible, if what we demand of proof is self-evident certainty. We can never, once and for all, prove that our inability to coherently represent to ourselves a human possibility is not our current lack—something others might later correct. Neither Cagean nor any other radicalism can be, in this Cartesian sense, disproved. Therefore we cannot expect to know with the crystalline necessity deriving from Cartesian proof that our concepts of music must be true (any more than we can expect our works of art to conform to Cartesian requirements of structural transparency). However, it was Wittgenstein's aim to show us that the absence of a proof to insure the infallibility of our appeals to the imagination does not warrant that we always have cause to doubt our powers of imagination. This would be, in Wittgenstein's example, like the person who always doubted "before he opened his front door whether an abyss did not yawn behind it" (*PI,* pt. 1, no. 84). Just because one cannot prove before opening the door that there is no abyss outside, this does not justify a genuine doubt that there may be one (unless one has a special reason to think so—there is construction going on outside, or war, or the building is dilapidated). The telling questions with respect to skeptical doubt such as Cage's are, first, the degree of conviction with which we can show that the doubt cannot be coherently rendered as an imaginative possibility, and second, whether we have some special reason to distrust our appeal to the imagination in the specific case. Put the other way, concerning Cage, the question is of the degree of necessity or security with which we can be convinced that our claims to know our own ears are true.

The analogy between Cage and Saint Francis is helpful for determining what strength of argument one can marshal against Cagean skepticism. Certain monks (perhaps more radical than Saint Francis himself) desire (like Cage) total detachment from a kind of mind and desire. Like Cage, their strongest view of themselves is that through their acts of detachment they will become more fully people, or better people, not lesser. The question is how disengaged they can coherently become. These monks can obviously achieve partial disengagement from their ambitions, appetites, and worldly goals. What of utter, total detachment? One might suppose that one can perform the thought experiment of imagining a totally detached monk, but

when fleshed out, what one has imagined is never more than relative (if equally impressive) detachment. One imagines a man engaged in a difficult life task, whose relation to his worldly self is profound, alienated, worked out, deluded, or otherwise problematical. The monk's passions appear in dreams or nightmares, in unnoticed behavior or acknowledged struggles— in some way or other. Perhaps the most vivid representation of the monk's project is Dostoyevsky's: Father Zossima of *The Brothers Karamazov* lucidly acknowledges his flesh and demands that Alyosha do the same by forcing him out of the monastery and into the world. That Father Zossima is made of flesh is made clear to all by the extraordinary stench of his decomposing body (Dostoyevsky's metaphor for expressing the intuition that purity is inseparable from flesh).

The thought experiment of imagining a totally detached monk is one we do not know how to begin because it asks us to imagine a person who is not a person. The monk can be called a person only if he continues to embody our form of life with its broad contours of appetite, desire, reaction, and the rest. We are asked to represent a being whom we call a person yet who ceases to embody that web of life, and this we cannot do. Human detachment only makes sense as partial detachment. If a monk really wanted to cease to be a person, he would have to chose more radical techniques than life in a monastery (lobotomy or suicide).

Cage's project of disengaging the ear from its fixations of mind and desire is similarly problematical. Again, there is no question that partial detachment is possible. We can learn to attend less to the subtleties of musical form and expression and more to the washes of sound in music, just as we can try to hear a language we already know as a rhythm of noise. We can try to listen to works of music as purely natural objects. It is such plasticities of aural capacity which Cage has done more than any other twentieth-century composer to cultivate in arid and arrogant modernist ears. But what of total detachment?

Cage asks us to imagine hearing sound as neither structured nor expressive, and we need to imagine what that would be like. Perception is inherently structure imputing: the eye or ear descries surfaces, seeking coherent patterns. With Cage's proposal that perception cease to do this, we seem to lose all grip on the concept of perception. Clearly, we need Cage or somebody to give flesh to the concept of nonstructural perception, to get us to see what it would be like. As an invitation for us to imagine what it would be like, Cage provides examples of partially destructuralized perceptual states as metaphors for total loss of structure, and further suggests that

such states, if intensified or generalized would lead to totally nonstructural hearing.

One such example is this: Cage does say that perception of sound should consist in attention to the structure of individual sounds (to their duration, loudness, etc.). Sounds should be presented as merely happening—as sounds unrelated to any other sound except by spatiotemporal location. This proposal preserves a minimal notion of perception as imputing some properties to sound while avoiding any notion of perception as imputing structural relations to sounds. The proposal, gleaned from meditation, works in those instances where sounds come discretely. But in general, sound arrives in continuous groups which we must parse into individual sound units on the basis of larger structural principles of phrasing, phonology, music. One cannot imagine how sounds could be otherwise parsed, except by artificial stipulation. It is because Cage knows this that he creates artificial forms for his works to provide us with a kind of parsing which we need not take seriously. But underneath such artificial forms the ear is still beholden to its natural and naturalized principles of parsing. Perception is hard-wired to do this and its hard-wiring is educated through culture and habit.

Another example is this: One imagines a kind of intrauterine acoustical environment in which sounds are absorbed in a fluid, unparsed way. This dream of ourselves in such a state of ambience is beautiful. But it is also a dream in which parsing of sounds still occurs in a more toned down way. When we dream ourselves in altered states we must somehow hold onto the thread of ourselves. An actual invitation through dream or drug to a totally unparsed, uninterpreted acoustical environment would be an invitation to the terror of madness in which that thread of self were lost—not to the beauty of relaxed and unusual perception.

Indeed, if consistently applied, Cage's proposal would invite the further terror of nearly complete dislocation from the ordinary, for not only would music be destructuralized, but with it, noise and nonmusic generally. Not only would Bach, Beethoven, and what we hear in concert halls be destructualized but also the sounds of bird calls, rush-hour New York, and indeed, the phonological structure and resonances defining the speaking human voice. After all, the nonmusical is also typically perceived as musically structured as well. We hear bird calls and human voices as phrased, rush-hour New York as contrapuntal, airplanes as Wagnerian in musical line. Such perceptions do not only occur at those moments when things which are not music ring beautiful, such perceptions are the norm. These things

simply lack the overall coherence or compositional hand of a Bach, Beethoven, or a folk tune. Yet the fabric of such noises and other nonmusical events is a key to our sense that the world is comprehensible and familiar, recognizable and a place to live. Indeed, our human attachments to the world and to others are deeply intertwined with sense of sound. Those who are deaf find other routes for cultivating such interconnections. Those of us who can hear and have developed these cannot easily fathom their unraveling. Yet to imagine the loss of this aural fabric, not through deafness but simply through ceasing to project structure and inflection onto it, is to imagine not the loss of a capacity to hear what one knows the world sounds like, rather, it is to invite a loss of the inscription of people and of the world in oneself in terms of which the world and others can be known and lived with—as if people and things are staring you in the face but are no longer recognizable. That is the condition of lobotomy.

Once pressed, each of Cage's suggestions for what totally nonstructural hearing might be like turns out to be incoherent (or the invitation to nothing less than psychological lobotomy). Conspiring to produce the illusion that we can imagine totally nonstructural perception are thoughts about a variety of unusual perceptual states, all of which turn out to be merely states of partially nonstructural hearing. Cage, like the monk, is asking us to imagine a person who is not a person, and this we cannot do. His is a collection of mirages. As a philosopher, Cage's contribution is to have raised certain skeptical questions, but these questions can be given a strong antiskeptical response. Cage's radicalism does not represent a coherent human possibility. Although we cannot, in a Cartesian sense, further prove with absolute certainty that our own inability to imagine Cagean radicalism as coherent entails that persons of some other place, time, and resources might not show us to have been wrong about what is imaginable, we have no reason whatever to actually take that prospect seriously. Cagean doubt can be—in a strong, if non-Cartesian, sense-disproven. Hence we know the capacities and possibilities of our ears. Our concepts of music must, in their general contours, be true, and it is a condition of rationality that we cannot fail to know this. We have no alternative to our form of life.[26]

IV

Cage's musical practice cannot succeed in transforming the world into the condition of completely natural hearing and by extension completely natural living, for this is unimaginable. What is paradoxical and amazing is that

Cage's musical experiments depend on this impossibility for the peculiarities of their power, and that in another of his voices Cage knows this. Like Duchamp's *Fountain* or Matta-Clarke's house split exactly down the middle, Cage's 4.33 is not merely a rhetorical instrument, it is an object, transfigured,[27] a modernist epiphany. His 4.33 is music destroyed and yet still strangely itself, an object constructed to be an intermediate case; it is too close to music to ignore that connection (through its employment of the form of our performance practices) and too far from music to ignore that connection either. We cannot similarly construct, even in the imagination, a kind of half person who is both like us and who embodies the Cagean perceptual position. Yet 4.33, once constructed, takes on the aura of being iconic precisely of that person we cannot imagine. Rhetorically it is meant to deliver us from our fixations on performance to the ordinary sounds of the ordinary world, but poetically it does nothing less than transfigure those ordinary sounds into the extraordinary. Its silence (lack of performed sounds) becomes a metaphor for destructuralizing the ordinary, for producing a hearing of bird calls that is more immediate than how we ordinarily hear. The work's delivery of compositional structure into the silent immediacy of the Cagean position becomes a mirror of us. We are the ones it seems to deliver. In it, performer and audience appear joined in silent, non-structural hearing as sound and silence seem to merge—call that the state of at-oneness with whatever. Such epiphany is no less enthralling and no less close to illusion than the idea that Tristan and Isolde become one in death.[28] It is this sense of transcendence (in this sphere of silent fantasy) which gives the art its power and makes the performance art.[29]

The irony in this is that 4.33 derives this power from its personification. Cage's complaint against ordinary music is that in it "things aren't so clear," that it is treated the way we treat a person, heard as a bearer of human feelings, impulses, and intent. But neither are things so clear about 4.33, for in claiming that it reaches out to us with its epiphanic character we are projecting a character onto it, treating it as a mirror of a person transfigured in a way we cannot understand. The work turns silence into an image of our form of life transfigured and aims to lead us or allows us to lead ourselves into that state of transfiguration. As such, its persona is unavoidably anthropomorphic because it is a delivering image of our form of life delivered. That Cage's art itself depends on personification is the exception proving the rule, or what Wittgenstein would refer to as the importance of intermediate cases for our concepts.

The Cage of his Zen voice, I think, knows this. In such a voice Cage no

more believes his radical vision can be imagined and fully embodied than the Zen master believes that one can answer the question of what the sound of one hand clapping is. The Zen master asks his question in full view of its incoherence. Is it, at best, a kind of problematical question, meant to throw the act of questioning and answering into relief. The disciple's frustrated attempts to formulate the sense in such a question are meant to lead him or her to let go of the need to take words as having sense and import. Such letting go need not depend on any belief that one can let go of everything. It is a peculiar kind of training (like meditation or riding a bicycle), cultivating a way of seeing. Call this the training of knowing how to act "at-one with whatever." In it belief and philosophy need play little role, because you are not being trained to believe anything but rather simply to let go of certain beliefs and attitudes. Thus the Buddhist Cage is not concerned to theorize about and articulate in detail the embodiment of a utopian position; this Cage is utopian at most in a gesture of striving.

Cage in his radical voice offers 4.33 as an image of utopian transcendence. But in his Zen voice, Cage offers 4.33 not as an image of transcendence but as a way of musically posing Zen questions in the context of Zen training. No skeptical philosophy need be taken up. On the contrary, such a special kind of training precisely aims to put a "full stop," to borrow another remark of Wittgenstein's, to the philosophy of music it cannot, in its other intention, help but raise. The person who asks for the answer to the sound of one hand clapping is the philosopher who resists the real meaning of silence—to stop thinking and let it be. She cannot stop asking about the meaning of what she hears, cannot stop taking what she hears as having meaning, cannot cease to impose structure and expression onto the sounds she hears. She is the person who hears 4.33 and still doesn't get it. She will cling to the pages of the score which the pianist turns as if to try to squeeze ordinary music out of them like orange juice. Needless to say, she will be forever disappointed. Cage's Zen artistry in 4.33 is to have invented a performance which flouts the possibility of being a musical piece, for there is nothing to squeeze out of its score. The score of 4.33, mere segmented time as such, is rendered as problematical as any Zen question so as to put a full stop to the urge to make sense of sound: one must make one's peace with it by giving something up. In this sense, 4.33 is meant to confound[30] the musican and the philosopher whom it also cannot help but elicit. It curtails philosophy rather than depending on a hopeless philosophy of sound.

It is worth noting that Cage's Zen practice only makes sense against the backdrop of our ordinary concepts and practices remaining in place. The

Zen question or Cagean assertion takes its intrigue from its ability to look like (be taken as) an ordinary question. Remove the ordinary question and the force of its extraordinary cousin would be deflated. In his more moderate voice Cage acknowledges this. "Actually when you drop something it's still with you, wouldn't you say? . . . Where would you drop something to get completely away? . . . Why do you not do as I do, letting go of each thought as if it were a void?"[31]

Cage is speaking of having "dropped" our musical practices. His acknowledgment that "it's still with you" casts his as a claim about, at best, partial detachment. We are never fully detached, so we must "let go" of each thought. This less than radical idea corresponding to his Zen practice is reflected in Cage's less than radical works. *Credo in U.S.* represents his way of coming to terms with our musical practices by "letting go" of the hold that classical music has on him. In that work he incorporates snatches of classical music into a larger framework of buzzers, prepared piano, and paint jars to be hit, thus diffusing its effect in a Rauschenberg collage. (He also does this through the wit in his writings, as when he says of Beethoven: "It's a shame that artists advertise. However Beethoven was not clumsy in his publicity. That's how he became known I believe.").[32] This is Cage in his more moderate as opposed to his more radical voice.[33]

As I said, this moderate voice gives us a way of taking Cage's words, including his radical words about forks, folk tunes, and the excellence of all sound neither theoretically nor even literally but rather as what Marjorie Perloff calls "intertextually,"[34] as a trumpet call to end all attachment to horn fifths, ninth symphonies, and Wagner tubas. Rather than relying on Cage's words to explain his music—specifically his 4.33—we should take the words as part of the new music itself, as their trumpet call. Cage makes music out of description and performance out of music, blurring the borders between the arts in a way central to his discipline of disengagement. His performed speech, for example, the Julliard lecture with its counterpoint and acute rhythmic organization, his effortless and kaleidoscopic montage of topics, his music incorporating prepared piano techniques, car horns, snatches from the classics, and slurps from Miso soup eaters are all gestures in which something is picked up and let go of in a free-floating whirl of bricolage. What is picked up and dropped in the Julliard lecture is the meanings of the words themselves, as if Cage is first saying: "Don't conflate music and people," and then inviting—requiring—one to drop those thoughts about the philosophy of music in favor of the experience of the sounds of the words themselves, all in the discipline of "letting go."

Cage blurs philosophy and art by turning his philosophical ideas into an art of performance, thus at once raising and dropping them. This practice aims to dissolve obsession and develop one's concentration. It aims to replace close attention to sound structure and expression by openness, focus, play, and detachment. Or, rather, it aims for a kind of noninterventionist and accepting attention to the play of sound differences from a detached position—"with your feet a little off the ground." (Transposed to the realm of people, Cage's attitude of noninterventionist attention to the differences between people is welcome in our multicultural, global world of difference.) The attitudes are difficult to achieve, as anyone who has tried knows. Openness to the play of sound (much less to differences between people) does not come easily in our high-strung and superdirected megalopolis of a world. Such (detached) openness is coordinate to the contentment and restoration to life that classical skepticism has, in its various ways, also preached, making Cage's aim of dropping philosophy itself philosophical without necessarily relying on the ideal skeptical position already discussed. (There is surely a question to be asked about why life is, in fact, more excellent the more one engages in this discipline).[35]

Taking the utopian goal of complete detachment to be incoherent: how far can we go? How far can Cage help us go? An alternative way to understand Cage's radical words in the context of his skeptical practice is, I said, as a call to test the ear, to awaken it in a certain direction. Cage is a modernist in the sense that he aims to stretch the limits of perception, to see just how far the ear can be weaned from its priciples of structuring sound and, correspondingly, how far people can be weaned in certain moods or moments of life and in life generally from their ordinary attitudes toward the things they hear. (In his goal of stretching the human sensorium, Cage's modernism is like Moholy-Nagy's experimentalist notion of extending our apparatuses in new directions.) There is no guarantee that people can change totally, nor need that possibility strike one as even coherent. Nevertheless, that people cannot totally alter does not mean they cannot change a lot.

It is this search to extend limits, to see just how far one can go, that makes Cage's work not only exciting but also a practice of philosophical relevance in its own right. Wittgenstein was keen to say that while our form of life does place certain general constraints on what it is possible to think, feel, and say, these limits often only emerge in the course of someone's sticking her neck out and trying to go too far—something he referred to as bumping your head up against the limits of the understanding (*PI*, pt. 1, no.

119). Granted the plasticity and variety of human life, there is always a question about how precisely and with what degree of confidence one can establish some putative limit on what human beings can do. Cagean practice, by representing a call for letting go, is philosophical. It makes us aware of how precise a limit there is to the human ear and to the person informing the ear. How far can we go? How far ought we to go?

V

In recent years Cage's utopianism has reemerged as a form of anarchism in global politics.[36] His noninterventionist ideas about hearing have become redefined as a way of making the world stop so that we can open ourselves as a body politic to the minds and desires of (each) other. What was formerly a concern with abolishment of the rule of musical structure and the expressive will of the composer is now a concern with abolishing political structure and the omnipotent wills of nations. Cage still identifies openness to the play of differences between sounds (or people) with noninterventionism. He still believes sounds or people are treated most humanely when they are nonjudgmentally allowed just to be themselves. In the sphere of politics this attitude leads Cage to a kind of utopian anarchism. Cage believes in a community of persons without laws, political structures, or impositions of authority, in which each will take the attitude of noninterventionist support with respect to the others—which means for him that each will respect the others. This attitude of respect and communion, Cage believes, is best articulated through the free play of silences. Cage is fond of quoting Thoreau, who said, "The best communion between men [let us say, people] happens in silence."

Cage's play among a variety of skeptical positions (held in various degrees) is still in place in this globalism, for he still identifies conceptual control with the obsessional imposition of omnipotent will (whether in the arena of sounds or of people and politics).[37] But he has extended his skeptical practice to the contemporary world. Its goal is a quiet, nonaggressive accommodation of the endless play of signs (or sounds or people) which comprise our global world, acceptance of the endless simultaneities of meaning and events in our global world—not in order to accept realpolitik or the revolting American megalopolis that looms from city to suburb, but rather to allow us a free and silent communal space in which we might discover in ourselves the capacity to resist such encroachments on nature and human difference and just be ourselves. Cage is emphatically no Mon-

drian; he is no adulator of the technological domination of nature. He prefers macrobiotic to macroeconomic plans for the modernization of the world and wild mushrooms to mushroom clouds (who doesn't?).

Then his anarchism is also a way of directing people to live in a certain way; it is not simply noninterventionist. As such, is is still a form of avant-garde praxis. Befitting his global concerns, Cage's mesostics and performance pieces tend to rely on texts of Thoreau, Buckminster Fuller, and Marshall McCluhan. Cage's *Lecture on the Weather,* an homage to America written for the American bicentennial, is a work in which twelve speaker-vocalists recite passages from Thoreau which have been subject to chance operations—all of this to the sounds of weather. It has an introduction worth quoting at length:

Even though the occasion for this piece is the bicentennial of the U.S.A., I have chosen to work again with the writings of Henry David Thoreau. . . . In 1968 I wrote as follows: "Reading Thoreau's *Journal* I discover any idea I've ever had worth its salt." In 1862 Emerson wrote: "No truer American existed than Thoreau. If he brought you yesterday a new proposition, he would bring you today another not less revolutionary." In 1929 Gandhi wrote that he had found the *Essay on Civil Disobedience* so convincing and truthful that as a young man in South Africa preparing to devote his life to the liberation of India he had felt the need to know more of Thoreau, and so had studied the other writings. In 1958 Martin Luther King Jr., wrote these words: "As I thought further I came to see that what we were really doing was withdrawing our economic support from the bus company. The bus company, being an external expression of the system, would naturally suffer, but the basic aim was to refuse to cooperate with evil. At this point I began to think about Thoreau's *Essay on Civil Disobedience . . .*"

I have wanted in this work to give another opportunity for us, whether of one nation or another, to examine again, as Thoreau continually did, ourselves, both as individuals and as members of society, and the world in which we live: whether it be Concord in Massachusetts or Discord in the World (as our nations apparently for their continuance, as though they were children playing, prefer to have it). . . .

It may seem to some that through the use of chance operations I run counter to the spirit of Thoreau (and '76, and revolution for that matter). The fifth paragraph of *Walden* speaks against blind obedience to a blundering oracle. However, chance operations are not mysterious sources of "the right answers." They are a means of locating a single one among a multiplicity of answers, and at the same time, of freeing the ego from its taste and memory, its concern for profit and power, of silencing the ego so that the rest of the world has a chance to enter into the ego's own experience whether that be outside or inside.

I have given this work the proportions of my "silent piece" which I wrote in 1952 though I was already thinking of it earlier. When I was twelve I wrote a speech called *Other People Think* which proposed silence on the part of the U.S.A. as preliminary to the solution of its Latin American problems. Even then our industrialists thought

of themselves as the owners of the world, of all of it, not just the part between Mexico and Canada. Now our government thinks of us also as the policemen of the world, no longer rich policemen, just poor ones, but nonetheless on the side of the Good and acting as though possessed of the Power.

The desire for the best and the most effective in connection with the highest profits and the greatest power led to the fall of nations before us: Rome, Britain, Hitler's Germany. Those were not chance operations. We would do well to give up the notion that we alone can keep the world in line, that only we can solve its problems.

More than anything else we need communion with everyone. Struggles for power have nothing to do with communion. Communion extends beyond borders: it is with one's enemies also. Thoreau said: "The best communion men have is in silence."

Our political structures no longer fit the circumstances of our lives. Outside the bankrupt cities we live in Megalopolis which has no geographical limits. Wilderness is global park. I dedicate this work to the U.S.A. that it may become just another part of the world, no more, no less.[38]

Can we trust silence as a political solution through its capacity to dissolve the restructuring impositions of power (call it the force of passive resistance)? communion as the replacement of verbal conversation by a conversation of the ears and of the feeling body in which mutual presence and mutual flow are what matters (call it a communion of nature between people or a communion of human natures)? Thoreau's words are naive and sophisticated, outrageous and deep. In a Thoreauvian manner, Cage, ever skeptical, stresses global complexity and global interconnectedness over global systematization and global domination. He stresses the indeterminacy of information over its determination, the interpenetration of events over their consistent unraveling and clear ranking, and acceptance over domination. The possibility of communion is for him contingent on our rejection of aggression and of all hierarchy. Is this wonderful and incisive or naive? Cage's return to Thoreau and his politics is, it seems, both.

Cage's connection to Thoreau also provides us with another way to understand his music: it is a body politic, the body and politics of a lecture on the weather whose message is the dissolution of lecturing in the service of a deeper communion. Emerson's praise of the Thoreau who produces a revolutionary idea a day, who continually restyles his ideas without shame, is praise that also pertains to Cage's music. To propose the new and repropose it after lunch (or a bicentennial later) is a defining feature of Cage's music. Then Cage, too, is to be praised as an American, and Cage's plethora of voices are to be understood not simply in terms of their placement on the map of the avant-garde but also on the map of that undefined sphere of

possibility and originality called America. His music reaches back to the roots of America, to its boisterous enthusiasms and polyphonous self-reflections, to its populism, pluralism, rejection of fences and of structures that fence you in, and to its acceptance of nobody and everybody. This is Cage uncaged. Cage's bicentennial silencing of American bigotry and grandiosity is his present to a completely boisterous America whose cacophonous rush-hour streets, Tamany Halls, redwood forests, and body electric ring with music. Charles Ives once sent two bands marching up the streets of his quiet Danbury in different directions playing different tunes to sent up his town but also as a Fourth of July present to it. Cage's Fourth of July present to us is to give us the occasion to be present to the idea of America, to everybody and everything simultaneously within the golden sphere of its silence.

Cage's place on the cultural map of America allies him with Charles Ives and his music in a still deeper way: both are concerned to exhibit simultaneity. Carl Schorske, in a recent set of lectures,[39] has stressed the element of simultaneity in Ives's music. In this regard, consider Ives's famous *Concord Sonata*.[40] Ives's sonata interweaves the four voices of its its four movements, "Emerson," "Hawthorne," "Alcotts," and "Thoreau," in such a way that one feels them to be simultaneously present American moods or attitudes, co-existing in a sublime and sublimely chaotic form of interpenetration, rather than following or sublating one another in the linear narrative manner of Beethoven or Mahler. There is a moment in the *Concord* Sonata's second movement, "Hawthorne," which exhibits Ives's musical mosaic especially clearly. "Hawthorne" begins in wild machinations of rhythm which move restlessly in a bricolage of song snatches across tonal regions (the dissonances in this music are too emancipated for any tonal key to be fully sustained). Suddenly, in the course of this movement, an enormous number of notes pile up and everything is arrested. The pianist is meant to hold the pedal down, so that a ringing of overtones is heard suspended in the ensuing silence. Before those overtones fade, a completely different music is heard, the quiet, harmonious music of "Alcotts." It is a music built from the sonata's core motif (the "da, da, da, *dum*" of Beethoven's Fifth Symphony), a music as simple as the novels of Louisa May Alcott herself and as poignant. As in a Russian film, the listener is unhinged by Ives's musical rupture or montage. The listener is suddenly transported into the music of a different sphere; he feels as if he has just entered a church, for Ives has designed this moment to feel organlike (Ives was for a number of years a church organist). The rupture is reinforced by the octave in which this new music is played:

one high up on the piano from its predecessor, suggesting by spatial trans-position an organ playing from high up in a church. Indeed Ives's effect is one of transportation or revelation. One is carried away from the noisy and disputatious streets of New York into a cathedral where the service has be-gun. One feels that the music of "Hawthorne" has suddenly revealed an unconscious spatial core of harmony and silence which lies underneath the frenetic wilderness of its textures.

Thus Ives's music seems to have regions of simultaneous existence which burst out from one another in concord and discord. The Alcotts' music sud-denly heard in "Hawthorne" is almost immediately buried, it is briefly brought forth again (for emphasis), and it finally disappears. Was it heard at all? Only in the third movement is its existence confirmed. In that move-ment, "Alcotts," the music has its day, or rather its placement, for one is made to feel that what one hears in "Alcotts" is not a sequential development of what has come before (required by the dictates of Wagnerian narrative or Beethoven's drama), but rather an elaboration of an already present region in the sonata (or sphere of life). What was unconscious, dormant, or unex-plored is now thematized. A continuous procedure of thematization oper-ates in the sonata. The strange whole-tone music heard at the end of "Haw-thorne" anticipates the regions of Debussy-like whole-tone scales and tone clusters in the sonata's final "Thoreau" movement, whose strange, near si-lences etherealize the listener as they give her peace. Despite these simul-taneities, the entire sonata maintains design, traveling from the strong di-rectionality and force of its first, most Beethoven-like movement, "Emerson," to an apotheosis of silence in the mists of a mountain top (or pond at the outskirts of town) which is, according to the sonata, Thoreau's domain.

The key is to understand that all of these movements and people (from Emerson to the Alcotts) are in concord (and in partial discord as one would expect of any conversation or set of moods), not simply in hierarchy or sequence. All represent aspects of the idea of a complete life and a com-pleted America.[41]

Cage would probably balk at Ives's Emersonian stresses. He is neither fond of Emerson—that is Cage's right—nor of Ives's element of male bond-ing with Emerson—about that Cage is surely right. Nevertheless, Ives's principle of musical simultaneity, of an interpenetrating pattern of musical voices, provides us with perhaps the most satisfying way to understand the mosaic of Cage's musical practice: as a mosaic. We have dealt with a number of Cage's voices. We have philosophically addressed his radical voice which

aims to make the conditions of life more excellent by totally destructualiz-
ing the way sounds are heard (and people are treated). We have understood
its practical, utopian call but have also described a more moderate voice
under which Cage's words can be taken as prescribing a musical practice for
one's soul, a training of at-oneness. We have seen that this voice has both a
Zen dimension and a philosophical aspect, concerned with the testing of
limits and a utopian politics of anarchism. We now have yet another way to
take Cage's arrangement of voices, namely, as a mosaic in concord.[42]

Cage's radical and moderate voices are a body politic, an Ivesian sonata
of moods in concord with one another. His goal is to institute the discipline
of peaceful flow between life's plethora of conversations and moods. Cage's
goal is to harmonize life's voices, to move between church and street, be-
tween at-oneness and discrimination, between chance and determination,
between the ineluctable dictates of mind and desire and the attempt to des-
tructuralize these. This he himself does magnificently, and he is, in this
sense, the exemplar of his art practices. His is performance art, with the
performance being how to live in and out of the space of creating art. When
he is gathering mushrooms, he does not rely on chance operations. When
he hears the sounds of screaming children in air raids, he does not try to
obliterate his mind and desire or his compulsion to help or his revulsion at
what has happened. He does not try (at least at the time) to be disengaged
from *this*. Similarly, when we hear the roars of ferocious lions on the radio,
we may listen to their excellence, but not when the lion is running at full
throttle toward our bodies. Then we are in a different mood of life's mosaic
and we do not stop to listen: we run or shoot or climb a tree. Life has its
exigencies. Both Emerson and Thoreau responded to these exigencies.
Though keen to extend the excellence of sound to the burgeoning life and
land of America, both were emphatic about the kinds of sounds they be-
lieved to be less than excellent—sounds of grimy factories, fusty moralists,
and quiet desperation. In the voice of interaction with the world, quiet des-
peration should be heard with Thoreau's indignant ears, not with Cage's at-
oneness.

But suddenly, as in the second movement of the *Concord* Sonata, we are
arrested, we stop. There is a moment of montage, and divine silence reigns.
In this new voice we notice that the sounds of rush hour New York sing
beautifully, that there are mushrooms growing in our fields, that the eleva-
tors in your building ring on their cables.[43] We are in moksha, in the space
of enlightenment.[44] This voice is interwoven with the tissue of life but sus-
pends it. Nevertheless it is part of life's mosaic, and to think that it could

subsume the rest of life is an illusion. Emerson will also have his day and Cage knows this.

Yet even within the space of the Cagean mosaic there are hierarchies and questions of illusion. For both Hindu philosophy and Cage, moksha is the highest state of enlightenment.[45] The Indian discipline of meditation and the Cagean discipline of music are meant to enlarge one's capacity for it. One can debate about the value of that master narrative called "the path to enlightenment," whether the geographical location of enlightenment is in Tibet or on West Eighteenth Street in New York. Moksha is not simply enlightenment but also liberation from the dictates of all of the other voices, moods, things, and attachments comprising life. Its form is not simply a brief moment of joyful oneness, a sort of empathy with everything, but the sense that everything to which one is attached is nothing. Is that a philosophical belief or simply the heightened illusion of feeling? Like 4.33, in this four minutes, thirty three seconds or lifetime of moksha, the power of its art seems to reside in the feeling or belief that everything has been transformed and transcended. If you turn that moment of illusion into a theory, you get Cage's radical philosophy or its Indian avatar, the philosophy of Sankara.[46]

On the Indian front, the philosophical belief in moksha was sorely tested in a famous interchange between Sankara (the great Indian philosopher of moksha) and the king. After hearing Sankara's news that everything is an illusion, the king set a tiger upon Sankara, who ran up a tree with great alacrity. When asked how much of an illusion that tiger was, Sankara responded (with admirable consistency) that the illusory "he" had just been set upon by an illusory "tiger." Whose illusion is that? Moksha, in short, is a state in which something close to Cagean skeptical belief, or at any rate illusion, is still operating, even if, from the perspective of another voice in this mosaic of moods, the beliefs held in the state of moksha (about tigers being illusions or all sounds being the same) are themselves fabrications. As in the case of constructivism, whether illusion is ever justified, whether we should ever take the Nietzschean side, is a complex question. Our place here is to note its role in the philosophy and in the art.

Ironically, if we take 4.33 to be a piece of transcendence into the Cagean skeptical position—the position of moksha—the metaphor depends on the incoherence of its radical philosophy. What we submit to when we are captured by the Cagean epiphany of moksha is the sense that we are being incomprehensibly detached from our modes of perception and restored to the totally ordinary, which is now transfigured to the totally extraordinary.

To believe in the power of Cage's metaphor is to take his work seriously as art, and perhaps seriously entertaining the philosophy behind the metaphor is part of that act of submission. But actually to believe his extreme skeptical theory is to submit not to art but to illusion (the illusion that the tiger is an illusion). That the world can even appear extraordinary is possible only because the obvious is secure.

But Cage's philosophical theory is itself blurred with the rest of his art in the service of ringing changes in life and making it start fresh. Starting fresh is going nowhere new; it is rather a matter of staying in the same place "with your feet a little off the ground." Cage's bricolage of theory, writing, poetry, and music is meant to restore us, in a complex and textured practice, to that slightly dizzying but very human place, the place from which a new body politic will blossom in polyphonous silence.

Itself polyphonous in its silences, 4.33 both is and is not a work guided by his utopian philosophical theory, just as it both is and is not music. In one voice it is structured by Cage's philosophical skepticism. In another voice it puts a full stop to the mind and voice of the philosopher by being a gesture that is as close to the sound of one hand clapping as one can get. Looking back on it from the perspective of Cage's later work, one sees that it is among the best communions between men, let us say between people, there is.

Part 2 / The Legacy of the Avant-Garde

6/ Reading Arthur Danto's Theory

"Art?" Warhol once asked in response to the inevitable question, "Isn't that a man's name?"

Arthur Danto

A main cause of philosophical disease—a one-sided diet: one nourishes one's thinking with only one kind of example.

Ludwig Wittgenstein

My studies of Constructivism, Mondrian, and John Cage have meant to prepare the topic of the second half of this book, namely, an engagement with the theoretical mentality that is our inheritance. Since Arthur Danto's philosophy of art and philosophical reading of the avant-garde is the clearest example of this inherited mentality, much of what follows will be an engagement with his ideas. Recall that Danto's reading of the avant-garde presumes it to be in the same business he is in: the business of making a philosophical discovery about the true nature of art. He claims to ride the cusp of art history by completing (articulating) its philosophical shape, thus liberating it into a pop utopian pluralistic space of free and unbridled creativity. The idea that art history has a shape is already a belief Danto shares with the avant-garde. The deeper assumptions Danto holds in common with the avant-garde, assumptions powerful enough to define the mentality which I have called avant-garde, are the two with which I opened the pages of this book: the assumption that theory defines art, and the commitment to find a radical art example (in avant-garde art itself) which will perfectly reveal the philosophical structure of art.

This is the time to bring out in detail the avant-garde character of Danto's thinking. It is also the time to subject Danto's assumptions to the same kind of intense scrutiny to which we have subjected the avant-garde's own assumptions about itself. My studies have developed strategies for reading the avant-garde art example; I have probed the question of how far the voice of philosophical theory goes in constructivism, Mondrian, and John Cage. The results of these studies will be of similar service in testing the truth of Dan-

to's claim that art is prefigured (defined) by theory—assuming Danto means by "theory" what the avant-garde means by it.

We are now ready to set up a conversation between the avant-garde and Danto about who means what by "theory." Both Danto and Gabo believe art is defined by theory, but does Danto mean the same thing by theory as Gabo? If not, then what is Danto's notion of theory, and how is it meant to intersect with the avant-garde's own notion(s) of it? Moreover, the avant-garde believes itself to be defined by its own theory, yet what makes its objects art is partly a matter of the way those objects resist the rule of their prefiguring theories. Indeed, the theory is itself part of the experimental game played by the avant-garde, part of its mode of praxis, part of its rhetoric of bringing about the new. What game does Danto play out over the topic of theoretical self-discovery? What are its reasons, its goals, and its utopian aspects? And what countervoices do we find in his philosophy of art?

Having ascertained what Danto means by the concept of theory, we must test the concept to see if it is true. Using Danto as an example, I will suggest that no single discourse should presume to account for any single (much less the entire domain of) artistic practice. This is because art is defined through the organic interplay or marriage of various factors. Throughout art history myriads of factors have, in varying degrees, entered into the construction and construal of art—from scientific knowledge to religious feeling and knowledge of religious iconography, from the capacity of the viewer's body to find and feel an orientation in the context of a painting to the artist's internalized sense of color, to the character of our emotional responses generally. To call these factors all theoretical makes the notion of theory too opaque and too general. In fact, Danto's own internal resistance to the monolithic rule of theory in art derives from his vacillations over how strong a concept of theory he subscribes to. Danto's account fluctuates between a strong notion of theory and a notion so weak as to be uncontroversial. On any reasonably strong notion of a theory, however, theory matters far more for some works than for others. (The high dosage of theory required to make Cage or constructivism comprehensible is unique to modernism.)

In brief, the plan of this and the following chapters is as follows. I will first provide a critical and extended discussion of Danto's notion, or rather, notions, of theory. This, along with a discussion of how his philosophy is avant-garde in mentality, occupies most of this chapter. In the following chapter, I will continue to probe Danto's philosophy, turning to more spe-

cific questions about his reading of the avant-garde. After that, I will discuss Danto's reading, in my view a brilliantly avant-garde misreading, of Warhol. Since Warhol is himself a part of the fractured legacy of the avant-garde that is our inheritance, the discussion of Warhol will allow us to understand one strand in the avant-garde's fractured legacy, a strand which replaces theory by indecisiveness, complacency, and play. The discussion of Danto and of Warhol will, in turn, set the stage for a discussion of modernist styles of thinking about contemporary culture and their role in the construction of the idea of the postmodern. That discussion will take place in the final chapter of this book.

I then wish to discuss Danto not simply because he is among the most sparkling of philosophers today but also because his style of thinking is a uniquely lucid inheritance of the theoretical mentality which is my topic.

I

My readings of the avant-garde have prepared the discussion of why Arthur Danto's claims are both insightful and problematic. Danto's claims are articulated on the basis of his own involvement over many years in the history of the New York school—as philosopher, critic, and early on, as painter. His claims are developed in immediate, intense response to the work of Andy Warhol and to modernism in general. We now have at hand a set of readings on the role of theory in twentieth-century art. Our studies of the avant-garde have shown how deeply avant-garde art is permeated by philosophical theory. Constructivism, Mondrian, and John Cage have felt the need to write their way into existence, as if without their announcements, pronouncements, discourses, digressions, disquisitions, tirades, testaments, prophesies, philosophies, stories, and theories, their art lacks identity. Constructivism is created simultaneously in the metal workshop and in the pages of *LEF*. De Stijl is brought into being through the paint brush and through the pages of *De Stijl*. John Cage sounds his musical "silences" along with the silences of his book, *Silence*. Words are part of the identity of the avant-garde, part of what makes it the thing it is.

But if my studies have shown how deeply the voice of philosophical theory runs in constructivism, Mondrian, and Cage, they have also traced the limits of that voice. Avant-garde art is a complex of many voices, some of which are neither theoretical nor philosophical but are, rather, rhetorical, poetic, Zen-like, or of the currency of the spiritual silence in paint itself. My

readings are meant to place Danto's claims about the theoretical voice in art as important but incomplete, for what makes avant-garde works the works they are is their overall mosaic of voices, some theoretical and philosophical, some emphatically not.

Nor is the theoretical voice any more essential to making an avant-garde artwork what it is than some other aspect of it, say, its expressive character, formal sensitivity, spirituality, politics, or inventiveness. What the cases of, for example, Mondrian and Moholy-Nagy exhibit, rather, is the crucial element of relationship between the theoretical voice and the authority of the eye in comprising a painting. It is only because Mondrian's Platonist theory is structurally similar to the balanced feel of his paintings—a visual feel that some person who might be incapable of understanding the details of Mondrian's theory could easily get from a Mondrian—that we can call his product painting and not simply theory plastered by fiat onto a surface. One can plaster theory anywhere one wants, but then what real difference is there between a painting and a book? Danto seems to believe that twentieth-century art has abolished that very distinction, that there is no difference worthy of note between reading a platonic dialogue and interpreting a Mondrian. With an audacity worthy of any avant-garde artist, he says of the famous Picasso/Braque collaboration: "For a time, neither of them even signed their works—one does not sign a theory." [1]

I am not sure whether one signs a theory or not (Einstein had no problem doing so). [2] In any event, my reading of Mondrian (who, it is worth noting, agrees with Danto's view of Picasso as a theorist) suggests that the difference between a Mondrian text and a Mondrian painting is, indeed, porous. Mondrian's theories are not mere theories, they are ingestions of philosophy turned into a spiritualistic practice through contact with theosophy at the service of utopia. Then the avant-garde exhibits no clear philosophical fact to the effect that its art is defined by its theory. It exhibits, rather, the problematic nature of the distinction between art, theory, and philosophy to begin with. The avant-garde shows how diffuse philosophy becomes when it enters into an artwork, and how diffusely conceptual the artwork itself becomes on account of the transaction.

Mondrian is, in a profound way, an heir to Plato who aims to embody philosophical truth in his paintings. He aims to shift the site of knowledge to the realm of the visual world. One cannot, I claim, understand how Mondrian achieves that shift which embodies (he thinks) philosophy in painting without taking cognizance of the visual elements of Mondrian's paintings which, in one voice, resist all signification. His theory by itself cannot suc-

ceed in structuring his paintings without bearing an affinity to the already present visual features of the paintings. Both must be worked in tandem and exist in correspondence. Moholy-Nagy's theories are themselves part of his utopian practice; the contradictions between his theoretical stances parallel the shifting perspectives found in his photograms. Theory does not have authority to radically rupture our ordinary patterns of vision; that would render them incoherent. Rather, it has the power to place them in the context of another perspective on reality. If someone tells you that what you are really seeing when you look at a chair is electrons in motion, you will think him mad until he tells you that he does not really mean you are seeing motion the way you see the chair move when someone rocks it or when it shakes during an earthquake. Rather, what he means is that you can understand, in virtue of a complex pattern of observation and theory called modern physics, that there is another way to see/understand/observe under special conditions what you ordinarily see. Theory listens to the rule of the visual just as the eyes listen to the rule of theory. That is, neither rules, no one wears the pants (thank god), or both parties do. In those cases in which the evidence from ordinary vision (about the expressive character of a painting, or its frissons of surface) fails to accord with the semantic claims about the picture made by the artist (or anyone else), we must begin to doubt whether we should accept the theory at all. This fact is what makes Mondrian's paintings problematical signifiers.

I am not denying that theory is an essential (defining) element of the avant-garde; my readings have, I certainly hope, shown that to be true. One cannot understand the avant-garde without understanding its practices, which require a turn to theory. But if Danto means by a theory what I have been meaning by it in my discussions of the avant-garde, theory cannot be a more essential ingredient of pictorial meaning than the evidence of perception, even for the avant-garde.

The argument derived from my readings, then, is that theory is one of a number of factors which jointly and in relationship conspire to define the art of the avant-garde. Theory cannot by itself be the essential definiens of avant-garde art. And since avant-garde art is surely as theoretical as most other art (in my view, more theoretical than most other art), it follows that none of the paintings of Murillo, Raphael, Van Dyke, and Giotto, the engravings of Dürer and prints of Hiroshige, the illuminated manuscripts in the collection of Jean Duc de Berry, the sculptures of West Africa, of Rodin, or Tony Smith, are essentially defined by theory alone or theory primarily.

II

Why does Danto, who is one of the most ebullient, sensitive, and clever readers of painting at work today, fail to take into consideration the crucial element of relationship between visual, emotional, cultural, and theoretical factors in jointly defining the identity and meaning of a painting? And why does he fail to note that theory, like iconography, has contexts in which it applies to the art object and contexts in which it is resisted by the art object? Perhaps he means something more abstract and less explicit by a theory than anything presented in an avant-garde pronouncement or manifesto. And this is just the problem. It is very hard to pin down exactly what Danto does mean by theory. He appears to have various notions in mind, some derived from philosophy—specifically from the philosophy of science and from Hegel—and others from art criticism and the theory of interpretation. His writing tends to slide from one notion to the next. It is therefore worthwhile to elucidate the kinds of notions Danto seems to have in mind both as a way of understanding him and because, in art, philosophy, literary criticism, and cultural studies, various notions of theory abound. These various notions need to be pried apart for any kind of perspicuous picture of art—especially contemporary art—to emerge. Since Danto's richness as a philosopher consists in his systematic interweaving of recent trends in Anglo-American philosophy with the frenetic currents of the contemporary art scene, discussion of Danto's notions of theory ought to help in the unraveling of contemporary art's theoretical reliances.

Consider various things Danto might mean by theory which do not accord with the avant-garde's own notion of theory. First, see how closely he connects the idea of theory with the idea of an interpretation held by the art world. Let us move away from the avant-garde's own theorizing for the moment to the flip side of art, to the scene of reception, in which a viewer must make a modernist work comprehensible to herself and perhaps also to others. Think about the modernist predicament of viewing, in which the putative art object as encountered feels out of sync with one's concepts of and expectations about what art is, as if one needs an explanation, a theory, or a conceptual shift in order to square the difference—in order to raise the visual features of the object to the status of art or to revise the concept of art to include the object. Modern art's exploration of new media, new forms of design, and found objects of every variety assaults the viewer's imagination to the brink of incomprehensibility. She is then required to bring the art object back from the brink of the incomprehensible, to accommodate it to

her eyes or stretch her eyes to accommodate it. Theory often helps crucially in this project of accommodation. Of course, theory can also lead in the wrong direction. If one can make the mistake of interpreting rifles, museum walls, and banana peels into existence as art, then it can easily look to one as if it is the interpretation, not the thing looked at, that makes the difference. I might have left the gallery basking in the glory of my fabricated theory about the banana peel's arthood—about its nostalgia for Duchamp, about its confrontation with American jingoism, the Monroe doctrine, and Latin American post-Colonialism, about the peel's relations to nature, to the discarded object, and to waste in cities, to trash and trashiness, to cannibalism in politics, and sexuality, and above all, about its uniquely apt mode of reintroducing questions of taste into art at this late date in the twentieth century. Wasn't it nice to think of all of that in one bite—nice until I slipped on the banana peel, and it ended up making a fool out of me. My words about the rifle are equally rife with misrepresentations as I blast my way into the description of its shotgun effect on the art world, its references to the world-historical acids of El Lissitzky, and its celebration of the connections between American cowboys and young painters from Cal Art. The point is that such slipups at the scene of interpretation can simply reinforce the thought that theory is what empowers objects with the status of art. They can appear to reflect what happens when interpretation goes right, when words produced find their home in the object and give it life and breath— life and breath as art, that is. The example of Warhol's *Brillo Boxes* is for Danto paradigmatic of this interpretive situation in which words baptize an object, giving it arthood. It is only a background interpretive theory supplied by the artworld which makes walls into art or marks on paper into painting or Brillo boxes into *Brillo Boxes*.

But a Mondrian abstraction is not like a banana. Mondrian the artist has his own interpretive theory about what his paintings mean. My question in the chapter on Mondrian was how much we should let Mondrian's own interpretation of his paintings be the arbiter of what they mean. The answer was, beyond a certain point, indecisive. My interpretive theory about Mondrian's paintings (was mine a theory, or simply a reading, and what is the difference?) took as its starting point both Mondrian's theory and his paintings. So if mine is an example of an interpretive theory by Danto's lights, then the interpretive theory which defines Mondrian's paintings ought to be connected to his own theory of his art (although it need not and, in this case, should not be the same).

By taking Danto's reading of Warhol as an example of an interpretive

theory, one gets the impression that Danto's notion of theory and (if Danto is right) Warhol's are the same. Of course it is Danto's word we are taking here about what Warhol implicitly believed; we have as yet seen none of Warhol's words, nor does Danto quote very many. Even a minimal overview of Warhol's unique form of verbal nondiscourse, will make things look very different.[3] Danto attributes Warhol's theory to Warhol in implicit form; he believes Warhol the incipient genius designed his *Brillo Boxes* with this theory implicitly in mind. Warhol's *Brillo Boxes*, according to the theory made explicit by Danto, showed the defining role of theory to be a universal truth about all art, not simply a truth about the avant-garde (i.e., about Warhol). Danto believes Warhol and company have simply shown about all art what is implicitly thematized by theirs: that it is a theory which makes a Rembrandt a Rembrandt, a Dürer a Dürer, or Brillo boxes *Brillo Boxes*. In the absence of a theory, a Rembrandt is nothing but pigmented marks in oil on scratchy cotton fiber. It is a theory which makes the Rembrandt into art. In Danto's own words,

The question before us, accordingly, is what connection there is between the artwork . . . and the common material correlate [i.e. oil on canvas]. . . . It obviously involves something I shall term "interpretation," and it is my view that whatever appreciation may come to, it must in some sense be a function of interpretation. That in a way is not very different from the slogan in the philosophy of science that there are no observations without theories; so in the philosophy of art there is no appreciation without interpretation. Interpretation consists in determining the relationship between a work of art and its material counterpart. But since nothing like this is involved with mere objects, aesthetic response to works of art presupposes a cognitive process that response to those mere things does not."[4]

Assuming for the moment the truth of what Warhol showed, what theory is it which in general makes the artwork into an artwork from a mere thing, and how does it relate to the artist's own explicit theorizing? In Warhol's case, it is the philosophical theory Warhol implicitly holds which defines his art (with Danto out front in the avant-garde interpreter's position). Again, Warhol never explicitly stated this theory to the public, nor is it clear he explicitly formulated it, even to himself. Returning from Warhol to Gabo and Mondrian, what theory defines their work in Danto's lights?

If Danto means by theory what Gabo, Mondrian, and Cage mean by it, then Danto must be wrong, for the theories of Gabo and company define their art only in relation to a host of visual factors. And in certain moods, none of these artists even thinks their theories define their art. Then what kind of theory does inherently define avant-garde art, and how does this

theory relate to the avant-garde's own notion of theory? Evidently Danto's notion of theory is much more basic and much less obvious than the avant-garde's. For in the preceding chapters of this book, theory has been thought of as separate enough from painting that (1) we know enough whether a Mondrian is a painting (a work of art) independent of Mondrian's theories, and (2) there is a question to be raised about the role of the theory in making the art what it is. On Danto's notion of a theory (interpretation), there is no nontheoretical access to the painting as a painting; it is the interpretation which tells us that the Mondrian is a painting. Theory enters the interpretative scene at its inception, at the place where artworks are identified as artworks. Theory, in Danto's elliptical utterance, supplies the "is of artistic identification." [5] One's eyes are never enough to turn ordinary things into artworks.

Then we have the rather odd situation in which few of the theories which artists have explicitly offered in defense of their work are really the defining theories of their work. The theory which does the defining artistic work is more basic. Theory, like the grammar of a language, is largely implicit. The making explicit of theory is largely the task of the interpreter. The interpreter, like the linguist, makes explicit what the artist typically holds only implicitly, unconsciously, or in inchoate form.

Taking myself as an example of such an interpreter, my readings of constructivism, Mondrian, and Cage are, by Danto's own lights, acts of theory from top to bottom. And the artists' explicit theories are, taking my own studies as a guide here, simply part of the data of interpretation, data which aren't definitive of the true theory behind the works. The key is that my readings, rather than the artists' own, supply the true theories (assuming my readings are correct); thus my readings are theories.

Are all readings of artworks, indeed, all responses to objects which identify those objects as artworks, then theoretical? If all interpretation is theory, it would appear so. From the moment at which I respond to and identify a Brancusi *Bird in Space* or a Michelangelo *Slave* as a sculpture, I am theorizing (interpreting). This is a rather odd thing to say, for from the moment I opened my eyes I felt that I was relating to the sculpture as a sculpture and not yet theorizing. I felt instinctively in tune with Brancusi's idealizing perfections and still points of balance of his *Bird in Space* in the same way that I am immediately and intuitively moved by water flowing evenly through fossils, by the chanting of mourners in evening prayers, or by a beautiful face. Then are those reactions on my part also theoretical? For it is on the basis of those reactions that I find myself speaking of the mourn-

ers and the water as "moving" and the Brancusi as "art." I do not yet find theory in my reactions or in my speech—not obviously, that is. Is it there implicitly, as it is implicitly in the artist's mind? Then how am I interpreting? I must be interpreting equally implicitly. (I could later call on philosophical theory to try to explain to myself some of my feel for the power in Brancusi or in Michelangelo, but that seems to happen later, after I have already become convinced that these works are art.) We need to unpack what kind of theory Danto's is which enters so implicitly into my art reactions at their inception, and what kinds of distinctions between artworks and ordinary things—"material correlates"—are drawn on by such theory when it so directly makes silk purses out of ordinary materials and ordinary ears.

Danto's idea of theory is a transposition to the domain of art of certain views held by philosophers about the nature of language. Specifically, Danto, who was a philosopher of science in the course of his journey from painting to its philosophy, is trading on the approach to language found in the writings of W. V. Quine (an approach later developed by Donald Davidson).[6] Indeed, as we shall see, the way Danto sets things up, Warhol comes off looking quite a bit like Quine, call him Quine cross-listed and cross-dressed in the world of the Factory.

Consider briefly Quine's views about linguistic interpretation. According to Quine, the key to the nature of linguistic meaning is to be found in issues arising from the interpretation of a distant tribe of people whose language is totally unfamiliar. This he calls radical interpretation. Radical interpretation, Quine believes, reveals the nature of all interpretation with dramatic clarity because it is interpretation from the roots. In the case of radical interpretation, all one has to go on are the sounds that members of the tribe utter in empirical circumstances, therefore an interpretation must be constructed from scratch. For an empiricist like Quine, construction from scratch means that the entire process of interpretation is revealed openly.

Quine's reason for setting up the approach to linguistic meaning in this radical form is to bring out what he believes are two central features of linguistic interpretation, underdetermination and holism. Underdetermination of meaning by empirical evidence is a matter of how the empirical evidence from the speech situation totally fails by itself to allow us to ascribe meanings to the words uttered. To get from the tribe's vocalizations in environmental context to language (like ours), we need more than raw empiricism, we need a theory. In Quine's famous example, a person from the tribe utters "Gavagai" while a rabbit runs by.[7] One assumes, not a bad assump-

tion, that the speaker is hurtling those words at the rabbit, that she is referring to him/her/it. But according to Quine, we have no immediately given license to assume that she means by *Gavagai* what we mean by *Rabbit*. She might mean by *Gavagai* the sum total of detached rabbit parts, the tail only, or the conglomerate rabbit-plus-the-tree-next-to-it. Empirical evidence alone is not sufficient for interpreting her words in one way as opposed to the other. (Indeed, we do not even know for sure if she uttered a full sentence or not. Does *Gavagai* mean "a rabbitish thing" or "there is a rabbitish thing" or "bring me that rabbitlike thing" or "bring me a slab—of that rabbitish thing" or "is that a rabbitish thing?" etc.) In order to attribute sameness of meaning between her word and ours or, conversely, to attribute a difference of meaning between her words and ours, we must attribute to her a large pattern of shared beliefs and shared meanings—beliefs about what objects are, about what animals are, what a life span is, how things taste and smell and look, about whether the rabbits are usually, in such circumstances, afraid or in heat or chasing a rolling nut or simply mechanical, as Descartes thought (as only a philosopher could think). Thus meaning is attributed holistically: a single belief or meaning depends for its attribution on a complex pattern of other beliefs and meanings which must also be attributed in attributing it. To attribute, according to Quine, a single belief, or a single meaning to a vocalization, is (1) to have already theorized that what is heard is language, and (2) to attribute a large pattern of interconnected beliefs and meanings to the speaker. That large pattern of attributions Quine refers to as the "theory."

Empirical evidence (the speaker's vocalization plus the presence of the rabbit) radically underdetermines the attribution of meaning to the word or sentence uttered. It is only in the context of a whole fabric of belief and meaning that the single vocalization can be interpreted. As we gradually build up an overall pattern of meanings and beliefs which interpret the tribe's language, at no point will our interpretation be fully saturated; at no point is interpretation free of underdetermination because at any point in interpretation there will be various possible ways to give meaning to the speaker's words or attribute belief to her, and the total empirical evidence will fail to determine which route to meaning is "more true to the empirical facts." Then the interpretation is a theory because it always goes beyond the totality of empirical evidence.

Quine's picture of radical interpretation is, as I said, a picture in which the theory of interpretation must be explicitly developed from scratch. Since we have nothing to go on, then theory must be built piece by piece as

we interact with the tribe. Quine knows well enough that ordinary interpretation does not proceed so explicitly from scratch. I listen to the words of mourning from my neighbors, or to my friend's call for help, and I immediately know what is said. I interpret immediately. But Quine is committed to the idea that radical interpretation illustrates the nature of all interpretation. When I interpret my friend's words, I rely on a theory of her words which I have been trained into and which is thus already in place. I can then respond immediately and intuitively. But the term *intuition* is deceptive here, if one assumes that it means *without theory* or *prior to theory*. Intuition (and observation) are theory laden; they are simply laden with an implicit, already internalized theory that I have about my friend, in virtue of the fact that we share a community of speech.

Quine's illustration of the place of underdetermination and holism in meaning and belief is a powerful picture/thesis about the nature of language. There is much to say about it, and much that philosophy has said about Quine in the last thirty years. The point here is not to continue that discussion directly, but rather to see how ready-made Quine's picture is for transposition by Danto into the scene of artistic identification and interpretation. As Danto sees it, the case of art almost perfectly matches up with Quine's picture of radical, linguistic interpretation. In the case of art, what underdetermines meaning are not the vocalizations of speakers but ordinary objects, or material correlates. And Warhol's *Brillo Boxes* is precisely the analogue of the language of a distant tribe; it is the art example which requires interpretation from scratch and which therefore illustrates with dramatic clarity the nature of all art interpretation. In Danto's account of how art becomes art, an ordinary Brillo box in a situation of a gallery plays the role of Quine's evidence. By itself, a Brillo box put in a gallery is a mere thing in the world (in the gallery). Qua thing in the world, the Brillo box has already been interpreted to be a thing. "Brillo box" is a name for a kind of thing, a mass-produced object. It takes a whole fabric of theory projected by a community in order for that name for a kind of thing to be comprehensible.[8] Now, by itself, the visual evidence (combined with theory) which tells the viewer that the thing is an object (a box), cannot tell the viewer that the box is an artwork. A new level of theory is required to yet again transfigure that ordinary object into something still more: an artwork. The Brillo box awaits a further pattern of theory to transfigure it from a mere object into the status of art. Quine's picture of language becomes reapplied at second order by Danto to turn an object (already for Quine the referent of a theory) into a work of art (the referent of yet a new theory).

For Quine, it is in virtue of theory that a speaker is taken to be speaking at all (taken to be a speaker at all, identified as a speaker). Similarly, for Danto, the new theory turns a mere object (a "material correlate") into an artwork. The new theory gives the object the kiss of identification. Second, the theory does not simply identify an object as an artwork; it interprets it (gives it meaning), and interprets it holistically. We need a great number of visual facts about an object in order to arrive at a rich theory of its interpretation. Thus we need to take into account the colors, shapes, iconography, and art-historical placement of a painting in order to interpret it. We must also take into account the background art-historical, social, conceptual, and religious context of the work.[9] But at every point, our theory of interpretation will outrun the total visual and contextual evidence as surely as Quine's theory outruns the evidence from a tribe's speech-in-circumstances. Hence the visual evidence is neither sufficient for our identification of the object as an artwork nor for our interpretation of its meaning.[10]

Like Quine, Danto's illuminating example comes from radical interpretation, from an artwork whose foreignness or originality requires interpretation from scratch. This is why the avant-garde with its profound innovations, its flirtations with incomprehensibility, and its own level of philosophical theorizing plays so apt a role as Danto's favored example. If any object in Western culture requires radical interpretation it is the avant-garde. If the avant-garde had not existed, Danto would have had to invent it, for the starting point of his theory requires Danto to imagine the case of a radical artwork which we must start from scratch and interpret step by step.[11] But the avant-garde and especially Warhol beat Danto to this task of invention. The avant-garde took unto itself the task of developing artworks which would illuminate the radical position of interpretation. It designed artworks whose acts of erasure, whose abstractions which start from scratch, whose found objects or Brillo boxes, whose reliance on theoretical ideas residing outside the art object all contribute to defamiliarizing the eye and forcing the mind to make explicit the procedures of interpretation, according to Danto's reading. That is why Danto's reading of the avant-garde is so imaginative. (1) He is struck by these genuine and genuinely difficult features of avant-garde work. (2) He formulates a theory about the avant-garde's own reasons for these features. (3) The reason (a philosophical one) allies the art with his own project by making avant-gardists into philosophical researchers. Danto's is Whig history; he reads the avant-garde from his perspective and then finds his own philosophical sources in it.

Again, like Quine, Danto believes that ordinary and familiar cases of in-

terpretation conceal the structure of interpretation because they do not re-
quire the interpreter to build a theory explicitly from scratch. When I look
once again at what is, in fact, my "old friend" Brancusi's *Bird in Space,* or at
a work I have not seen by an also-familiar artist (Raphael), I do not go
through the tortuous stages of building an interpretation step by step; I
intuitively respond to the power in these artworks. Their meaning comes to
me in a flash. But Danto, like Quine, is suspicious of the idea of intuition.
What looks like mere intuition is really internalized theory in disguise.
After a lifetime of art education within a cultural community, I have been
trained into a theory of art, including a repertoire of interpretations of art-
historical styles, which I can draw on naturally in my responses to the fa-
miliar repertoire of art objects. Only the radical cases of art interpretation
(Warhol's *Brillo Boxes*) illuminate the nature of interpretation generally by
forcing the interpreter (in this case, me) to do explicitly what he usually
does automatically. Put another way, what the avant-garde shows is that it is
not your eyes which tell you, which have ever really told you, whether some-
thing is art, it is the theory you have inherited, habitualized, and which you
must now reinvent to encompass the new.

The claim that radical interpretation illuminates interpretation generally
is a claim Danto shares with Quine. Its sources are partly to be found in the
philosophy of the seventeenth and eighteenth centuries (in the rationalism
of Descartes and the empiricism of Locke and Hume). The claim can also
be called modernist in its assumption that interpretation has a structure
which can be revealed from scratch by the right radical example (real or
imagined). Behind radical interpretation is the goal of showing the essential
structure of interpretation by finding a case of it in pure form, which means
that interpretation has an essential structure. Like a Cartesian constructiv-
ist, the interpreter builds his theory from scratch, as if his theory were a
Gabo sculpture or a Bauhaus building. This is a modernist theory of theory
building.

In a recent paper, Peter Galison has argued that the philosophy of science
has gone through three stages in this century.[12] The first stage, represented
by logical positivist philosophy of science, was committed to the building of
an edifice of scientific knowledge on the basis of direct observation. The
positivist claim, in essence a piece of foundationalism, decreed that science
is to be constructed from simple observations according to clear rules of
construction. The guiding thought was, in this phase, that of transparency.
The second phase, Galison argues, rejected the central metaphor of obser-
vation and experiment and replaced it with another: the idea of theory as

the pivotal piece in the building known as science. This phase is exemplified by Quine himself. Theory, rather than the human eye, the scientific instrument, or the decisive experiment, was held to be the key to the scientific edifice. Which means that philosophy of science was still committed to the metaphor of an edifice called knowledge with an essential mode of construction (theory).

It is the retention of this commitment to an edifice with a kingpin, moreover, an edifice whose clarity emerges in those cases in which the building is shown to be constructed from scratch, which makes Quine's philosophy, and Danto's appropriation of Quine, modernist. Danto's search is the search for a radical object which will reveal transparently the essential structure of this building called "interpretation." His is the search for a leading example which will lay bare the essence of interpretation from its roots. Compare it to Gabo's attempt to produce a radical art object which will exemplify the inner structure of (its) construction as such. Danto searches for an avant-garde example because his own philosophical modernism demands that some object (real or imagined) exemplify the true structure of things. He finds such an example in the avant-garde itself. And well he should, for the avant-garde shares with Danto the project of producing a radical art example which will reveal the philosophical structure of art and reality (and thus change the world). This commitment to the centrality of the telling example, to its capacity to embody or reveal the essential structure of things—from scratch and without encumbrance—is a basic avant-garde feature.

But the picture of Danto as a fully formed theorist about art who conveniently finds the example his theory requires in the avant-garde is also misleading. For Danto's philosophy of art also arises out of his reading of the avant-garde, out of his feel for the avant-garde's theoretical positions, out of his sense of its search for its own basic structure, out of his sense of its radical desire to start from scratch. Danto's notion of what a theory is is not the same as the avant-garde's notion, yet both share the presumption that theory transparently defines its object. We can say that Danto's style of thinking is part of the mentality of the avant-garde and pronounce Danto's relationship to the avant-garde a dialectical one.

Indeed, Danto's reading of that unitary shape called the avant-garde/Warhol, his cheerfully announced discovery that Warhol, of all people, completed the grandest project in all of art history since the Renaissance, has an audacity and shock value worthy of any pronouncement by an El Lissitzky or a Mondrian. Danto's own reading of Warhol exemplifies his theories, for

it far outruns the visual evidence of avant-garde artworks and pays little attention to their visual evidence. Danto dispenses without argument with the visual features of *Brillo Boxes*. He knows his reading to be audacious and radical in its scope since he constantly attributes "implicit" theorizing to Warhol and company while paying little attention to their own explicit theorizing and even less attention to the visual details of their artworks. Danto's reading is a perfect instance of the kind of reading his theory decrees, namely reading from scratch which goes far beyond the evidence of one's eyes into the decisive terrain of theory-building about art. Not all reading is like this; Danto the philosopher has a style which must be called avant-garde.[13]

This placement of Danto on the map of the avant-garde should be developed in various ways, especially in terms of Danto's own utopian adulation of the role of theory in art. Danto's game played over theory is in its own way a utopian one. In the manner of some latter-day Hegel, Danto believes that the reputedly avant-garde project of self-discovery has brought art history to a grand conclusion, with artists now free to inhabit the postmodern space of Warhol. (I will take up Danto's utopianism in chap. 9.) It must be admitted that merely to call his ideas modernist, to say they belong to the avant-garde, is not to prove them false, it is merely to place them. Both Quine and Danto have genuine insights about interpretation which are less matters to be rejected than to be relocated in a larger picture of the complexities of interpretation—which brings us to Galison's third phase in the philosophy of science. Galison speaks of recent trends in the philosophy of science as *postmodern*. By this he means that recent trends have abandoned the commitment to finding a central metaphor for explaining the structure of scientific knowledge. Such philosophers, notably Galison himself, stress instead the relationship between three distinct, central factors which have in tandem defined the history of science and the formation of scientific knowledge. The factors are those of (1) observation and experiment, (2) theory, and (3) the history of scientific apparatuses, instruments, and technology.[14] Science is and has been produced out of the interaction of these three factors, none of which is essentially more central than the others. (At certain times in the history of science one factor or the other may have played a locally more dominant role.) Postmodern thinking about science has dismantled the metaphor of the edifice. Science is no longer thought of as, in essence, a construction built from simple elements on the basis of a central metaphor for its construction. Science is no longer thought to be a transparent construction at all. It is better pictured as a

marriage between various factors which may exist in various states of harmony, in relationships of local dominance, in states of running quarrel. Science, like marriage, is a terrain whose factors may demand new modes of negotiation.

There is no transparent terrain to science, nor is there to art. I believe my studies have already suggested that it is a similar marriage of factors which defines art, and I am dedicated to rejecting a central metaphor for artistic experience and definition, be it the eighteenth century's metaphor of immediate sensuous apperception of beauty in art, or the twentieth century's metaphor of immediate theorizing. My thesis is that art is defined by an ongoing marriage of various factors (theoretical, visual, contextual). Along the lines of Galison's paper, the three factors of (1) observation (what the eye sees in art); (2) theory; and (3) the history of technology in art, along with the history of its institutions (the museum, the patronage system) must all be given their due as figuring centrally in the definition of the art object. There are other factors, other social practices inscribing social norms (religious, political, conceptual), other psychological needs (perceptual, psychoanalytical) which are equally central in the explanation of art. Then what is not central? That can only be given a contextual answer; it is crucial to any work of art, to any style, and to any art tradition that certain factors are more important than others, yet the pattern of their interplay and the relative importance of each can only be detailed in context. My thesis about art may seem disappointingly plain, but do not be disheartened. That is because mine is less a theory than a way of picturing art which aims to allow the complexities of artistic practice to emerge with the right kind of sensitivity, uncertainty, and attention to detail. I wish to return us to the richness and prismatic nature of the example.

In what follows I will test Danto's theory of theory in art against the practice of interpretation as one actually knows it from experience, that is, from the throes of having read and felt one's way into art. We need to think about how Danto's picture squares with the robust experience of seeing, feeling, immersion, and projection that seems to be our way of understanding, for example, Brancusi's "object" to be art prior to theorizing. The point garnered from my readings of the avant-garde was that central to identifying something as a work of art is the experience of one's eyes. Theory tells you things, but your eyes also tell you things, and my point was that neither had absolute authority in interpretation. Indeed, if either was to play the more crucial role in being what one relies on in calling a Mondrian art, the eye had a far better chance than any of Mondrian's recherché theories. Danto's

claim is that theory enters into the definition of art at its inception, and therefore what appears to me to be an intuitive vision and feeling about Brancusi or Michelangelo is, in fact, the product of my internalized theory. How pretheoretical is the evidence from one's eyes? How does one decide? What kind of theory structures my intuition? No one is denying, least of all me, that theory plays a crucial role in the ultimate outcome of one's encounter with an artwork. The more one thinks about what Mondrian says about the platonic character of his art, the deeper, or at least more articulate, one's experience of his work will, one hopes, be. But neither will theory replace the role of the immediate power of an encounter with Mondrian's vibrant, serene, and purist abstractions in empowering our claim to call Mondrian's work art with conviction. Indeed, the eighteenth century would say that our immediate experience of the Mondrian canvas simply is the judgment that it is art (or a beautiful object). The question is whether theory rules even the initial work of my eyes and my feelings when I form the intuitive judgment that the Mondrian is art.

The crux of Danto's account is therefore to deny that we can visually grasp and appreciate a Mondrian painting, feel its force as art without a theory. Our eyes lack, by themselves, coherent visual power. We do not identify a Mondrian as a painting, we do not appreciate it as the art it is, without theory having already entered the scene. It is to this point that we now turn.

III

There are two distinct things Danto can mean when he says that vision (plus feeling plus one's ordinary knowledge of something as an object) underdetermines the identification of a thing as art without a further theory:

1. He can mean that theory is a necessary condition for identifying and interpreting art. Without theory there can be no art. But theory is holistically interwoven with one's ordinary vision of an art object and with one's feeling for the object. A complete description of what makes a work of art a work of art will, in the standard case, refer to visual features of the object seen, felt, and theorized into art, where seeing, feeling, and theorizing are all crucial and all interdependent conditions of reception and interpretation. There is no observation without theory, nor theory without observation. Theory does not rule vision any more than vision, theory, but both are so interpenetrated that one can neither say what vision is without speaking of theory nor what theory is without speaking of vision. Put another way,

our mode of receiving a work of art is profoundly visual in the inflated sense of "seeing-as," yet seeing-as is theoretical in that it is permeated by theory.[15]

2. He can mean what Quine seems to mean when he says that mere empirical evidence radically underdetermines interpretation. Vision, even conjoined with feeling, plays a noncentral, nondefining role in art. The key word is *radical*. The visual features of an object radically underdetermine whether the object is to be called art. This is suggested by Danto's use of his radical examples. For example, he says about Brillo boxes and Neolithic paintings, "What in the end makes the difference between a Brillo box and a work of art consisting of a Brillo Box is a certain theory of art. It is the theory that takes it up into the world of art, and keeps it from collapsing into the real object which it is. . . . It would, I should think, never have occurred to the painters of Lascaux that they were producing *art* on those walls. Not unless there were neolithic aestheticians."[16] The Neolithic wall painter had vision and some kind of feeling but did not make art because he or she failed to have a theory (the right concepts). What vision forces on us is by itself unable to define art. Warhol's *Brillo Boxes* is turned into art not through one's experience of its visual features but, rather, through a theory.

The theory is conceptually independent from one's ordinary visual experience of the object's features, for one could, in principle, give a complete list of every visual feature of the object, and one would have described nothing but an ordinary, nonart thing (according to Danto).[17] Then the theory alone makes the box into an art. Vision is completely insufficient. After learning the theory, however, one may see the object a bit differently (through theoretical lenses).

Thus there are two distinct voices in Danto's work and these are not consistent. The former simply asserts that theory is a crucial defining ingredient of art, and that theory is holistically interwoven into what and how we see; the latter begins from the force of Danto's radical example and claims that theory, a feature conceptually independent from the structure of one's robust vision of an art object, alone makes the object into art. The second claim is far stronger than the first for it isolates the role of theory from that of ordinary, robust vision and claims it is theory which does the work of art in art. The first voice, itself more plausible, may be thought of as a voice of resistance to the full avant-garde strength of Danto's position; the force of Danto's writing has to do with the way he slides between these two voices in the course of his writing. In this he is like John Cage or Gabo. Consider Danto's first voice first.

There is much that is right about it. Ordinary perception, whether of plastic artworks or of other objects, involves not only visual processes but also an interpretive background. The interpretive background is highly complex and textured, which is to say, it is holistic in character. What informs the work of the eye in its acts of perceptual recognition are such things in the background as knowledge of how an object looks from a variety of angles, knowledge of related objects, knowledge garnered from personal involvement, knowledge inculcated from one's partaking of a larger pattern of shared, socially constructed concepts, knowledge from one's sense of the object's interconnections with other things and with human life generally. That interwoven background contributes to the structure of the individual appearance, and to its processing and interpretation. Ordinary visual understanding of an appearance is deep because the appearance is visually grasped on the basis of a pattern of factors whose sources are broad, pervasive, and deep in the holistic background of mind and life.

Is the background I refer to which informs vision (of art objects or other objects) the same as Danto's theory under a different name? These are close in many respects. Both are holistic, and both involve a pattern of concepts and observations—neither of which can be spelled out without the other, and neither of which is ruled by the other. If all that Danto means when he speaks of our immediate visual experience of a Mondrian as theoretical is that it is a visual experience which has been prepared not simply by the eye as such but, further, by a history of art experience, by the formation of taste, by experience in the world, by a set of concepts of art, by knowledge of art history and its revolutions in style and theory, and by familiarity with abstraction (not to mention by facts of gender, power, and colonialism), then let us say Danto is right.

One can ask whether the term *theory* as a code word for everything that comprises the background of the eye is a completely satisfactory one, for vision operates not merely on the basis of theory but also on a broader basis of human responses and activities. Are all the human activities, patterns of socialization, social functions, psychological necessities, and forms of cultivation which structure the seeing eye to be glossed as theoretical? Why adulate the feature of theory in human socialization as the central feature when there are so many other features which also play their role in the background to vision (e.g., training or intimacy or domination)? Similar questions have been addressed to Quine who identifies the whole of language with a theory. (Language, too, has many intersecting features and many parts.) Better to call one's visual background an organicist admixture

of socially inscribed practices, styles of response, theory, psychological pro-
jections, and memories, comparisons, ideas, poetic resonances, and musical
ones—in short—a style of life rooted in a form of life. Language is very rich
in supplying us with words for the different elements which jointly and in
relationship comprise our perceptual backdrop, much richer than the one
word *theory* suggests. Quine, speaking of language as a theory, uses that
word to show that interpretation is structured by two central features: un-
derdetermination and holism. He uses it because he identifies interpretation
with science and science with theory. But Wittgenstein, the more attentive
to the ordinary facts of the matter, would tell us that what structures a lan-
guage is the total web of factors comprising our form of life, not simply one
factor.

Consider now the second thing Danto can mean: that visual experience
will get one nowhere in informing one that an object is a work of art. Vision
is, apart from the elaboration of a detailed theory, no more helpful (if no
less helpful) in telling one that something is an artwork than Quine's empir-
ical evidence is in telling one what a speaker's words mean or what he be-
lieves. What does one mean by the incapacity of vision? That one should
distrust one's immediate visual experience of a Mondrian or Brancusi on
principle. But then what could ever help one in theorizing one's way into
believing that a Brancusi *Bird in Space* is an artwork if not the power of
one's feeling eyes—which indeed are prepared by a background, including
a theoretical one? (Must they be? How much? Cannot a Rumanian peasant
immediately know a Brancusi? He will not know much about the history of
art but will know other things relevant to Brancusi's work, things about
materials and craft and solidity and endurance over time, about the conti-
nuity of time, and about the erotic. But why not say that a Brancusi really is
a bit like a work of nature, one that, like a sunset, a rose, or a waterfall will
reach the heart before the mind? It is not certain whether theory is the
ineffectual element here, the hanger-on, rather than one's eyes. And why say
this peasant holds an implicit theory of the Quinean type?)[18]

Robust vision, seeing-as, these are crucial defining elements of art gen-
erally. They are characterized by an immediate experience, a gestalt, in Witt-
genstein's well-known words, "half visual . . . half-thought,"[19] in which a
Brancusi is seen, felt, seen as a bird, or as a mirror, felt to be a mirror, known
to be a bird by the imagination's kinesthetic completion of its urgency
toward flight. These various kinds of seeing—seeing, forming a gestalt,
seeing-as, feeling, and kinesthetic understanding, all of which feed back
into what is seen—slide into one another, making seeing truly robust. I

think Danto's weaker notion of the role of theory in art more or less ac-knowledges the richness and centrality of these kinds of art perception, but his second, stronger, conception of theory does not.

According to Danto's second notion, robust seeing is either an ineffectual element in art identification or it becomes effectual only when empowered by a theory. Danto is taking the position of radical interpretation as repre-sentative, he is taking the radical example of Warhol's boxes as typical, when he denies a crucial role for robust vision in identifying art.[20] Danto's claim that the radical speaks for the typical is, as I said, part of his philo-sophical modernism. (It is of a piece with Mondrian's claim that, at bottom, all painting conforms to Mondrian's own purist principles of visual con-struction.) But radical interpretation is not typically representative of inter-pretation. It does not reach the roots of all interpretation, and it is impor-tant to see why Warhol's boxes cannot be philosophically illustrative of the role of theory in defining art generally. There are three reasons.

First, let us assume that Danto's interpretation of Warhol's *Brillo Boxes* is essentially correct. If we take the radical case of Warhol's boxes to be indicative of all artistic identification, if we accept Danto's claim that our visual experience of Warhol's *Brillo Boxes* is relatively useless in defining that work of art and then take this uselessness of vision as the norm in art, then the role of seeing and seeing-as becomes typically viewed as highly attenuated, or highly post-theoretical. The norm in art is that you "see" only after you understand the theory. But in fact the radical position from which Warhol's *Brillo Boxes* (and perhaps conceptual art) strikes home as art de-pends on ordinary styles of receiving art remaining in place which do re-serve a crucial, defining place for the visual. It is precisely Warhol's inten-tion, in the Duchampian voice of the philosopher, to create an object about which there is little to see, feel, and engage in the way of an ordinary art-work. Warhol, ever so cool, replaces artistic immersion with blankness, ar-tistic creation with mass production, and visual poetry with a mixture of mass consumption and philosophical stimulation. Warhol presents the viewer with an art object that looks like a mass-produced thing so as to force the viewer to withhold her pattern of expectations about how to enter into the artwork. The viewer cannot respond to *Brillo Boxes* in anything like the way she responds to a Rembrandt, a Turner, a Hiroshige, a Brancusi, or a Tatlin. The viewer's normal mode of response is to find her way into the object visually as well as conceptually. What is visually striking about the Warhol is that it strikingly like a mass-produced object.

Warhol invokes a clear distinction between ordinary things and artworks

as part of the rhetorical composition of his art. Warhol himself believes in one voice, that artworks are no different than mass-produced things, that it is only a context which makes the one different from the other. But is the complexity of that context given its due by the notion of a theory? For even in the case of Warhol the art resides in Warhol's capacity to strike one's vision by striking the expectations about vision that one brings to vision. Those expectations are not simply, one assumes, theoretical, but a pattern of expectations about what to notice, about kinesthetic responses to an object, about the poetry in feeling, about the role of thinking in seeing—unless that is, theory is simply identified with seeing, in which case the claim that theory defines art is nothing other than the claim that your feeling eyes define art and those eyes are theory-laden with the traces of your conceptual scheme. Let us assume that Danto means something stronger by a theory than this.[21]

One cannot find the provocation in the Warhol to think about what makes art art and how artworks relate to commodities without finding one's ordinary expectations about visual engagement with his artwork flouted by its mere status as a thing, which means that the Warhol artwork depends on that pattern of ordinary expectations being in place for its point and its power. Remove the fact that everyone expects to be drawn into a work in a profoundly *visual* way, and the Warhol has no point. It will reduce to the status of a mere Brillo box. Thus it cannot possibly be that Warhol's work is philosophically indicative of the interpretive structure of art in general. It cannot be that Warhol's work philosophically reveals the essential nature of art to be theory rather than (also) seeing/feeling. Rather, following the Danto line, we find Warhol recommending that we replace art with a cool, theoretical attitude in which vision does, in fact, play a relatively minor role. It is only because a Rembrandt or a Brancusi moves us so profoundly that Warhol's box exasperates and moves us so profoundly. Without Brancusi there is no space for the erasure of Brancusi (and his expectational viewer) by that most urban of nonpoets called Andy. Deflate the ordinary role of seeing-as in artmaking and art-defining, and you deflate the possibility of Warhol's extraordinary box being more than just a box.

Second, is it accurate to say that visual features internal to *Brillo Boxes* play no fundamental role in our making even Warhol's box into more than just a box? What Warhol's boxes offer the viewer are precisely on Danto's line, little more than ordinary, mass-produced objects, and that is precisely visually striking. Seeing Warhol's *Brillo Boxes* in a gallery is as striking as being brought on a trip to the mountains under the expectation that the

sublime will fill your eyes, only to find yourself arriving at an artificial mountain covered with Astroturf in some huge Los Angeles convention center. The disappointment, the confusion, the sense of shock, the sense of wonder or exasperation at the audacity of the gesture is a complete replacement of the sublime. The visual route to art is blocked. Warhol replaces the role of seeing-as in our engagement with an artwork with another kind of seeing, the seeing that shows one precisely nothing (nothing expected). Does that mean that seeing plays no role in the force of Warhol's art? The tenor of what is seen in the box, of its character and (lack of) content, seems to play a crucial role, but in a different form. Seeing is a matter of being immediately shocked. It is the conflict between what one sees and what one expects to see that plays the role of engagement with these boxes. Warhol's provocation is established visually.

Moreover, as is well known, the abstract expressionist who designed the Brillo box thought to sue Warhol for stealing its arthood and stealing the poor man's own fifteen minutes of glory and success. So perhaps Warhol, the student of industrial design who emerged out of advertising, is placing this object on display as one whose features are already worthy of note, as it were, aesthetically. That is to say, Warhol's own belief is that mass production need not interrupt the traditional role of the visual in art. A mountain in a Los Angeles convention center might not have a look worthy of Mont Sainte-Victoire, but neither is it a mere visual blank. Then Warhol's own art is more ambivalent about the role of the visual in its persona than perhaps Danto acknowledges, and, in that ambivalence toward the role of the visual, by extension ambivalent toward the role of beauty and aesthetic interest in contemporary art and contemporary American life.

Third, we have so far assumed only the acute likeness between Warhol's boxes and their ordinary counterparts. Let us turn to their visual differences. I said that Danto acknowledges that Warhol's boxes look different from ordinary ones, but he immediately and without argument elides the point, saying that for all intents and purposes—for the purposes of his philosophical criticism—the two are the same. For whose intents and purposes? Warhol's? If Warhol meant for his boxes to be in essence the same as ordinary ones, why did he make them look strikingly parodic of ordinary boxes? In fact, his point is to make his boxes look both strikingly like and strikingly unlike ordinary boxes, for their play is established through their flirtation with sameness and their parody of it.

Let us pursue the visual differences between Warhol's boxes and ordinary ones. Warhol's boxes are, I said in chapter 1, oversize, partly painted and

silk screened. They look like balloon inflations of actual Brillo boxes. Sharing in Claes Oldenburg's gesture of parody, they make a game of the objects they also mimic and, in some pop sense, honor. Then it appears too simple to say Warhol seeks to visually identify his boxes with ordinary ones so as to provoke reflection on the differences between things and artworks. He also means the differences between his boxes and ordinary ones to be glaringly obvious. Warhol is playing a game with mass-produced objects (his boxes are half mass produced and half silkscreened and painted). He is flaunting an identification of art with mass production and retracting it at the same time through the touch of his palette on his boxes. This ambivalence is accomplished visually. Warhol's boxes play with an identification with real ones in the way a child dresses up in his mother's clothes, or a flaneur tries on a fancy suit in a store like Bloomingdale's. One effect of this play is to engender thought about the fact that artworks are more or less the same as ordinary things. Bernini's sculpture of Saint Catherine is more or less the same as she is. Or is it? No two things could be more different than Bernini's sculpture and Saint Catherine herself. Yet we fall into the experience of finding similarity in these, and this experience is one deep in the nature of art. It is an experience Warhol's work adulates and mocks by making an object so close to an ordinary one that there seems no enormous difference, no requisite space, for the experience of depth, the experience of mimesis, of more or less sameness, to arise. "You want a thing with only a little difference from reality, Well you've got it. Here it is," Warhol, in effect, tells us. Does Warhol's play on this experience of mimesis destroy the ancient powers of art to mime, mock them, or simply recast them? The answer is not clear. Then other than a vague and celebratory aura of parodic play with art and things, Warhol's game of likeness and difference is itself not clear. I shall return to this in the next chapter.

I do not mean to say that vision is the essential element in making art out of a box or even out of a Rembrandt canvas if only because I accept Danto's weaker claim that seeing is structured by a background and works in tandem, to a greater or lesser degree, with thinking and theory (especially in the case of a Warhol). I am merely resisting the counterclaim that it is theory rather than vision which makes art out of mere boxes. What is striking about the Warhol, what makes art out of it, depends on ordinary styles of vision and on the special kind of visual provocation and visual interest in the Warhol gesture. The example of radical interpretation is thus by its very nature nontypical, and as such it must be placed against the background of the typical. (Warhol's box also is more visually typical than Danto acknowl-

edges, since [1] Warhol is, in the voice of the industrial designer and the artist/flaneur, visually interested in the designs of ordinary American life—i.e., the Brillo box—and in their playful parody, and [2] the opacity of the game he plays with art is established through the visual play of sameness and difference between his objects and ordinary ones.)

Danto's telling examples of radical interpretation are not simply culled from actual art, they are also fabrications based in recent art practices. Danto begins *The Transfiguration of the Commonplace* with a thought experiment illustrative of the position of radical interpretation. In an act of zany virtuosity, Danto sets up the example of a number of canvases, all of which consist of visually identical red squares. These, he tries to show, illustrate the radical distinction between what one sees in an art object and how one theorizes about it. He proceeds to give quite different imaginary readings of these canvases, some of which make the canvases come out as artworks, others as something else (such as the underpainting for an imaginary unfinished—unbegun—work by Giorgione). (There is a delightful piece of wish fulfillment here, one wishes there were more paintings by that grand master of small output.) Other interpretations assigned to these identical red canvases make them turn out to be about the Israelites' crossing of the Red Sea, or about Kierkegaard's mood.[22]

The question is what Danto intends to prove by his thought experiment. If all he intends to show is that there is a range of possible contexts in which the same object can (in principle) come out differently, that would be to show something true. There is always the possibility (the threat to any museum's collection) that a representational canvas can turn out to be a fake or a painting by a disciple. It can be reread in the light of new historical evidence, more refined eyes, or changes in taste, ideology, or psychology or reread to be about a different range of things. As I noted in chapter 3, abstract art is especially open to being titled, known, or contextualized in a number of possible ways—although not in just any way.[23]

What Danto aims to show, however, by his virtuoso act of imagination is what he also thinks Warhol the philosopher has shown in gel: that any number of different theories can account equally well for the empirical evidence (in this case, the identical red canvases) yet with completely different interpretive results. Therefore there is no visual fact about the object (the red canvas) which can prove decisive between radically divergent identifications and interpretations of it, either as an artwork or not. Thus vision (the visual inspection of the canvas) radically underdetermines identification and interpretation of it, and theory plays the crucial role.

Consider his thought experiment. Danto means to show that any interpretation is plausible as a reading of this set of identical canvases; he aims to convince us that the mere red paint on canvas plays no real role in how the object is identified and interpreted. His examples sound convincing since he aims to impress one with the great variety of possible readings of identical things. But what would it mean for the concept of painting if one could arrive at a similarly profound variation in interpretations of paintings typically? (Take five canvases identical to Rembrandt. Can one imagine five similarly divergent readings of these?)[24] It would mean that the visual element would do no work in the picture's interpretation, in which case there would be no difference between a pictorial object and a linguistic or conventional sign—a word, a letter, a street sign, a lamp post. A Rembrandt canvas would be no more definitive of its meaning, reference, expression, and beauty, than the number 2 or the string of signs *Abracadabra* or the red traffic light.

If Danto's position about radical interpretation is valid generally, the concept of a pictorial object reduces to the concept of a mere conventional sign in the theoretical commerce of the world, to be variously interpreted at will. Then why does anyone bother to paint when it is so much easier to enfranchise a sign by fiat with reference and expressive meaning? Why does anyone bother to look at a painting when one can simply read a manual or book of theory which tells one what the pictorial sign means and how to feel about it? We have strayed too far from our natural and naturalized visual relation to the pictorial object. One might as well dispense with the paintings and read the books, something many have felt about some theoretical art made these days. (Not about all of it, the question being how the art marries theory with its object; I will return to this point in the final chapter.) People look at paintings because the visual element carries its own semantic and expressive weight, because it is in the formulation of meaning through a relationship between the visual, kinesthetic, and theoretical elements that something worthwhile emerges.

So let us then assume there is some visual import in these identical red paintings. Let us assume the visual element does play some role in defining the meaning and feel of these canvases. Then Danto's examples are seriously underdescribed. We need to know more about the precise nature of the canvases before we can evaluate the truth, quality, or degree of plausibility of the various interpretations Danto offers.[25] In what arrangement are the red squares? with what degree of varnish do they reflect light? what kind of acrylic is used? with what degree of gesso or staining? with strong black

geometrical lines dividing the squares or white ones or edges of color which just touch in the manner of Rothko? Is the overall look one of an ancient, stained patina of red or a uniform treatment of the color? Does one feel subtle gradations in the paint (as in Ad Reinhardt), or is it strongly applied like Franz Kline's? How subtle is the feel of the picture? how earthy are its reds? are they ochre, burgundy, or rose? are they soft, brilliant, or Day-Glo? How are the paintings stretched, lit, and positioned? These things matter. Once we have a full enough description of a picture (and when is the description full enough?), we have a preliminary reading of the character of these identical canvases, and we can begin to assess the relative plausibility of the various interpretations Danto offers. Our reading will no doubt be modified by the differing pictorial contexts in which we find these canvases: contexts that include titles, oeuvres, further interpretations given by the artist or by communities of reading, contexts of art history, culture, and of the history of the picture in hand. But it is in terms of the highly complex visual qualities of these canvases that we will evaluate how such contextual factors—including the theories—apply, do not apply, half apply, or apply metaphorically to the pictures in each case (and with what degree of plausibility).

Let us invent an example. If the red canvas has a very subtle feel (like a Helen Frankenthaler), then finding out a canvas bears the title *Sea Voyage* will color the painting differently than finding out its title is *Daffy Duck*. *Sea Voyage* will interact with the visual qualities of the canvas in a way which makes them undulate, brings out their qualities of water and staining, and focuses the eye on their poetic innuendos (all in the manner of Frankenthaler). The title *Daffy Duck* applied to this same canvas will be taken to be an ironizing joke, say, a joke painted by some young postmodern Turk about the seriousness of Frankenthaler's work which also serves to honor it. (Or it might simply be a mistake by some careless gallery assistant.) If the canvases look garish and sloppy, then the title *Daffy Duck* will be more of a blithe joke on art by a painter like Jeff Koons who is laughing all the way to the bank for pulling this off. Or it will spell out an exploration of connections between cartoons and abstraction in painting, say, a study in abstract animation. We will not be able to decide how successful the abstract animation is without close scrutiny of the canvas. The point is not that we will be fully successful in bringing each of these acts of interpretation off; the point is, rather, that, successful or not, the visual qualities of the canvas will matter regarding how the theory or words apply (or not) to the canvas. Theory does not define the work, it qualifies it. To think other-

wise is to abolish the concept of the fullness of painting in favor of the concept of a visual sign whose semantics are decided purely on theoretical grounds. This would be to remove the problem of how to read Mondrian's paintings altogether from our avant-garde studies. There would be no problem there because no integral concept of painting would be left for us to work with and by which to test the rule of theory. All we would need to do is read his essays and our work would be done.

I now want to turn to the further question of what would happen to the very notion of theory in such a circumstance. It looks like the concept of theory would rule the definition of art, were Danto's strong position correct, but, in fact, such a victory would be Pyrrhic. For without recourse to defining visual features of an artwork in terms of which to partially test the theory which also defines it, we no longer know what theory is. There are striking philosophical results of unfortunate cultural relevance to be found out about this.

IV

What kind of theory is it which could rule the meaning of the visual sign completely? What is a theory which rules the visual yet cannot be tested in terms of the visual (or apparently in terms of anything else, as if it were an absolute monarch with the divine right to rule?). There are strong reasons, deriving from Wittgenstein, to think that such an absolute conception of theory is not simply false but, in the end, incoherent. The argument runs thus: Conceive of the act of identifying an artwork as an activity; conceive of calling something a work of art as an act of baptism. And conceive of the baptism of art by theory as an act wholly unconstrained by the visual. In discussing what, if anything, serves as the basis (and explanation) of rule following, Wittgenstein states in a famous passage from his *Investigations,*

This was our paradox: no course of action could be determined by a rule, because every course of action can be made out to accord with the rule. The answer was, if everything can be made out to accord with a rule, then it can also be made out to conflict with it. And so there would be neither accord nor conflict here.

It can be seen that there is a misunderstanding here from the mere fact that in the course of our argument we give one interpretation after another; as if each one contented us at least for a moment, until we thought of yet another standing behind it. What this shews is that there is a way of grasping a rule which is *not* an *interpretation,* but which is exhibited in what we call "obeying the rule" and "going against it" in actual cases.

. . . And so obeying a rule is a practice.[26]

Calling something an artwork may be thought of as an act of following a rule. Furthermore, the problem of how to go on in the modernist situation and identify some new object to be an artwork may be thought of as the question of how to go on and apply the rule to a new case (perhaps reconceiving the rule in the process). Wittgenstein's idea is that if having an interpretation (i.e., a theory) is alone deemed sufficient to ground the application of such rules, then any outcome a person gives when they claim to follow the rule can be made to accord with a rule or to go against it. All one has to do is restructure the interpretation of the rule. And what is to constrain that restructuring of the interpretation, since there are no constraints (in our case no visual constraints) on the interpretation? A person appears to follow the rule for addition, giving outcomes of "2," "3," "4," "7," "8," and so forth. We want to say he has followed it wrong, that he has made a mistake. But he could simply be interpreting the rule differently from everybody else. His interpretation of the rule for addition could be different from the norm, making his outcomes the correct ones and everybody else's outcomes wrong. If the criterion for correct rule following consists in nothing but the having of an interpretation of the rule, then we have no way to distinguish correct from incorrect interpretations of it. Thus we have no way to distinguish correct from incorrect ways of following it.

Divergences in outcomes can always be explained by differences in how a rule is interpreted, and the only way to resolve these divergences in interpretation is by reference to another interpretation which explains the first. People can then disagree about what the second interpretation means, and you will have to have recourse to a third, and so on and so on, ad infinitum.[27] Thus everyone can interpret the rule differently in order to make the examples come out correctly or incorrectly, and there will be no way to decide whose interpretation is correct except by an infinite regress of further interpretations of interpretations. "Neither accord nor conflict" will be possible.

A rule cannot be identified with its interpretation alone, because then the very identity and integrity of the rule will be obliterated. There must be more to the story of what correct rule following consists in than simply having an interpretation.

It will immediately be objected that there are many constraints on the absolute rule of theory (interpretation) in art. But Danto in his most stringent mood writes as if this were not true. Thus he provides us with a rule for transfiguring objects into artworks. The rule is: "$I(o) = W$."[28] (An interpretation mapped onto an object gives us an artwork.) Danto's rule states that interpretation (and nothing else) serves as the rule which identifies

objects as artworks. So someone goes into a gallery and says, in the manner of some Clement Greenberg, "That, that, and that are artworks; that is not." We want to know if he is correct or not. As in the case of any other rule, if it is only an interpretation which gets you from objects to artworks, then any number of other interpretations could also do this, and any number of still other interpretations could make the identification of something as an artwork turn out to be a mistake. What then are the stakes of accord and conflict, if all that counts in following the rule is having an interpretation? Indeed, Danto celebrates this very instability about interpretation and its outcomes in his marvelous opening to *The Transfiguration of the Commonplace* in which he sets up the already-discussed thought example of the red squares. There, any interpretation seems to serve, since interpretation is unconstrained by the visual object or by anything else except the inventive capacity of the author, as if the author were some Don Quixote able to authorize his existence and that of the object before him.

Does Danto's virtuosity not prove, rather, that mere interpretation gets you nowhere since it can get you everywhere? If it were true that mere interpretation were all that made art out of objects, then art as a concept would lack all integrity and shape since any set of alternative theories about what the rule is (about what makes a work of art a work of art) could be produced with equal interpretive conviction to cover the same facts, that is, to define the same things in the museum. Or, conversely, the art objects in the museum could be deaccessioned at will, purely by someone's making up a new set of interpretations of the rule (a new set of theories) which would deify some other group of objects and cast out the present ones. It is not simply that the concept of painting would be lost, a painting being nothing other than a semiotic sign for a theory, but that the theory which by itself defines art would have no import, since disputes about what it meant could not be resolved other than by recourse to more of it, and more of it. Neither a theory's meaning nor its truth could be ascertained. The artist J's red painting (one of Danto's red squares) really could make a million dollars with the right critic to back it up, for that is all he would need, art being nothing other than a matter of theory, with no grounds for evaluating the theory other than more theory. And more theory. Now, all of this is beginning to look like the 1980s art scene, in which the value of the art object has been measured in numbers of words written about it, in which questions of the meaning and truth of those numbers of theoretical words have been addressed by compounding the amount of theory, as if the truth of one's article in an art magazine is measured by the number of quotations and footnotes

from famous texts one exhibits. Theory itself becomes meaningless, unde-cidable, and what really counts is who is doing the talking—a famous col-lector, a famous artist, a famous postmodern theorist. Truth is decided by who has their fifteen minutes, and that is the condition of Warhol making a slight mockery of Warhol the philosopher, who apparently told us that a theory makes art art. It just goes to show that mere theory cannot write the ticket of art, since it is too fickle; it could write the ticket of any object or of none. Its own internal indecisiveness opens the door for the replacement of vision and hard thought by fame, fortune, and personality. That is, I take it, part of the extended cultural implication of Wittgenstein's *Philosophical Investigations* (pt. 1, no. 201).

Modernism seems to have gone awry, the avant-garde seems to have ex-ploded in our face. Taking Danto's words (not to mention art magazines) at their face value, theory no longer intends to prefigure art (the avant-garde's project) but ends up replacing it. Of course, Danto aims to avoid this prob-lematic by stating that there are constraints on theory, namely, historical ones. It is not mere theory which makes an object into a work of art, but rather a historically evolving theory held not simply in one person's mind but by the artworld. It is then the fact that the artworld as a whole holds one theory rather than another (at a given historical moment) which eliminates the problem of interpretive instability. But Danto's reference to a historical community of shared belief will not by itself erase the force of Wittgen-stein's problem. Suppose some members of that community called "the ar-tworld" produce different outcomes than others. This is bound to happen because the very nature of art identification and interpretation is liable to some level of disagreement even in the best of nonmodernist times. How are such disagreements to be resolved? Since it is my own view that beyond a certain point such disagreements should not be expected to be resolvable, I do not claim that the community must be able to achieve complete consen-sus about how to interpret and follow rules all the time. But agreement must be possible sometimes, otherwise the theory (the rule) will lack semantic integrity. As Wittgenstein so nicely says of the obvious, "A sign-post [i.e., a rule] . . . sometimes leaves room for doubt [about which way it points] and sometimes not." [29] A signpost which never pointed in a clear direction would not be an integral signpost. But if all that makes art art is a theory (an interpretation), then differences in outcomes can always be explained in terms of differences in the interpretation of the theory. It might be said that the norms of the community are what in the end decide what the theory says, but how are those norms interpreted, and whose interpretation is to

count—the majority's? Since all that Danto allows to serve as the criterion of correct rule following is a theory, then we will need another interpretation of the theory to resolve these differences in its interpretation and another and another, and we are back in the paradoxical position of finding that anything can be made to conform to or diverge from the rule. There is no nonparadoxical picture of rule following possible for the artworld if all we have to use in our explanation of the artworld is the mere fact of shared theory. No dispute about the theory's interpretation can ever be resolvable. And since some, if not all, disputes are, in fact, resolvable and resolved in practice, we need a larger story of what it is for a community to interpret art in a common way, a story about shared practices, about shared styles of response, about shared inclinations, feelings, belief systems, about a shared system of art training in the context of a shared web of life generally, which gives sense by giving context to the words of an interpretation. Wittgenstein's point is that in order to interpret theoretical beliefs, we need to refer to things beyond the sphere of mere interpretation.

The notion of a historical artworld that holds a theory must be given flesh. Indeed the very tenor of the term "the artworld" suggests not simply a pattern of shared belief held by a set of persons but a robust living *world*: a world of shared practices and responses, of styles of education, of habits of viewing, of ideology, dress, shared friends, and of texts which everyone has read, of galleries in common and paintings everyone has seen and of stories about the history of art (say, a story of art beginning with Jackson Pollock and ending with Warhol). In one sense, the term suggests a place where art happens: New York or, as a second candidate, Paris. In another sense it suggests a practice: a practice of treating, judging, and responding to art. When George Dickie interprets Danto's term of art to mean a practice, Danto may challenge Dickie, but in a way Dickie is right; that is what the term implicitly suggests.[30] It is on account of semantic waffling—between "the artworld" as (1) a code for a set of beliefs, and (2) "the artworld" as a code for a robust historical world of practices set in a city that is itself part of the stream of art-historical life—that Danto's account looks true. For the implicit suggestion in Danto's term of a world of practices is what gives life to Danto's explicit idea that theory is essentially what makes the artworld tick. We are already invited by the implications of the term to consider a world in place when we think about its theories.

Danto's historical artworld can be identified in one or both of two ways. Either the artworld is what it is in virtue of the fact that all of its members hold the same theory; or the artworld is identified independently of the

theory. If the first applies, then I have said we need to refer to the shared practices of that world to give its theory meaning and flesh. Mere theory holding is not enough to make the world into an artworld. If the second applies, we must ask, Who is this corporate person called "the Artworld" who is identified independently of the theory she, he, or it holds? Either we refer to her corporate art practices (which will bring back the notion of theory, but theory understood as part of a locus of practices which give it flesh) or we simply find her and take what she decrees about art to be gospel. "Art," Warhol says, "Isn't that a man's name?" (It could also be a woman's name, call her Artemis.) If the artworld is identified independently of the theory it holds, then Warhol is absolutely right. You find and identify what art is through finding the right corporate person. That art-defining corporate person is to be found in the Factory, or in Montparnasse, or as a natty, marvelous man playing with his marvelous dogs somewhere near the Eighth Avenue subway line and upper Broadway.

If you approach the artworld by trying to identify not the right theory but the right people, you end up replacing the criterion of overall engagement with art and its world by that of what the right person says at the right time, as if art were nothing but a status or fashion or a symbol of connection to the fanciest people you can find. That is to evaluate a concept solely by who holds it, not by whether it is right or even by what it is. Art is a matter of whose fame flashes its fifteen minutes across the title page of the latest European art magazine. Or it is to engage in a move whose politics are transparent, the move of making the concept of the artworld tractable through condensation of its entire histories and theories and practices and people into the space of a city called new York or Paris (as if localizing conceptual space clarifies the concept). That is rank, undefended self-importance, for however important one's city is, its picture of art is (1) incomplete and (2) a picture of art which it has inherited from others, a picture whose origins do not begin with it alone.

Finally, it might look like Danto's appeal to a special corporate person called "the historical community" itself sets a constraint on the theory and allows us to interpret it, as it were, extra-artistically. Theory would be given historical flesh in terms of the history of social practices, shared social attitudes, ideologies, social goals, and historical necessities, as if Marx were the collaborating author of the history of art. Yet how far can such a history be written without bringing in the role of the visual: of visual training, of styles of seeing, of visual cultivation, and shared visual responses? History cannot, as a whole, serve to interpret theory independent of an appeal to the visual.

To authentically identify the members of the artworld is to have interpreted them and to trust in what they say and do. You discover, and accept or reject, these people (or some of them) dialectically, by finding in the course of your instruction from them that you accept or reject what they do, say, and feel about art, just as they help you to form your opinions, ideas, and styles of response to art. And what then is this artworld which you dialectically enfranchise and disenfranchise while it educates and enfranchises you? It is an amorphous plethora of persons, critical texts, already accepted art objects, of institutions at hand and far away, of galleries on local streets and museum collections peered at in faded books, of readings from art history classes, and of the history of art. It has remained the same and it has radically changed.

The artworld is, in reality, everything having to do with one's engagement with art; so to state, as Danto does, that it is a theory held by the artworld which makes art into art is to state nothing because it is to refer to everything having to do with art. If you approach the artworld through its shared theories, you will find there is no compact theory to be found but rather a network of practices, beliefs, histories, and experiences, all of which bear a dialectical relation to you. (The artworld is everything under the sun.) Some crucial piece of the story of this definition is missing from Danto's account, even if his account is historical. What is missing is a story about practices, about feelings, about vision, about the history of culture and economics and politics and wars, and about the history of painting and its materials and their technological changes. In this regard, I refer to Philip Fisher's work on the role of that institution called the museum in shaping the way art in the West has been made, viewed, understood, and appreciated. I also refer to Lewis Mumford's work on the role of technology in shaping concepts of art and architecture.[31] Let us call the sum total of these stories the story of Galison's three factors—observation, theory, and material history—transposed to the domain of art. Or, more compactly, let us call that the story of art (following Gombrich). Let us, returning to Danto's weaker version of holism, say that theory is part of that story by being interwoven with a whole configuration of attitudes practices, beliefs, habits of action, and styles of feeling, which as a whole creates, coheres with, and influences theory, and which allows us to interpret it, just as theory in its turn plays its own influencing role in the education of the eye and the mind.

This, then, is the problem with Danto's weaker and stronger conceptions of theory. On the one hand, he gives us a picture of theory as holistically interwoven into the fabric of perceptions, practices, and styles of life gener

ally. According to this picture, if theory is that which makes a work of art a work of art, then everything else interwoven with theory must also play its role in making art art. In other words, a variety of factors, visual and theoretical, interwoven to various degrees, serve in various weights and measures, to make art art. The stress is on the joint interaction of these factors, on their organicist interpenetration and their partial separability. On the other hand, starting from Quine's position of radical interpretation, a position, according to Danto, transposed into the domain of art by a set of radicalized art examples (Warhol and some red paintings), Danto claims that theory—as opposed to perception (and a variety of other factors)—is the essential element which makes art art, as if you could give a complete description of every visual quality of an art object typically and leave the question of what makes it art totally underdetermined. Both ends of Danto's conception of theory cannot be true. The first, holistic, claim seems to me arcane in its formulation but nevertheless incisive and correct. The second claim is not even true of Warhol's radical art. In addition, it will lead to an insuperable paradox about how to identify the meaning of the theory amid disputes about its applications.

7/ Reading Arthur Danto's Reading of the Object

I

I have suggested that Danto's modernist attempt to write the history of art in terms of the defining role of theory, has unhinged the very idea of theory. Reading his philosophy carefully, one ends up with the picture of an artworld in which theory has replaced vision in defining the meaning and integrity of paintings and in which painting is indistinguishable from its theory. One also ends up with a set of resulting questions about how painting differs from books you read in academic bookstores, a resulting essential undecidability about how to understand theory from within the circle of mere interpretations of it, and finally, a recourse to the authority of whichever fancy critic or famous twenty-year old artist has his or her fifteen minutes. Danto's philosophical difficulties, paradoxically, turn out to exhibit a set of conceptual connections between (1) loss of the visual, (2) the rule of theory, (3) the undecidability of theory, and (4) reliance on personalities (and ideologies and kitsch) to replace concepts and hard visual work. These conceptual connections exactly picture a possible world whose nightmare version is (perhaps) happening today. Then Danto's philosophy has a paradoxical and wholly unintended cultural role to play in the elaboration of the artworld of the 1980s through its unwitting presentation of a set of conceptual connections which turn out, just suppose, to be descriptive of the current scene.

How much this nightmare vision of theoretical art corresponds to 1980s reality and how much Warhol, the great elaborator of the world of the fifteen minutes, finds a place in this den of iniquity are questions I will raise in the subsequent chapters of this book. For "cultural," read, "difficulties in the life history and practices of an artworld." Let it be noted that I am skeptical of finding a clear answer to the question, baldly put, of what the character of the artworld has been in the 1980s. (My skepticism about cultural explanation will itself be a main topic in the final chapter.) But first, we have not yet finished with Danto's philosophical claims and with his reading of the avant-garde.

Danto posits a metaphysical distinction between artworks and real things. It is at the core of his philosophy, which claims that a theory is what turns real things into artworks. He further claims that the avant-garde art-

ists, his philosophical compatriots, have also been concerned to discover his metaphysical distinction; their art has shown how real things become artworks. That the avant-garde has turned to the world of things for its medium, making sculpture out of wire, found objects, and even the landscape of the earth, is well known. Surrealism has turned art into a kind of bricolage assembled from old photographs, dolls, postage stamps, and anything else it could find in the flea markets of Paris. Picasso and Braque have made collages out of the intimate objects of their lives: a pipe, a glass, a bottle of rum. The list goes on and on. Danto believes these events have been implicit gropings for philosophical truth, the truth of the distinction between things and artworks which Danto himself, with the help of Warhol, discovered.

In this chapter I will test the metaphysical distinction which Danto claims he has discovered. I will then consider whether it was the avant-garde's purpose to discover this putative truth when it turned in a variety of ways to the things of the world for its materials, sources, and subjects. I will end with some remarks about the role of objects in this century's art and culture.

The first question to be asked is a philosophical one about the relation between artworks and ordinary objects or real things. According to Danto, Warhol shows us that the position of radical interpretation is true of his art and of art in general. Warhol's revelation has the dimension of generality worthy of philosophy. From Warhol the artist/philosopher (and from Danto who has made Warhol's gesture verbally clear) we learn the truth of the rule, "$I(o) = W$." It is an interpretation mapped onto an object which makes the object into an artwork. I have disputed the claim that it is mere interpretation which gets you from an object to a work of art, but I have left standing the starting point for his claim: the distinction between mere objects and works of art. This distinction is supposedly at the heart of what Warhol tells us since his artwork shows, according to Danto, what it takes to get from mere Brillo boxes to *Brillo Boxes*. If I am right, Warhol's *Brillo Boxes* is not so easily identified with its real counterparts. Warhol's boxes are inflated, visually appealing (and visually deadening) objects, half crafted and half mass produced. Then, rather than show one something philosophical about how it is the air of abstract ideas which turns real things into artworks, Warhol's boxes show one just what one would expect: that it is the artist's silkscreening, his play with size, his painted deadpan look, his ironizing, his play with similarities and differences between art and real things which makes Warhol's boxes art. Warhol cannot be relied on to demonstrate Danto's philosophical point. Then who can be relied on?

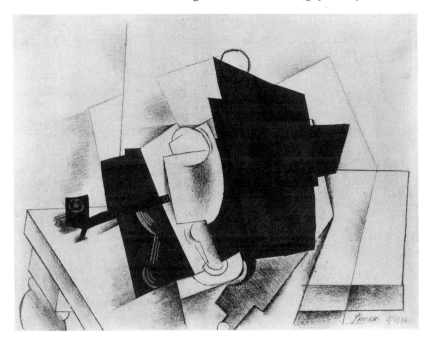

Pablo Picasso, *Pipe, Glass and Bottle of Rum,* 1914. Cut-and-pasted papers, pencil, gouache, and gesso on cardboard, 15 ¾ × 20¾ in. Collection, The Museum of Modern Art, New York. Gift of Mr. and Mrs. Daniel Saidenberg. Photo ©1992 The Museum of Modern Art, New York.

Let us rely on Danto himself. Danto makes his own claim about how real things relate to works of art; it is a claim worthy of discussion on its own terms. Danto's distinction is a metaphysical one between two orders of reality: mere things versus artworks. Now in order to metaphysically distinguish artworks from real things in the way Danto's theory requires, one must be able to give a complete characterization of real things (the *Brillo Boxes* qua mere boxes, the Rembrandt canvas qua mere marks of oil paint on paper) independent of bringing in an art-making description of the box, or the paint on canvas. Only then will the artwork be a new, metaphysical dimension added to the already existent, mere thing.

Danto expects that a new order of theory is the ingredient which, when added to real things, makes them into art. I have rejected that idea as too simple. It is a variety of factors in combination which define art, not simply (or even primarily) a theory. But can we retain the metaphysical distinction between artworks and real things without relying on the expectation that theory is what will spell out the difference between these? Let us try, let us

try if only because (1) since the eighteenth century, the history of aesthetics has continually stressed essential distinctions between art and reality of all kinds, and (2) our ordinary concepts of art ought to contain some sorts of distinctions between art and other objects, otherwise we have lost the subject of art altogether. What, then, is the distinction between an ordinary thing and an artwork?

Nothing, apparently, could be clearer than the distinction between these two orders of reality. One might dispute the fact that it is theory alone which transfigures a soap box into a museum piece yet still believe that something (or everything) must get on the soap box to add that special *je ne sais quoi* to it which makes art out of mere Brillo. And nothing seems more natural. Rembrandt starts with a mere piece of canvas stretched across a board, adds splotches of color to the canvas and ends up with—splotches of color on a canvas which are also, mysteriously an artwork. Rodin begins with a block of marble and ends up with a block of marble which has been decimated at enormous cost of time, energy, and exhaustion for the sculptor and his model—a block of marble which is now more than a mere block of marble. An artwork is a mere thing and something more, the something more being not the addition of another thing added to the basic thing but, as Danto puts it, the original thing's transfiguration. (Similarly, according to Quine's irresistible insight, language is mere sounds sounded in a place and time, or mere marks on paper, plus something more—the something more being not the addition of yet another thing to the mixture but rather the addition of a linguistically transfiguring interpretation in terms of meaning and belief.)

Nothing appears clearer than Danto's starting point, the distinction between artworks and mere objects. Indeed, there are two such distinctions which ring true: one between artworks and other things, the other between an artwork and the materials from which it is made. Both distinctions must obtain in order for the concept of an artwork to have even the slightest shred of integrity. The first states that not all objects can be artworks. Concerning it, every thing in the world can no more be an artwork than every thing can be a tree, a number, the moon, or a person. The seriousness of art depends on its contrast to objects which fail to deliver what it delivers,[1] or which deliver something else. Moreover, one can only learn the concept of art (or any concept) by coming to appreciate a set of contrasts between objects classified as artworks (or trees) and other classes of things.[2] The second states that there is a difference between mere materials and the artwork made from them. Concerning it, the very idea of a work of art involves the

idea of a kind of work done on some materials. And related, the idea of a medium demands a distinction between materials and the art from which they are made (sculptures from mere clay or mere bronze).

Such distinctions have their place but also their limitations. The idea of a medium also causes us to wonder just how stringent the distinction between artworks and mere materials is since a medium depends on a profound inner link between materials and the art from which they are created. The mere materials used in a medium of art are known from the perspective of the use with which they are invested in the art. A canvas is not simply known to be a stretch of cotton but an object for painting. A block of marble, the right marble Michelangelo searches in the stone quarries of Carrara to find, already contains, to his way of thinking, the form in the stone. To someone else, the stones of Carrara may be mere blocks; to Michelangelo they are already art in gel. Then is the stone "just an old stone," which awaits transfiguration by Michelangelo, or is it already a thing among whose features is its capacity to shine through in classical sculpture?

What, in short, is the mere thing? How do we identify and characterize it? A location chosen for filming is chosen from the perspective of what it has to offer the film. A hilltop is Tuscany is not simply a spot of land but a place immediately known for its perfection as an architectural setting, for its potential setting for a city, as if the place is not simply a place, but in the ordinary commerce (belief schemes) of medieval or Renaissance Italian life is a place whose ordinary status will be interpreted from the perspective of its architectural possibilities. Insofar as our ordinary modes of knowing things, materials, and places are colored by our cultural history, by our styles of art making, and by our immediate perceptual responses to their beauty, dignity, and sacredness, insofar as we know things and places from the perspective of their possible uses in a medium, then the ordinary object seems to contain possibilities for art and aesthetic aspects among its defining features. Lurking behind our ordinary descriptions of basic things are concepts of their arthood or their aesthetic aspects. Then the distinction between two orders of reality cannot be kept immaculate and is partially attenuated.

This capacity to know ordinary things from the perspective of their use in art or from the perspective of their beauty, pleasure, expressivity, and poetry runs very deep in our ordinary experience of objects. Indeed Brancusi's *Bird in Space* series is possible only because our ordinary experiences and conceptions of birds already have aesthetic dimensionality. When you know a bird, do you not know (among other things) its crystalline patterns

of flight as if they were a kind of transfiguration of you? Is not a bird's capacity to transpose itself through our vision of it part of what the bird is, or at least part of what we know the bird to be? Without this ancient knowledge of birds, a Brancusi *Bird in Space* could not strike home, for it would have no home to strike, the homing instinct in that sculpture being its capacity to recall our secret knowledge of birds. So is the bird—I mean the eagle, not the Brancusi—then a work of art or an ordinary thing? It is a living being, part of whose definition (if not biological definition, then more general definition in the commerce of life) resides in its poetry. All natural beauty, from sunsets to the white cliffs of Dover, blurs the distinction between things and their transfigurations, since the beauty of nature is an amalgam of its features and our capacities to artifact nature into a scene, or to project emotionality into nature's forces and features. And what of the expressive faces of people or the poetry in their souls? These features of people take on the aura of art (the face of an Italian girl from Perugia which recalls a Perugino, which in its turn is a painting fashioned from the faces of her ancestors). The entire range of ordinary objects which are made well or made badly, made to look cleanly functional or garishly kitsch, made to be used and to define their use through their features of expression and form, is a range of things of which it is too simple to say they are mere things as opposed to art. They have their element of art. The possibility of art resides in the poetry of ordinary things: in the hard, idealizing feel of a polished block of marble, in birds, the drenched bogs of late November New England days, in the faces of Jimmy Stewart, Edward G. Robinson, and Garbo. Of course, what one can see in ordinary things and what one can create from them exist in dialectic. Brancusi depends on our ordinary recognition of the voices of birds for his art, but perhaps no one would have noticed, or have been able to notice, the fragile twitch in Jimmy Stewart's eyes and mouth before Hitchcock's *Vertigo* or been able to fathom just how beautiful marble is before the days of classical art, which only goes to show that either an artist has an eye for things—for *things,* which is to say, for their features—or an artist's transfiguring work with things contributes to how the things will later be seen. It works both ways.

Stanley Cavell says about John Dewey's *Art as Experience,* "What Dewey senses in his insistence [is] that art could not make happen with experience what it makes happen, unless it were already happening, as it were, inartistically."[3] The distinction between art and other things does not disappear, but it cannot have the complete force Danto thinks it has since the very possibility of art partly resides in our capacities to invest objects with

expression, beauty, and dignity of form; in our tendencies to form attractions and repulsions toward objects (and people and dogs and sunsets); and in the art already defining the shape of our constructed environment. It is for this reason that the designer of the Brillo box could think of suing Warhol for stealing the art already contained in that most ordinary thing. Warhol celebrates the art already resident in the Brillo box by putting the Brillo box on display within his *Brillo Boxes*. I described Warhol as invoking the distinction between ordinary things and artworks in part to show that there is no such distinction, for the designs which comprise America, from its buildings to its city spaces to its shop windows on Madison Avenue to its deco ironing boards and its handmade country nails, for these designs are already of the domain of art. When the avant-garde wants to change the face of life, it tends to opt for re-construction of the total environment, for the artistic construction of life is everywhere, hence its reconstruction must similarly take place across the board. Avant-garde art must start from scratch because the world is permeated by art from top to bottom.

Where, then, is the metaphysical distinction between an ordinary Brillo box and a work of art? There is some distinction to be found between artworks and other, ordinary things such as Brillo boxes, but one should not take the distinction to found a metaphysical claim to the effect that a new kind of object is being created out of the mere thing called an artwork when the right interpretation is added. It must be a more permeable distinction, one which acknowledges that an artwork flows from, grows out of, works with, discovers, reveals, cancels out, works in tandem with, or attempts to annihilate the thing it begins from. An artwork brings out the aesthetic qualities in the thing or its possibilities of art. It mirrors these, or idealizes them, or fantasizes them into supererogatory existence, or it simply shows the thing off in its best light. It is part of Danto's own modernism to assume a radical split between art and life, as if art is a new order of persona on the scene of the world which can then recast life in its radical lights (or fail to do this). This Danto shares with the avant-garde, whose search is for a radical example which will be the beacon of that new order of reality on the horizon of the world called "the future." But the radical split, the metaphysical split, between artworks and real things cannot, it appears, be maintained either by Mondrian's art, which aims to institute revolutionary change by bringing philosophy into the world, or by Danto's intention to show once and for all the nature of the cleavage between art and reality.

Consider certain facts about the porousness of the distinction between artworks and real things. The other side of Warhol's celebration of the lack

of distinction between artworks and ordinary things, is his so very American conviction that high and mighty art is lacking in special distinction. Warhol's populism (and his professed love of the veneer of everything) may or may not be (completely) true, depending on the sort of distinction one has in mind (or the sort of veneer: burl walnut, marble, formica). As is well known, Warhol is raising thoughts about the fact that artworks are commodities, part of the commerce of cultural, political, and economic life, when he denies that fine art is an art of distinction (distinct from everything else that is designed, such as a Brillo box).

Fine-art artworks are also ordinary: they have a host of ordinary uses; they are subject to a variety of ordinary abuses; they, too, can sell their souls or be sold; they, too, are created in the context of systems of patronage, for social purposes, with specific utilities in mind, pleasure itself perhaps being one (as when the eighteenth-century nobleman could take pleasure in his representation as Achilles, or take pleasure in the latest version of *Suzanna and the Elders,* with Suzanna, of course, making a cameo appearance in the nude. Surely if Titian's *Venus* defeats pornography, it also *is* pornographic. That is what makes loving it difficult.)[4] In general, artworks can be among the most ordinary things of one's world with the most ordinary uses.

Notice that I am referring to the art object under the descriptive kind term "artwork," for it is as an artwork that the thing is known and appreciated as the kind of thing it is. Collectors of art acquire artworks to have and to hold, to decorate the spaces of their houses in the way others breed dogs or collect matchbook covers. Is the fact of collection an abuse of art or not? It obviously can be. Artworks, if taken seriously, become part of the fabric of one's ordinary world. That is among their uses.

It will be denied that Danto's distinction comes to any such extreme position about the use characteristic of ordinary things versus the lack of use characteristic of artworks. It will be denied, that is, that Danto's distinction is an inheritance of eighteenth-century aesthetics. All Danto wishes to claim, it will be objected, is that while ordinary things may share the same uses with artworks, the difference between the one and the other is a matter of how theory is applied to the former. Whether the theory which makes art out of ordinary things prescribes or proscribes the artwork's uses is a matter of the specific innuendos of the particular historical theory. Thus, eighteenth-century theory proscribed all uses for fine art. Early twentieth-century art theory, by contrast, investigated and debated how deep the use of art should go, with the constructivists split over this issue. (Tatlin argued for art's complete utility; Gabo, for its capacity for exemplification.) This

sounds reasonable. Yet it depends on the prior view that it is theory which turns things into artworks, in this case, the artist's own theories. And this is the crux of the matter. Only by recourse to a theory can artworks be metaphysically distinguished from real, ordinary things, granted how much artworks *are* ordinary, real things. Give up the idea that theory is what makes real things into artworks and you have given up the capacity to spell out a metaphysical distinction between real things and artworks. We have given it up. The only other way to metaphysically distinguish artworks from real things would be to return to the full force of the eighteenth century's distinction between fine and useful art.[5]

The very idea that we have a clear way of dividing the world up into things versus artworks made from them does violence to the concept of what a thing is. It is a leading idea of Wittgenstein's that a thing is known through its use. A thing is, if one takes Wittgenstein's line, the thing it is through its use, through how we treat it. In the sphere of art, the thing referred to, known, and taken interest in will often be the artwork itself. For example, collectors do not collect "clay," they collect sculpture or, more specifically, clay sculpture, or Mayan clay sculpture, if that is their taste. The thing referred to, known, and serving as the object of the collector's interest is here the sculpture itself, not the mere clay. Then the ordinary thing is, in many contexts of use, the artwork, not the mere clay, thus collapsing the distinction between artworks and things. In India, one can buy old silver objects by the gram, regardless of how finely they are made. There, the thing is identified through its material correlate, not through its degree of craft or arthood. But anyone whose interest in a Rodin had to do with the clay alone, anyone who paid top dollar for a Rodin only for the clay, would have to be out of her mind. We identify what the thing is by our interest in it, and our interest here is in the artwork. It is odd to hear someone in a museum speak of "that piece of clay over there" rather than "that Rodin"; one does not initially know to what she refers, for one does not expect the object to be identified by that arcane description. (You might also have heard right but understood wrong; she meant "that Klee piece over there.")

The very integrity of a thing depends on a context of use and a conceptual scheme. There are, in sense, no things without a context. If no person had ever lived, then it would be too simple either to say that a tree had fallen or that it had not. The thing we call a tree, granted our existence and our concepts, would have fallen regardless of whether we were there or not. In that sense we draw a distinction between our way of describing the thing and, dare one say it, the thing itself. But neither is it quite right to say that,

independent of our conceptual scheme, it would still be a tree, for part of what it means to say that the thing is a tree is to say that we have picked out/ conceptualized certain of its features in our terms, in terms of our concepts and our interests. We have conceptualized the thing as a piece of the glory of nature, which means we have a rich concept of what nature is. We have thought of it in terms of how we use its wood and leaves, how we watch the birds play in its branches, how we fathom the expression in its bending boughs. Without us to characterize the thing, the thing which falls in the forest is exactly what Kant says it is, an "I know not what." What the thing is remains undefined without our holistic characterization of it and, related, our beliefs and attitudes about its use.

Thus the only place for the concept of a thing independent of our mode of conceptualizing the thing, is a place for an undefined, incomprehensible existent.[6] When we move from the concept of a thing as an undefinable, to the concept of a thing we can know, we move to the idea of referring to the thing, naming, and identifying it. Naming, identifying, and characterizing are done from the perspective of our conceptual scheme, a conceptual scheme which, in turn, reflects our various modes of interest in the thing. What we then parse as the thing depends on our context of interest.

To continue this train of thought, what we call the *thing* in the sphere of art depends (1) on the context and (2) on who is doing the interpreting. In one circumstance, the silver is the thing, the thing which matters. In another, the play's the thing (or the painting) for that is exactly how what is happening is identified, defined, interpreted, and has an interest taken in it. Our route to the thing in art is through our descriptions or, at any rate, through our vale of experience. Sometimes the thing is the painting, at other times we refer to the thing and mean the material correlate or the lines on the canvas or the painting's frame itself. From the perspective of money, the thing at auction is the artwork; from the perspective of love, the thing one loves is the artwork; from the perspective of the avant-garde, the thing which aims to change our lives or bring about utopia is the artwork; from the perspective of the experience of sculpture, the thing one experiences is not the marble alone but the total sculptural form. Then it is too simple to say either that an artwork is or is not a thing. It depends. Thus there can be no overarching distinction between artworks and things per se.

Distinctions then have their ordinary uses and their ordinary limits. A sign of the variable character of distinctions between artworks and mere things is found in Danto's own vacillations concerning what the mere thing is to which his artworks are opposed. Sometimes Danto formulates his dis-

tinction as one between artworks and mere "material correlates." Here the contrast is between a painting and the mere paint on canvas from which it is made. At other times the distinction is between an ordinary object and an artwork (Brillo boxes and *Brillo Boxes*). At still other times the distinction is between a mere painting and an artwork (when Danto states that it would take Neolithic aesthetics to turn the cave paintings at Lascaux into works of art). These do not compute into a single metaphysical distinction. They compute into a number of distinctions drawn from a number of perspectives. If one decides for reasons of philosophical realism that the only real thing is the material stuff, then paint on canvas is the metaphysically real thing, as is clay or marble. (Similarly, the real thing in language will be the mere sounds sounded in a physical context.) But if that is one's route, then the ordinary Brillo box or the cave painting are no more the real stuff of the world than the Rembrandt made from paint on canvas or the Rodin or the Brancusi. The ordinary Brillo box will not, from that perspective, be a thing because it is a designed and produced object. Yet according to Danto, the Brillo box is itself Warhol's medium of art, just as mere oil paint on canvas is Rembrandt's, and is therefore a mere thing.[7] So the Brillo box both is and is not a thing by Danto's own lights.

Ordinary things are too complex to be placed into the procrustean bed of Danto's distinction. They are and are not "mere things," depending on how the distinction is fleshed out. But so are the media of art. The distinction between the stuff of a medium and the art made from it does not strictly coincide with the distinction between things and artworks, for art is now made from art. Rauschenberg erases a painting of De Kooning's; Cage takes his material in *Roratorio* from *Finnegan's Wake*; Cindy Sherman works from film stills and from herself. De Kooning's painting, the source of Rauschenberg's art, is then both an artwork and a mere thing (material correlate). Ordinary things are made from artworks, which are made from ordinary things, which are made from other ordinary things, which become artworks, which are themselves called things with their own internal uses. Wallpaper is as it is because of Mondrian and Frank Stella. And a Rauschenberg will then take that wallpaper and turn it into papier mâché. And so history and the world is constituted and reconstituted over time.

All Danto means by his distinction, it may be objected, is that at a given point in time we have a set of things, some of which are made into artworks by interpretation (or whatever vision, feeling, community, and history it takes), and others not. Some things are not artworks but are mere things (like the paintings of Lascaux, or Brillo boxes), fine and required. But

merely to say that some things are art and others not, is not yet to say anything more about what the distinction is. In particular, it is not yet to invoke the metaphysical distinction between orders of reality—thing versus art—for all that has been said is that, at a given time, some things are art and others not.

It is this further, metaphysical distinction between orders of reality which must be objected to. It leads to a concept inadequate to the richness of what an ordinary thing is. We have seen that most objects to a greater or lesser degree have something more—a bit of beauty, or ugliness, a bit of design or its flagrant lack thereof, an attractiveness or not. Then they, too, are not mere, ordinary things. Ordinary things can be constructed from artworks and bear the traces of their artistic antecedents. At a given point in time, mere things are invested with the traces of art; they are not mere things. Nor are they quite artworks either. They become ghostlike inhabitants of some metaphysically obscure region.

Then Danto's metaphysical distinction between mere things and works of art ends up unable to account for its very starting point, the claim that a Brillo box is just a Brillo box until something comes along (a theory or whatever) to make it more. A Brillo box already is more, just not quite enough to be art. And the correlative claim that Warhol's box is protected from the status of being a thing by a theory is also false. It is an ordinary thing in many ways. The distinction between artworks and mere things is more dialectical than Danto imagines, let us say, more dialectical than metaphysical. Nonart is continuous with art, while at the same time, the class of artworks is marked out as distinct from other things. Distinctions between artworks and (other) ordinary things must be put in their right place, that is, re-placed.

Let us briefly pursue their replacement. There is literally nothing, it was Dewey's claim, that is not aesthetic. Dewey's problem was to find a way to acknowledge the continuity between artworks and other things required for the possibility of art without totally collapsing all distinctions between artworks and other artifacts, natural scenes, and so forth (as Warhol would seem to desire). For as I remarked, there must be some distinctions between artworks and nonartworks in order for the concept of an artwork to have integrity. Distinctions must have their place. And if they have their place they have their limits. Dewey is not successful in negotiating the problem because he does not grasp the contextual character of distinctions. Artworks are, in fact, distinguished from nonartworks in a multi-perspectival way. One cannot define artworks without beginning from the fact of the

history of a medium, from the fact of classes of things called paintings, sculptures, and drawings. One begins from the experience of these genres of art, and art is defined in part through reference to those genres of objects—to paintings, musical works, and films. One begins from the history of norms regulating the activity of such genres, from their roles in society, their receptions by communities, from their placements in nexuses of social reality. At the same time, the reception of these classifications and genres occurs along with an education into the powers in these groups of art objects. These objects create differences between themselves and other things simply because they are known together and made in recognition of one another, as Jacopo da Pontormo paints to respond to Andrea Del Sarto or Michelangelo designs to outdo Lazzari Bramante, which means these architects have a shared style of doing. But the art objects also form a family whose features are alike, and whose features are known through their interpenetration with one another.[8] Artworks are known to be the things they are through the way they emerge from a million features of experience that are already happening, from the experiences of projecting of moods onto nature, from human attachments, from the need for play, and from the capacity to communicate, the need to assault, reach, engender, possess, represent, or annihilate the world and the people in it. Artworks emerge from the form of nature, the feel of cities, the light of Venice which the Venetian painter already knows, they emerge from nowhere (which is to say, no clear place) and from everywhere (which is to say modern life), from other works of art and from other books, from an artworld, from changes in the materials of paint and in technology, and from the same landscape painted yet again, from the designs of America (its Brillo boxes) and from the designing facts of American money, stylishness, and success. In short, artworks can be different from the rest of things only by sharing in their likeness, which is to say, the metaphysical distinction between art and mere things will get you exactly nowhere if you want to understand how artworks come into existence and hold together as a class. Tools, sunsets, ordinary sounds have their artistic aspects. One can, in certain moods, make art out of them by applying one's ears or eyes in the right way (Cage's lesson). And the distinction between artworks and nonartworks is flexible, subject to some degree of shift in the winds of life and theory, and subject to intermediate cases which it is too simple to speak about as art without remainder, or about which persons can forever disagree.

Thus one cannot formulate the distinction between artworks and ordinary things with full clarity; rather, there are a set of interrelated distinc-

tions which have their uses (and their limits), which play a role in the for-
mulation of one's experience of a certain class of objects, and which are
proved applicable in the course of one's experience of those objects. These
collectively spell out the subject of art, a subject which is only comprehen-
sible against the background of everything that is happening in and around
art. Art is distinguished from the world in which it inheres dialectically.

II

I now wish to return to Danto's reading of the avant-garde. His reading
states that the avant-garde has, in the spirit of Warhol, thematized objects
in order to solve the philosophical problem of how things become art. The
avant-garde's interest in objects has been the same as Danto's; it has groped
toward an understanding of the metaphysical distinction which Danto fi-
nally elucidated (thanks to Warhol). Danto's distinction has been criticized,
but was it the avant-garde's desire to discover it? Or was the avant-garde's
thematization of ordinary things put to some other purpose? We have al-
ready seen that the avant-garde's game of theory was utopian in inspiration.
What of its game played with objects?

I wish to make the point that the avant-garde does not simply, or even
primarily, thematize objects in the course of its ongoing search for some
metaphysical truth about artworks and real things. It confronts the object in
the course of its revolutionary play with the world, in the wake of its fire-
power directed at objects, in the process of its exploration of the flexibilities
of objects. The avant-garde search is for new arrangements and new con-
texts in which objects become capacious, in which they serve to undercut
established patterns of thinking, in which they take on powers of excitation,
of reverie, of horror, and of other extreme states, in which they are invested
with the lunatic chemistry of which El Lissitzky speaks. Avant-garde artists
approach objects in order to change them or to use them in the alchemical
transformation of the world, not simply in order to interpret them. And if
the avant-garde does aim to interpret objects, the mode of interpretation is
more that of an unmasking or uncovering which, like a psychoanalytic in-
terpretation, is deep.

Our century has indeed been obsessed with the whole topic of things
and what can become of them in art in a way no other century has been.
While our century has been obsessed with raising things to the level of art,
it has also been obsessed with demystifying the sphere of art to that of yet

another kind of thing in the world. Warhol is an inheritor of this play with art and with things, a play with its sources in dada and Duchamp. But Danto has gotten the level of this play wrong. Twentieth-century play with things and artworks is not so much a philosophical exploration of timeless, universal relations between things and art (although that is involved, especially with Duchamp) as it is a way of interceding between art and things. Avant-garde play with things is a way of disturbing received expectations viewers have about the order of things; it is an attempt to break out of that order, as if by breaking through the order of things one can break through the human mind and the social arrangement of humanity. This is the century of the found object, of the collage in which numbers, newspapers, paintings, and pictures of guitars become merged in an art which celebrates the ordinary while at the same time placing it under estrangement. This is the century in which the irrational associations exhibited by arrangements of objects are celebrated by the surrealists, in which the capacity for an object to be transfigured by an extraordinary use is invoked—as if the order of the world or the mind could be broken through if only one could find the right assemblage of things. The surrealists take old prints, faded photographs, hairbrushes, watches, paintings of the Virgin, hotel bills, wine labels, and bits of wainscoting and tinsel and make magic, assembling these so as to make one dream the pages of Rimbaud. Objects, like people, have become our friends. There are a hundred different relationships to objects which we have realized are possible, and the character of our relationships to objects has been as stable and as unstable as the relationships we have had to other people in this fateful century. This means that objects have also become our enemies, the things which have required recasting or annihilation. The world has become the material to be recast by art because the avant-garde has wanted to place the world under transfiguration.

Marjorie Perloff says of Picasso, "In a Picasso collage or construction, the intrinsic properties of the medium are . . . less important than the oscillating role the collage-piece plays in the larger pictorial synthesis. As Picasso himself put it: 'The sheet of newspaper was never used in order to make a newspaper. It was used to become a bottle or something like that. It was never used literally but always as an element displaced from its habitual meaning into another meaning.'"⁹ Perloff goes on to describe the avant-garde as a laboratory for the new whose chemistry is the displacement of signs from their ordinary commerce in the interests of liberation and rearrangement. This is certainly how El Lissitzky thought of art. Our century

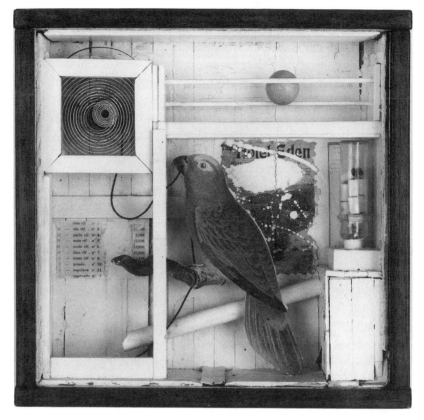

Joseph Cornell. *The Hotel Eden,* 1945. Assemblage with music box, 38.3 × 39.7 × 12.1 cm. National Gallery of Canada, Ottawa.

has brought to light the object as a medium in order to engender what Perloff glosses as "a radical questioning of existing modes of representation," not to mention of the world.[10]

Philosophical theory may be involved in this laboratory of disruption when, for example, disruption occurs on the basis of a theory of the mind (Freud's theory was important for the surrealists). Theory will especially be called on when the aim is to turn disruption of the old into exemplification of the new. When theory is called forth to articulate the terms of the future, and when the future is conceived of in Cartesian or scientific terms—as something to be built from scratch—then at that point the art tends to turn from a concern with the disrupted object to a concern with articulating a pristine art example representative of the divinely cast future edifice of life.

At that point the ordinary object drops out; it is no longer useful for the future. Rather, the glow of utopia finds itself illuminated *abstractly* through the construction of abstract art objects prefigured by theories and design principles. These objects are themselves developed in a laboratory for the construction of new and transparent media. The most philosophical of the constructivist's work, like that of De Stijl and of the Bauhaus, is not built from the rearrangement of objects, it is built from scratch transparently to exemplify the philosophy it aims to embody. (It is significant that these movements are typically architectural, broadly speaking. Architecture is the plastic art least able to be built out of ordinary objects and most amenable to prefigurement by theory of design. Architecture becomes the model of the utopian avant-garde.)

In his recent book *Making and Effacing Art,* Philip Fisher explains this century's concern with objects from another perspective. Fisher retrieves Hegel's idea that in each age there is some part of the world which is alienated from humanity and which therefore requires humanization. What is required is that culture bring the alienated part of the world into reconciliation with people.[11] Fisher thinks that in this century, the alienated region of the world, which art has had the task of bringing into reconciliation with culture, is the domain of objects as such. According to Fisher, the combined forces of mass production (which commodifies everything) and the museum as an institution (which pulls objects from their home and context, imposing an artificial sequence on them as if they are on some aesthetic assembly line) have alienated us from objects (including art objects). The artist's task has therefore been to reestablish a livable, nonalienated relationship to objects. This she accomplishes precisely by reaching out to the alienated object and making a new and comprehensible thing from it called an artwork, in which we can both recognize our complex relationship to objects and humanize our feeling for them, as if objects were wild animals or threatening people.[12] (One might add to Fisher's claim the thought that what the artist is working out through the humanization of objects is also a symbolic humanization of people, from whom we have also, in this horrifying, repulsive century of human actions, become alienated.)

I find Fisher's idea a nice complement to my own discussion, because it brings out the multiperspectival character to this century's artistic play with objects. Art has turned objects into its medium, material, and subject for highly specific reasons, not simply (or primarily) for reasons of philosophical self-discovery. There is a sense other than that of self-discovery, however, in which this turn to objects by the twentieth century is itself philo-

sophical. In my discussion of John Cage, I spoke of a kind of philosophy in Cage's play, having to do with Cage's testing of limits and his exploration of the possibilities of objects (i.e., noises and wordplay). The remark may be generalized. If one wishes to speak of a philosophical message in the twentieth century's machinations with objects, it is that the twentieth century has studied the possibilities of objects and shown that the possibilities of objects cannot be listed in advance by any philosophical cataloger. Change the use, change the arrangement, change the environment in which an object is situated, and one may change the force of the object or even its nature. The twentieth century has transposed romanticism's sense of the permeability of nature, of its suceptibility to changes in mood and complete anthropomorphism into the domain of all objects (the surrealists are romantics in this sense). Duchamp has shown how easily poetry is wrought from objects when their use is disrupted.

Yet this pressure on objects to reform themselves in context has also shown how solid they are, how resistant to revamping their interpretations remain, for it is only because one's concepts of a hairbrush or a watch or an etching of the Madonna remain in place that new uses for these things can appear so transfigurative. Remove the figure and you remove the transfiguration. That is the lesson of Cage's 4.33 for philosophy (and of Danto's attempt to generalize from Warhol to all art). It is a general lesson about the plasticity and hardness of our conceptual scheme and our form of life. (The twentieth century also has shown how deeply objects are defined by unconscious trains of association, how much our ordinary relationship to them is structured in terms of codes of all kinds, ideologies, feats of control, omnipotent fantasies, and expressions of defacement. In this sense, Foucault's concern in *The Order of Things* to expose the relations between concepts, objects, representational schemes, power, and modes of objectification is the next stage after the exposition, unmasking of, and alienation from, the object already implicit in the avant-garde.)[13]

One final point. Danto's distinction between objects and artworks is sometimes formulated in terms of a distinction between the material correlates of a medium (Carrara marble) and what is done with that medium (sculpture). There is something to say about why the twentieth century has been required to thematize that distinction as well. It has to do with the avant-garde's obsession with originality. The twentieth century, it is often noted, makes the reinvention of old media and the invention of new ones among its basic projects. When the norms of established media of art break down, part of what breaks down are norms internally relating "material cor-

relates" to their art productions. The result is that it is no longer clear to a viewer approaching a new work of art where the materials (objects) end and the *art* begins, that is, what is being formed from what, done with what, or exhibited from what. In the avant-garde situation, one must negotiate this problem at every juncture. What the thing is or the materials, what the art-making principle or context, what the point of it all, these questions jointly emerge whether for the disruptive art of collage sculpture or for the invention of abstract expressionist techniques of staining a canvas. Hence the distinction between object and artwork is thematized as a question of how to make sense of the artwork in the absence of clearly established norms (the norms of collage, sculpture, and color-field painting, with its staining of unprimed canvases, are by now established; others remain unclear).

Danto has, I think, seen the importance of twentieth-century thematizations of objects but mistaken the level at which these particular transfigurations of the commonplace have operated in twentieth-century art. They have occurred not in order to state philosophy but to truly transfigure the world, to break through it, and to humanize it. The world of objects (and artworks) is for the avant-garde under rethinking and disruption, not under metaphysical reflection about a general fact of orders of reality.

Danto has, I think, similarly misconstrued the level at which Warhol's most recalcitrant objects must be read, in spite of the originality, audacity, and genuine philosophical interest in his reading of Warhol. But without Danto's reading, it would also be hard to see the level at which Warhol should be read. It is to that topic that I now turn.

8/ *Andy Warhol without Theory*

Here is a prediction: When the multivolume *Popular History of Art* is published, ours will be the age of Warhol—an unlikely giant, but a giant nonetheless.
Arthur Danto

Andy Warhol was the perfect glass and mirror of his age and certainly the artist we deserved.
Carl Andre

I have suggested that Warhol's concerns are far less philosophical than Danto thinks. I do not think it is right to consider Warhol a member of the avant-garde, much less its point of culmination. Warhol does appropriate the avant-garde to his own purposes. He is fascinated and repelled by the purist and intense commitment to art characteristic of abstract expressionism. (He is fascinated and repelled by a lot of things, like stardom and human intimacy.) Warhol is in some sense an heir to Duchamp's antics of art play and art parody and to the originality of design found in Matisse and Picasso. But while Warhol is part of the legacy of the avant-garde, he is crucially not an avant-garde artist, and it is important to see why—important for the understanding of both Warhol and the avant-garde. At the end of chapter 7, I remarked that Danto's reading of Warhol allows us to understand something about the nature of Warhol's voice which would otherwise be less available.

Danto thinks that Warhol's art demonstrates the putative fact that objects (paintings, Brillo boxes) radically underdetermine the characterization of them as art, a fact which I have now spent some time rethinking. I do not think it was any part of Warhol's intention to establish this fact. But I do think Warhol's art has a relation to underdetermination of a different sort. Warhol's art of gaming, of ambivalence toward everything (including art itself) underdetermines any clear interpretation of it to a degree that most other art, including the art of the avant-garde, does not. He refuses us the materials to interpret his art. He does not leave his art hanging to demonstrate that it is only our theories which can serve to pin the art object down but, rather, to make art which is precisely undeterminable. Warhol's game

of indeterminacy aims to defeat theory, to defeat interpretation, and above all to defeat the possibility of having convictions in art. (We are far from the terrain of the avant-garde.) Warhol gives the critic a license to say nothing precisely by giving him a license to say everything. Warhol was notorious in encouraging critics to say whatever they wanted about his art; he even went so far as to get his friends to answer for him, as if to encourage their free play of theory unhinged by the art object. But theory unhinged by the art object floats aimlessly, without the possibility of clear reference, without any homing instinct. Warhol's game was then to produce the state in which theory cannot home in on its target, a state of the unbearable lightness of theory.[1] It was as if, rather than proving Danto's theory true by demonstrating it, Warhol did the exact opposite. He showed that theory, unhinged from the visual and from the art object in general, is empty—a reductio ad absurdum of Danto's extreme philosophy Warhol was more than pleased to live with in his Yellow Submarine.

It will be a central theme of my reading of Warhol to explore the way his art underdetermines meaning and voice, the way it fails to deliver the interpretive goods. Underdetermination is a Warhol logo, it is stamped on every one of his works with authority and ambivalence, interest and disinterest, like a silk screen of Jackie. I will follow out the shifting, blurring, vague quality of Warhol's art, its manner of dissociating itself from meaning. This could be called the character of its meaning and of its style, the question being how exemplary Warhol's peculiar style of inviting and abandoning meaning and theory is for the legacy of the avant-garde. If we have inherited the avant-garde's theoretical practices, then how does Warhol fit in? What is his legacy or counterlegacy? The avant-garde has fractured into a number of different shards since its halcyon days. Warhol's art is one example of how it has fractured. How representative is Warhol's inheritance and rejection of the avant-garde of our age? Both Arthur Danto and Carl Andre take Warhol to be exemplary—with different opinions of the significance of this putative fact. We ought to ask about other styles of art and theory into which the avant-garde has been dispersed. In what other ways has the avant-garde been appropriated, dismantled, toyed with, subjected to flirtation, or reworked? And whose reworking, theoretical or not, is of what significance for whom?

Naturally, asking such a question about the legacy of the avant-garde in this point-blank way can only lead to blankness—at least until we have in view a representative set of examples of art and theory from the 1960s, 1970s, and 1980s. (And what counts as a representative sample? Should

anyone claim to venture an answer?) Yet Warhol is so continuously referred to by so many people, he is so totally fetishized, that either his example or his mode of fetishization or both ought to tell us something about the legacy of the avant-garde. In this chapter I will be concerned with Warhol, with how to understand his art and his example, an example—or is it an aura?— which he was as keen as a movie star to fashion and which has clung to his work the way fans might haunt an aging diva. Danto takes Warhol to be his compatriot. Others in art and theory do not. They view the world, which in some sense was Warhol's oyster, through the eyes of Carl Andre and dedicate their theorizing to the project of overcoming or combating Warhol's world and legacy as they see it. After considering the extreme sense in which Warhol is not theoretical, I will return in chapter 9 to theoretical legacies of the avant-garde, legacies which both accommodate and resist the work of Warhol.[2]

I

Andy Warhol does not aim to recast the world of things according to some utopian conception nor does he intend to radically disturb the fabric of things in the manner of dada or surrealism. He invokes the distinction between artworks and real things, as I suggested, in order to collapse it or to celebrate the fact that the distinction between high and other art, between artworks and commodities, between commercial and fine art, between depth in art and its sleek visual surface is in America already collapsing on its own. In this celebration of the ordinary, Warhol is not avant-garde. The avant-garde wants to transform the world, not to celebrate it. Warhol's vision of the future is that it is already happening in the pop images he sees blossoming across the highways, byways, and golden valleys of America. He has seen the future, and it is the world of the mass-produced object, the Brillo box, the Hollywood studio, and the advertising slogan. If he wishes to transform the world, it is to make the world of art as commodified as the rest of America is becoming (then perhaps it is too simple to say that he is in no way an avant-gardist). About a trip made in 1963 from New York to Los Angeles by car, Warhol says:

The farther west we drove, the more Pop everything looked on the highways. Suddenly we all felt like insiders because even though Pop was everywhere—that was the thing about it, most people took it for granted, whereas we were dazzled by it— to us, it was the new Art. Once you "got" Pop, you could never see a sign the same way again. And once you thought Pop, you could never see America the same way

again. The moment you label something, you take a step—I mean, you can never go back again to seeing it unlabeled. We were seeing the future and we knew it for sure. We saw people walking around it without knowing it, because they were still thinking in the past, in the references of the past. But all you had to do was know you were in the future, and that's what put you there. The mystery was gone, but the amazement was just starting.[3]

We will have to ask what Warhol means by "labeling" a sign. If labeling a sign does not amount to theorizing it into existence, then what is this act called labeling? Does Warhol, in effect, mean that he, the artist/philosopher, knows that it is the theory behind the label which makes art from mere signs, or is Warhol speaking from the imagination, reserving for himself the right to see the world in a new way, call it pop?

We shall proceed indirectly. By way of beginning, first note that the place and time to which Warhol refers in his above remarks is 1963, America. Then, just three years after he had made his first works from comic strips (Batman, Dick Tracy) and his first images of Coca Cola bottles, America was not yet covered with signs, advertisements, and shopping malls. It was not yet a megalopolis of suburbs and freeways and cities metastasized like overlong Midwestern airports, not yet the place which John Cage abhors in his Bicentennial *Prelude* where he remembers the America of Thoreau in order to combat American aggression and the megalopolis. At the moment when Warhol first painted and then silk-screened his pop images, one could still find new movies alluring, Coca Cola bottles fun to drink out of and television glorious. When I discovered there actually was a street in Los Angeles named "Green Acres," I knew it was the place to be, and farm livin' was the life for me (in upper Beverly Hills), for I no longer knew which came first, the city or the television program, the egg or the free-range chicken, or what the difference between the two was. Mass production can feel as though it has equaled nature in its capacity to enforce pattern on the world, engender rebirth each spring fashion season (when "green" is in), and create new "high-concept" objects from what feels like nowhere. This is the moment of Andy Warhol, a moment that makes his pop celebrations look good. It is not clear that thirty years later the mass-produced artifices of America provide an equally attractive lens through which to see his pop celebrations. Mass production has destroyed too much, the megalopolis has encroached upon too much land, art making has been turned to a level of complacency and commodification which is too dangerous. The delicate balance posed between mass production and handcraft in Warhol's work has been in many ways disrupted by contemporary artists who are less subtle in their fetishi-

zation of advertising techniques and artistic production lines. What Warhol celebrated as a golden future is no more golden than the Soviet future dreamed of by Tatlin in 1923. It is as naive as any Mondrian pronouncement from 1942. Is it more naive about art or about the future than the fantasies of the avant-garde? That is not clear. Nor is it clear that Warhol can be viewed independently from the art and America which came after him and for which he is ambiguously responsible.

Warhol's art, while relinquishing both the claim of utopian reconstruction and its opposing claim of profound disturbation, derives in other ways from the avant-garde.

Thomas Crow in a recent article speaks of there having been three Warhols: "The public Warhol consists of not one but, at a minimum, three persons. The first, and by far the most prominent, is the self-created one: the product of the artist's famous pronouncements and of the authorized representations of his life and milieu. The second Warhol is the complex of interests, sentiments, skills, ambitions and passions that are actually figured in paint on canvas. The third Warhol is the persona that has sanctioned a wide-range of experiments in non-elite culture far beyond the world of art." [4] These Warhols are interlinked in many ways, and no interpretation of Warhol can afford to avoid discussion of how. Warhol is an artist whose total art game is styled in a complexity worthy of the avant-garde, with its amalgamations of paintings, sculptures, journals, pronouncements, effacements, demonstrations, gestures, and the like. Warhol's is an amalgamation of his mode of being, his self-styled self-presentation, his velvet happenings in the underground, his paintings, serigraphs, and silk screens, his screening of himself from others and for everybody, his films, his establishment of a factory in which "others would do the work for him" (something all of his assistants vigorously deny really happened; Warhol was always in artistic control while others did the manual labor),[5] his liberation of the Factory into a mixture of hard-core porn/pop life and Shakespearean fantasy, his peculiar style of nonconversation enfranchised as art, his willed conflation of avant-garde practice with love of Bloomingdale's. This panoply of art, spilled across the city of New York into every corner and closet of Warhol's life, shows what Warhol absorbed from the avant-garde: a style. It was as if the avant-garde, while having played out its aims of utopian reconstruction or hermetic seriousness, remained as a style of life for Warhol to adopt in the way others adopt the style of becoming a Hollywood entertainment lawyer or film producer. To some, that is a revolting degradation of all the avant-garde stood for; to others, a way of finally getting past its crazy utopianism

or anarchism and into its fun and romance. The point is that in many ways Warhol's own art mirrored that of the avant-garde and was made possible by it. His reception of Duchamp is the reception of art as a kind of game or activity played out like chess over objects and artworks. His reception of dada anarchism and John Cage's *Happenings* are part of what make his underground events happen, part of what makes them possible. A number of people have pointed out that the exhibition of *Brillo Boxes* in 1964 was a parody of the Happening.[6] My view is that, for Warhol, parody is always also a way of doing homage to the style in the work parodied. His explicit homage to Duchamp came by way of his *Piss Paintings*. Are these a hilarious, audacious homage to (and parody of) Duchamp (not to mention of Jackson Pollock's action painting from the body and famous macho gesture of pissing into Peggy Guggenheim's fireplace), or are they Warhol's way of trashing the philosophical legacy Duchamp worked so hard to establish? It is hard to say. It is also hard to decide how important the antics, the decadent friends, the love of window-shopping and collecting, the sixties happenings are for explaining the significance of Warhol's paintings. A reading and evaluation of Warhol's paintings and silk screens can be quite different, depending on how much one relies on what Thomas Crow calls the first Warhol, the self-fashioned dream image, as a guide to the interpretation of Warhol's paintings. Warhol loved fame and attention so much that he continuously upstaged his own silk screens by his own clothes and his own pronouncements. Is his upstaging desire for center stage and total voyeurship the clue to what his images mean? Is his own personal life an example to rely on when interpreting his silk screens of *Jackie,* or is it simply another region of his total art? We have here a similar quandary to the ones raised about Mondrian, Cage, or constructivism: the question of how the various voices of an artist do or do not intersect, of how important the words or gestures or magazines are for the paintings or silk screens and vice versa. In the case of Warhol, the best strategy is to listen to John Cage and Jasper Johns: "The Situation must be Yes-and-no not either-or. *Avoid a polar situation.*"[7] Warhol's life-style tells you everything about the artwork, and tells you, in another sense, little. Indeed the deeper and more nagging question about Warhol's work is the question of why so many critics feel the need to depend so strongly on Warhol's life for the evidence of what his art means. Is that because Warhol's fine art of gaining attention has seduced them? Is it because the silk screens don't, of themselves, tell you enough? Or is it because Warhol's art of images and stars and his life of image and stardom are so alike that each reveals the other like a twin, as if rather than a correspon-

dence between theory and the art object à la Mondrian, we now have a cor-
respondence between art and life-style? Or is it because we cannot look at
Warhol without thinking about the whole contemporary art scene with its
performers, artist/advertisers, and gallery promoters, with its flaccid at-
tempts at understanding the current world and its flaccid attempts at criti-
cism, with its uneasy celebrations of the money and success and its failure
of creative nerve? Is Warhol, as Carl Andre seems to believe, a mirror of all
of that? Is he responsible for it, for setting it up as a viable trend in art?

Warhol takes on the avant-garde whole as a style of life but without its
original politics, its utopianism, without, that is, its original raison d'être.
The avant-garde is, in Warhol's hands, a game of life, a new look, a new pair
of dark glasses, and a life-style. Yet Danto is, I believe, also, in some sense,
right. Warhol is also an artist who occasions philosophy even if he does not,
as Danto thinks, go so far as to make a philosophical statement in his art.
Warhol is fascinated by the fact that mass-produced artifacts can exist and
can so totally charm him, he is fascinated with the facts of stardom and
success and the American dream which revolves around such things. War-
hol has often been called Horatio Alger, the poor immigrant boy who made
good and is fascinated with the American dream of making good; he is more
likely an amalgamation of Horatio Alger and Shirley Temple, whose auto-
graphed picture Warhol collected at the age of six, for she became a some-
body faster and more thoroughly. That is, it is hard to pin down what the
terms of Warhol's game of art are and why he is playing it.

Warhol modernized art by giving it the appearance of being an explicitly
mass-produced thing, made by his factory with the look of any other mass-
produced thing, and in doing so he intended to further attenuate the dis-
tinction between artworks and things. His series of *Marilyns* taken from
photographs, his introduction of image repetition into the silk screen, his
draining of expression, characterization, and pictorial detail from his im-
ages of Marilyn or Jackie (call it his draining of the artwork of painterli-
ness), identify Marilyn the icon with a mass-produced thing. And she is a
product of film and media and complex circuits of information. Warhol's
introduction of repetition into art through the exfoliation of the image is
truly an artistic advance. His works from the early to mid-1960s jolt the eye
from its ordinary expectations about portraiture, jolt the mind from its or-
dinary expectations about the importance of character and characterization
in art and in people, about the hard pictorial work of knowing a person
through the lens of a paint brush. Warhol replaces the projects of knowing
people—feeling for them or against them, taking the poetry from them, or

representing them in a social nexus, projects defining traditional portraiture—with that of fascination with the construction of the image of people through advertising, film, and the American dream. Put another way, his images of Marilyn are not portraits. This is not the territory of Thoreau's American dream in which people communicate through the hard and natural work of silence; it is the territory of an America which could not have been possible before a lot of things Thoreau was not in a position to know about: things like America's position after World War II, the growth of the factory, and the advent of adverts, films, and everything that goes with them. It is not easy to say what the "everything" which goes with them is, so one should not expect Warhol to have it all figured out. One speaks of "mass production" and "the American dream machine" because one doesn't really know how to explain what these are. Warhol opens the door to our consideration of those opaque and obvious facts and as such, occasions philosophy (and sociology and cultural studies and economic studies and psychological studies) which need to get going and get thinking.

Warhol's paradox is that just as he so totally celebrates the aura surrounding stardom, its glamour and success, he removes from art its aura by doing everything he can to collapse the distinction between artworks and other artifacts of culture. Or rather, he aims to give art a new aura, the aura of the film camera, the ad slogan, and the gaze of millions by removing it from the sphere of individualistic creation, hermetic difficulty, and unrepeatability and investing it with the structure of film and mass production.

It is worth digesting this point. Walter Benjamin claims in a brilliant essay (whose fifteen minutes have rightly arrived as far as the art community is concerned) that the technical forces of mass production are in the process of destroying the aura of art.[8] But, in fact, what Warhol showed is that painting can be invested with something Benjamin was perhaps not in a position to appreciate: the aura of film. There are various conditions of film which jointly can give it an aura. The first has to do with the peculiar presence of an actor on screen, something which entranced Warhol. Concerning it, for Benjamin an aura is the unique power resident in the original. We must be present to the original, as if to a burning bush, in order to receive its aura. Benjamin believes that an actor in the theater has an aura because we must be present to his unique performance in order to receive its force. But in a film, that aura is lost because the actor is no longer actually present to us. Hence for Benjamin, the only role for an aura in film is that of a mass-market effect, the studio buildup of a glamorous star in order to seduce the public and sell films. What Benjamin fails to appreciate is Erwin Panofsky's

insight that in film, the film character and the actual actor are in some profound way the same.[9] In film, the actor—Cary Grant himself or Chaplin or Rosalind Russell—is the visual (and verbal) material for a film in the same way that a block of marble from Carrara is Michelangelo's material, or oil paint, Rembrandt's (or a rare violin, part of the material of musical performance). Of course Cary Grant is not present on film in the way he would be present if he were in your living room; he is, after all dead (unfortunately). The presence on screen of an actor is a Wittgensteinian "intermediate case," one about which it is too simple either to say that he is present, or that he is not. Stanley Cavell registers this fact by saying that Cary Grant is present to us; it is we who are absent from him.[10]

However, the film actor is present to us on screen in a way that is no longer quite him either; he has evaporated only to be reborn in a peculiarly new way. He reappears on screen as an eternally present object or an eternally past one. He reappears as piece of visual (and verbal) material, as if his life is now caught between that of a person and that of a thing.[11] It is this opaque rebirth of the actor on screen as a piece of the eternal present (or the eternal past replayed),[12] that nearly builds an aura into the film medium itself. Note, however, that the aura of film is different from that of the theater. In the theater, it is we who are present to the actors as if to a miracle. That is presence to an aura. In film it is the aura which is mysteriously made eternally present to us, while we are distant, absent from it. Nevertheless, both are (or can be) auric events. For in the case of film, what happens to the actor on screen—his rebirth as a piece of the eternal and eternally presentable which can be visited by the film-going public at any convenient moment—is exactly like the way an aura is shaped around an artwork, place, or thing.

An aura is a mythologizing that surrounds the thing, it is the thing given a halo, worshipped as if in a religion of aesthetics (the religion of the nineteenth century, Franz Liszt, and later, of Proust). The Villa d'Este was built to be a place of pleasure, not a place of worship. When Liszt worships it he is responding to an investment in it which goes far beyond its original purpose, intention, or use. Then the aura both is and is not identical with the original thing itself. It is built from the unique qualities in the original thing (the specific stonework, gardens, and setting of the Villa d'Este), but it also goes beyond these in an act of worship surrounding the thing. I think Benjamin did not appreciate the way the aura supervenes on the original, hence he could not see that an actor's appearance on screen is built from the actor himself in a similar way.[13] The eternal presence of Cary Grant on screen is

Andy Warhol, *Gold Marilyn Monroe,* 1962. Synthetic polymer paint, silk-screened, and oil on canvas, 6 ft. 11 ¼ in. × 57 in. Collection, The Museum of Modern Art, New York. Gift of Philip Johnson. Photo ©1992 The Museum of Modern Art, New York.

an image which both is and is not the real Cary Grant (it is an image built totally from his face, his eyes, his voice, his zany acrobatics, but he is made into a universally available icon). This is not to say that the mere presence of Cary Grant or any other actor on screen is enough to make him into an aura. It is to say that the transformation of him on screen easily prepares the auric, just as the setting of an individual villa in a special landscape does.

Other conditions are needed to make an aura out of film actors and films. A style of public receptivity is needed, a public's desire for seduction, for idealization and romance. Under these conditions catapulting an actor or actress into the eternally present netherworld of the screen can strike its public as the magic of transfiguration. The cult of the star (Valentino) started early in the history of cinema for this reason, not simply because of any studio buildup, although that certainly helped. And while such condidtions are sufficient for the creation of the auric, as film gradually developed a historical past, its capacity for the creation of the aura was vastly enhanced. Garbo was almost immediately worshiped, but it took a bit more time for her full aura to emerge. Only then could her eternally replayable, eternally available presence capture the public's imagination as eternally replayable and iconic. Furthermore, as films acquired the patina of history, the character of nostalgia, and the allure of the distant (something they had acquired by Warhol's time if not by Benjamin's), it became easier to approach them as if approaching a halo. You tend to worship the distant, not your own back yard (unless a spaceship or burning bush lands there).

A character on-screen is exactly a person who is no longer merely herself but is recast as a presence, a piece of material, an eternally available icon. You only have to go to the cinema to see her, you do not have to go all the way to some Italian villa or craggy alpine mountain. Then film has precisely recast the fact of the aura. It has freed the aura from its dependence on the artwork which occupies a unique place. Benjamin's idea was that the technical forces of reproducibility (with film and photography playing important roles) have attenuated the aura of art by making the artwork available everywhere, independent of its unique site. What film has done, rather, is the exact opposite. Film has redefined the original as the film print (perhaps restored) which can be mass produced. Film starts from its original material—the actor himself (and the sets, locations, etc.)—and then recasts him in an auric position on screen so that he is precisely available for everybody. The film print carries the actor's presence on screen, which, seen repeatedly under a special attitude of desire, becomes an aura. Film has remade the

very idea of the aura with the help of the forces of mechanical reproduction.[14]

These remarks may seem beside the point of Warhol, but they are not. Only when we understand the mechanics of this auric evaporation and rebirth of the actor on screen can we understand Warhol's fascination with the film star. And only then can we understand the way he modernizes plastic art in a similar way. Warhol is fascinated with the film star because she dies on screen and is recast as present in an eternalized, "living," re-presented, past. There she is both herself (with her own qualities) and the film's material. It is as if Warhol's fantasy is to die and become reborn as a film image whose life is replaced by glamour and the gaze of everybody. The artist's own relation to his silk screens draws its inspiration from Jackie's relations to the icon *Jackie* or Garbo's to the icon *Garbo*. Warhol identifies with the condition of *Jackie* the icon and aims to live in it through his art—through his silk screens and through his immaculately self-fashioned life. His images are the place where he can disappear from life and emerge as an image fashioned as if through the medium of film—or through the media of TV, print, money, and success. Warhol, like Jackie or Garbo, will be redefined in Camelot terms by the gaze of millions. He will become auric.

This is what Warhol's art is meant to do for him. Instead of expressing him or characterizing him or allowing him a space for formal subtlety and its attendant pleasures, Warhol's artwork is a space in which he can symbolically screen himself into existence, as through an aura. Warhol structures his silk screens like mass-produced things so that symbolically he can live in them like stars living in the public eye. (They also bear important hand-painted, individual traces of the artist, like the faces, figures, and idiosyncrasies of speech of a star). But screening in is also, to rely on another of Cavell's ideas, screening out,[15] and Warhol's art allows Warhol to be buried under the bright lights of his images (both of himself and of Jackie and Marilyn). This leaves him free to watch life as a voyeur without involvement in it, since he is now a kind of fabric which is meant to be seen, not to be touched. (We will have to think about his *Death and Disaster* series in these terms.)

By structuring an artwork like a film image, advert, or label, Warhol's art sets the stage for a new kind of relation between the artist and his artwork: that of the relation of a film star to his or her films. Warhol sets out to change the relation between the artist and his painting from that of the individual craftsman, the person in need of expression, the romantic who

aims to secure reverie through art, the critic of society, or the modernist philosopher/utopian who is part of an art movement, to the relation between a film star and her films. Warhol turns the canvas into something like the condition of film, in which Jackie or Marilyn are the stars who turn into mirrors of the artist and veils for him. In these images, as in the self-fashioning of his life, Warhol screens himself out of sight and screens himself into the eye of everybody. He becomes *Jackie* and disappears into her. As in the case of all stars, it is because of his "screen" image(s) that we are interested in him, and it is because of him that we are so interested in his silk screens. Both he and his artworks play off each other with the same dialectical glamour, the same edited fashioning, the same lifelessness and plasticity. Warhol famously said he wanted to be a machine. He wants to be created and edited by a machine in the way the camera creates Garbo or Jackie. He wants to create art in an apparently mechanical way, not to deface the aura of art by replacing it with the aura that derives from machine-made things. The rest is darkness, or death, the dark underside of a person re-made as an image (or a person from whom tragedy has allowed this fashioning as in Marilyn, or a person like Warhol whose need is to die as a person in order to be reborn as a fetish).

Consider Garbo's aura. It combines the image of Garbo wrested from her films and her own edited persona, which actually screens out Garbo the shy, lonely, difficult person. Or these qualities of her character are turned into part of her aura. Fans can glamorize anything (and empathize with nothing). We have the greatest difficulty reading and responding to Garbo the person on this account. Nor can stars respond to themselves unless they are very well put together psychologically or they construct elaborate defenses against the public eye (as Dietrich may have done). Otherwise their self-reception is trapped in the aura of self-glamorization. Therefore there is a melodrama in being a star: a Jackie, a Marilyn, or a Garbo. There is entrapment by the persona, loss of the emphatic eye from others and from oneself, incapacity to act normally—a condition grossly amplified by our gendered world which defines all women through the public eyes of men. A star (and a woman) wants to resist the glamorized reading of her so she can retain her own privacy since it is so easy for her to internalize the glamorized false knowledge of her that everyone has. Her task is to dissociate herself from her aura or to accommodate it or to enjoy it (again, Dietrich).

Warhol's images vamp the auric because they are more concerned with the mere fact of stardom than with any sustained study of the difficulties of stardom. Warhol is also uninterested in what it is about persons which

makes them suitable material for a type of stardom. For in film, it is specific details which make the person of Garbo suitable camera material and comprise her film persona. It is Garbo's combination of visual radiance and infinitely sad eyes which is unique to her aura and which brands her roles in *Camille* and *Grand Hotel* with the power to define her aura. It is the way Gary Cooper's tight face erupts in a violent twitch around the jaw that defines his characters with that strong silent type of nervousness. It is John Wayne's swagger or Chaplin's walk which matter. Some of these details are fashioned by the actor for the film persona, others come naturally to the actor. But in all cases, the detail in the gestalt does the work, as in certain nineteenth-century French paintings. Warhol drains his images of all such details. He is only interested in the fact that someone is a star, not how the stardom derives from visual/emotional features specific to them. Nor is Warhol's art, at least at first glance, concerned with the person, with the condition of being a star, with how stardom defaces or reinforces the star, with how the star sorts out or does not sort out her person from her persona. (We will partially amend this later.) His art withholds visual penetration or characterization and banks, rather, on such familiarity as either being in place or not relevant to the star. His art, therefore, is not like films in the filmic reliance on the place of the visual detail but is an urge to copy the aura of stardom surrounding film.

Warhol's contribution to the avant-garde (it is too simple to say that he is in no way part of the avant-garde) is, then, to modernize the aura of plastic art. He does this not simply through a set of pictorial innovations in the surface of the image (its elimination of all but surface, its creating from photographs, its introduction of repetition) but also through an attempt to change the relations or production and embodiment between the artist and his artwork. Warhol makes the artist a symbolic producer (screener) of himself as an icon or star through his art images. Warhol's silk screens of Marilyn are the mirror and vehicle of Andy. A corollary of this new relation between artist and artwork is that a new kind of element from the artist's life becomes relevant for the interpretation of his art. We are enjoined by Warhol's style of art to be interested neither in what he read nor in what he wrote, but rather in how he fashioned himself and who he talked to and what his antics were.

Warhol adopts the *Happening* to these purposes: His happenings in the underground are both edited acts of art and edited acts of self-promotion which are meant to reflect on how we understand his silk screens. They are self-advertisements for the art, the creation of a performance persona which

in turn reflects into Warhol's auric silk screens like a star's buildup does, and vice versa. We like the art because Warhol made it and he is alluring, and we are fasinated with him because he has the talent and the gumption to make these images. This is modernization, but it is too simple to say without remainder that it is avant-garde. For recasting the terms of avant-garde art in terms of (1) entry to a work through who made it, and (2) fascination with the work because of its appropriation of the aura of film and mass production is precisely to defeat the avant-garde, which sets for itself the task of making the future conform to the dictates of a new philosophically inspired vision.[16] For Warhol, seeing and being seen are the be-all and end-all, not an avant-garde occasion for bringing forth a theory in visual terms. In this regard, Danto could not be farther from the truth about Warhol. Nothing is less theoretical than his art. We are back, as it were, in the nineteenth century, with beauty being a matter not of a unique sunset or some unique Italian places of pilgrimage celebrated by Franz Liszt but of the latest mass-produced hairdo. Is that worse on both counts—worse than both the avant-garde's attempt to better the world and the authentic beauty of the nineteenth century?

A heady question, the question whether Carl Andre is ultimately right; whether with Warhol we got just what our glamour-seeking, star-struck yuppie world—a world in which the education of feelings is replaced by job security and job advancement, in which recognition of the difficulties of reading the world is replaced by time and energy spent in contracting for a new house, in which the power of memory is replaced by fantasy island— deserves. We got a glamour-seeking, star-struck artist who celebrates the stupid, who reads, characterizes, and memorializes nothing.

I will not exactly attempt to answer that question, nor will I even attempt to answer the question whether ours is an age of which one person (i.e., Warhol) is the mirror. If we could find the terms to raise Carl Andre's despairing, embittered question, that would be an advance. That is to say, we need to decide what we got in the end when we got this modernizing Warhol before we can decide if that is all we have and what we deserve. We have to decide how stupid we believe Hollywood is, or mass production, or self-fashioning as a way of art making. These are not obvious. I myself am of at least two minds.

But then so is Warhol of two minds about the total mechanization of art, for as we have seen, many of his works (most notably *Brillo Boxes*) are not simply given the look of mass-produced things, they also bear the traces of his individual hand. Many of his objects are partially painted and partially

hand made. Philip Fisher might explain this as Warhol's attempt to human-
ize his objects by harmonizing in them the forces of mass production and of
individual craft and individual design. Perhaps this is so; or perhaps Warhol
is simply ambivalent about how far to go.

Warhol is also, I think, ambivalent about his desire to disappear into his
images. The other side of Warhol's hiding from himself through his work is
his intense desire to be gazed at, but gazed at none too closely. This side of
him wants his own self-presentation to be the reference point for his art,
which means his artworks cannot contain too much or they will obliterate
him. Like many stars who are in competition with their screen personae,
Warhol is in competition with his paintings. One way to understand the
emptied, half-mass-produced look of his pictures is by contrast with War-
hol's own flamboyance. He dressed as he lived, totally one of a kind, with
his wig, his clothes, his tape recorder, surrounded by his velvet under-
ground of artist/nuts. He lived all dolled up so that his artworks shouldn't
outshine him, while he also lived in darkness so that they should. Indeed
his artworks advertise him in the manner of billboards while also obliterat-
ing him (like billboards).[17]

These remarks bring us to the question of Warhol's essential ambiva-
lence, to the question of his vacillations and shifts in perspective, just at the
point where one feels one has understood him. Warhol's art is radically am-
bivalent about the very idea that it should mean anything at all. It elicits
meaning or interpretation and trashes these. It follows from the ambiva-
lence in Warhol's art toward meaning—call it toward art—that Warhol's
artworks are, in fact, indeterminate as to their meaning. They suggest a hun-
dred different interpretations but deliver the visual or theoretical goods for
none. Warhol aims to strike us dumb, to play dumb, to give us an image of
a star or an accident about which we cannot say that it is a critical represen-
tation or a conceptual exploration or a psychological study or even that it
has a fully articulated expressive quality—that it is fearing or awesome, an-
gry, cynical, or empathic. He disappears into the images of his own creation
without comment: with neither adulation, criticism, nor indifference. His
images are themselves fascinating and boring; his attitude toward them be-
trays the same ambivalence. Warhol's silk screens remain fairly mute about
what Jackie is, about where Warhol fits in his picture, about what stardom
or mass production or any of these things are. They remain ambivalent
about the prospect of our even asking. Nor does Warhol aim to radically
abolish the role of structure, mind, and desire in art in the manner of Cage.
Even that is a strong avant-garde assertion of will and philosophy and prac-

tice in art which Warhol, ever passive, ever unengaged, ever voyeuristic, re-sists. Cage has a vision of America, Warhol has at most an overall fascina-tion with it. The general tenor of Warhol's images is to suggest everything, articulate nothing (not even interest) except a vague aura of glamour. This aura derives from Warhol's blotted line, his strong colors or filmic black and white, his repetition of the image, his draining of emotion or detail from the faces of his portraits, his reliance of photographs, and it reaches us through our excessive familiarity with the image, a familiarity he is banking on to have already gotten us interested only in the icon and not in the visual de-tails.

A number of Warhol's associates, along with critics of contemporary art, have made remarks about the lack of a clear position, voice, attitude, or reason for painting exhibited by Warhol's work. A sample of such remarks follows.

In Pop art, both ends of the ironic smile are kept in optimistic balance. Thus the painting of a soup ad comments on a detail of ugly Americana, but also implies that ugly Americana is very beautiful too. The Brechtian dialectic has been dissolved in a glow of ambiguous satisfaction (isn't it great how automobile wrecks are horrible!).[18]

I can't pinpoint the reason behind them [Warhol's *Death and Disaster* series] except that he was obviously fascinated with the idea of death. One can read into that so many different philosophical ideas, but whether they were ideas that concerned Andy, I don't really know.[19]

Benjamin Buchloh speaks of "this unresolvable ambiguity in Warhol's work between an apolitical conservatism and a camp aloofness on the one hand and a topically subversive precision in pictorial production on the other."[20] And with admirable honesty, Lawrence Alloway, the critic who coined the term *pop art,* responds to Patrick Smith's question about why Warhol switched from commercial to fine art by saying "I don't have the least idea."[21]

All of these persons speak of endemic vacillations, underdeterminations, and unclarities in Warhol's work. This could be because Warhol is a giant and we have not yet sorted out his achievement. Yet for all the indecisiveness people felt about Picasso earlier in this century, it quickly became clear to many serious critics that the work was a powerful assertion of some voice or other; just as it became clear to critics after a certain amount of time that the surrealists, or the futurists or Mondrian were engaged in forcefully ex-pressive and ideologically grounded acts, whatever exactly they were. A sense of the power in the gesture preceded better appreciation of what the gesture was. Yet serious critics today doubt whether Warhol has been en-

gaged in any such thing, for a strong sense of the early gesture in Warhol's silk screens has been followed by an increasing uncertainty about whether there is any position to be found behind them. Similar doubts arose about the art of Warhol's progenitor Duchamp, along with doubts about another of Duchamp's "students," John Cage. Yet both Duchamp and Cage have had profound and complex projects, or rather, a number of different projects held together in a mosaic of voices. Whether there is any further voice to Warhol's images than their concern with mass production and its auric possibilities remains a question.

Danto takes Warhol to be an exemplar of the fact of radical underdetermination of meaning in art generally. Danto has picked up the importance of underdetermination for Warhol's art, perhaps for a segment of contemporary art generally but has misconstrued its place. Underdetermination does not reside in the space between mere things and artworks but in the nature of Warhol's art itself. My claim is that underdetermination of meaning for Warhol is underdetermination of voice. Such underdetermination is due to Warhol's half-believed nihilism. Warhol's art practices may derive from the legacy of the avant-garde; his will to not-having-a-voice, his nihilism, does not. That is what sets Warhol apart from most avant-garde art (even from Duchamp). It is also what makes Warhol so difficult to interpret and what makes Carl Andre's remark so hard to work out. We don't quite know what we have when we interpret a Warhol. Maybe that is precisely its defect as art. Not only does Warhol resist the modernist master narrative;[22] he gives us no narrative at all, no way of negotiating the world, no tools to understand it or resist it. He gives us no exemplar of human expression or refinement or knowledge. He doesn't even give us love of painting, quite. Yet he gives us a set of images about which we can think. Do we deserve more than that? Or is it rather that I am reading him wrong? That is the problem, a problem of skepticism about one's own interpretations so aptly engendered by Warhol. Perhaps it is also a crucial problem for our age, insofar as our age conforms to the flaccid, half-articulated shape of Warhol's art or to Warhol's ambivalence about the project of finding meaning in things. (Warhol's ambivalence makes him postmodern.) Or perhaps Warhol's nihilism is a matter of the skeptical position in which he places the interpreter (which also makes him postmodern).

Let us think about reading some of Warhol's pop images. Among the first critics to respond to those images was Rainer Crone, who, misled by some remarks of Warhol's about Brecht, by Warhol's line, and by how he personally would take the raw images of soup cans and the American landscape of

signage, claimed Warhol was engaged in a serious project of social criticism.[23] Crone's interpretation is now widely believed to be overstated. Warhol, the son of Czech immigrant workers who grew up poor in Pittsburgh and became a rich, self-made star, is too interwoven by choice into the world of money and its romance to be fundamentally critical. He is no Theodor Adorno; he is not one born into high bourgeois culture and money, who then criticizes his context of *Bildung* while remaining deeply and perhaps correctly ambivalent about it. Warhol's images open up the possibility of social criticism, but he is too enamored of soup cans to be fundamentally critical of the system that has produced these. In the famous interview with G. R. Swenson in *Art News,* Swenson asks him, "Why did you start painting soup cans?" Warhol: "Because I used to drink it. I used to have lunch everyday for twenty years, I guess, the same thing over and over again. Someone said my life has dominated me; I liked that idea. I used to want to live at the Waldorf Towers and have soup and a sandwich, like that scene in the restaurant in *Naked Lunch.*" [24] Warhol's choice as an artist is the choice of what to paint. His landscape, the landscape of interest to him, is soup cans, not the Eiffel Tower or the environs of Paris. He says, "I'd like to work in Europe but I wouldn't do the same things. I'd do different things." [25] The soup cans then are not simply his private landscape but that of America. Warhol goes on to say in another interview, "I feel I represent the U.S. in my art but I'm not a social critic. I just paint those objects in my paintings because those are the things I know best. I'm not trying to criticize the U.S. in any way, not trying to show any ugliness at all, I'm just a pure artist I guess. But I can't take myself seriously as an artist." [26] I don't know that we can unconditionally accept Warhol's statement that he intends to show no ugliness whatever, especially as far as his disaster paintings (and certain of his films) are concerned. Nor is it clear what a "pure" artist would be. However, we can believe him when he denies that he has a project of social criticism; he is too at home in his pop images. His choice of well-known and well-loved objects and persons, the absence of any obviously negative detailing in his silk screens and paintings, and their general lack of overt character, make one suspicious that he had any such project. Rather, he is showing America the role of fantasy in its ordinary self-construction, something he, the collector of autographed film pictures at the age of six, knows very well:

Everybody has their own America, and then they have pieces of a fantasy America that they think is out there but they can't see. When I was little, I never left Pennsylvania, and I used to have fantasies about things that I thought were happening in the Midwest, or down South, or in Texas, that I felt I was missing out on. But you can

only live in one place at a time. And your own life while it's happening to you never has any atmosphere until it's a memory. So fantasy corners of America seem so atmospheric because you've pieced them together from scenes in movies and music and lines from books. And you live in your dream America that you've custom-made from art and schmaltz and emotion just as much as you live in your real one.[27]

There is something right about this. Somewhere I heard Bill Moyers ask Aaron Copland how a Jew from Brooklyn could know so much about the wild West. Copland replied, "by reading Walt Whitman." The art of inventing America has much to do with the unfilled, untraveled, luminous space that defines it, a space which leaves room for the imagination to take over. (This is the cultural side to the historian Frederick Jackson Turner's view of American history.)[28] As a child, I dreamed of a California constructed from songs ("California here I come"), from the gold rush, and from movies, I saw, in the mind, a California which was to me part of Candyland, not on the same map with Boston. I dreamed of the South, which was to me the place of Uncle Wiggily, not of slavery, combat, poverty, and old boys. Warhol has captured something about the way America is constructed. He has also captured the element of fantasy in America without criticism. The space of the imagination can quickly slide into kitsch or illusion or avoidance; Warhol seems to celebrate that as well in a gesture of high camp. (It is appropriate to point to Angela Davis's note that Warhol's silk screen called *Race Riot* is actually an image of peaceful black demonstrators being assaulted by the police. Warhol has not looked closely at Uncle Wiggily.)[29] Yet note that while the juxtaposition of one Warhol image with another stimulates one's own imagination to think about the role of fantasy in ordinary thoughts about America, Warhol nowhere paints a picture which explores the connections between the ordinary and the fantastic in one's feel, fantasy, and illusion of America. That is what Rauschenberg would set out to do. Again, Warhol's work remains underarticulated, which is why one must look to his words about America here.

Warhol's interest in the aura of things is also an interest in how the auric, distant, star-bright, fantastic, or shocking becomes ordinary through innundation and habituation. He is among the first to have noticed that continuous exposure to a set of images without perspective or explanation tends to make these images, however powerful or shocking they might be if taken singly, banal. Mass innundation with images can, it is now a commonplace to say, make the most powerful images—of car crashes and deaths in the electric chair—turn into the everyday and the unnoticed. Distance makes the heart grow sharper; habituation to an unceasing flow of overwhelming

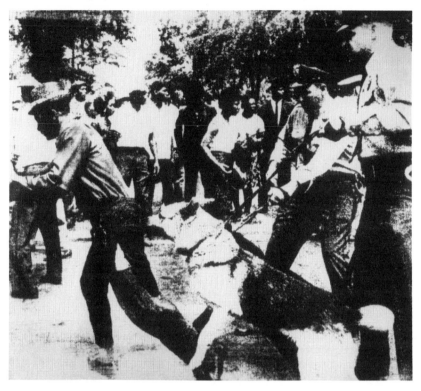

Andy Warhol, *Race Riot*, 1964. Oil and silkscreen on canvas, 30 × 32 ⅞ in. Museum of Art, Rhode Island School of Design, Providence. Albert Pilavin Memorial Collection of Twentieth-Century American Art.

images makes the heart grow dull and the mind read automatically. This banality of reading is, in effect, accommodation to the banality of evil, produced through overconsumption without analysis. One can only be shocked so many times, whether by the gruesome or by the avant-garde. Warhol understood both of these things. One of Warhol's assistants, Ronnie Cutrone, said Warhol began to paint Mao and the hammer and sickle because these also were becoming familiar, and mass dissemination can "familiarize everything, drain it of meaning."[30] Warhol himself says:

I've been quoted a lot as saying, "I like boring things." Well, I said it and I meant it. But that doesn't mean I'm not bored by them. Of course, what I think is boring must not be the same as what other people think is, since I could never stand to watch all the most popular action shows on TV, because they're essentially the same plots and the same shots and the same cuts over and over again. Apparently, most people love watching the same basic thing, as long as the details are different. But I'm just the

opposite: if I'm going to sit and watch the same thing I saw the night before, I don't want it to be essentially the same—I want it to be exactly the same. Because the more you look at the same exact thing, the more the meaning goes away, and the better and emptier you feel.[31]

It is as if his own personality, which aims to empty itself of psychological content through repetition and enjoys doing so, was brought into the world in order to be able to notice (and show in art) the role of familiarity and nihilism in mass culture. Warhol personally enjoys the loss of meaning which follows from complete repetition; his natural affinity for the meaningless puts him in the unique position of being ready and willing to receive the nature of what becomes of things, people, and events through habit, repetition, and inundation. He makes images of Jackie, Marilyn, Elvis, and car crashes which look inadequately characterized and boring in order to force this thought on you about the extent to which these are icons drained of meaning, but also because he likes to make—and be in contact with— dead, expressionless, repetitive things. One's reaction to his images is, then, a mixture of appreciation and revulsion, for he is both revealing and camping. (Note again Thomas Hess's words [at n. 18 above] about pop art's dual relation to its material.)

Warhol's idea that meaning is lost through familiarity may only be half true. I'm not sure that most people lose the meaning of the Kennedys or of Marilyn through inundation by images of Camelot, *The Seven Year Itch,* the assassination, and the suicide. Perhaps for most people, familiarity is not boring but is a way of achieving attachment to idealized figures. The character of these attachments may depend on the special places of these stars in the hearts of Americans (like the royal family for certain English persons). One thinks of the nostalgia for Kennedy's youthful liberalism, redolent of a fantasy of American dominance and American goodness.[32] Warhol's idea that meaning goes away through mass production and consumption is highly debatable; repetition can also be a ritual designed to insure connection. It depends how much repetition, of what kind, and who is watching what. Warhol's idea is really *his* fantasy of what he wishes to happen through exact repetition and of what he wants his art to do. His art erases the meaning in habituated attachment to the star in the way it erases the individual details from which stardom is fabricated.

Yet there is also something right about Warhol's conception, something echoed by Susan Sontag's well-known suspicion about the role of photographs in contemporary society, a role which inures us to the power in an image through excessive exposure to a number of images of the same in-

tense type without explanation, and through innumerable repetitions of the same image.[33] This is especially true, it was Sontag's desire to point out, of extreme and shocking images. It was for this reason that the great film director Claude Lanzmann chose to make a film about the Holocaust which contains not a single stock photograph or newsreel of barbed-wire camps and emaciated victims.[34] Lanzmann's film begins by placing one of the two survivors from Chelmno, Simon Srebnick, back at the site of that camp in Poland. The site is now an empty field of green grass. Lanzmann's cinematic choice has many reasons and many forces, one of which is to shatter the defenses we have built up against recognition of the full power of the event, defenses maintained through our immediate reliance on a stock of images which we have seen so many times that we feel nothing when we see them now. We read these stock images with the blank deadness the event can so easily inspire in us. Lanzmann forces us to enter into the power of the event by showing us that it exists nowhere except in the past, which is nowhere; that it exists nowhere except in the survivor, the historical record, and the green grass of a place which shows exactly nothing you need to see; that it exists nowhere independent from our capacity for its recollection, its memory, and its recording; that it exists nowhere independent from our immersion into it. So seeing nothing but the green grass of a place which was a camp makes us intensely aware of how little we do see. Our imagination, our willingness for absorption into an event with an inscrutable power to shatter us from time, place, and habit, is everything there is. (The rest is silence.) Lanzmann forces on us the work of resuscitating an event which is avoided either through factual denial (French fascists) or more commonly through mindless overexposure to it in exactly the same way, with exactly the same comments, facts, and images. Then Warhol is right. Yet Warhol's own art, unlike Lanzmann's, does no work to penetrate the deadening forces of repetition; indeed, it celebrates those forces just as it mocks them. Warhol, unlike Lanzmann, is truly ambivalent about the fact that the condition of overexposure and deadness demands resistance.

Those who dislike Warhol dislike his desire to deaden the image, to make an art which desires and celebrates lack of meaning and lack of invitation to meaning. Warhol's images (unlike Lanzmann's) seem to call off the work of immersion. They opt for the insurance of repeated TV programs, that is, to exist in the condition of a machine, a tape recorder whose tape is on continuous loop. Those who like this attitude will praise its vapidity and vamping of nihilism. Since I think Warhol set a trend for an art which is all too ambivalent toward the project of recovering the meaning in the powerful

events of car crashes, electric chairs, and holocausts, which is content to claim in one voice no narrative risk or artistic work of peeling away the skin of inurement and overexposure, since I think he set the tone for an art of the overpaid and the underdone, I find it hard to tolerate this vamping. Yet one can force more into it if one wishes; one can force it to speak eloquently about a dead world through its lack of voice, if one wishes. That voice present but dormant in Warhol's art of banality can be revved up. It is a voice which makes Warhol come out as a critic of the violence in everyday banality through exposing us to an example of it in this unspoken and understated art.

On this interpretation of Warhol, his work is designed to invite scrutiny of the banality of images through the frustration it is calculated to engender by its very banality. By simulating the condition of something, Warhol forces reflection about it. On this reading, Warhol looks like Manet (the archfrustrator of erotic and voyeuristic expectations about the Olympian heights of viewing to which we the bourgeois feel entitled), or like Duchamp (whose *Étant Donnés* forces reflection on voyeurism through its dramatic oversimulation of it). It is hard to say which reading is right. That is, Warhol's art refuses to supply enough interpretive tools for a decision about its intentions. The work is resistant to interpretation, ambivalent to the prospect of being read, not ambivalent enough about the condition of boredom and banality to make any clear statement. When Warhol says he wants critics to say whatever they want to say about his work, he is really saying he wants to license them to say exactly nothing.

The thought that Warhol's art can be taken as a critique of deadened meaning by simulating that condition leads to a question about the permanence of pop art. It may be that the artistic choice of criticism through simulation is unfortunately unsustainable, that it is a gesture whose shock value quickly evaporates. We become quickly habituated to the gesture of simulation, and soon the gesture itself becomes banal, or appears that way, because it is a gesture with neither visual depth nor with a complex background to sustain the shock and sustain the critique. Thus it may be that this side of Warhol's art is especially hard to recover, even after only two or three decades. Then a sympathetic reading of Warhol's intentions can attribute to him the intention to criticize the deadness of images through their simulation. Such a reading can speak afterward to the difficulty of retaining the force in the deadpan object.

I will return to this question in chapter 9, for critique through simulation has become codified as a contemporary art style. Let it be said here that

whatever vague attempt at the shock theater of simulation Warhol's art might suggest is undercut by the vagueness of the gesture. Critique through simulation must be decisively formulated to have any effect, and any such gesture Warhol might have had in mind is diffused by his ambivalent camping and fascination with the very thing he also wishes to criticize.

Considering the banal, what kind of person lives with his mother for most of his life, eats the same lunch every day, the same one his mother used to make for him, and has his mother sign his paintings? Is Warhol like the guy who still eats his pastrami on rye at the old deli every day because that banal lunch still rings with the gentle suggestion of custom and nostalgia? Or is he rather more extreme, the kind of boy whose "best friend is his mother"?[35] Henry Geldzahler refers, in conversation with Patrick Smith, to a telling incident with Warhol's mother: "I remember one time she [Warhol's mother] forbade Andy to take planes because she said, 'many big-shot guy in the sky might die.' And she already had a vision of Andy as some kind of big shot, which was really quite marvellous. So in a way Andy fulfilled her invention of him."[36] Geldzahler takes Warhol to be the fulfillment of his immigrant mother's fantasies of success and stardom. On this reading, Warhol's ambivalence toward the condition of being a star is a sign of his own ambivalence toward his internalized image of his own place in the domain of American big shots, a place decreed by his mother and ingested along with his soup and sandwich. The Horatio Alger story is, as I said, often applied to Warhol. Jackie Curtis, one of Warhol's film actors, speaks of another story which is even more revealing:

Jackie Curtis: . . . like when he changed his name.
Patrick Smith: From Andy Warhola to Andy Warhol?
Jackie Curtis: No. I mean from Andy Warhol to John Doe. . . . we were watching Meet John Doe on TV. That's my favorite movie. Not to mention Gary Cooper is in it. You know? And we went on the radio. We went on Howard Smith's radio show, and he said, "Oh I'm changing my name to John Doe."[37]

Warhol's announcement on the Howard Smith radio show can be viewed as his latest casting of himself in some TV or film role, but it also has the ring of identification, an identification which makes sense if one thinks about this American nobody—either John Doe or Andy Warhola—who is wrested from the condition of being poor, unnoticed, and down-and-out and flung into a kind of media-produced blitz of stardom. The fabricated John Doe's capacity to charm the nation, symbolized by his running for office on the John Doe party ticket, his manipulation by big bosses who pull the strings of stardom and success and politics from behind the lines, his own fraudul-

ence in the condition of stardom, his ambivalence toward glamour, and his capacity for suicidal despair, all of these must have moved Warhol to identify himself as the American GI Joe glamorized and melodramatized by the forces of American money and American media which prey on John Doe/ Gary Cooper's own loneliness and ambition.

Warhol's identification with John Doe gives us a way of understanding a connection Warhol implicitly exploits between the stardom of American money and the stardom of American film. American fortunes, typified by the Kennedys', arise, it appears to the public, from nowhere. The Horatio Alger myth is a myth about a boy who starts from scratch and rises to the top. This peculiarly American version of modernism is the myth, indeed the American reality, of erasure: erasure of one's former life in the old country with its attendant class, status, religious, and political limitations. It is the idea of a future to be born in a place without limits, a place whose new land is capable of conformity to the dictates of American mythology. America may not be the Russia of 1917, poised at a moment of utopian construction, but America has its utopia and its form of modernity. It, too, has its claim to make the land conform to the dictates of a peculiar philosophy. It, too, is (or was when it fired the shot heard round the world), dare one say it, *avant-garde*. America, the beacon of nations, is meant to lead the way from the cinders of its European past to a new condition of democracy and prosperity. And America is, or was, every-ready to sermonize to the rest of the world about its own example. Of relevance to me is that America's peculiar, bourgeois belief in its existence as the avant-garde model of nations, approximates its fascination with the film star; for the film star is, it appears to the viewer, born on film from an equivalent nowhere. Esther Blodgett is erased and transformed into Vicki Lester in the screen image. Like a Horatio Alger (originally named, let us say, Horatio Algieri), the film star appears to be cast into stardom from scratch.[38]

Then one person's avant-garde need not be another's, and Warhol's modernization of the aura is, in its own way, a good American boy's response to whatever makes or has made America avant-garde. Warhol's avant-garde— now so codified as to be a conservative mythology or a kitsch—is America's.[39] Then Warhol's fracturing of the avant-garde, of which I have spoken earlier, is an accommodation of it to the terms of its conservative American predecessor (the Horatio Alger myth). No wonder Warhol is someone America cannot get away from.

To return to more psychological aspects of Warhol, one can delve very deep very quickly into Warhol's obsessions with stardom, with becoming a

star, with habit, repetition, and nostalgia and, related, with a mother who signs his work ("because she has such nice handwriting," says Warhol in a sublime statement of camp). His work does not exactly invite a sustained psychological conversation with it, but does the work benefit from such a conversation? In the light of psychology, Warhol's work can take on an expressive cast which it otherwise might not appear to have. One can see resonances of nostalgia in the Campbell's soup can which are highlighted if one thinks of it as a sign of Warhol's attachment to life. His paintings of soup cans do not directly invite this interpretation; indeed, their flat tonality directly disavows all such expressive traces. That is why one looks for more to fill in the image with psychological or other depth—because depth is not in the image to begin with and one can fill the image in with such depth. Then the *Soup Can* can seem more interesting, for one can claim that Warhol is at once showing us that (1) ordinary mass-produced things betray no trace of our attachment to them—they are all identical, and yet (2) we are nevertheless attached to them, or we can be. One must look beneath the surface of the mass-produced object to find traces of our connection to it. And similarly, one must look beneath the Warhol image, not in it, in order to find conditions for attachment to it. One wishes one did not have to look to Warhol's words or to his mother or to his life to find out that he is attached to eating his Campbell's soup. One wishes Warhol's art were less resistant to revealing its attachments to the objects and persons it cherishes; one wishes it were less resistant to revealing Warhol himself. One must fight the resistance to speech in Warhol and in his art. Or one must, as in Orson Welles's *Citizen Kane,* take all the pieces of the puzzle and rearrange them—and in a number of different possible ways—to make meaning. The pieces are there, between Warhol's artworks, his words, the events of his life (self-constructed and otherwise), and the American 1960s context, but we must do the work of something.

His resistance is made explicit in his *Do It Yourself* paintings. These are a brilliant joke on art making, on modern art—something a child could do—and on the relations between art making and popular mass-produced things. They are also expressive of Warhol's desire to make things easy. And they are a fine parody of abstract expressionist seriousness (which is anything but mass producible). But they also can be read to express Warhol's resistance to interpretation. They give you a map of how to construct and enter into the art object, as if you will really be somewhere when you follow the map to the buried treasure. But what do you have when you have finished the game? A meaningless image expressive of nothing.

Andy Warhol, *Do It Yourself Landscape,* 1962. Acrylic on canvas, 70 × 54. in. Museum of the City of Cologne. Gift of the Ludwig Collection. Photo: Rheinisches Bildarchiv.

Warhol's words do exactly the same thing as his images. They hide every-thing and tell one everything at the same time. Warhol's camp exercise in mock philosophy, *The Philosophy of Andy Warhol,* has a section on the topic of time. Most of the section has to do with being fifteen minutes late for an appointment at Bloomingdale's, or how to set your watch. But amid

all of that, Warhol inserts the following piece of text: "When I was little and I was sick a lot, those sick times were like little intermissions. Innermissions. Playing with dolls. I never used to cut out my cut-out dolls. Some people who've worked with me might suggest that I had someone else cut them out for me, but really the reason I didn't cut them out was that I didn't want to ruin the nice pages they were on. I always left my cut-out dolls in my cut-out books." [40]

As in most Warhol utterances of any significance, he asserts this and then immediately gets off the topic. This is the only piece in his section called "time" in which issues of memory, nostalgia, the future, or anything of any significance is discussed. The passage is very revealing, especially in virtue of its made-up word *innermission*. What is an "innermission"? A mission to draw inward, a way of pointing to an incomprehensible insides, a slip? The moment in time in which we read this utterance is itself like an interruption from the boredom of all the other things Warhol says. He reinforces the seriousness of this moment by his witty remark that some of his readers will assume he got others to cut the dolls out for him. (They will assume he was camping and lazy even as a child.) But at this moment, he is being serious, not playing around. We are in an intermission from play which points inward: to playing with dolls and being sick, to fragility and beauty and to the noninterventionist appreciation of nice things. One can find a lot in these few words about cross-dressing and dolls, about wanting to be a doll as well as a girl, about a boy's identification with what he thinks of as the feminine (and the motherly). And what is a doll but a fragile, lovely, dead thing which exists to be gazed at and played with.

One should reconsider Warhol's Marilyn and Jackie in the light of dolls. These women are stars of a doll-like order of fragility. This prompts the thought that Warhol's art is about the emptiness in a system of stardom, about how stars break and fall down dead, about how you have to die in order to become a star or a doll, about the fact that Warhol wants to fall down dead and be a star, which is to say he wants to become a doll. Warhol has the desire to erase memory from his life; he calls this the condition of existing as a machine (Locke went so far as to identify personal identity with memory, so important is the role of memory in one's life, so annihilating to one's life is its loss or its massive avoidance).

Warhol acknowledges in his interview with Swenson that death is a central part of the *Marilyns* and *Jackies*:

Swenson: When did you start with these death series?
Warhol: I guess it was the big plane crash picture, the front page of a newspaper: 129 die. I was also painting the Marilyns. I realized that everything I was doing

must have been death. It was Christmas or Labor day—a holiday—and every time you turned on the radio they said something like, "4 million are going to die." That started it. But when you see a gruesome picture over and over again, it doesn't really have any effect.[41]

Death is a central theme regulating his choice of subjects. Note how specific that set of choices is: Campbell's soup, Marilyn, Jackie, Elvis, and sexy guys with whom he has a highly eroticized relation, images relating sex and crime as in the *Death and Disaster* series, skulls, Mao, and a few odd pieces, plus portraits, commissions, and then the films. Death is a feature of Warhol's expressionless presentations of the images he presents. Indeed, total lack of expression or the total boredom induced through repetition are the closest approximation of death there is short of catatonia or unconsciousness. As a matter of public life, Warhol turns himself into a uniquely fabricated fragile person, into a doll, whose existence is to be gazed at by a public intrigued by the mystique. His identification with Jackie and Marilyn is with stars whose inner souls are fragile and whose condition, tragic. Stardom is adulated in Warhol's art but also the loss of memory associated with living through the gaze of others in stardom and success. Warhol's recipe for how to live as a star is to renounce one's memory and exist in the condition of a film. It is a recipe not for hollowness but for the two-dimensionality of an on-screen existence. Life is replaced by the imitation of life, by zirconium look-alike diamond teardrops of a Douglas Sirk melodrama, by the tears of poor little rich girls, and poor little poor boys in Pittsburgh playing poor little rich girls, of people who prefer ersatz to real and live in all-night discos bathed in ersatz Day-Glo lights under the sheltering darkness of New York. This is melodrama and the love of disappearance.

At the Warhol memorial service, Nicholas Love read some words of Warhol's which are appropriate to our thread of discussion: "I still care about people but it would be so much easier not to care. I don't want to get too close. I don't like to touch things, that's why my work is so distant from myself."[42]

Considering that Warhol was always trying to make things easier for himself, this is quite touching and obviously revealing about his work. At that memorial service Warhol finally got what his entire life was devoted to—death and transfiguration as a star, also death and transfiguration with Catholic underpinnings. I see Warhol's work, and I do not defend this, as a kind of Catholicism in cross-dressing, with its panoply of saints, saviors and souvenirs. In its wake, transfiguration places the soul in film, not in heaven; one sits in a picture frame, not on a rose. Again the work gives one nothing of this; indeed, until the late work there is no trace of Catholic reference in

the Warhol corpus. That secret guide to the work remained safely concealed in Warhol's own private world of charities and good deeds (of which Warhol, who went to church sometimes four times per week with his mother and who financed a relative's professional education, had many).

The lifelong concern with death has its most explicit expression in Warhol's *Death and Disaster* series. Warhol began these in 1962 with his hand-painted copy of a June 4, 1962, *New York Mirror* front page that featured a picture of a plane crash with the caption, "129 Die/Jet Crash." He proceeded to make a set of silk screens based on photographs of car crashes, criminals, assassinations, guns, suicides, poisoned foods, burn victims, the atomic bomb, race riots (which, as I said earlier, Angela Davis has pointed out are, in fact, images of innocent blacks being beaten up by southern police),[43] and the electric chair in a number of different poses, filtered colors, and degrees of repetition. Simply making these gory scenes a subject of art in the sustained way Warhol did was, in my view, already a contribution to the history of art of the same order as the introduction of genre scenes into painting, of haystacks, or of the making of a Campbell's soup can into a pictorial subject. The images have a power which cannot be denied, a power which is intensified to the point of documentary film through reliance on actual photographs of the events. When Warhol introduces color into these images, the color is uniformly applied in the manner of a photographic filter; color intensifies rather than detracts from the immediacy of the photographic basis.

These images speak powerfully of their subjects. They also speak powerfully of the loss of meaning which an image, even of death, acquires through repetition. Warhol answers Swenson's question,

Swenson: Why did you do these "death pictures"?

Warhol: I believe in it. Did you see the *Enquirer* this week? It had "the wreck that made the cops cry"—a head cut in half. . . . It's sick, but I'm sure it happens all the time. I've met a lot of cops recently. They take pictures of everything, only its impossible to get pictures from them.[44]

What does Warhol believe in when he says he believes in "it"? In doing the pictures, in the ubiquitous fact of death in our mediated lives, or in death itself? His reply to Swenson is, as usual, cagey. He begins by noting how powerful and gruesome death is in our society and how ever-present it is in the papers but then goes on to speak about wanting to get pictures from the cops and not being able to get them. Why the switch? As always, Warhol is camping. He has a knack for introducing a topic and immediately diffusing its force, for diffusing his reaction to it and his involvement in it. In

switching the topic from death to getting pictures from cops he can distance himself from the power of the fact of death by assuming the pose of the voyeur—the one who wants to possess a lot of photos of death as a matter of fascination. Fascination is then a replacement for concern, a way of hiding from it and not caring about it, reflected in his images as the distancing of death by cinematic means: filtered light, photos, and the repetition of the image. For Warhol's cinematic techniques both present death in unfiltered immediacy and displace it through filtered colors, screening, and silk-screening. The number of pictures Warhol made of death and disaster is also, paradoxically, a way of deadening the effect of the original impulse to show the power of these images—Warhol himself says that when you see too many they don't mean anything, and look how many he made. By repeating himself, he can distance himself from the topic he also wants to project. Then the use of photos and photographic means in silk screen both brings death closer and displaces its force. Warhol's series is a psychological defense against its subject: it displaces through the very act of presentation.

Warhol is overwhelmed by the fact of death in our society and by our strange glamorization of it, of the one who dies and thus gets her fifteen minutes if her death is original, well orchestrated, or gruesome enough— like other news or like feature films. Ours is the world in which, if you can't be a star, you jump off the Hollywood sign and become a sign (until the next person does it); in which people slow down after there is an accident on the freeway, not because they can't get through but because everybody wants a good look at the accident. We are fascinated, and repulsed, by our fascination with the gruesome. Warhol's images speak powerfully of the events themselves, of the media which brings these events daily to our living room until "it doesn't really have any effect,"[45] of our fascination with watching these events, and of the way disaster catapults the dead or the victim to stardom. That is the inverse of, or the dark mirror for, the images of Jackie and Marilyn, whose stardoms contain seeds of tragedy which is forgotten in the wake of their aestheticized, golden mystique.

Warhol's own personal fascination with death is betrayed especially in his single images of the electric chair. These are done in a level of detail he would never give to his images of stars or even to his portraits done on commission. The chair is highly "painterly." Set in an ambience of subtly graded, filtered colors or in a silvery black and white, it is strangely alluring and strangely electrified. What is its allure? the allure of (ig)noble deaths by great American bad guys raised to mythic heights in gangster movies which take place in cities like Chicago; the allure of crimes and their electric

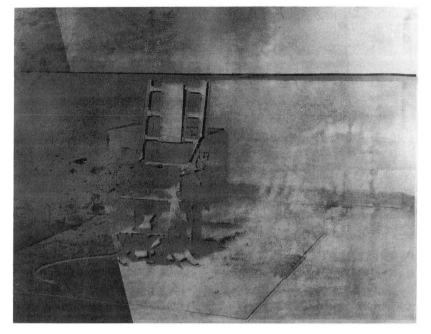

Andy Warhol, *Electric Chair,* 1967. Oil on canvas, 137 × 185.5 cm. Moderna Museet, Statens Konstmuseer (National Swedish Art Museums), Stockholm. Photo ©Statens Konstmuseer.

retributions which have captured the imagination of the nation; the fact that the ten most wanted, unlike John Doe at the beginning of the Capra movie, are really wanted. We are fascinated by such persons, who stimulate our own premoral desires to blast our way to the top—as if morality is just another name for fear and the only difference between them and us is that they are gutsier and hence more glamorous. Their narratives of crime and retribution work like clockwork. We think of the ten most wanted as amoral, as free of guilt and pain and suffering. Viewed from the distance of voyeurism, we do not fear these persons but, rather, take pleasure in the symphonic perfection of their famous narratives (while at the same time celebrating our differences from these persons, our own sense of normalcy). We aestheticize their narratives, so (apparently) free of guilt. We relish the fifteen minutes of narrative pleasure taken in these amoral individuals who are so wanton and so wanted.

But the electric chair means more to Warhol than that. Many of his images are of the chair without anyone in it. Warhol's focus is on its powers,

not on the lives of criminals whose end occurs here. The electric chair is itself the locus of fear and fascination. In his single images of the chair (not in the repetitions), Warhol positions the chair so that it almost directly confronts the viewer. Its frontal placement invites you in. That, conjoined with the allure of the electrified, photographic backgrounds (colored or silvery black and white) in these silk screens, cannot help but cause a small stimulation in you as you imagine being drawn into the chair and zapped by its megaton of voltage. The level of fear is stimulating and the level of stimulation, fearful. You feel drawn without being able to resist toward this eroticized chair in which your *fleisch* will be *gesitzt*. Warhol's fascination with death turns on a conflation of sex and death. Freud went so far as to speak of our having a natural instinct for death which is as compelling as our sex drive. In Warhol these lines of instinct have gone haywire. This conflation of sex and death is more explicitly betrayed in Warhol's *10 Most Wanted Men* series, where a pistol is a phallus and, as Caroline Jones has suggested, it is not clear whether "wanted" means "wanted by the law" or "desired."[46] Then Warhol's conflation of sex, crime, and death ought to speak to his need to sustain distance both from any directly expressive intensity his images might have and from intimacy with people. These pictures tell us about how electrified he believes intimacy (or assertion of voice) to be; intimacy is for him a matter of fibrillation. He will be zapped, which is too good and too bad for words. Hence his retreat from images into words and from the seriousness in words to camp (and from camping to vamping). Is he alone in this? In an America where crime gets you on the talk-show circuit, gangsters are walking phalluses in the movies, and killing usually wins you the woman in westerns (if you are the cowboy type), he is not alone in being seduced by the allure of crime. Nor is his psychology so unique, if filmmaker Alfred Hitchcock's view of people is correct. Hitchcock's films are about the person who, on a Saturday afternoon, likes to enter a dark room and pay five dollars to watch some blonde called Janet Leigh get stabbed by some boy called Anthony Perkins, whose best friend is his mother. And Hitch's popularity proves that he is correct; people like to watch, to watch from the safety of the art theater. Indeed, I could not grasp the expressive force of Warhol's hot chair if I could not feel it myself, which means I have the capacity to feel excitement at death myself. Lucky me. (One should again note that Warhol's retreat from intimacy and assertion in art and life also has its flip side: invitation to thought about the distancing fact of images.)

Two further remarks are in order. First, one can find in Warhol's words

from the section on "time" (*The Philosophy of Andy Warhol*) a love of nice things, which suggests that one reason he went from advertising into fine art was simply that it gave him the freedom to do what he loves best, to paint things and make things without the pressure of advertising assignments. Warhol flirted continuously with the condition of advertising, with the thought that artworks are commodities and nothing more, yet this flirtation with collapsing the distinction between art and things was made possible because of his distance from advertising (and because of his closeness to it). Warhol was, qua independent artist, free to do what he wanted—to celebrate the condition of art as advertising through his own art, which was not an advertisement for products (other than for himself and his studio). Like so much of the rest of fine art, his is an art which appropriates the resources of a kind of functional art without itself exactly sharing the function. Thus his art depended, and depends, on the fact that some distinction between it and mere "commodification" is in place. Warhol played in his art at abolishing that distinction by advertising that he would do anyone's portrait for twenty-five big ones, but that was his antic (partly in service of raising money for his films). Warhol's art is ambivalent about its status of being something more than mere advertising art. It celebrates connections between advertising design and fine art, connections which are indeed strong enough to attenuate any Danto-like metaphysical distinction between the two. It advertises itself through its iconic poster images, its size, and its lipstick reds and Day-Glo yellows, saying, "Look at me." But Warhol's art is not quite a mere commodity, either.

Andy Warhol speaks of his realization that, having labeled *pop* the things he saw on the highway, while driving toward Los Angeles in 1963, they could never be seen in the same way again. Let us imagine that Warhol sees an advertisement for a Brillo box looming up the highway somewhere in west Texas, and he labels it with the label *pop*. He treats it as an example of the art of the future, of the art of a new America whose forces of mass production, populism, and banality have erased the distinction between high and low. There is no longer any place in America for a high road and a low road, there is only the freeway and the free mind. All that has remained is for Warhol to have noticed that fact and to have been the philosopher/artist who labeled these objects *pop*.

When Warhol speaks of labeling the sign, we are now in a position to say that he refers to a way of seeing it and treating it, not to a way of placing a theory on it. Warhol has a vision of life and way of seeing that allows him to live in a stylized way. He has no further theory than that. Moreover, has

Warhol's application of a label and mode of seeing succeeded in making these signs on the freeway into art? All he has done, he says, is to have seen the art which is already in them, as if they are the postmodern version of the stones of Carrara. There is some art in them prior to his vision, which he picks up. He, in turn, invests the signs with further significance, the vision of *pop* projected onto them. But even this vision is not enough to make these signs unproblematically over into art. Warhol's very vision of these signs as art is, rather, compelling and powerful only because they are not quite art. Signage is continuous with art, but a distinction between artworks and mere signs on the freeway is nevertheless in place and Warhol, impish, cagey visionary that he is, knows this.

By contrast, Warhol's *Brillo Boxes* on exhibition at the Stable Gallery is art not simply because he (and the art world) applied a theoretical label to it but because (1) his boxes have visual differences from their real counterparts, differences which are of significance for Warhol's provocative play with things, and (2) Warhol's boxes, which also do approximate their real cousins, are part of a complex gesture of exhibition which we take to bear the authority of art in the complex context of its making and its reception. I have said a lot about what that context is, a context involving a way of placing and replacing the avant-garde, a context of ambivalence toward the distinction between fine art and mass production, a context inviting thought about America and meaning, a context in which each and every one of these invitations to meaning is presented with ambivalence. Warhol's art in context invites the philosophy of art by placing one in a situation in which one is invited to think about a locus of questions concerning the meaning of an art object in an age of mass production, about its possibilities of expression, characterization, and depth, about the modernization of the aura, and about the very distinction between fine art and a whole conglomeration of mass-made signs, symbols, and things. In this sense it invites Art's philosophizing, and here I mean the philosopher's name. But Warhol's art, unlike Art's Warhol, also resists philosophizing in its ambivalent play with meaning as such. Its frustrating and inviting nature invites everything— from a critical reading to a celebratory one to a deadpan one to a philosophical one—while delivering the interpretive goods for no reading of any real depth. Have I also been seduced into my own reading? Who can say for sure? Warhol makes a racket out of underdetermination.

Warhol invites theory by his game of suggesting everything (including all possible words) but makes a mockery of theory by refusing to hinge theory to sustained features in his art objects. It is as if Warhol's nihilistic game

played over the domains of voice, conviction, and theory were but a mirror of Wittgenstein's paradoxes about interpretation unhinged from all else. Warhol shows, by enjoying it, that interpretation unhinged from the art object can never rule the art object; Wittgenstein shows that in such a case, interpretation then itself becomes as indecisive as Warhol's art object. Together, they demonstrate the impossibility of Danto's stringent avant-garde claims about theory. Warhol is Danto's disproof, not his proof.

Nevertheless Arthur Danto has, in a sense, done right by Warhol by trying to place him as a philosopher, not because Warhol is a philosopher but because an authentic response to Warhol's essential ambivalence toward meaning is to force meaning out of his art the way others try to squeeze musical orange juice out of the score of John Cage's 4.33. Danto has pushed Warhol's work to speak about something, in this case, about philosophy. He has fashioned Warhol into a serious, original, and daring philosopher. Perhaps that is the correct style of response to Warhol's racket of underdetermination. However, it is not the response of one ally to another. Warhol is not in the same game as Danto. Rather, Danto, in forcing Warhol's mute art to speak, is doing combat with Warhol; he is interceding, not interpreting. (Danto's intercession is interesting, nearly as interesting as Warhol himself.) However, it cannot be said without qualification that Warhol is philosophical any more than it can be said that he is critical or psychologically deep or even interpretively subtle. What can be said without qualification about Warhol is exactly nothing, and even that gesture of nonassertion is inappropriate because it is unengaged.

Then what does one do with an artist like Warhol? Danto's intercession with Warhol is representative of those theorists in an age of fracture and diffusion who aim to make the artwork or the age speak—and in a single voice as clear as a bell. While thought of by Danto himself as an alliance, Danto's interaction with Warhol is an intercession with culture as potent as any other offered by the avant-garde. It is an imposition of theory in the service of making not only meaning in the face of nihilism but modernism in the face of its denial by Warhol. Danto's grand narrative about art projected onto Warhol is one with a shape as powerful and as liberating as any picture Gabo tries to force onto art and life. Danto's mode of intercession by theorizing is therefore a legacy of the avant-garde, and the avant-garde has fractured into the terms of a quarrel over the role of a voice and a theory in the conduct of life. Danto's appropriation of Warhol is genteel but also urgent, for it is an urgent attempt to find clear meaning where none is clear. Others with a more negative view of Warhol will speak even more urgently.

The Uses of Theory in the
Contemporary Artworld

I

Danto's interpretive urgency, forced onto Warhol, is a legitimate response to
Warhol's antics of radical indeterminacy. If Carl Andre is correct and War-
hol is even partly a mirror for the times—the question being what he mir-
rors and how much of the times are captured in his glass—then perhaps
Danto's mode of intercession by theorizing is also a mirror, a mirror of a
style of theorizing, inherited in nearly pure form from the avant-garde.[1]
Then how much of the times are captured in his glass? Both Warhol and
Danto are, let it be said, one of a kind; no one paints as Warhol does and no
one philosophizes quite like Danto. Yet both are, I think, in some sense,
exemplary, and it is my intention to decipher their examples without read-
ing too far or claiming too much. To claim that Danto's inheritance of the
mentality of the avant-garde is representative of a style of intercession by
theorizing is already to have ventured to say a lot. Danto's inheritance of the
avant-garde's mentality includes (1) his belief in the transparent rule of
theory over the art object; (2) his belief that a special art example may be
found which perfectly illustrates its prefigurement by theory; (3) his com-
mitment to a grand narrative generally; and even (4) his adulation of the
utopian role of theory in liberating art history, something received both
from the avant-garde and from Hegel. Yet it is almost a commonplace of the
age that no one today (at least in the circles of the artworld) trusts in the
(Danto-like) grand narratives of the past. Is Danto then merely a modernist
throwback? In the light of contemporary tendencies toward disbelief in all
forms of grand proselytizing and utopian narrating, my assignment to
Danto of a representative place in the contemporary art world must be de-
fended.

Jean-Francois Lyotard has articulated contemporary tendencies toward
disbelief, along with what he calls the general existential tiredness of the
age, in his justly well-known book, *The Postmodern Condition: A Report
on Knowledge*. Lyotard glosses our current postmodern condition as one of
"incredulity towards meta-narratives."[2] It is, let it be said, hard enough to
decide what a metanarrative is. The concept of a metatext originates in the
theory of a formal system, where the distinction between an object language
and a metalanguage employed to state or prove things about the object lan-

guage can be articulated with appropriate clarity. The distinction becomes less clear when one is speaking about cultural narratives. Where does a mere narrative end and a metanarrative begin? Do we distrust only metanarratives and not first-order narratives, and if so, what does that mean? What Lyotard has in mind, of course, by metanarratives, are the grand modernist narratives about art and its relation to life characteristic of modernism in art (and of Hegel in philosophy). He also has in mind the grand narratives about knowledge in general and how it is justified, which are endemic to the history of philosophy. That is, he has in mind some of the narratives this study has been concerned to articulate and engage, and one must include Danto's own narrative (derived both from the avant-garde and from the history of philosophy) as an example of these. Indeed, many of us are incredulous about the grand sweep of such narratives both in art and in philosophy. We no longer quite trust the narratives about representation offered by the art and art theory of former times; we no longer trust the narratives about knowledge given to us by the history of philosophy or by the great competitors with that history (who are also part of it) such as Marx and Nietzsche. We no longer trust narratives about American populist or liberal democracy of the kind so important to FDR and even LBJ, for we know that an alphabet soup of power stood (and stands) behind American claims to equality and populism, from the FBI to the DAR to the CIA to the Savings and Loans. We no longer trust narratives pronouncing equality between the sexes or theories of breeding and of education. One could fill a whole book with claims we no longer trust, or at least claim to trust no longer, including most of the great narratives about the history of art and from the history of aesthetics about what a work of art is and how it acquires its meaning.

In the light of our dark suspicions about all cultural metaphors of light, clarity, and illumination,[3] the avant-garde's own visually constructed images of knowledge, its images of an art object which would transparently instantiate its theory in a visual form so clear that vision would have no room for doubt, are also unbelievable. But what do we believe about art in our own time? What counts in our own time as a metanarrative as opposed to a mere first-order narrative, and do we believe it? If not the self-illumination and utopianism prophesied by the avant-garde, what do we believe about art and its relations to culture and politics? To say we believe nothing is as yet to have said nothing, for everybody must believe something, including us, in virtue of being able to negotiate the world (of art) and in virtue of having an identity. And we do negotiate the world of art, in spite of our beliefs to the

contrary, which means we have beliefs of all sorts about art. So the question is what we believe and how we believe it.

Belief is, needless to say, an unbelievably complex thing. One holds and expresses beliefs of all kinds, one reveals them in one's behavior (perhaps in spite of one's own denials). One knows one's beliefs or does not know them. One clings to one's beliefs or represses them, and so on. No doubt we hold beliefs in all of these ways, both about art and about life in general, which is why the difficulty of any investigation into the current belief tendencies of the artworld should not be oversimplified. What I am interested in here is the status of our metanarrative beliefs about the use of theory in art. I claim that we have a tendency to believe metanarratives about (1) the transparent application of theory to the art object, and (2) a variety of ways in which theory empowers both the art object and the interpreter. Moreover, I claim that our tendency is often to believe in theories, in metanarratives, rather than in any actual narratives themselves (insofar as this distinction can be drawn). But such beliefs in theoretical transparency and theoretical empowerment are, I think, held in a number of different ways. They are held consciously and unconsciously, knowingly and unknowingly, lucidly and vaguely, in theory and in practice, which is why it is so hard to argue that the beliefs are actually there when others deny it. For they are often held quite amorphously. Such beliefs are often shown in practice, in spite of denials to the contrary. We claim to distrust our own theories, but our practices of applying our theories to artworks (or of making artworks on the basis of theories) without the slightest hesitancy can speak otherwise.

Thus, from my perspective, Danto is representative because he holds to his beliefs about the role of theory in art so explicitly. His work is uniquely representative because it is so uniquely clear and so highly developed. To prove that Danto's status is representative is, of course, a matter of proving that the tendency I speak of is in place (something I have said is not easy to do in the light of the complex issues regarding belief, which is why Danto's approach can help us to frame a picture of the tendency which be helpful in ferreting out its less obvious examples). What I am referring to is a tendency to inhabit the modernist space we have inherited from the avant-garde. We have inherited the avant-garde's assumption that theory (a metanarrative) applies transparently to its objects, and also its assumptions about the power of theory to change the social order of art and the world. While such transparent empowerment is no longer formulated as the blithe utopianism of the avant-garde, theory is nevertheless believed to empower artworks— and art writing—with social agency today. This inheritance should be

viewed as neither wholly negative nor wholly positive. Theory can indeed stand today as an act of resistance to the oppression of socially inscribed narratives and socially dominating practices (including art practices). By tracing relations between concepts and powers, theory is an act of proclamation of disbelief in the face of a monolithic system of power, an act with a rhetoric that feels like acid. It is the legacy of El Lissitzky in the guise of Foucault. In response to the perceived atrophy of current times, in response to the dizzy whirl of the current world in which big money, fast advertising, power, and complacency have turned American dreams into a farce (and turned art into the condition of Warhol), theorists enlist the firepower of decisive interpretation in service of armed combat with the age. If Danto forces Warhol to speak, then such theorists (I speak of Jameson, Baudrillard, Foucault, Lyotard, the writers of *October* magazine, the theorists of the "gaze," and others) aim to do even more: they aim to resist the age by forcing it to open its mouth and deliver the full truth about its difficulties. Such theorizing, needless to say, is done with full urgency. If my remarks at the end of the chapter 8 are right, the need for theory is urgently felt, for in the absence of utopian revolutions looming on the horizon of culture, in the absence of any clear picture of what current diffuse times are like, and in the wake of an artist like Warhol (who refuses to engage the world but, rather, saunters merrily past the shop windows of New York department stores all the way to the Factory, the all-night party, the movie screen, the art-deco collection, and the bank) we search, or yearn, for an explanatory key to the age, a master narrative to empower us with understanding and the possibility of resistance. This is in spite of our avowedly "theoretical" resistance to the very idea of the grand narrative. We seek a voice with which to speak the world, as if merely finding the right words to explain the world is already an act of resistance to the attenuation of language, art, education, and conversation one feels too acutely nowadays.

That the world is (up to a point) monolithic, that concepts are the definiens of powers, that proclamation can help, are matters I in no way wish to deny. In this sense, theory is required by the face of the world today—as it was required by the contextual games of the avant-garde. Theory is required as a resistance to the accommodating theaters of Warhol, Jeff Koons, and of the art market. Indeed there is a tendency in contemporary art and theory to treat theorizing about art and culture as if it is the one remaining avant-garde activity on the face of the earth. When John Cage was told that a number of art theorists had all proclaimed that the avant-garde is dead, he responded with his typical lightning intelligence: "What about them?"[4] Are

not such persons trying to carry on the mode of intercession by theory established by Gabo, Adorno, and Benjamin? That is not to say such persons are entirely successful either, or that the terms are quite the same. What Cage meant was that, yet again, one should avoid a polar situation, here the oversimplified claim that the avant-garde is dead or that it isn't. Rather, the avant-garde has fractured into a number of related shards, each of which retains one or more avant-garde features—political, stylistic, theoretical, rhetorical, obnoxious, and so forth. Conversely, none of these legacies of the avant-garde retains the full, seething configuration of norms which, as a whole, made the avant-garde what it was. So it is too simple either to say that the avant-garde lives or that it is dead. It depends from which perspective one is talking, it depends what one wants from the avant-garde, and it depends which region of its legacy one is referring to. Here my topic is specifically the continuation of the avant-garde in the medium of theory, a continuation which I claim can often retain traces of the avant-garde's assumptions about theoretical transparency and about immediate theoretical empowerment.

I can only applaud present continuations of the avant-garde's spirit of resistance in the mode of theory. What I wish to do is to find a way of draining such continuations of their traces of the avant-garde's norms of transparent theoretical application and instantaneous social empowerment. I can only do this by way of genealogy—by tracing current practices to their sources in avant-garde norms—and by way of argument. Naturally I cannot do this as a whole, given the great variety of such practices. My remarks must be tentative, on account of the amorphousness of the belief tendencies in question. In fact a tendency is itself a speculative, if not a theoretical construct, for it suggests a dynamic process by which certain examples illustrate paradigmatically the direction which other examples only hint at, as if there were a general direction from which those other examples are best understood. Yet there are times when talk of a tendency inspires trust, trust in its pictographic and explanatory force. The picture can help in a variety of ways. It may be proven truer by our finding more examples which illustrate it than, for example, I will offer in this final chapter. But the speculative force in speaking of a tendency is also dialectical; it is meant to suggest further scrutiny of a variety of other ways in which (in this case) avant-garde theoretical commitments remain in place. Discourse is meant to stimulate reflection, which can help bring subtle remnants of the tendency to light, thus showing that they are there. Talk of a tendency or direction can intercede in the course of events by increasing awareness of

a possibility—a possibility to be hoped for or feared, prayed for or de-spised—and that awareness can change the course of events (for good or ill). Talk of a tendency may be a way of alerting people to a possibility, or foreshortening it, of opening it up for scrutiny, of offering a perspective on it from which other perspectives on culture can be realigned. Beyond that, there is no further proof that the tendency is there in the first place and no further content to the idea of it. I hope my own remarks about theoretical tendencies are of use.

Note their circumspection. A more complete treatment than mine of the origins of contemporary tendencies toward theoretical stances in art, would have to refer to trends deep in the history of French and German philosophy, to the history of Europe in this century, and to American history, to the origins of feminism and to the oppression of women, to questions of race, and to many other topics which are part of the agenda of current conversations. I have therefore wished to fill in a different part of the genealogy of theory, namely the story of how art and art criticism have emerged from the pages of the avant-garde itself, from its practices and its mentality. (I have stressed the practices of the utopian wing of the avant-garde in my genealogy, but Duchamp's somewhat different theoretical games, which are important antecedents of postmodern theory, have also entered my discussion—if obliquely—by way of Cage and Danto).

Take, for example, Lyotard's theory of the postmodern condition, which I identify as a modernist theory of postmodernism closely keyed to the idea of the avant-garde. Lyotard's title suggests that his book ought to be taken in a somewhat tentative vein: it is a "report on knowledge," not a final summary. Yet the book itself presents its report in high theoretical form, and with a sense of theoretical completeness. Lyotard assumes that three factors jointly define the postmodern. First and foremost, the postmodern is defined by our age's incredulity toward metanarratives. His second and third defining conditions on the postmodern are ways of further interpreting the first; they develop his analysis of how and why we are incredulous toward metanarratives. The second factor is this. Under the combined pressures of technological capitalism and the diffusion of information, all contemporary social institutions and practices have been forced to rethink their concepts of legitimation. Old metanarratives of legitimation are no longer viable, granted the pressures of late capitalist production and granted the vague and multiplex dispersion of language games played over forms of knowledge in our contemporary global world. The world is interdisciplinary, multiperspectival, and shifting, thus denying all the old repertoire of justifica-

tions for the forms of knowledge (by forms of knowledge is meant the sciences, philosophy, the humanities, forms of social training, ideology, etc.). Nor are any new large-scale pictures of legitimation adequate to the diffuse and brutal terms of the age. Thus we are incredulous toward all general concepts of legitimation. (The contemporary instability of knowledge practices to shift and realign themselves also has, according to Lyotard, its positive side: it provides for the possibility of new and creative modes of knowledge in which disciplines converge and social institutions realign. These new sources of knowledge cannot be legitimated by anything more— or by anything less—than their specific uses. There is no longer a grand scheme of legitimation; legitimation is contextual.)[5]

Third, it is a mark of the postmodern that art is now faced with what Lyotard calls the sublime of self-presentation itself. The very mode of address by which art speaks, its voice, its media and its form of relation to its audience, are all radically in doubt. Art is faced with the problem of conquering—by acknowledging—the difficulties of speech itself. It must find a voice it can trust, one not unduly infected by the illusions of the avant-garde, by the ideologies of colonialism, race, and gender, by the corruption of the art market, and above all, by the gap between speech and its reception by others in a world of shifting information processes and cultural differences.

Any general discussion of Lyotard's second factor, that of incredulity toward all grand schemes of legitimation in the wake of new social pressures and the plasticity of information, must go far beyond questions raised in this book into the terrain of sociology of knowledge, into questions about capitalism and technology, the history of legitimation procedures in general, and the varieties of kinds of things we call *knowledge*. Such questions are in no way limited to legitimation in the sphere of art, although art has had its own problems about how to legitimate itself and how to go on and exist in a way which matters in light of the pressures within the art market to produce bigger, more original, and more salable objects and difficulties regarding the use of global information in the grand department store of world culture, where everything is available for appropriation. (Art's turn to theory can be understood as one response to this conundrum, one form of legitimation through the assumption of a voice of resistance and self-criticism.)

However, what should be noted here is that, for Lyotard, the avant-garde's experimentalist character, its shifting indeterminacies of form, and its sublime incapacity to imagine the very future it aims to bring about make it the

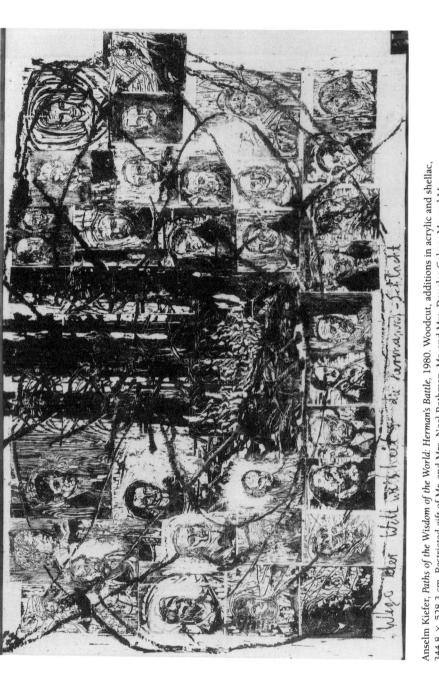

Anselm Kiefer, *Paths of the Wisdom of the World: Herman's Battle*, 1980. Woodcut, additions in acrylic and shellac, 344.8 × 528.3 cm. Restricted gift of Mr. and Mrs. Noel Rothman, Mr. and Mrs. Douglas Cohen, Mr. and Mrs. Thomas Dittmer, Mr. and Mrs. Ralph Goldenberg, Mr. and Mrs. Lewis Manilow, and Mr. and Mrs. Joseph R. Shapiro. Wirt D. Walker Fund, 1986. ©1992 The Art Institute of Chicago. All rights reserved.

model for postmodern knowledge practices generally. Lyotard's theory identifies the creativity and vitality of postmodern knowledge practices as a whole by their avant-garde, artlike character. Such knowledge practices blur disciplinary boundaries, invent new forms of (conceptual) structure, and picture the world in new ways—all in the absence of any ultimate legitimation or conceptual determination. Like so many postmodern theorists (and like Theodor Adorno and John Cage before them), Lyotard identifies conceptual determinacy with sociopolitical totalization and omnipotence. Conversely, for Lyotard, forms of knowledge that resist such determinacy, that remain at the level of the "sublime," are believed to contain the power to resist the sociopolitical order, the order of late capitalism. Thus, drained of its (largely Marxist) metanarratives, the concept of the avant-garde is simply extended by Lyotard—without the slightest doubt—to characterize all authentic knowledge practices.

According to Lyotard, the postmodern is nothing but the most extreme intensification of the modern, the moment in which experimentalism, indeterminacy, and the sublime are extended to the work of art's own language, medium, and voice (and by the *modern* he means the avant-garde drained of its commitments to revolutionary planning and theoretical transparency, as if the nature of avant-garde experimentation could be easily pried apart from its metanarrative theories). This adulation of postmodern knowledge practices also informs Lyotard's analysis of postmodern art. In its reformulations of medium, its gestures of uncertainty, and its difficulties of voice (all of which Lyotard glosses as its sublime character), postmodern art intensifies the avant-garde's gesture of cultural resistance. Postmodern art, by acknowledging its inability to speak transparently to its culture, and by correspondingly inventing ever new forms of imaginative mediation, resists the culture of totality, conceptual determinism, and technological power.

The question is whether Lyotard's rosy picture of resistance is accurate as a way of explaining those devastating doubts about expression which have racked many a postmodern painter (including the most authentic ones). Postmodern art's suspicions about its own mode of address, its own dramatic self-criticisms, its suspicions about its inheritance of all values from the past, about its relations to art history, to beauty, to narratives about truth, and to the repertoire of representations in general, its suspicions about its own medium—all these concerns are well known. To take an example, the painter Anselm Kiefer sings of the apocalyptic ashes of Wagnerian myths that are, from his perspective, German history itself, in a voice

which is itself Wagnerian in scope. Kiefer's voice, the voice of his inheri-
tance, of his patrimony, is used by him to sing of the loss of that voice, which
is to say, to sing of its essential destructiveness. Then how is he to use it;
how is he to legitimate his (or anyone's) use of that voice? The answer is
that he does not and cannot legitimate it. The great German singspiel Kiefer
voices in the reverberations of his wide-angled, mannerist spaces, in his raw
peasantlike German materials (straw, the earth of Parsifal), in his romantic
motifs (Goethe, etc.), and in his references to the patrimony (*The Sword
My Father Promised Me, Ways of World-Wisdom*) is a ballad whose myth-
ological nature claims the capacity to engender cycles of both destruction
and rebirth, as if to say that the very act of singing the song of the destruc-
tiveness in that voice may cause the voice to be culturally born again like a
phoenix. Would such a renewal legitimate the speaking of the myth by ren-
dering it of all connection to fascist grandiosity, as if it might be purified
though the mood of mourning (*Trauerspiel*)? Or is the very hope of resur-
rection through purity itself a repulsive German fixation which makes Kie-
fer's hope of renewal essentially illegitimate? Does Kiefer believe that his
use of the Wagnerian voice is a legitimate prayer for renewal, or does he,
rather, believe that the very act of using this voice, even if only to sing of its
own self-destruction, is, in a sense, illicit? Perhaps Kiefer uses it because he
cannot avoid using it, because it is his and there is no alternative for him
other than to be himself. Then is he illegitimate? Should he be punished?
Since I find it more or less impossible to decide between these alternative
readings of Kiefer's position, since I believe in my heart that all of these
interpretations capture aspects of his work, I can only conclude that there
is no way to escape essential doubts about the legitimacy of Kiefer's means.
For Kiefer, the sublime goal (therefore unreachable) would be that of un-
problematical expression itself, the capacity to rely on a voice without sus-
picion. Kiefer would, with the usual modesty of the German romantic, de-
scribe his own relation to the German voice as Mosaic; he is the one who
sees but cannot enter the promised land of speech and history. (Note that
his appropriation of the voice of Moses has had its German predecessor in
none other than Arnold Schoenberg, another Tarzan of the artworld.) Is
Kiefer, then, resisting an order, or in doubt about how to resist it? And
would that doubt count as resistance?

Lyotard's own analysis identifies the sublime as the place where the
crushing pressure of the capitalist "monad" is resisted. According to Ly-
otard's Kantian analysis, art of resistance is art which cannot be encom-
passed by the imagination, but which, rather, overwhelms it, defeating all of

Anselm Kiefer, *Flight from Egypt,* 1984. Synthetic polymer paint, charcoal, and string on cut-and-pasted photograph and cardboard, 43 ¼ × 33 ¾ in. Collection, The Museum of Modern Art, New York. Denise and Andrew Saul fund. Photo ©1992 The Museum of Modern Art, New York.

the mind's interpretive strategies. Lyotard favors this kind of art because he claims that, in virtue of its incapacity to be pinned down, the art of the sublime cannot be squeezed into submission by the "late-capitalist monad" which intends to crush all cultural autonomy in its wake.[6] Whether the art of the sublime contains this power of resistance is hard to tell, for Lyotard's examples of the art of the sublime are the works of the avant-garde itself (of constructivism etc.). These have, of course, aimed for such resistance, partly through their articulation of theoretical images of the future, partly through their rhetoric, partly through their innovations in media, and partly through the very restlessness in their ceaseless activity. However, in general, the question of which artworks can resist which social forces of encroachment seems to me so complicated and so totally contextual, that all generality should strike one as dubious. If one looks to contemporary examples of the art of resistance, surely concrete works by women like Jenny Holzer have as much power as any other, and these are anything but sublime in style. They have a voice; in that sense they have conquered the problem of voice in a way Kiefer has not and cannot. But they are not sublime in any clear sense of that term. They are hard-hitting, thought-engendering attempts to force the artworld to think specifically, very specifically, about relations of power and gender between art, words, images, and social language. They do not aim to overwhelm interpretation but to force it.

A basic feature of Lyotard's theory is that it favors one kind of art example (the art of the sublime) over all others. Or, conversely, it begins from an abstract conception of the art of the sublime (more or less Kant's conception) and proceeds to turn that concept into a general category of analysis, meant to apply to all serious art being done now. The category is too abstract to capture much of the actual art of resistance it is meant to capture (i.e., Jenny Holzer's). Yet in spite of its abstraction, it is a category derived from Lyotard's meditation on the fact of avant-garde art, a meditation which has caused him to make a connection between that art example and Kant's philosophy. Lyotard both adulates (without suspicion) the experimentalist aspects of the avant-garde, extending them to the domain of all conceptual innovation, and inherits the avant-garde's own claims to theoretically define its cultural object with total transparency. In spite of the power in Lyotard's analysis, it fails as a theoretical whole to do justice to the complexities of postmodern art. And it fails precisely at the point where it attempts to theoretically define an essential shape to the age which privileges one style of art, itself culled from the pages of the avant-garde, with unique powers of

social resistance. It is precisely at the point where Lyotard inherits without criticism the mentality of the avant-garde (and, one must add, of Hegel) that he falters in an excellent analysis.

His modernist turn, his claim to impose a general theory transparently onto the age, is partly motivated by his desire to resist the age. Lyotard, who for years gave up philosophical writing in service of political struggle,[7] wishes to find a translucent perspective from which to separate himself from cultural amorphousness by attaining a clear picture of it from which to target culture and from which to identify sites of resistance to it. If the avant-garde was motivated in its turn to theory by its utopian desire to project the future, contemporary theories such as Lyotard's also yearn for an equally clear theoretical perspective from which resistance can be lucidly imagined. Lyotard's inheritance of avant-garde norms is also conditioned by his yearning for the practical power of theory.

This claim to impose by theoretical fiat an essential shape onto the complexities of current times, making current times into an "age" in the manner of Hegel, is a modernist coup of theory. It assumes that the highly developed countries of the West evidence a definable shape, an underlying set of ideas or economic and social conditions, whose expression (and resistance) is the defining goal of serious art and theory. Lyotard's is, in this respect, a modernist analysis of postmodernism. It is an analysis with a mixture of avant-garde and Hegelian features. It is the same with Danto's theory of the postmodern. Consider the final chapter in Danto's narrative of the history of the avant-garde. It is a master narrative which paradoxically seems to take all the pain away. Danto's narrative seeks accommodation to the present age. Recall that Danto announces that Warhol's work completed the mission of the avant-garde and thus engendered a utopian, polymorphous space in which art might happen: "Warhol said, 'How can you say one style is better than another? You ought to be able to be an Abstract Expressionist next week, or a Pop artist, or a realist, without feeling you've given up something.' Who can fail to believe that, in art at least, the stage had been attained that Marx forecast for history as a whole, in which we can 'do one thing today and another tomorrow, to hunt in the morning, fish in the afternoon.'"[8] It is a correlate of Danto's comparison between Warhol and Marx that for Danto, art history has come to an end. Art history, like the history of the class struggle, has accomplished its massive goal and so written itself out of existence. There is no more need, Danto thinks, for artists to feel the need to contribute to art history, to transform culture through art, to impel art into

ever new and risky waters in search of a half-understood, half-glimpsed task. Art, in understanding art's task, has brought art to an end. This is 1917, and we are about to be free to do everything and be everything.

This conclusion to Danto's master narrative of the avant-garde represents the final link between his writing and the avant-garde's own theorizing, for what it shows is that, in the end, Danto accepts the utopian place of theory in art, just as the avant-garde does. Danto's own avant-garde philosophizing has been directed at completing art history and thus liberating art. Gabo's art was also part of an act of liberation through theorizing; it is only that Gabo himself misunderstood, according to Danto, the nature of the liberation. For the results of avant-garde art have failed to liberate life as a whole; they have failed to drive the revolution on to a happy conclusion. But avant-garde art did, according to Danto, at least succeed in saving itself, in procuring for itself the "heady space" of which Marx himself dreamed. That space is, in Danto's view, happening now (or was happening in the 1970s).

Danto's master narrative is therefore uniquely part of the legacy of the avant-garde, since it shares in all the main features of the avant-garde's own master narrative about the place of its own art in culture. Danto speaks of the liberating giddiness of the times, of which his own art criticism is, in my view, a part.[9] There is (or was, early in the 1970s) a certain giddiness about the art situation, a feeling of freedom, a certain absence of requirement to push art further, a freedom from need, and a freedom to act which Danto, the author of a book on Jean-Paul Sartre, must also know is, in the end, among the most difficult conditions there is for a person to bear. Either the condition of giddiness is not utopian or there is trouble in paradise. What does one do who has profound freedom and possibility combined with neither an overriding historical need nor an overriding project? Giddiness easily slides into vertigo, excess of possibility slides easily into stagnation, and both slide into decadence, atrophy, the condition of late Roman empire, or the oblivion of Warhol's Yellow Submarine. In the current department store of world culture, with every artistic style available for use and no project to set constraints on what is to be used, how does one begin to paint? The very plethora of choices can itself be devastating. When a middle-class child can choose to be a doctor, lawyer, professor, surfer, traveler in Bali, artist in New York, advocate for the rain forest, real estate megaperson, megapresident, rock singer, video-maker, or a person who lives on the Venice beach in Los Angeles, watching the whales, doing time in the pen (Gold's gym at Muscle Beach), stopping to talk a little metaphysics after lunch, when nothing appears ever to get better, then what is the difference between one career and

another? The answer is unclear. It may be the money. Or it may hang on a turn to theory as a desperate attempt to reinvest art with decency and seriousness.

Warhol's Yellow Submarine is a place in which the illusion of total possibility in a neutral environment is taken as real, for no one really says anything, it is a place in which nothing at all is done (other than living creatively), no voice speaks, no position is taken, and no full-blown beauty is achieved. The very idea of freedom is partly an idea gestated in such simulacra. I have sixty-eight cable channels on my TV, and I often flip through them at night to find exactly nothing I want to watch. This stupefying situation exhibits a deadening combination of lack of quality, overwhelming quantity, and lack of real alternative. The issue of freedom of choice in artistic production can appear in a similar light to the artist. Wittgenstein tells us that a style, like a concept, finds its meaning and force only in a context, a web of practices, beliefs, commitments, and styles of feeling. If there are sixty-eight styles in art to choose from but each must be adopted independently of its context of use and independently of a clearly defined new project of use, then how can one know how to use these styles? And are they really available? The availability of a concept or a style is a matter of one's knowing how to go on and follow the rule it sets in a new context or in a further version of the same context. If one fails both to know how to go on and use a style, and how to transform it, then the apparent freedom of art— like salt water to a person dying of thirst—is really its impossibility. Then are artists really as free as Danto thinks if they have neither a context in which a style can be put to its natural use nor a grand narrative plan of action which allows for a mode of stylistic appropriation? Just surviving can take all of their energy, and I mean culturally surviving by finding something to use and something to paint. Such cultural malaise, such existential malaise, leaves an artist ripe for the influence of theory and/or money, the influence of anything that will get her started and get her motivated. Postmodernism is, therefore, an existential condition, not simply an economic one. Without a reason for using a style, the use of the style quickly turns into its consumption, a matter of taste, pleasure, or a new hat, something chosen at will, purchased at will, consumed at will, a thing rather than an active form of life activity. This is the condition of Warhol, for it is a condition which Warhol thrives on. Others turn away, perhaps to theory. Or they consume theory like dollars and cents.

Danto's own theory vacillates between claiming that the result of the avant-garde's project has been (1) to turn art into a branch of theoretical

Avant-Garde, a clothing store in Beverly Hills, CA (where the avant-garde has become the latest look). Photograph by the author.

philosophy (in the manner envisioned some two hundred years ago by Hegel), and (2) to produce a situation in which art is, instead, free of the burdens of philosophizing altogether like Marx's postrevolutionary person. In fact, art today is caught between the poles of theory and of mere play, yet it is this schism and its modes of negotiation which need explanation. Danto gives none, nor do I think there is any simple explanation to be found.[10] There are many ways in which this schism is (or is not) negotiated by artists.

One mode of its negotiation is for artists to make theory and the free play of art converge through reliance on a theory which has already been partly made over into fiction (art). Thus there are reasons why Jean Baudrillard is a writer in whom artists are especially interested—reasons of style as well as content. Baudrillard's claims about politics, late capitalism, and the loss of what he refers to as the "real" in contemporary life are powerful, totalizing, and dramatic, but his style takes pleasure in the very world he lambastes, and his narrative procedure is as inventive, as audacious, as intricate as any piece of science fiction. Baudrillard is a surrealist of the hyperreal; he arranges his texts so as to make the world strange, so as to invent it from

nowhere. He aims to give the world an order which can only be the product of imagination bordering on fantasy. Baudrillard is a science fiction writer, an artificer of the intellectual. He tells theoretical tales spun in the labyrinth of Borges in a narrative style that eviscerates reality just as his ideas approach it. Like some existentialist who is laughing himself all the way through the absurd, Baudrillard savors the one-dimensional wastelands of California or New York as if they were some imported delicacy from that famous Parisian food shop Fauchon. Yet his existentialist view of culture wrests it from all connections with the past and presents it as a landscape from another planet, a world whose order is simulated in Baudrillard's own imagination. He defamiliarizes culture to the point of an avant-garde intervention in it. Culture in his pen becomes a thing thematized like the moon, an object turned by his artifice into the artifice he already thinks culture has become.

One reason for Baudrillard's act of artifice is to bring home his belief that culture has become a web of artifice, a maze of simulations in which what he calls "the real" has dropped out. Baudrillard's style of intellectual invention is therefore serious; it lambastes the culture of simulation by simulating it. This subscription to the act of defamiliarization by simulating and fictionalizing is Baudrillard's inheritance from the avant-garde, yet Baudrillard's simulation is also as unstable as Warhol's, for his is a style which, like Warhol's, both criticizes its subject and dissociates itself from its subject so totally as to turn its subject into a game of play. On the one hand, Baudrillard teaches cultural resistance through his defamiliarizing style and his critical concepts; on the other, he teaches accommodation to a world now cast as a mere fragment of fiction. Baudrillard shares with Warhol the capacity to speak and to deflate the seriousness of speech at the same time. He offers a view and turns it into the occasion for a mere play of signs. America in Baudrillard's hands is a text, the text of his *America,* a mere occasion for the play of fabrication, an anecdote enjoyed over a lunar landscape. This is Baudrillard's art of play which, like Warhol's, derives from, and interrupts the seriousness of, the avant-garde. Then every question I have put to Warhol must be put to Baudrillard. Is the point in his stylization to simulate the condition of cultural artifice, cultural strangeness, and cultural simulation in service of criticism, or is his point to make up a game in which criticism itself ends up being merely simulated, turned into a fictional game of fable making? Baudrillard exhibits the same underdetermination of voice that Warhol does. He is postmodern in Warhol's sense. It is impossible to tell if

Baudrillard's is a simulacrum of criticism or the critical act itself, which must mean it is not the critical act itself, for the critical act must be transparent to at least some group of readers.

Baudrillard is also a modernist. He begins the second chapter of *Simulations,* entitled "The Orders of Simulacra," with the following. "Three orders of appearance, parallel to the mutations of the law of value, have followed one another since the Renaissance:—*Counterfeit* is the dominant scheme of the 'classical' period, from the Renaissance to the industrial revolution;—*Production* is the dominant scheme of the industrial era;—*Simulation* is the reigning scheme of the current phase that is controlled by the code." [11] He assumes that "the current phase" exhibits a clear shape which a single concept or analytical category ("simulation") can theoretically characterize. Indeed, there is a central tension in *Simulations* between the first half of the book, which presents a variety of obliquely related ways in which simulation obtains in contemporary culture, and the book's second half, which lumps all of these disparate examples into a single category, which is then explicated (in, to my mind, an incomprehensible way). The first half of his book exemplifies its title, which is in the plural, thus acknowledging the varieties of simulation in culture; the second half mysteriously assumes all of these distantly related examples can be explicated under the same concept. The assumption is never argued. There is thus a split in Baudrillard's writing between the acute observer of the individual example and the modernist who assumes it all can be transparently assimilated into a single critical, theoretical construct. I resist this claim of transparency in Baudrillard as strongly as I resist it in Gabo (in fairness to the complexity of Baudrillard's work, one is also interested in him because the age of Warhol really is one of the replacement of life by simulacra, and Baudrillard has obvious imaginative insight into this fact).

I find, although I cannot begin to argue this here, the same split in Fredric Jameson's writing.[12] Jameson's observations of cultural details are offset by his desire to assimilate them all into the category of late capitalism and its logic of cultural production. (Indeed, like Lyotard, Jameson wishes to resist the age by completely characterizing it, in his case, by forcing recognition of the full force of its hopelessness.) Thus, if I am right, the modernist sensibility is a tendency or aspect which can be found in writers who only partially subscribe to it. And if I am right, it inhibits the capacity of these writers to take full cognizance of the cultural example and the richness of culture. They tend to turn culture into a thing, a single object whose form can be completely characterized by theory. While this modernist turn

in their writing gives their words great power—the power of resisting the deadening and complacent whole of culture by articulating its shape—this power (an avant-garde power of the sort found in El Lissitzky or Mondrian) is also purchased at the price of contact with the events of the world in their manifold complexity.

What we long for is the pen of resistance, the pen which can impose theory onto the tenor of the age, encompassing its details. We do not believe anymore that theory can prefigure the utopian future, yet we hope for an authority to write at least the terms of the present. Thus we capitalize on our inheritance of the history of such theorizing from Hegel, Marx, and from the avant-garde. With regard to the latter, note the connection between Baudrillard's rhetoric and Gabo's and El Lissitsky's. Baudrillard's rhetoric slides among disruption, defamiliarization, and synoptic theoretical explanation. This sliding represents his inheritance of the avant-garde's dual rhetoric of (1) theoretical definition and (2) censure in the interest of social change. The popularity of Baudrillard must have to do with our yearning for a new avant-garde metanarrative and rhetoric of censure, of course, one no longer about the golden utopian future to come but about the present. Baudrillard gives us both the metanarrative and the rhetoric of acid to go with it, as if he is both Gabo and El Lissitsky in one. Yet since we are also ambivalent about our yearning for serious metanarratives told even about the present, since we are unsure about how serious we can and ought to be, Baudrillard also allows us to indulge our ambivalence through his Warholian antics of play in the ruins, through his tales spun in fantasy, and through the pleasure he takes in the American void. "Who cares," his voice says, "if it is all hopeless"? "I'm having fun in the wasteland, n'est-ce pas?" Baudrillard's popularity is therefore a measure of the depth of our (unresolved) ambivalence toward the avant-garde and what the avant-garde stands for.

II

I wish to turn now to ways in which art history, art criticism, and art itself have absorbed the positions of the avant-garde. Consider first the multiperspectival position which both the art historian and the art critic find themselves in when interpreting a work of art. If artworks are overdetermined in the way I have shown the avant-garde to be, then criticism should not expect to reduce an artwork to a single theoretical perspective; nor should it expect that all such perspectives add up into a consistent picture—for the picture

"pictured" by vision and interpretation may itself not be consistent. That is the lesson of the avant-garde which has, in my view, entered into the stream of art history (even if unconsciously).

To take an example, consider the perspectives from which Titian's *Venus of Urbino* is now approached. John Berger tells us that this painting is part of the dominant history of the nude in the West.[13] The history of the nude, or what Berger refers to as the construction in Western history of the idea of the nude as a category of representation, is the construction of a style in which women are represented for the male gaze as compliant beings whose body and sex are made available by the painter for the voracious, possessive eyes of male viewers (and female viewers who have been constructed by the terms of the male gaze). As an exemplar of the represented nude woman, Titian's Venus offers, according to Berger, neither resistance nor individuality. She is unabsorbed in her life; she waits passively for the surveying gaze of the next viewer. Nor does she appear free to chose who her lovers will be. She is universally available, a being whose sexuality is that of being ever ready for seduction by the eyes of everyone and whose sexuality is her total nature. Her desire is not hers in any authentic sense but is, rather, a form of electricity to be turned on by the seething current of the male eye. As is well known, Manet, among the first to have exposed the terms of this representational style for what they are, in effect representationally deconstructs Titian's Venus (and Titian's *Venus*) by casting her in his *Olympia* under the aspects of aggression, boredom, and discomfort. Manet's Olympia does not comply with the demands of the male eye, but, rather, extorts a price for the gaze we give her, the price any disinterested prostitute would demand for sexual services rendered.[14] The price Olympia extorts for visual services rendered is that of our discomfort at being forced to acknowledge how bored she is, how constructed she is, how trapped, how aggressive, and how lacking in sexual desire she is for us. For in the fantasy of sexual encounters with prostitutes or visual encounters with nude women in pictures, the male fantasizes a quite different woman, let us say he fantasizes his way into a Titian nude. Manet has set the theme for Berger, who, of course, knows Manet's work well. He, in turn, sets a familiar feminist theme in his reading of Titian's *Venus,* the theme of representation as a system of power relations which enforces disenfranchisement of the identity of women and corresponding enfranchisement of the power of men through their phallic eyes.

What, in the light of this knowledge, are the acceptable conditions of looking? Let us accept Berger's (and Manet's) reading of Titian's painting. Then what should one say about the art and beauty in Titian's *Venus of*

Urbino (and in his oeuvre in general)? What should one say about what Richard Wollheim refers to as Titian's shimmering, anthropomorphic surfaces, Titian's capacity to make the spreading textures of his paint resonate with the life of the body, Titian's earthy, sensual colors, and the undeniable beauty of his female form?[15] Is there no way to take pleasure in these aspects of the painting without participating in the painting's illicit terms of representation? The situation—that of visual participation in a picture—is the interpreter's side of the artist's problem of voice, the postmodern problematic announced by Lyotard and exemplified by Kiefer. What kind of participation in the voices from the canons of art is legitimate? This is the unresolved question at the bottom of postmodern suspicions about viewing. It is a suspicion partly derived from the avant-garde's own practices of suspicion: from Manet's critiques of the role of art in French bourgeois society, from Duchamp's exposure of voyeurism in *Étant Donnés,* from De Stijl's lambasting of those "hairy apostles" of nineteenth-century art, Ruskin and Morris.

Feminist theories are the most powerful means available, other than avant-garde art itself,[16] for articulating suspicions about the tradition of the nude (which Berger makes clear is not a monolithic tradition) and for defamiliarizing our participation in traditional representational styles. But then what does one do with Wollheim's insights into the beauty of a Titian? One can only presume that almost every art historian and art critic has felt the beauty in a Titian—perhaps while being simultaneously disgusted with its voice—in the way I, as a Jew, am simultaneously overwhelmed and repulsed by Wagner's operas (or in a lesser way, by Kiefer's paintings). This experience of beauty must also be given its due. I think the notion of a plurality of readings associated with Jacques Derrida has its place here.[17] For both Berger's and Wollheim's interpretations are indecisive regarding their explanatory scope. Both are convincing and neither can univocally rule interpretation. One cannot obliterate the force of the beauty and sensuality in Titian's *Venus of Urbino* by a feminist analysis, but the feminist analysis (which should be everybody's analysis, part of everybody's way of engaging this picture) is also an interpretation and reaction to the picture which is visually, culturally, morally, and psychologically right. Neither style of engagement obliterates the other. These readings and responses to the voices in Titian neither compute into a completely consistent picture nor do they obliterate or disprove one another, which means the question of participation in the voices of art remains essentially unresolved. Let us say it is the mosaic of voices in this picture, and the mosaic of our own reactions to it, which in relationship constitute the picture's meaning and force. It is

Marcel Duchamp, *Étant-donnés: La Chute d'Eau, Le Gaz d'Eclairage*, 1946–66.
Mixed media assemblage, appx. 95 ½ × 70 in. Philadelphia Museum of Art. Gift
of the Cassandra Foundation.

this mosaic which tells us who Titian was, what his art is, what culture is like, maybe what I am like (what impels my ever-ready aestheticizing and eroticizing eyes). As in avant-garde art, it is the relationship between voices, not any single one, which is of the greatest interest. Art history's discovery of this fact is a legacy from avant-garde art, not simply from poststructuralist discourses.

This legacy also imposes its tendencies toward theoretical abuse. Both De Stijl and constructivism manifest a desire to eradicate the art of the past through a rhetoric expressed in their manifestos, theories, and artistic inventions. This rhetoric is partly an attempt to produce dramatic separation from the terms of the past (in order to free the present for the future). In its theater of separation, we have seen that the avant-garde represses the complexities of past art and of its own art. This avant-garde aim of separation— of making a decisive break—can also be found to underlie feminist repressions of the complexity of tradition. The exigencies of the drama should be respected; separation from the terms of the male gaze may demand a decisive use of theory and rhetoric like that of the avant-garde's (or are feminist intercessions in art to be thought of as *part* of the history of the avant-garde?). Yet the repression of artistic complexity in this rhetoric and this use of theory must also be appropriately criticized. Too much denial of complexity produces loss: the loss of values of looking, the loss of a self-critical voice, the loss of what we know art to be, and the loss of the very project of separation from the past, for one ends up exercising the authorizing norms of a position whose claims to authority one is precisely aiming to overrule (i.e., avant-garde norms licensing the right of denial through theory).

Contemporary art exhibits the same variations in its uses of theory that art history and art criticism exhibit. The turn toward theory is subject to a similar politics and a similar mode of empowerment; it demands a similar mode of analysis. Theory today has its well-known uses in art. One can turn to a range of examples of contemporary art in which theory is appropriated to continue (or recast) the avant-garde's concepts of social engagement without its utopianism. The examples here are familiar: Jenny Holzer, Barbara Kruger, Hans Haacke, and others.[18] Jenny Holzer's *Inflammatory Essays,* colored sets of paper posters on which inflammatory texts are arranged in a repeating pattern, are an example of theory well integrated into the practice of art. She, I am told, has said that the texts of this piece could be arranged in any number of ways, but the way I have seen them arranged in a rising pattern made them look like a skyscraper ascending the museum wall.[19] Holzer's work then appeared to dwarf even the largest wall posters.

URGES IS SO
IS UP INSIDE
ST COME OUT.
LD BACK TOO
OUT FAST AND
A LOT OF
T PEOPLE GET
CONFUSED SEX
N'T KNOW
UNTIL TOO
HOULD LET
SS THEMSELVES
GET MEAN EARLY.
MAKE SURE THEY
ETS. ALL
RESPOND TO
DON'T MAKE FUN
AND SEND THEM
R TO
V TO GET FORCED.

A REAL TORTURE WOULD BE TO
BUILD A SPARKLING CAGE WITH
2-WAY MIRRORS AND STEEL BARS.
IN THERE WOULD BE GOOD-LOOKING
AND YOUNG GIRLS WHO'LL THINK
THEY'RE IN A REGULAR MOTEL
ROOM SO THEY'LL TAKE THEIR
CLOTHES OFF AND DO THE
DELICATE THINGS THAT GIRLS DO
WHEN THEY'RE SURE THEY'RE
ALONE. EVERYONE WHO WATCHES
WILL GO CRAZY BECAUSE THEY
WON'T BE BELIEVING WHAT THEY'RE
SEEING BUT THEY'LL SEE THE BARS
AND KNOW THEY CAN'T GET IN.
AND, THEY'LL BE AFRAID TO
MAKE A MOVE BECAUSE THEY DON'T
WANT TO SCARE THE GIRLS AWAY
FROM DOING THE DELICIOUS
THINGS THEY'RE DOING.

DESTROY SUPER
FLESH, SHAVE T
BONE, CLARIFY
WILL, RESTRAIN
THE FAMILY, FL
THE VERMIN, VO
THE DEAD. LIMI
AMUSEMENT, DE
ACQUAINTANCES
FORGET TRUTHS
MOTION, BLOCK
SWALLOW CHATI
TOUCH, SCORN T
LIBERTY, SCORN
SCORN EXALTATI
SCORN VARIETY,
SCORN RELEASE,
SWEETNESS, SCO
QUESTION OF FO
IT IS A MATTER (

URGES IS SO
IS UP INSIDE
ST COME OUT.
D BACK TOO
UT FAST AND
A LOT OF
PEOPLE GET
CONFUSED SEX
'T KNOW
UNTIL TOO
HOULD LET
SS THEMSELVES
ET MEAN EARLY.
MAKE SURE THEY
ETS. ALL
RESPOND TO
ON'T MAKE FUN
AND SEND THEM
R TO
TO GET FORCED.

A REAL TORTURE WOULD BE TO
BUILD A SPARKLING CAGE WITH
2-WAY MIRRORS AND STEEL BARS.
IN THERE WOULD BE GOOD-LOOKING
AND YOUNG GIRLS WHO'LL THINK
THEY'RE IN A REGULAR MOTEL
ROOM SO THEY'LL TAKE THEIR
CLOTHES OFF AND DO THE
DELICATE THINGS THAT GIRLS DO
WHEN THEY'RE SURE THEY'RE
ALONE. EVERYONE WHO WATCHES
WILL GO CRAZY BECAUSE THEY
WON'T BE BELIEVING WHAT THEY'RE
SEEING BUT THEY'LL SEE THE BARS
AND KNOW THEY CAN'T GET IN.
AND, THEY'LL BE AFRAID TO
MAKE A MOVE BECAUSE THEY DON'T
WANT TO SCARE THE GIRLS AWAY
FROM DOING THE DELICIOUS
THINGS THEY'RE DOING.

DESTROY SUPER
FLESH, SHAVE T
BONE, CLARIFY
WILL, RESTRAIN
THE FAMILY, FL
THE VERMIN, VO
THE DEAD. LIMI
AMUSEMENT, DE
ACQUAINTANCE
FORGET TRUTHS
MOTION, BLOCK
SWALLOW CHAT
TOUCH, SCORN
LIBERTY, SCORN
SCORN EXALTAT
SCORN VARIETY,
SCORN RELEASE
SWEETNESS, SC
QUESTION OF F
IT IS A MATTER

URGES IS SO
IS UP INSIDE
ST COME OUT.
D BACK TOO
UT FAST AND
A LOT OF
PEOPLE GET
CONFUSED SEX
'T KNOW
UNTIL TOO
HOULD LET
SS THEMSELVES
ET MEAN EARLY.
MAKE SURE THEY
ETS. ALL
RESPOND TO
ON'T MAKE FUN
AND SEND THEM
R TO
V TO GET FORCED.

A REAL TORTURE WOULD BE TO
BUILD A SPARKLING CAGE WITH
2-WAY MIRRORS AND STEEL BARS.
IN THERE WOULD BE GOOD-LOOKING
AND YOUNG GIRLS WHO'LL THINK
THEY'RE IN A REGULAR MOTEL
ROOM SO THEY'LL TAKE THEIR
CLOTHES OFF AND DO THE
DELICATE THINGS THAT GIRLS DO
WHEN THEY'RE SURE THEY'RE
ALONE. EVERYONE WHO WATCHES
WILL GO CRAZY BECAUSE THEY
WON'T BE BELIEVING WHAT THEY'RE
SEEING BUT THEY'LL SEE THE BARS
AND KNOW THEY CAN'T GET IN.
AND, THEY'LL BE AFRAID TO
MAKE A MOVE BECAUSE THEY DON'T
WANT TO SCARE THE GIRLS AWAY
FROM DOING THE DELICIOUS
THINGS THEY'RE DOING.

DESTROY SUPER
FLESH, SHAVE T
BONE, CLARIFY
WILL, RESTRAIN
THE FAMILY, FL
THE VERMIN, VO
THE DEAD. LIMI
AMUSEMENT, DE
ACQUAINTANCES
FORGET TRUTHS
MOTION, BLOCK
SWALLOW CHATI
TOUCH, SCORN T
LIBERTY, SCORN
SCORN EXALTATI
SCORN VARIETY,
SCORN RELEASE
SWEETNESS, SCO
QUESTION OF FO
IT IS A MATTER

Jenny Holzer, selections from *Inflammatory Essays*, 1979–82. Offset paper posters, 17 × 17 in. each. Installation view from "A Forest of Signs: Art in the Crisis of Representation." Museum of Contemporary Art, Los Angeles, at the Temporary Contemporary May 7–August 13, 1989. Reproduction, courtesy of the artist through Barbara Gladstone Gallery, New York.

One had the feeling that the stories of her language carried the ascending power of the stories of a building. Her fragments of language appeared as sedimented as the big-shouldered buildings of American cities, a vivid way of causing us to think of the real power contained in language (both repressive and liberating).

What kind of power is contained in such language? Holzer's sense of the answer to that question is clearly influenced by feminist theory, Foucault, and Baudrillard. The power in such language is gendered, and it is also an amorphous product which is partly the result of capitalism, advertising, media technology, and the simulacrum in which we take images to be the real thing and advertising slogans as truths. In this respect, Holzer's work is influenced by theory, but she does not rely on mere reference to those discourses to give her artworks meaning. In the *Inflammatory Essays* Holzer has found a way of making an authentically visual contribution to our understanding of the power in words and images. She relies on the immediacy, size, and boldly colored typefaces of her visual art objects to illustrate the way in our specular society words are transposed into images and images are confused with their interpretations. Behind her manipulations of word images is the way TV news programs have turned words into the mere rapid-fire adjuncts of equally fast-hitting images (usually of violence, sex, and the spectacular). Behind her posters are the catchphrases, adverts and high-concept forms of psychobabble that we use to fashion our self-presentations. Behind her artworks are those postmodern paintings (not to mention American presidents) which have, in Arthur Danto's words, replaced deep interpretation by the mere look of importance. And behind her ouevre is the peculiarly American capacity to turn critique into the latest style of life that is "in." Thus her work is in dialogue with theory because, being visual, it can bring out so clearly the role of the visual in the structure of contemporary linguistic power. Indeed, her work also suggests that the spectacle of power extends to theory's own use of its words, words which in art all too often are disseminated in the form of powerful images, as if they, too, are big billboards (consider the artworld's interest in Baudrillard's words, and even in Foucault's, in this regard). Holzer's work is thus a lesson for theory; it is not simply a visual embodiment of theory.

What sort of art is it that does rely on theory as on a billboard or advertisement? I wish to present at least one example of an extreme version of an uncritical reliance on avant-garde theoretical norms, and I choose as my example a recent exhibition at the Museum of Contemporary Art (MOCA) in Los Angeles called, "The Forest of Signs: Art in the Crisis of Representa-

tion" (Spring 1989).[20] That forest of nearly two hundred artworks on display there seemed to me to picture so clearly the potential disfigurations of art by theory that it could have been a show invented to serve the purposes of illustrating what Danto's picture of the defining role of theory in art would look like in practice. There is no better way to render suspect a philosopher's views than to provide a living example no one wants to see of what life (art) would be like were his theory true. Nor is there a more effective way to warn the artworld of a tendency than by exemplifying its excesses.

Armed with the background theories of Foucault, Derrida, and other poststructuralist writers,[21] the artists in the MOCA show aim in their art to address the whirl of commodity, power, and epistemological relations that exist in contemporary society and art by using the materials of advertising, dialect, and image that are the currency and vernacular of contemporary (American) life. They respond with slam-bang images, big words, with canvases drained of expression, with slang, slogan, and sign. Their aim in all of this is to fight fire with fire: to confront and examine the condition of linguistic depletion by reducing their canvases to the point where nothing fills the twenty feet of one wall but an image of a suitcase made desirable by the words that advertise it ("Mitchell Syrop"). They aim to expose the reduction of thought to image by giving us words turned into nothing but images, to implode the gaze of men that encages women as things by giving us a woman turned into a thing, lying naked in the bath and holding her breasts as if surprised (shocked? delighted?) by a mouse (Jeff Koons). They aim to halt the reduction of artworks to commodities by giving us canvases whose sole content is in effect the words: "Buy me" (Syrop). This is social critique by theory and by simulation extending to the topic of art itself. Yet the question is what images the artists have relied on in making their art; whether their images of empowerment by theory have not inflated their artworks with the very hype and self-exhibition that is the problem they intend to address.

The works shown in this MOCA exhibition which have, I think, failed, have done so because they are caught between a rock and a hard place: they have neither worked out a way to embody theory in the details of their art objects (in the manner achieved by Mondrian or Holzer, who was also in the show), nor have they succeeded in developing a provocative gesture (perhaps by way of simulation) that inspires thought and theory à la Duchamp. They have done neither, instead relying either on slogan and image to instantly engender thought or on heavy doses of theory to do the work for

Richard Prina, *Upon the Occasion of Receivership,* 1989. Courtesy Luhring Augustine (Gallery), New York.

them. This reliance on mere reference to theory to empower their works of art with meaning cannot help but make one ask why one shouldn't, rather, dispense with the exhibition entirely and simply read the books.

Concerning the works themselves, Richard Prina's *Upon the Occasion of Receivership,* a set of sixty-one works on paper which contain translations of a sentence about translation into various groups of languages, looks nice. The paper is Berlitz's finest and the work's scale (horizontally a good fifty to one hundred feet) intrigues. But one remains at a loss as to what kind of thoughts about translation and communication one is supposed to find stimulated by this work. Nothing is occasioned in the work until one reads in the catalogue that Prina is influenced by poststructuralism, and even then how that myriad of theories relates to this object still remains opaque. The work lacks the focus required by visual art to direct thought. Mike Kelley's *Pay for Your Pleasure* is a set of forty-two paintings, each a picture of a famous artist or personage who painted (including a murderer) and each with some of the painter's words about connections between art and morality placed below his image. It is pleasingly painted; the colors balance well,

and the lines are well drawn. But its point is supposed to consist in the moral reflection it engenders, and Kelley's selection of art remarks is of no more interest than what one could get from an abridged dictionary of quotations. In particular, the artist himself has taken no risk and explored nothing. Robert Longo's *Untitled* charcoal, graphite, and ink works on paper are freeze frames in which men are caught in the contortions of motion; often they look as if they are being shot or attacked. The artist's hand is suave. His attempt is to put you in the position of looking at violence—a position of voyeurism—and to raise the question of whether the artist's act of representation has imposed violence on his subjects. Yet the actual images look too clichéd, too close to ordinary images of new-wave figures for the gesture to come off. The work does not involve the viewer sufficiently for the viewer to be truly implicated in this voyeurism and violence (unlike, say, Hitchcock).

This dramatic failure to stimulate thought by art needs explaining. One remark would be that not everyone is successful at marrying theory and practice or at engendering thought through gesture. Such projects are hard to do, and some people fail (sometimes). But I suspect that these artists feel that theory—or the image itself—is so omnipotent that either will instantly invest its objects with power and depth, such that no possibility of failure could arise. I suspect that such artists are bewitched by both the inherited theoretical gestures of the avant-garde (by the Mondrian who, in the voice of the theorist, claims that every inch of his canvas is defined by a Platonist theory of demonstration) and by the seductive power of those big images it is Holzer's desire to criticize, as if image and theory were some television program instantly delivering knowledge of whatever. That makes one wonder if the failures of these artists do not reflect the very social condition the artists claim to address. In a culture in which the history of the French revolution and "I Love Lucy" reruns have the same degree of historical reality; in which former careers in advertising or performance (which some of these artists have had), reading a few books, and being at the right place at the right time are deemed sufficient to provide knowledge of how to use a medium (be it education, art, or politics); in which the ideology of liberation from the strictures of class and tradition (a founding idea of America) is conflated with the idea that you can do or be whatever you want (so long as you have the money) because nothing further is required, in such a culture these artists seem to believe it is enough that thought is engendered from paint—or paint from thought—almost instantaneously. It is hard enough to paint a bottle well or a piece of landscape in the south of France, as Giorgio Morandi and Cézanne have made clear. Taking on the world as a

whole must be that much more difficult. Whereas Julian Schnabel and others place the hype in the art object itself, believing bigness means power and profundity, the danger of the art I am discussing here is that it can conflate theoretical armament with profundity or the right look (what Danto calls the look of importance) with subtle invention.[22] Both are matters of hype, reducing art to a piece of self-advertising and inflating theory to a mega-image mediating art with a power channeled from the pay channels of some TV blitz.

Such hype is made possible only because avant-garde norms of theoretical prefigurement and instantaneous theoretical empowerment are already, in some amorphous way, in place in the artworld. These contemporary examples of theoretical abuse depend on the history of avant-garde norms which I have traced to Gabo, Moholy, and Mondrian. In spite of Gabo's attempt to marry theory to his sculptural objects, in spite of his restless shifting between theories, and in spite of his many voices, it is in his avant-garde practice that the sources of these contemporary abuses must, in part, be found. Hype by itself cannot rise unless factors exist which can prepare it.

We have, in the excesses of this show, an example of Danto's nightmare, a situation in which the visual has dropped out, for the visual has been written off as nothing more than a semiotic sign waiting to carry any sort of meaning assigned to it (Mondrian also partly suffers from this belief, as we have seen). Recall the paradoxical, nightmarish results we derived from Danto's theory of theory. I speak of the situation in which (1) theory has replaced the visual element in painting rather than entering into painting in relationship with the visual; (2) theory, since it is itself uninterpreted in terms of practices, feelings, or visual features outside its own circle of words, becomes an empty circle in which (3) the content of the theory itself ends up being undecidable, and (4) theory is judged either by the amount, fanciness, or image of heaviosity it exudes or by whether the person who asserts it has his or her fifteen minutes of fame or not. This nightmare of a cultural possibility was shown to be a conceptual result of Danto's extreme position on theory. The MOCA show is an example tailor made to substantiate the nightmare, its ultimate paradox being that the theory relied on by such artists and critics is never tested. It is assumed to be an alchemical magic, capable of turning canvas into gold. When art is priced in terms of a theory which is not tested for conformity to the art object, then the price of art has no value beyond who sets that price and who is buying. Within this community, the paradox is that theory itself loses all falsification and mean-

ing, for one can, in the end, say anything and get away with it as if Warhol were writing the script. Theory itself becomes measured only by the price of the artist who uses it, by the critic who is talking, the public who is watching, and the collector who is buying.

Such artists would do well to discard the theoretical ideologies (that theory unconditionally rules the canvas) set by Mondrian and focus instead on how Mondrian (like Holzer) goes about trying to marry his theory to his art objects. The avant-garde artworks of Mondrian, Gabo, and company resist their theoretical master conceptions, or alternately, force theory into adjustment with the power in the artworks' visual images. Mondrian's marriage of art and theory is not one of domination (in spite of Mondrian's theoretical intentions); in it, the artwork maintains its own visual identity and integrity. It remains insubordinate. Words do not necessarily find their application to a given set of visual features.

What more can we learn from the avant-garde about how such a reliance on theory came about? I have said that the reliance on theory by this art must be understood as a result of norms regulating the visual features of art which were instituted in the course of avant-garde art practices. Let me amplify. When theory is excessively relied on, one might expect that the fetishization of theory is connected to a disappointment in (or fear of) other features of art, in this case, the visual features of art. Such a disappointment can be traced to norms regulating the visual elements of art, which were established in avant-garde times. For Gabo, Mondrian, the Bauhaus, and others, what gives the visual dimension to art meaning and worth is its capacity to carry the weight of philosophy and truth. An artwork is an exemplification of the new, utopian age because it is an example of how to construct the future according to a clear, theoretical plan. The avant-garde aims, in its theoretical voice, to prefigure the art object according to a stringent theory of formal structure.[23] For Picasso—or more precisely for how he is received by the mythologizing of his times—the visual element in painting is not substantiated by a theory but by the capacity for radical originality in painting.[24] Then in both cases the visual features of painting are deemed valuable only through their connection with some avant-garde myth: theoretical empowerment, radical originality, or whatever. The idea that what justifies a painting is simply what one looks at—how it strikes one as tasteful, lovely, or expressive, what it discloses about life, or how it humanizes one by cultivating one's mind and feelings—is out. Visual sensuality is proved worthy, is made over into art only by the big picture, the big intention, the big myth.

Now if the avant-garde has raised the thought that the visual features of painting take on meaning and worth only through their capacity for theoretical prefigurement, avant-garde originality, or some other myth, then the visual has already been attenuated by that avant-garde ideology. I say *ideology* because in actual practice the works of all of these painters resist their conceptions; in one mood Mondrian simply loves to paint and it is enough for him to do just this in one of his moods. But in another of his voices, in his master voice, theory becomes a norm of art rather in the way Christian iconography was a norm of art in past generations of art history. Christian iconography was a norm in the sense that the visual elements of art were made under the master thought of connection to the church, and the visual was disdained, indeed, disallowed, if unconnected to this master thought. Theory and originality are not avant-garde norms with quite the compulsion that Christian iconography and design possessed when they ruled the Middle Ages; artists are not killed or thought devilish for failing to comply with avant-garde norms (though in certain circles they may be marginalized). Nevertheless, disdain for the visual in itself (independent of a master thought) is an avant-garde norm. This rhetoric of disdain is crucial to the avant-garde's project of separation from the values of the eighteenth century and romanticism, to its project of separation from the values of taste, pleasure, connoisseurship, and *l'art pour l'art,* values articulated in terms of the free and autonomous reign of the visual by itself. (Needless to say, the values of the eighteenth century and of romanticism were themselves to some degree illusions; no art exists in a realm of visual pleasure, taste, and invention entirely independent of social context and, indeed, theory.)

These avant-garde norms of theory and originality are still in play today. Yet both are only half believed. An unceasing barrage of original art objects has, over time, largely drained the commitment to artistic originality of its force and excitement; original art is now the rule, the everyday, and moreover, the commodified and the salable. It can be found in every museum, exhibition, gallery, and au courant home. In addition, the belief that the visual can serve as the site of utopian philosophy has been proved amazing (amazing that anyone would have believed it in the first place; artists are as crazy as philosophers, or rather, they are or can be philosophers). Thus the problem is (1) regions of the artworld still believe that the visual is only proved worthy when empowered by norms of theory and originality; (2) some subset of those persons believe this, yet in addition, they no longer trust in the authority of either of these norms (theory or originality);[25] hence (3) those persons are left with nothing but disappointment in the

visual. Such persons are like the one who believes life is only proved worthwhile if it prepares him or her for heaven but who no longer has faith in the prospect of heaven. Life will look like nothing but a disappointment to those persons until they either restore their faith in the prospect of heaven or until they find a new way to value life in some other terms (perhaps simply by living it well and happily).

Since these persons have not come up with a new way to value the visual (in terms of a new myth, a new project, or by reclaiming older visual values of beauty, taste, sensuality, sensitivity, formal charm, and craft as humanizing attributes), disillusioned pastiche[26] reigns as Warholian play, or mere entertainment. Little study is given to reclaiming (albeit critically) the powers of the art of the past or of projecting the visual into a new (avant-garde or post-avant-garde) project like Jenny Holzer's. The freedom to merely relax and paint can therefore look to a painter raised on the heights of avant-garde modernism like freedom to sit at home and do nothing. "How can you keep them down on the farm, after they've seen Paris?" especially the Paris of Andre Salmon, Picasso, Duchamp, Mondrian, and Apollinaire? This is the problem with Danto's blithe description of post-Warhol pluralism. The condition of pluralism can appear to be an enormous letdown in spite of liberating calls from Danto and Robert Venturi.

The fixation on theory is, paradoxically, to be understood in these terms. If one takes away the possibility of really empowering the visual with philosophy, originality, or a grand political narrative yet retains the norms which claim that the visual only has worth in terms of those norms, if one takes all of that away or renders it suspicious, then the yearning for theoretical power, for originality, or for the power of the visual image to signify are all that is left. Such a condition can lead to the fetishization of theory, of originality, or of the superimage. If there is nothing to accomplish in art, then there is nothing better to do than either engage in visual window dressing (Warhol's fetishization of the idea of style) or abdicate the visual and opt instead for making large-scale pronouncements about why nothing can be accomplished in art. Or one can fetishize the size and incoherence of the image as a guarantee of its significance (this is Danto's look of importance), for we mistrust theory when it really aims to change the world (the theories of Gropius, Mondrian, fascism, Lenin), so we are content to fixate on theory which does nothing essentially harmful but provides the feeling of supreme empowerment. And we tend to mistrust any claim to institute new forms of style. So, correspondingly, we fixate on the ghost of originality for its own

sake. No longer trusting in the possibility of genuine originality but being unable to relinquish the norm, we turn originality into the new fashion.

There is a fine idea of relevance for the artists in the MOCA show in Adorno, that theory goes farthest in praxis when it continually distrusts itself, rather than when it overdramatizes itself—when it puts aside its immediate claims to authority and is instead most attentive to the minute details of the vicissitudes of the contemporary scene, most sensitive to a variety of related ways in which attenuation is happening and retrieval of values may be envisioned and worked out, most critical of its epistemological stance, and most urgent in its voice all at once. One might say the same for the norm of originality and for the power of the image to signify.

III

A final remark about art is in order. It should not be thought that theoretical art, must less the excessive reliances on theory characteristic of the MOCA show, is the one dominant mode of artistic production today. It is my own view that there is no one form of dominant production today. The very assumption that there is a univocal shape to the postmodern, that amid its family of interpenetrating concerns and modes of production some theorist can discern a unifying, Hegelian shape definable in terms of a single analytical category, is itself the assumption of modernist theory. It is this legacy of the avant-garde (and of Hegel), transposed into the domain of cultural explanation, which causes the theories of Lyotard, Danto, Baudrillard, and others to be oversimplified. I am frankly skeptical of all such attempts to produce a modernist theory of postmodernism. I cannot, of course, prove that some big picture of the big shape called postmodernism might not be true, but I believe that postmodernism is best construed as a diversity of underlying issues. These are connected in myriad ways which link various conceptions (historical, stylistic, genre based, economic, theoretical) of the postmodern to further notions of contemporary culture in a manner that might have been envisioned by a Montaigne or a Wittgenstein.

In light of my skepticism, I wish to make it clear that theoretical painting is not the dominant mode of painting today. As is well known, major painters from the 1970s into the 1990s have been painting canvases of originality of vision, great visual beauty, and expressive intensity, canvases which, in many ways, should be called postmodern, but which are no more ruled by theory than was Matisse's art. I refer to the Italians (Enzo Cucchi, Sandro

Enzo Cucchi, *Danza delle vedove matte* (Dance of the mad widows), 1983. Oil on canvas, 239.5 × 309.5 cm. Öffentliche Kunstsammlung Basel. Emanuel Hoffmann Collection.

Chia, and others); to the Germans (Georg Bazelitz, Jorg Immendorff, and others); to the English (Malcolm Morley etc.). These painters express the turbulent times of postwar Italy, of a divided, postwar Germany which forgets exactly everything and nothing of its past, of a mythological England. The Italians inhabit lands of art where the nostalgia for classicism, the aim of return to the classical world as if to some Arcadia in paint, where the recurrence of religiosity and the return of the metaphysical are central themes. These facts are well known. Italian artists continue to paint out of Italian futurism, out of nostalgia for the Renaissance and classical past, out of the postwar disfigurations of Italian society, out of Marxism, out of terrorism, fascism, and the sense of a senseless future. They continued to meditate on loss and restitution. Such have been their times.[27]

Since the Italians, along with those other painters from Europe and the United States such as the ones I have just listed, were among the most vibrant and well-received painters of the 1970s and early 1980s, one ought to be suspicious of claiming that theoretical art is the only central contempo-

rary art trend and, by extension, that the avant-garde has produced only one form of appropriation and only one legacy.

IV

The examples of theoretical practices I have marshaled in this chapter paint a partial picture of the age, and in doing so, raise the question of generalization. I do not choose to try to answer the question of how representative these examples are, for that would be to assume that even this question can be answered. Nor do I read these examples in a way which makes them the most important ones for a theory of the shape of the age, not because I deny the centrality of the tendency I have sketched but, rather, because I do not believe there is a shape to the age. My words about theory and the visual pick up certain tendencies in the age whose scope must remain somewhat vague.

One wants, as a thinker, to find significance in the art example of some generality. Otherwise, what does it mean to call it an example if it is not an example of anything in particular? To find the right amount of significance in the example is a matter of finding in one's words the capacity to characterize some piece of the world in terms of it, but it is also a matter of finding in those words a capacity to stand as a maxim, a reminder or picture of what might be partially true, of a direction that may be pointed toward, of a place to which one does or does not want the age or the human to go. How modestly the maxim is articulated or how immodestly, how tentatively it is offered or how confidently, how placidly or how desperately are matters of the rhetoric of thought, of the place and time of its offering, of the illocutionary force demanded by one's perspective.

My maxim is that it is a mark of most of the art and philosophy I have discussed that it represses the complexity of its own example, of its own art object. Where the avant-garde norms of transparent rule by theory and immediate theoretical empowerment are in play, there is, therefore, repression.

Avant-garde theorizing of the kind found in Gabo and Danto is offered in the full spirit of a delirium over the new, a drunken confidence in the future. It is noble but quixotic in the spirit of the times. When the idea of the future turns sour in the minds of others, the mood of theory changes. Drunkenness turns to urgency, utopian security to dystopian drama or better, more moderately conceived projects of social praxis. Such a reception of theoretical norms may, in spite of its use, remain within the framework of avant-garde epistemological confidences. It will then repress the complexity of its

own examples. Let us learn from the examples of that. But learn exactly what? I offered the reader a set of philosophical paradoxes arising from excessive reliance on theory, paradoxes which have some application to current art. But what I also offered the reader was the complexity of the art example over the simplicity of its theoretical formulation. Thus I offered a self-critical and more politically acute use of theory.

It was Proust whose attention to the complexity and richness of things caused him to stress the essential indecisiveness of theory yet whose book vacillates between suspicion of theory and continuous use of it. Proust tells us that the presence of theory in art replaces the work of the novel by a self-adulating statement of its novelistic value:

It is perhaps as much by the quality of his language as by the species of aesthetic theory which he advances that one may judge of the level to which a writer has attained in the moral and intellectual part of his work. Quality of language, however, is something the critical theorists think that they can do without, and those who admire them are easily persuaded that it is no proof of intellectual merit, for this is a thing which they cannot infer from the beauty of an image but can recognize only when they see it directly expressed. Hence the temptation for the writer to write intellectual works—a gross impropriety. A work in which there are theories is like an object which still has its price-tag on it.[28]

A price tag of theory is an emphatic self-advertisement for the novelistic value of a book, but the presence of theories ends up, Proust thinks, repressing the work and value of the novel. The work of the novel consists in its capacity to show, in the full glory of detail, in the full robustness of context, in the full prismatic light of experience, how a life is lived or a work of art received. This work of showing, of illumination, is lost in the abstract assertion of theory. In Proust's words, "A writer reasons, that is to say he goes astray, only when he has not the strength to force himself to make an impression pass through all the successive states which will culminate in its fixation, its expression."[29] Proust's idea is that writers who rely too explicitly on theory lose sight of the telling detail and the whole picture of an individual or social life which lends the detail significance. For a painter this must mean losing sight of the visual detail. To really know life is to know how "that clink of a spoon against a plate, that starched stiffness of a napkin"[30] ring with spiritual depth, sensuousness, comedy, or nostalgia. In painting, these resonances of detail, these capacities to prepare the detail and to make it sing are to be found in Corot, Degas, Manet, Titian, Leonardo, Picasso, and Braque.[31] Proust's book shows us how unpredictable impressions are, how delicately prepared an impression is by the total con-

text of a person's life. Impressions are prepared by the inscription in one's memory of the places one has been: by the people known, the art felt and remembered, by the society in which one dwells, the things one's family has had, the books one has read, the roasted chestnuts one has tasted. To acknowledge the force of such things in preparing one's experience of the detail is to acknowledge the facts of repetition, remembrance, reliving, of living from a thousand perspectives, the same thing. These facts point to the unpredictability of an impression wrung from a detail, to the role of accident and timing in occasioning it, for one can rarely say in advance whether (or how) the specific shade of a spoon's color, the degree of starching in the napkin, or the style of silver will matter. What prepares one for an understanding of the details of life and art—let us say, of the fullness of the individual example—is not a general concept (a theory) but a succession of past impressions. The meaning (significance) of a particular experience must therefore be shown through the work of recovering what has prepared it and how it has marvelously crystallized. The significance of an experience, like that of an art example, cannot be defined abstractly.

For Proust, theory can only come after the fact of experience because it is the experiencing of individuality and richness which theory must take cognizance of. Theory by itself can never disclose the richness of the example; that takes a picture, a picture assembled from the right details, the right ambience, the right succession of impressions, the right context of reception.

Of course, all of this sounds like a theory Proust is inflicting on the reader. Indeed, it is strange for a writer who has just finished giving the reader his theory of the novel to announce that works of art with theories cheapen novels (or paintings, or books of philosophy). Is Proust claiming that his book is not cheap because it has no theories? That would be massive act of self-delusion. Perhaps it is, rather, that he knows that his novel has its theory, but he also knows when to take his price tag off (after the book is bought and before it is read) and when to put it back on (at the end of the novel). It is the context in which a theory is articulated and its scope in that context which sets its price. Proust states his theory of the novel only after the novel is mostly written, only after one has been brought through his novel's innumerable succession of places, names, people, and events, through its recesses of smell, its shapes, its colors, and its own self-remembrances. It is only after the hard novelistic work of acquaintance with life and art has taken shape that a general theory finds its place in the novel. (I am reminded of the philosopher Henry Aiken's equally empiricist remark

that all the claims in a philosophy book should come at the end of the book, not at the beginning.)[32] But then, at the novel's end, Proust's own theory, appropriately stated as tentative, does acknowledge the novel's shape; in fact, it gives a shape to the reader's already-evolved impressions about what has happened in the novel, about what the life of its novelist/narrator Marcel has been like. Theory, according to Proust's book, plays its role in the acknowledgment of life only after acquaintance has been given its due.

Therefore Proust is a kind of empiricist for whom all knowledge is based on acquaintance, all ideas on impression. He inveighs against generality or theory in advance of the fact. One could criticize his empiricism by denying that experience is really theory free. But neither is Proust enjoining explanation or theory per se, for throughout his book the form under which Marcel receives the impressions he receives is often the mode of self-narrative, as if there is no ultimately clear distinction between impressions, narratives, ideas, and theories. Proust himself knows the place of explanation in experience. Marcel (the book's character/author) constantly summarizes, explains, suggests, hypothesizes, and philosophizes, subjecting Marcel's (Proust's own) quasi theories to revision or even contradiction in the light of new (dimensions to) experiences. Part of what Proust shows the reader is the succession of theories which are interwoven in the fabric of experience. What the reader learns from this book is that a variety of theories, pictures, views, accounts, narratives, or notions of art and life all have their place in the light of some dimension to experience which is thematized at a relevant juncture for a relevant reason. Each of these quasi theories about art, people, society, or sexuality has its place in recording a certain perspective on experience (on art, people, etc.). The various theories are not all equally right, but enough of them are right enough to preclude systematization. Each awaits other perspectives, and together these quasi theories form a mosaic in the manner of John Cage's music. Only then does the pattern of perspectives articulate a fully human perception of the nature of things. How all of these impressions, thoughts, pictures, and quasi theories add up to a general account of life or literature—what Proust calls "aesthetics"—is left unanswered, precisely as unanswered as the question of how experience adds up is left unanswered.[33]

Let us rely on Proust to emphasize the point that only through a prismatic approach, a multidimensional reading, and only in the wake of a shifting and partly unstable pattern of theories can a specific art or cultural example be known. A single theory, taken by itself, radically underdetermines understanding. (Indeed, since knowing the example is, for Proust,

reliving it, and there is always more reliving to do, no experience or art example can ever be completely known.) As such, the avant-garde ideology of finding a single theory and a single example can serve to attenuate the very values those who theorize probably hold:[34] Proust's values of subtlety, sensitivity, sensuality, attention to the (visual) detail rendered significant by a specific train of experience, and recognition of interpenetration and complexity within the prismatic world of experience that does not fully add up. The ideology inherently represses acknowledgment of the complexity— and life—in the example.

What should I call Proust's book—a work which proceeds by showing us the nature of the example, by shifting its theories in the work of continuous acquaintance with the example, rather than by prefiguring the example—if not a work in art and a work in philosophy? One wants marriage between theory and the art example, not domination. There is a time to theorize and a time to worry about the role of theory. The time for both is now.

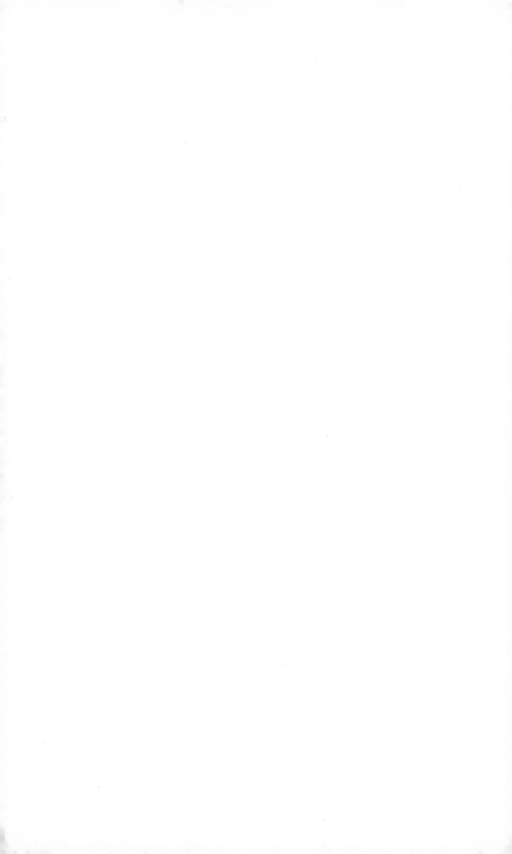

Notes

Introduction

1. For a discussion of the Bauhaus's relations to logical positivism, see Peter Galison, "Aufbau/Bauhaus: Logical Positivism and Architectural Modernism," *Critical Inquiry* 16, no. 4 (Summer 1990): 709–52.

2. Pierre Cabanne, *Dialogues with Marcel Duchamp,* trans. Ron Padgett (New York: Da Capo Press, 1987), p. 39. For an interesting discussion of Duchamp's retinal/conceptual distinction, see Thierry de Duve, *Pictorial Nominalism: On Marcel Duchamp's Passage from Painting to the Readymade,* trans. D. Polan, with the author (Minneapolis: University of Minnesota Press, 1991).

3. Michael Baxandall, *Painting and Experience in Fifteenth Century Italy* (Oxford: Oxford University Press, 1972).

4. I have taken up the question of psychoanalytic accounts of painting in my article, "The Work of Art as Psychoanalytical Object: Wollheim on Manet," *Journal of Aesthetics and Art Criticism* 49, no. 2 (Spring 1991): 137–53.

5. R. Venturi, D. Scott Brown, and S. Izenour, *Learning from Las Vegas* (Cambridge, MA: MIT Press, 1972).

6. The avant-garde's conceptual claim that theory prefigures the art object should not be confused with a historical discussion of which came first, the theory or the art. In fact, avant-gardists were simultaneously articulating their theories and designing their new art objects. Relations between both were, as a matter of historical record, dialectical. Yet the avant-garde still (only up to a point, as we shall see) held to the conceptual assumption that theory prefigures art.

7. I intend to show that their philosophical theories are best reconstructed as positions held in the history of philosophy (as Platonist positions, Cartesian ones, etc.). This is what I mean by a philosophical theory here.

8. I make no claim to have captured the sum total of all the art one wants to call "avant-garde," much less the essential characteristic of the avant-garde, as if there were only one or as if we could even clearly decide which of the manifold characteristics of the avant-garde are essential and which are not. What I believe I have captured is a tendency in the avant-garde, a mentality to be found in it (and in modernism generally) which is exemplified by some of the avant-garde's paradigmatic examples. The term "avant-garde" has, in general, a certain capaciousness, a set of root uses which, in turn, branch out in various different directions. One starts, for example, from a historical notion, well known, of the avant-garde as a web of interrelated artists and art movements comprising a world—usually called Paris/Berlin/Moscow/Milan/Venice—a world of art, art writing, of mutual influence and disinfluence, of mutual alliance and hatred, of shared concerns with artistic originality, with a taste for the rhetoric of the new, with a taste for the shock to taste laced with a

generous dose of antibourgeois food and drink. One starts from ideas of the banquet years in which paint is splashed across the pages of history in a carnival of originality and liberation from past norms (cf. Roger Shattuck, *The Banquet Years: The Arts in France 1885–1918* [New York: Harcourt Brace, 1958]). This banquet embraces Picasso, Matisse, constructivism, futurism, the whole show. This is our original diet of examples. Or one begins from Peter Bürger's claim that the avant-garde must be theorized as a mode of social praxis (Peter Bürger, *The Theory of the Avant-Garde,* trans. M. Shaw [Minneapolis: University of Minnesota Press, 1984]), in which case the central examples of avant-garde work look different, with Picasso and Matisse playing noncentral roles, and the avant-garde movements (constructivism, De Stijl, futurism, surrealism, vorticism) appearing central. Neither conception of the avant-garde (and there are others) is primary, although in this book the facets of the avant-garde on which I focus, namely, its game of utopian theory and how such theory connects to the avant-garde's art objects, allies me with Bürger's ideas.

Bürger argues that the avant-garde (according to his notion of it) turns the romantic conception of *l'art pour l'art* into a form of praxis. Which is to say that the avant-garde takes the autonomous, formally inventive space of romantic art and turns it into a space in which formal inventiveness becomes originality at the service of social critique and social praxis. There are questions to be asked about Bürger's gloss on "romantic art" (was Wagner's *Gesamtmusik* merely a case of *l'art pour l'art,* is Wagner a romantic, and if not, what is the scope of Bürger's term "Romanticism"?) and about his univocal conception of the avant-garde (I have said there are various intersecting notions of it, none of which is primary and each of which has its uses). Nevertheless, the idea of turning formal inventiveness to the purposes of critique and praxis is one I find congenial as an explanation of the avant-gardists with whom I am concerned. It is my addition to Bürger's conception to add the crucial role of theory to the avant-garde's own project. Form becomes in the avant-garde's hands an occasion for the embodiment of utopian theory—in an art object whose powers of critique and praxis consist in our taking them as an example of the perfected utopian future. Formal inventiveness is thus connected in the work I discuss to praxis (partly) through its capacity to embody the future, which is to say, through its capacity to embody theory. One finds, and this is part of my thesis, that the utopian dimension of the avant-garde, so central among its features, is directly connected to the level of *theory* in the avant-garde. Neither Picasso nor Matisse is utopian, and their lack of utopianism is related to a lack of abiding concern with theory on the part of either of them. Picasso and Matisse are concerned with artistic power, beauty, originality. Both painters connect themselves to the finest art of the past rather than to the future that will be. Both Picasso and Matisse are obsessed with the canonical genres of past art: Matisse with landscape and with the female figure, Picasso with the female figure. Neither is a painter whose concern is to change the course of human life through the example of a new kind of artwork. If theory enters their work, it is more at the level of technical discourse about the nature of three-dimensional suggestion on a two-dimensional surface, more at the level of how to portray an object, more at the level of what color can mean. Thus from the perspective of my concerns, these painters are not central.

The term *modernist* is even more capacious than the term *avant-garde,* since many artists (such as Giorgio Morandi) whom one might wish to call "modernist" are not in any clear sense part of the avant-garde. In the course of this book I will sometimes refer to the mentality of the avant-garde art I discuss as modernist, especially when I wish to highlight connections between that mentality and the modern philosophies of Hegel, Marx, and others; however, in no sense do I wish to claim that the mentality in question is definitive of modernism as such. The avant-garde/modernist mentality I discuss represents one significant domain of modernism.

9. Thus I do not read the circle of painters surrounding Cage (Johns, Rauschenberg). This is not because they are not important artists; they obviously are. It is because their discourse is not theoretical in the way that Cage's is. Nor do I examine Constantin Brancusi, a sculptor whom Mondrian and Theo Van Doesburg admired and felt an affinity with, because Brancusi's discourse is explicitly antitheoretical. (Rauschenberg, Johns, and Brancusi may be theoretical in some broader sense and are certainly philosophical in some general way, but then so are a lot of musicians and artists).

10. Within the disciplines of art, art history, and art criticism, others have done excellent work in calling attention to the importance of avant-garde theory for reading avant-garde art. Yet with the exception of avant-garde architectural theory, which has been well studied, the relations between avant-garde theory and avant-garde artworks in their visual, emotional, and spiritual aspects have been too little explored or, rather, have been explored without full attention to the intricate, philosophical questions about how to read, which must arise in the context of engagement.

As examples of writing on the role of theory in architecture, I refer to illuminating work on Mies Van Der Rohe by Franz Schulze (see esp. his introduction in *Mies Van Der Rohe, Critical Essays,* ed. Franz Schulze [New York: Museum of Modern Art, 1989], pp. 10–27); Wolf Tegethoff, ("From Obscurity to Maturity: Mies Van Der Rohe's Breakthrough to Modernism," in ibid., pp. 28–95); Reyner Banham (*Theory and Design in the First Machine Age,* 2d ed. [Cambridge, MA: MIT Press, 1989], and by others. I refer to James Holston's work on Le Corbusier and Brasilia (*The Modernist City: An Anthropological Critique of Brasilia* [Chicago and London: University of Chicago Press, 1989]); and I refer to Venturi, Scott Brown and Izenour's postmodern annunciation, *Learning from Las Vegas.*

11. Bernard Williams, *Ethics and the Limits of Philosophy,* (Cambridge, MA: Harvard University Press, 1985), Introduction.

12. The interpretive question is why that specific set of forces has fitted together to cause that artwork. Psychoanalysis tells us that human life is characterized by conflict, ambivalence, coordination of disparate interests, forces, and motivations. The deeper the action, the twentieth century says, the more it tends to stand at a juncture not of one univocal and consistent force but of a complex arrangement of multiply determined forces which jointly define the intensity and significance of the action. The soul is a battleground (Dostoyevsky), a place of psychic compromise, not a place where Bach cantatas play on in divine four-part harmony. That is heaven. This idea of actions whose depth is a matter of their placement in the nexus of a

battleground of forces, I think, captures the tone and voices of the avant-garde, the way its depth is best construed. The specific configuration of voices is what makes the constructivist artwork the intense and powerful thing that it is.

The avant-garde art object is multiply determined. Overdetermination, as it has been defined by recent philosophical literature, is the condition in which an object or action has various causes, any subset of which would have been sufficient to cause the object or action. If two persons each place very deadly poisons in a well and the owner of the well dies of poison, his death is overdetermined, in that either of the two placements of poison in the well would have been enough to kill the owner. Multiple determination, a concept of importance in psychoanalysis, by contrast, characterizes action's being determined by a variety of causal conditions which, as a whole and in that precise pattern, give the action its meaning. Unlike the case of overdetermination, if some part of that pattern of causes had not obtained, action would be profoundly different, for it is the pattern of conjunction or enmeshment of the total causes which, as a whole, structures the outcome. Since I am interested in the way a pattern of causes structures the avant-garde object as a whole, I find the concept of multiple determination useful. For a discussion of it, see Robert Waelder, "The Principle of Multiple Function: Observations on Overdetermination," trans. M. Milde, *Psychoanalytic Quarterly*, 5 (1936): 45–62.

13. Arthur Danto, *The Transfiguration of the Commonplace* (Cambridge, MA: Harvard University Press, 1981), p. 56.

14. "Today" being the late 1980s and early 1990s. Danto is an award-winning art critic for *The Nation*. In recent years he has been interviewed or featured in *Flash Art,* and the *New York Times Magazine*. He has been asked to write for *Vogue* and other such magazines. He speaks at innumerable museums, and his work is read by younger artists (as well as by academics in philosophy and in other disciplines).

15. Again, these assumptions are not definitive of modernism. Modernism is a family of related things. These assumptions lie deep in modernism, however.

16. As we shall see, it is hard to discern exactly what Danto means by a histori-cally evolving theory held by the artworld, a fact which will be of importance in the discussion of his philosophy (see chap. 6).

17. Art historians will be familiar with a style of modernist thinking related to Danto's through the formalist writings of Clement Greenberg. Greenberg claims that it has been the point of modernist art and sculpture to legitimate itself in the wake of capitalist onslaughts against the autonomy of culture by clarifying its own me-dium to the point where the essential defining features of the medium shine through with complete transparency. This work of clarification Greenberg thinks of as the work of *abstraction*. By abstracting itself from all inessential elements of painting (or sculpture), the plastic medium reveals its essence, which is for Greenberg a mat-ter of its formal properties. Thus abstract art is for Greenberg the essential medium of choice in this century. Greenberg differs from Danto, and is oblique to my book, because, according to Greenberg, the defining property revealed by the modernist medium is a purely "visual" one, namely, form. (Form is also metaphysical in the sense that it is the essence of painting or sculpture.) By contrast, for Danto the defining property revealed by (Warhol's) art is a property which is neither visual nor

intrinsic to the art object, namely, a theory (cf. Clement Greenberg, *Art and Culture* [Boston: Beacon Press, 1961], esp. "Avant-Garde and Kitsch," pp. 3–21, and "The New Sculpture," pp. 139–45.)

Let it be noted that Gabo and Mondrian, artists I will discuss, share Greenberg's formalist ideas about pictorial self-clarification and pictorial transparency, but both go far beyond Greenbergian formalism in claiming that a further philosophical theory prefigures the formal structures of their art objects and invests the formal structures of their art objects with Cartesian or Platonist philosophical contents.

However, Greenberg's mentality is modernist in the sense that (1) he does not doubt the capacity of *his* formalist theory to transparently define artworks, and (2) he believes there is a unique example (avant-garde abstractionism) that perfectly exemplifies his theory. Greenberg is, of course, not utopian; he does not believe avant-garde art will bring about utopia. Hence he has no use for the defining importance of utopian theory in the art of the avant-garde. But he does believe the avant-garde's self-reflective turn has social motivations. By turning inward, avant-garde art has made itself into a site of resistance to the encroachments of the capitalist world. It has shielded itself from the encroachments of *kitsch* and thus preserved its freedom and autonomy.

18. The idea of locating philosophy as part of modernist culture is a new and growing one. One can date it to intellectual studies of Wittgenstein by Stephen Toulmin and Alan Janik, who claimed that Wittgenstein can only be understood in terms of *fin de siècle* Viennese culture. More recently, Hans Sluga has argued that the archmodernist house Wittgenstein designed for his sister Margaret Stonborough in Vienna should be used as a guide to understanding the modernist character of Wittgenstein's philosophical book, the *Tractatus*. Sluga claims that the pristinely modernist features of the *Wittgenstein House* allow us by analogy to find equally modernist features in Wittgenstein's book, for the *Tractatus* is, as the later Wittgenstein was the first to note, itself a kind of modernist philosophical building. See Alan Janik and Stephen Toulmin, *Wittgenstein's Vienna* (New York: Simon and Schuster, 1973); and Hans Sluga, "Wittgenstein und die Architektur," in *Die Wiener Moderne,* a symposium held at the University of Kassel, ed. J. Hautz and R. Vahrenkamp (forthcoming).

19. The idea of philosophy as exhibiting styles of thinking is an idea one owes to Foucault. Important to me has been the way this idea has been developed by Arnold Davidson. See, e.g., Arnold Davidson, "How to Do the History of Psychoanalysis: A Reading of Freud's *Three Essays on the Theory of Sexuality,*" *Critical Inquiry* 13, no. 2, (Winter 1987): 252–77.

20. The idea that it is a central task of philosophical understanding to place a thinker in a broader cultural context is a typically French one. It is also a guiding theme of Stephen Toulmin's *Cosmopolis: The Hidden Agenda of Modernity* (New York: Free Press, 1990), where Toulmin argues that it is a modernist feature of philosophical thinking, one dating from the reception of Descartes, that philosophy can and should be understood and assessed in its own internal terms of theory and argument, terms independent of broader cultural and political context.

21. I discuss the influence of philosophy of science on Danto in chap. 6.

22. I develop this remark in an essay ("The *Journal of Aesthetics* and Danto's Philosophical Criticism" [April 1993], in press) for the fiftieth anniversary issue of the *Journal of Aesthetics and Art Criticism*.
23. Holston, *Modernist City* (n. 10 above), 316.
24. The avant-garde's theories arise from their words as much as from their art-works. Gabo, Tatlin, Malevich, Mondrian, De Stijl generally, Cage, and even Warhol (not, significantly, Picasso) value their words on a par with the way they value their artworks themselves. Marjorie Perloff, whose work can be conveniently thought of as a starting point for my own discussion of the avant-garde, argues in *The Futurist Moment: Avant-Garde, Avant-Guerre, and the Language of Rupture* (Chicago and London: University of Chicago Press, 1986) that futurism actually develops the manifesto as a kind of rhetorical art form, as if the manifesto's charged words are part of futurist art practices, not adjuncts to them. The constructivist journal, *LEF*, is edited by none other than Vladimir Mayakovsky. A poet, apparently, is required to do justice to the art of avant-garde words. Words obviously matter for these artists and in various ways. How do the words enter into relationship with the art objects these artists make? How do the words inform, agitate, explain, compliment, or fight with the art objects? Only when we answer these questions can the place and importance of theory and the reason for its place in the art be understood.

Chapter One

1. Others in American philosophy and criticism who have taken the modernist predicament truly seriously as something which stands in need of philosophical engagement are Stanley Cavell and Michael Fried.
2. Cf. Georg Wilhelm Hegel, *Philosophy of Fine Art,* trans. T. M. Knox, (Oxford: Clarendon Press, 1975), esp. introduction, pp. 1–90.
3. There is something of Clement Greenberg's ideas in this (cf. esp. Clement Greenberg, "The New Sculpture," reprinted in *Art and Culture* [Intro., n. 17]), pp. 139–45).
4. Arthur Danto, "Andy Warhol," *The Nation* (3 April 1989), p. 459.
5. Caroline Jones has helped me with this description, and she has helped me to see that these differences are significant for Warhol's art.
6. I owe this point to Marjorie Perloff's recent article, "Avant-garde and Difference," *New American Writing* 7 (1991): 88–96.
7. Danto, "Andy Warhol," p. 459.
8. Ibid.

Chapter Two

1. See Bürger, *Theory* (Intro., n. 8).
2. From *LEF,* the constructivist journal Mayakovsky edited. The quote may be found in Manfredo Tafuri, *The Sphere and the Labyrinth,* trans. Pellegrina d'Acierno and Robert Connolly (Cambridge, MA: MIT Press, 1990), p. 135.
3. El Lissitzky, from *The Conquest of Art* (1922); reprinted in *El Lissitzky,*

1890–1941, exhibition catalogue, Busch-Reisinger Museum (Cambridge, MA: Harvard University Art Museums, 1987), pp. 60–61.

4. Quoted from Franz Schulze, *Mies van der Rohe: A Critical Biography* (Chicago and London: University of Chicago Press, 1985), p. 104.

5. El Lissitzky, *El Lissitzky,* p. 20.

6. Charles Rosen argues in *The Classical Style,* pt. 1 (New York: Norton, 1972), that the term *sonata* takes its meaning from its paradigm examples, namely the sonatas of Haydn, Beethoven, and Mozart. In this, art is different from language, for in language, according to Rosen, what one wishes to explain are the ordinary instances of speech, while in art it is the likes of Haydn, Beethoven, and Mozart who set the terms of definition and explanation. (One should not overstate this fact; there will be other instances in which it is the ordinary musical examples which serve as paradigms.)

7. It will be made again in the discussion of Mondrian, and later in the discussion of Danto.

8. This is a claim which Perloff develops at great length in *The Futurist Moment* (Intro., n. 24).

9. For an excellent study of Tatlin's work, see John Milner, *Vladimir Tatlin and the Russian Avant-Garde* (New Haven, CT: Yale University Press, 1983); see also Rosalind Krauss, *Passages in Modern Sculpture* (Cambridge, MA: MIT Press, 1988), p. 56.

10. Naum Gabo, "The Realist Manifesto," reprinted in *Russian Art of the Avant-Garde,* ed. J. E. Bowlt (London: Thames and Hudson, 1988), p. 212. This manifesto of 1920, a central one in the history of constructivism, was written by Gabo. His brother Antoine Pevsner also signed it.

11. Krauss, p. 58.

12. Ibid.

13. Naum Gabo, *Circle: Constructive Art in Britain, 1934–1940,* catalogue of the exhibition Circles: International Survey of Constructive Art, held at Kettle's Yard Gallery, February 20–March 24, 1982 (Suffolk: Lavenham Press, 1982), p. 60.

14. Gabo, "Realist Manifesto," p. 213.

15. Naum Gabo, "Letter to Herbert Read," in *Gabo: Constructions, Sculpture, Paintings, Drawings, and Engravings* (Cambridge, MA: Harvard University Press, 1957), p. 172.

16. In the course of completing my work on Gabo, I have come across Peter Galison's excellent piece "Aufbau/Bauhaus" (Intro., n. 1). Galison wishes to understand connections which, as a matter of historical record, developed between logical positivism and the Bauhaus as rooted in a shared utopian commitment to the idea of transparency in construction, or to "aufbau." I find that Galison's discussion bears a striking affinity to my own discussion of Gabo's aim of transparent self-construction. This is as it should be, since, after all, the Bauhaus and constructivism were closely related in any number of concepts and through any number of people—most notably by the presence of the constructivist Moholy-Nagy on the Bauhaus staff. Galison's discussion is pervaded by a deep knowledge of the philosophy of science (which I do not have) and is concerned to explore not simply philosophical (foun-

dationalist) aspects of architecture but more primarily modernist aspects of the philosophy of science—a concern which is not mine. Nevertheless, I have found the continuities between his interpretation of the Bauhaus and mine of constructivism quite striking and in some sense confirming.

17. El Lissitzky, "Proun," *De Stijl* 5, no. 6, (1922): 81–85, quoted in Tafuri, (n. 2 above), p. 146.

18. Indeed, what it means to share a human nature is in part itself defined as possessing the capacity to be perceptually struck by the elementary world in the way everyone else is.

19. "John and Mary talk" is built from "John talks" and "Mary talks." "John talks" is built from "John," "Mary," and the relation "talks." These may in turn be further constructed from the things that make John John, talking talking etc. For the early Wittgenstein of the *Tractatus,* it is on account of this pregiven arrangement between language and the world that the use of language to refer to the world is made possible. That is, the logical structure of language (and its isomorphism with the structure of the world) is the condition of the possibility of language as such. For an excellent discussion of this point, see, David Pears, *The False Prison: A Study of the Development of Wittgenstein's Philosophy,* vol. 1 (Oxford: Clarendon Press, 1987), pt. 1, introduction, pp. 3–34.

20. This assumption of total uniformity in perception on the part of everybody (everybody, one presumes, of sound mind) is of course itself something debatable in the light of cultural (and other) differences. A German will probably perceive a large patch of orange quite differently in texture and feel than a person from India, where orange splashed on walls, temples, streets and the heads of holy persons, is the perceptual norm. The German will find the orange more strident, shocking, or at least striking; the Indian will find it normal and natural. The fact that experience and context appear to modulate perception makes one wonder how much there is to the foundationalist concept of a simple element whose perceptual meaning is given independently from the issue of where it is located and to whom it is presented. There is also the question of how much the perceptual meanings of individual elements depend on their placements in larger configurations and contexts. How much is there to receive about "fa" or "do" independent from their placements in larger musical phrases or works or independent from their existence as part of the ambient sounds of rush-hour New York or the call of a bird from a tree, or even as human speech? Is "fa" received the same way in each of these instances? By a New Yorker and a man from Placerville? To what degree? How does one decide this? Similarly, is a line received the same when it traces the neck of a Raphael madonna, when it is conjoined with a grey shape in a Lissitzky Proun, when it is scratched into the Berlin wall, when it is the lines the paper one writes on? How does one decide that?

Such questions are of a piece with questions the later Wittgenstein and others addressed to foundationalism from the 1930s onward; cf. Ludwig Wittgenstein, *Philosophical Investigations,* trans. G. E. M. Anscombe (New York: Macmillan, 1968) (hereafter cited as *PI*), and *Remarks on Color,* trans. G. E. M. Anscombe (Berkeley and Los Angeles: University of California Press, 1977).

21. Russell's problem is that, granted that the meaning of a name is completely exhausted by its reference—names being merely denotations—how can the name

of someone who does not exist (i.e., the king of France, not to mention such fictional persons as Julien Sorel or Humbert Humbert) even have meaning, granted that there is then no one for the name to refer to and gain its meaning from? Since Russell knows that such "names" (words) do have meaning, he concludes they cannot be authentic names. Rather, they are disguised descriptions, complexes built from more simple names which apparently do refer and thus have meaning. As mentioned, Russell leaves the question of what such really simple simple names are to psychology (Bertrand Russell, "On Denoting," in *Logic and Knowledge,* ed. Robert Marsh, (New York: Capricorn, 1956), pp. 39–56.

22. Again, the relevant question concerns the extent to which Gabo's "simple elements" are (1) self-evident in meaning to any or all people and (2) epistemologically basic.

23. Wittgenstein speaks of foundationalism as a house of cards, a building built on illusion. The importance of visual metaphors for thought, reason, and proof, and their critical interpretation, has been a twentieth-century project. One notes, in addition to the work of Wittgenstein, Martin Heidegger's "The Age of the World as View" (Die Zeit des Weltbildes), in *Holzwege* (Frankfurt am Main: Klostermann, 1950), pp. 69–104; and Jacques Derrida's "White Mythology," in *Margins,* trans. A. Bass (Chicago: University of Chicago Press, 1982), both of which discuss the importance of ideas of vision (seeing clearly the world or one's mind) and of light (the light of truth) for philosophical epistemology. I have been influenced in my own thinking about connections between philosophy, art, and the visual by Derrida's piece especially.

24. For a discussion of the role of theory in turning the modernist city into an exemplar, see Holston, *Modernist City* (Intro., n. 10).

25. Gabo's own words about influence are instructive: "I firmly believe and am convinced of only one thing—that ideas have no boundaries, and their roots reach far back into the past, into all that has been done and thought by the collective human consciousness. No wonder that these roots sprouted independently in different countries, producing similar flowers. Whether these ideas are scientific, pictorial or poetic, they are the products of a state of consciousness which is simply human, not Russian, French" (*Of Divers Art,* A. W. Mellon Lectures, p. 174 [Princeton, NJ: Bollingen Press, 1962]).

26. There are many reasons for foundationalism in philosophy itself, the elaboration of which has been the task of countless foundationalist and other books. Anything approaching a rich discussion of these reasons would have to range over philosophy's desire to respond to positive developments, first, in science (Descartes, British empiricism) and then in logic (Gottlob Frege, Russell). Also involved has been philosophy's desire to rid itself of a romantic, obscurantist, and grandiose past (Russell wishes to rid it of all traces of nineteenth-century German idealism), to bite into that past with the acid of clarity and banish it once and for all as Gabo will banish the history of aesthetics by his creation of the new. One would also have to speak about the philosophical desire (whether in language, concepts or in art) for total clarity, a philosophical aspiration as old as Plato which Wittgenstein will think of as an intoxication with illusion, the illusion of a crystalline world of reflections in which one dwells with complete conceptual control. Discussion of foundationalism

as a set of responses to skepticism would also have to be part of the picture. Furthermore, foundationalism responds not simply to science, logic, and philosophy but also to culture generally; this has been argued by Nietzsche, and by much of recent French philosophy. As there are many good books on such topics, let two stand for the rest: a work on Descartes and the history of science (Margaret Wilson, *Descartes*, in *Arguments of the Philosophers* ed. T. Honderich, [London: Routledge & Kegan, Paul, 1978]), and one on foundationalism as a response to the threat of skepticism (Stanley Cavell, *The Claim of Reason*, [Oxford and New York: Oxford University Press, Clarendon Press, 1979]). Stephen Toulmin, in a new and original book, argues that the reception of foundationalism in the seventeenth century must be understood in still another way; it is a rigid reclaiming of the feat of reason in the light of the seventeenth century's divisive fanaticism and violence (exemplified by the wars of the Counter-Reformation). Toulmin further argues that foundationalism is instituted as a social style of reasoning because it is of theoretical use in the emergence of the European nation state as such (see Toulmin, *Cosmopolis* [Intro., n. 20]).

Chapter Three

1. Most notably through Tatlin's famous monument to that meeting, his *Homage to the Third International*.

2. I owe this term to Arnold Davidson, himself influenced by Foucault.

3. El Lissitzky; "Suprematism in World Reconstruction," reprinted in Bowlt, ed. (chap. 2, n. 10), p. 158.

4. It is not obvious that a new and improved graphic layout of *Das Kapital* has more revolutionary utility than Tatlin's sculptural *Homage to the Third International* or that graphic design has more revolutionary utility than public sculpture generally.

5. Why the struggles to dominate sculpturally chaotic materials expressed in the materiality of Michelangelo's "unfinished" *Slaves* (which must be completed by the viewer or which are already complete in their act of unfinished struggle to formulate themselves); why Beethoven's heroisms, or even the cultivating sensitivities of Jane Austen should not help in the ultimate forging of the human that is the work of revolution is a question worth asking constructivism here. The constructivist will answer that these things might have had a productive role to play in human history and to an extent still do, but the moment is one in which a new conception of the person—a more material and biological conception—is on the scene and on the production line of revolutionary history, and it is to this which the art of the future must be addressed. That is to say, art is to be measured by its needs and its possibilities, not by its past. But in reality, the thoroughness with which constructivism impugned the art of the past is a function of its dramatic need to separate from the past. In its desire to start from scratch and develop a utopia to come, constructivism was required to overdramatize its differences from the values of the past. Its rhetoric and theory served this function: the function of repressing constructivism's own continuities with the past, even if a thinker like Gabo would, in other places, acknowledge his own continuities to the past.

6. Raoul Heinrich Francé, *Die Pflanze als Erfinder,* p. 30. I have learned this fact through the catalogue essay on El Lissitzky in *El Lissitzky, 1890–1941* (chap. 2, n. 3), p. 30. Biological theory was, at the turn of the century, a grounding model for cultural (and psychological) concepts generally.

7. László Moholy-Nagy; "Production-Reproduction," *De Stijl,* n. 7 (1922), 97–101, reprinted in *Moholy-Nagy,* Kristina Passuth, trans. E. Grusz et al, (New York: Thames & Hudson, 1985), p. 289.

8. Ibid.

9. Moholy-Nagy, "Education and the Bauhaus," *Focus,* no. 2 (1938), reprinted in Passuth, p. 345.

10. Ibid., p. 346.

11. Moholy-Nagy, "Contribution to the Debate on the Article 'Painting and Photography' by Erno Kallai," *i 10,* no. 6 (1927): 233–34, reprinted in Passuth, p. 301.

12. Here is the place to note the contrast between Gropius and Gabo. Gabo was not interested to a similar extent in designing *types* of construction, as we have witnessed from his sculptural practices.

13. Note how Moholy's scientific conception of art is Cartesian in spirit. Moholy's goal is to construct artworks which will discover—and mirror—universal visual laws. The goal is to discern the universal in the art example, which is to say, the singular artwork should transparently reflect the laws of which it is an example. Insofar as art is research, it is a search for some general visual relationship, say, between the color red, a three dimensional rhomboid shape, and the glass materials from which this shape is built. The general law an artwork demonstrates must state something transparent about this specific type of visual relationship—here about the visual coherence and visual effects in a red rhomboid made of glass. The artwork must therefore demonstrate a general principle of visual aesthetics through the visual proof of the example. It must define a type of relationship transportable to all other examples (of the same type). Furthermore, the proof of the law is, as Moholy asserts, "purely visual." Already we have a point of connection to Gabo's Cartesianism, where the artwork is also supposed to visually demonstrate a general law. In Gabo's case the law demonstrated is supposed to be a law about how to essentially construct the art object from its elements. For Gabo essential self-construction is meant to shine through in the represented shape. But Moholy's laws are not so different; the kinds of laws Moholy wishes his art to discover and reflect are laws about how the visual effects of a given artwork are produced (constructed) from the work's materials, colors, and shapes. Moholy's laws are then laws about the effects produced through the construction of a type. These laws should also shine through in the object transparently.

Moholy's aspirations for a scientific art then have a Cartesian dimension, since for Moholy the aim is to produce artworks which transparently reflect general principles of their own visual effects of construction. Moholy does not go the whole way; he does not require that the artwork mirror its total construction, merely that it show us something essential about the visual nature and effects of its construction. Both Gabo and Moholy share a basic dosage of foundationalist Cartesianism: the artwork must demonstrate to vision a general principle (law) of its construction.

14. Ted Cohen has reminded me of this.

15. Note that since Moholy, unlike Gabo, does not appear to require that the entire essence of the artwork be exhibited by the work and be generalizable from it, but only that some generalizable effect in the work be shown which in some important way or other contributes to its construction; then his effects would have more possibility of generalization than Gabo's. How much generalization is possible is, again, an experimental question left unresolved.

16. As I said in the acknowledgments it was in Caracas that I first had the opportunity to see large amounts of constructivist art and to meet museum persons, intellectuals, and artists (sometimes the same individual in three incarnations) devoted to the idea of the movement. This was under the auspices of the Instituto Internacional des Estudios Avanzados, which hosted the International Conference on the Theory of Art, Caracas, December 1984. I date my interest in constructivism as a theoretically informed artistic practice to that visit.

17. Jesús Soto, *Soto* (Neuchâtel: 1984), Editions du Griffon, p. 52.

18. Jesús Soto, "Interview with Claude-Louis Renard," in *Soto: A Retrospective Exhibition* (New York: Solomon Guggenheim Foundation, 1974), p. 14.

19. Ibid., p. 12.

20. Ibid., p. 19.

21. See Galison on the Bauhaus (Intro., n. 1).

22. From private conversation and a lecture given at the International Conference, Caracas, 1984. I wish to thank Mr. Cruz-Diez for his hospitality during that time, hospitality which included a visit to his studio.

23. Tatlin did design the highly useful stove mentioned above.

24. Gabo, "Letter," (chap. 2, n. 15), p. 171.

25. Ibid., pp. 171–72.

26. Ibid., p. 171. Note that it was Kant's intention to pave a path between the two. A leading thought of Kant's is that you cannot sort out the difference between perception as a mode of "reception" of the world from perception as a spontaneous presentation of it. A further idea of Kant's is that the world is at once real and given only through our representation of it (see Immanuel Kant, *Critique of Pure Reason,* trans. Norman Kemp Smith [New York: St. Martin's Press, 1965]). Yet another question concerns the degree to which truth is flexible (i.e., amenable to change or radical reconstruction). Moreover there is the question of how—and how much—the concept of truth is to be analyzed (as a metalogical notion, a pragmatic one, etc.).

27. The question of how much radical changes in our beliefs, values, and truths can be coherently imagined is taken up in my discussion of John Cage (chap. 5).

28. "Constructive Art," *The Listener,* 16, no. 3408 (November 4, 1936): 846–48, reprinted in *Gabo* (chap. 2, n. 15), p. 169.

29. It is a tragedy of German history that Schiller was not taken more seriously, because he has all the right antitotalizing and antifascist moral instincts: love of humanity, hatred of repressive authority, passionate concern for the freedom for all, altruism, etc.

30. In a similar vein, Peter Galison suggests that the Nazis closed the Bauhaus because they understood its aims of transparent vision to reflect an attitude politically dangerous to Nazi mythical ideology (cf. Galison, "Aufbau/Bauhaus" [Intro., n. 1]).

31. This seems to me especially true in the light of Gabo's history of exile in Britain and the United States and his continuous concern for the role—a utopian one—of art in shaping the ever-darkening world. He wrote these words about shapes in the 1940s and 1950s, during and after the Second World War.

32. El Lissitsky, (chap. 2, n. 3), p. 59.

33. El Lissitzky, quoted in Tafuri (chap. 2, n. 17), p. 146.

34. El Lissitzky, reprinted in *El Lissitzky, 1890–1941* (chap. 2, n. 3), p. 20.

Chapter Four

1. Theo Van Doesburg, *De Stijl,* vol. 2, p. 103, quoted in Hans L. C. Jaffé, *De Stijl: 1917–1931* (Cambridge, MA: Harvard University Press, Belknap Press, 1986), p. 150. All other references to the magazine *De Stijl* are also quoted from Jaffé's text and will be cited giving the pages from Jaffé in which they are reprinted or quoted.

2. Threlfall's recent book is a highly detailed study of Mondrian's theosophical and Hegelian influences (Tim Threlfall, *Piet Mondrian: His Life, Work, and Evolution, 1872–1944,* New York and London: Garland, 1988). Hans Jaffé's book is magisterial in its discussion of a variety of influences on De Stijl ranging from the Dutch landscape to Protestant moralism. If I criticize below the lack of critical perspective on Mondrian's words in both of these books, this is because, in spite of their fine writing, neither of these writers has taken up the philosophical question of how to take Mondrian's words, a question at the core of Mondrian studies. Therefore let me state right off how much I have learned from both books.

3. Mondrian joined the Dutch theosophical society in 1909 and remained an avid reader of theosophy for the rest of his life.

4. Jaffé, *De Stijl,* p. 142.

5. Piet Mondrian, "New Art/New Life: The Culture of Pure Relationship," trans. Til Brugman, (1931), in Jaffé, *De Stijl, 1917–1931,* p. 244.

6. I owe this formulation to the art historian Caroline Jones (conversation with author).

7. There is no general answer to the question of how much an abstract symbol can be invested with semantic values. Different kinds of abstractions can carry different kinds of powers of signification, so we must become as clear as we can about how Mondrian's paintings are meant to signify (demonstrate) philosophical truths before we can decide the question of their success as signifiers. Different visual objects can approximate the powers of language with different degrees of semantic power. They can denote, refer, depict, represent, or symbolize (these terms are themselves hard to keep straight) with various degrees of clarity and power, depending on the circumstances. In certain circumstances, a culture may possess a semiotic code for interpreting abstractions. In India, colors have specific narrative meanings: blue means, in the right circumstances, Krishna. And in India there exists a catalogue for assigning expressive moods to colors. There is always the question of whether the code explains the total use of the color, however, a question to be put to Kandinsky, e.g.

8. Newman's fourteen *Stations of the Cross/Lema Sabachthani* were composed from 1958 to 1966. They are in the National Gallery, Washington, DC.

9. Numbers 1,2, and 10 are in Magna, 3–8 in oil, 9–13 in acrylic polymer, and the fourteenth is in acrylic and duco.

10. There is a book to be written about modernism and theosophy generally, about the various incarnations of theosophical, mystical, mysterious, or superstitious thinking in the Russian avant-garde, in modern music (Arnold Schoenberg, Alban Berg, Anton Webern), and in De Stijl—with Rudolph Steiner and P. D. Ouspensky as bibles, romanticist symbolism as the legacy, and with the impending eruptions of irrational psychology and culture as historical ambience.

One way of linking the logicist, rationalistic obsessions of Frege and Russell with the theosophical perambulations of De Stijl is through the assumption, shared by all, that some form of purist conceptualization will reveal the deepest realities of the world, realities which are mysteriously hidden from view. Wittgenstein speaks in the *Philosophical Investigations* of this puristic language of abstract thought (or abstract painting) as a "mysterious intermediary," concealed in ordinary language. Mondrian finds it concealed in the history of nonabstract painting to date, which once conceptually (or pictorially) grasped, has the sublime power to reveal the fact and furniture of the world. The idea of a "mysterious intermediary" which can bring us into sublime contact with the shielded reality of things is not so far from theosophy. It is the idea of science as *seance.*

For an excellent discussion of the role of Ouspensky (through Velimir Khlebnikov) in the sculpture of Tatlin, see Milner, *Tatlin* (chap. 2, n. 9). Also see Marjorie Perloff's work on the strange role of numerology in modernist poetry, *Poetic License,* (Evanston, IL: Northwestern University Press, 1990), chap. 4.

11. Mondrian, "Towards a True Vision of Reality" (1942), reprinted in *Essays,* ed. and trans. H. Holtzman, 3d ed. (Murray Printing Co., 1951), p. 10.

12. Mondrian's interpretation of cubism continues into the present, through the formalist views of John Golding (*Cubism: A History and Analysis, 1907–1914* [Cambridge, MA: Harvard University Press, Belknap Press, 1988]); and William Rubin, (*Picasso and Braque: Pioneering Cubism,* catalogue of the exhibition [New York: Museum of Modern Art, 1989]). It has been criticized, most famously by Leo Steinberg ("The Philosophical Brothel," *October* 44 [spring 1988]: 17–74); see also Richard Wollheim's subtle challenge to the formalist idea ("The Moment of Cubism Revisited," *Modern Painters* 2, no. 4 [Winter 1989–90]): 26–31.

13. I owe the observation about Mondrian's use of varnish to Alan Kaprow (private conversation with author).

14. Mondrian, "Towards a True Vision," in *Essays,* p. 10.

15. Mondrian, "Art and Life", in Jaffé (n. 1 above), p. 257.

16. Mondrian, "Liberation from Oppression in Art and Life" (1941), reprinted in *The New Art/The New Life: The Collected Writings of Piet Mondrian,* ed. and trans. H. Holtzman, and M. James, (Boston: G. K. Hall, 1986), p. 43 (hereafter cited as *NA/NL*).

17. Plato, *Euthyphro,* in *The Trial and Death of Socrates,* trans. G. M. A. Grube (Indianapolis: Hackett, 1975), p. 8.

18. He does come closer, or at least produces a deeper and more comprehensive definition in the process.

19. Mondrian, *De Stijl I,* p. 68, in Jaffé (n. 1 above), p. 151.

20. Mondrian, *De Stijl VI* p. 3, in ibid., p. 122.

21. Mondrian's paintings do not, if he is correct, merely employ a two-dimensional space in its own so-called real terms, they infuse that space with philosophical signification. The beauty and power of a Mondrian is supposed to hinge on the visual connection between word and picture, on the idea that you look at it as a piece of visual philosophy. That philosophically inflated vision seems no more closely tied to the "real space and real depth" of a painting than, say, the ripple of grace in a Fra Filippo Lippi. Mondrian's problem is how to square the reduction of a painting to its physical essentials with his desire to semantically enlarge it to the point where it can present universal relations as such.

22. If one accepts, as I do, Wittgenstein's replacement of essential definitions by family resemblances, then Mondrian's Platonism and all other claims to find the essences of things will appear misguided. An essentialist wants to produce a clear distinction between the essential and the nonessential elements of whatever, and he or she wants to keep the list of essential elements small. Yet it is hard to say how many properties are essential to what makes, for example, a person a person (the person's psychology, history, economics, possibilities of work, culture, his or her body—natural and constructed. If these are all essential, then what is nonessential?). The idea that a simple list of elements (two-dimensionality, real space) will provide an essential definition of painting is always either too thin or too rich. Mondrian's list is too thin; it fails to distinguish painting from written words on a page, mathematical proofs in symbolic language, or any other pictographic system of representation. One might try to make it more rich by adding a list of the materials of painting (acrylic, oil, tempera). This list will probably leave something actual or potential out, since painting at certain times in its history and especially now has extended itself from basic resources to embrace the materials of the world with its scribbles, its shards of broken plates stuck in paint, its film and photographic images, its ropes, and its dirt, cement, and flowers pasted on canvas. That is not to say acrylic and oil are not crucial elements in painting; who would deny that? It is to say one will never explain the variety of ways in which these essential elements have been important in the history and idea of painting by so crude a theory as one merely dividing elements into essential and nonessential.

The idea that Mondrian's bare-boned essentialist approach can suffice to define the essential elements of painting has already been belied by Mondrian's difficulties in explaining the semantic powers of his paintings: *words* would have to be an essential element in his paintings, something which his theory of the essential elements of painting does not allow for. In general, what is essential for one pictorial type may not be so essential for another. Are words equally essential for all painting, or only for some, say, for the kind of avant-garde art this book is exploring?

The very identity, integrity, and meaning of a painting, and, more generally, the very concept of painting as a whole, depends on our being able to say for some or all painting that certain elements matter more (are more essential) than other elements; if every element of the world were equally essential for painting, then the very idea of painting as opposed to everything else would be lost. Yet in ordinary critical language the distinction between the essential and the nonessential is displaced by a complex set of more subtle ways in which various elements of some or all paintings

are assigned degrees of interconnection and importance. To return to the example of oil and acrylic, instead of assuming that one must yoke the materials of painting into categories of the essential and the nonessential, with, for example, oil and acrylic as essential materials and sand as inessential, why not, rather, say what one knows about the use, centrality, and relative importance of each? Why not state all the ways in which oil is and has been crucial for the history (and concept) of painting? Why not then speak of the capacity of painting to extend itself at certain times beyond such simple materials for certain reasons? Why not say, finally, that the idea of painting would be attenuated without reserving an essential place for the use of oil and acrylic (less so for sand as a pictorial material). And why not say this without further claiming that oil and acrylic the only materials that have mattered for painting?

Moreover, if one looks to the history and variety of paintings, the idea that one can find one (essential) pattern of composition (i.e., harmonization) underlying its diversity of compositional styles is a bit ludicrous—granted that pictorial styles range from Renaissance three-dimensional perspective and its *disegno* to baroque contrapuntal design to New York School abstractions in every variety to postmodernist montage, to Indian miniatures with their crowded musical poetries, to folk paintings of every sort, and to Chinese landscape painting. It is because Mondrian knows this that he claims past painting has concealed in a million ways what really underlies it: pure abstract harmonization and two-dimensionality. His Platonism claims it is his work which essentially uncovers at the bottom of this plethora of compositional styles the one underlying form. But this is Mondrian's own modernist self-assertion; it is surely nothing that Raphael or Tiepolo, not to mention Jackson Pollock or an Indian miniature painter or a Chinese calligraphic artist would assent to. Nor is is critically true of their artworks that at the basis of each is the One Form; it is no part of one's experience of a Tiepolo or a Pollock or an Indian miniature painting to believe that (although some sense of harmony and of disharmony is present in some specific total configuration of movement, music, stillness, chaos, order, and feeling in the composition of each).

Thus Mondrian's essentialist idea is not a description of what the actual essence of painting is and has been. There is no essence to painting, only complex strands of similarities between the varieties of painting, with essential commonalities, essential differences, and every gradation of interpenetration and interconnection and historical linkage in between. What links paintings together into a concept (with its blurred edges and various paradigm cases) is a family of related things plus the very fact of the interpenetration and interdependence between genres of painting in a mosaic of historical causality, stylistic interdependence, and mutual revelation through mutual similarity and mutual difference.

23. The locus classicus of Plato's idea of love is in the *Symposium*.

24. As if the pages of Kant's *Third Critique* (see n. 27 below) about beauty as the harmonization of form and the symbol of universal morality were almost completely correct.

25. Mondrian, "Neo-Plasticism in Painting," in Threlfall, *Mondrian* (n. 2 above), p. 36.

26. Mondrian, "Plastic Art and Pure Plastic Art," *NA/NL* (n. 16 above), p. 58.

27. The resonance of Mondrian's thoughts is not simply with Plato but also with Kant here, specifically with the distinction Kant insists upon between inclination (what we can call ordinary emotion with its connections to intentionality and desire), and a highly sublimated emotion which is not quite an emotion, called by Kant in the *Third Critique* pleasure unconditioned by inclination (see Kant, *Critique of Judgement,* Trans. James Meredith, [Oxford and London: Clarendon Press, 1978]). This distinction undergirds for Kant the distinction between merely liking something and finding it beautiful. Mere attraction to or enjoyment of something does nothing more than express one's individual preferences. I like coffee, you like tea, I like movies, you don't. We each have our likes and dislikes; none of these speaks universally. According to Kant, to find something beautiful is to take the sort of pleasure in it that is drained of inclination or, at any rate, is not conditioned by it. Since such pleasure is disinterested (dissociated from all interests); it cannot be pleasure taken in the specific individuality of the thing sensually encountered, for specific individualities are always matters of specific interest. One is thus not caught up in the particular details of the thing when one finds it beautiful. Rather, this pleasure is taken in the form of the thing, in the way its form harmonizes with one's own imagination. Since one's pleasure depends on nothing specific to the peculiarities of oneself (on one's tastes, interests, memories, desires), it is the same pleasure which anyone else could feel in that object's form and harmonization independent of his or her own particularities of taste and passion as well.

Such pleasure, grounded in disinterested harmonization, is universal in the deep sense that it is pleasure taken by a person drained of all things specific to her persona except the bare fact of her personhood as such, which is to say, it is a way of taking pleasure in precisely those capacities that make her a part of humanity: her capacities for freely harmonizing the form of the world to the fact of her imagination, and her capacities for morality. The taking of disinterested pleasure in form as such becomes for the viewer an occasion to take pleasure in her own moral capacity, in her capacity to freely harmonize the world to the dictates of her good will. For her to speak in the universal voice is for her to claim that everyone else should take pleasure in the beautiful object because such pleasure is nothing other than the way for a moral agent to freely experience her own moral capacities. Since these moral capacities are the same for everyone, each viewer of the beautiful is, by taking pleasure in her moral capacities, taking pleasure in the moral capacities of every other: we are all experiencing the shared thread of morality and humanity. Kant's conception is almost tailor-made for a Mondrian, with one exception. For Mondrian the moral capacities acknowledged in the experience of beauty are, first and foremost, capacities for disinterested conceptual harmonization, not capacities for moral action. Mondrian, being a Platonist, believes moral action follows from conceptualization, as if, by getting the idea of the world straight, we will straighten out the world.

28. The interpretation of the rejection of the body as a form of cultural masochism is Nietzsche's theme in *The Genealogy of Morals* (Friedrich W. Nietzsche, *The Birth of Tragedy and The Genealogy of Morals,* trans. F. Golffing [Garden City, NY: Doubleday, 1956]).

29. Mondrian, "The New Plastic in Painting" (1917), *NA/NL,* p. 35.

30. Mondrian, "Liberation From Oppression in Art and Life," *NA/NL,* p. 40. Mondrian definitely opposes the materialist biologism of the Bauhaus and of El Lissitzky.

31. In this Mondrian parts company with Kant, among whose most powerful ideas is that, in the case of beauty, artifice and nature merge. Works of art are seen, according to Kant, as if nature when seen as beautiful. It is as if the beautiful work of art possesses the form, fluidity, finality and—why not say it—the naturalness of nature. Conversely, artifacts of natural beauty (the sky at violet midnight, the snow in late Japanese April, the rocks of Cézanne's Provence) are just that, artifacted, as if formalized like works of art by the perceiving mind's eye. Hence nature imitates art and art nature, a deep idea quite foreign to the ultimately more platonic Mondrian. See Kant, *Critique of Judgement.*

32. Mondrian, "Towards a True Vision," in *Essays* (n. 11 above), p. 10.

33. Mondrian, "A New Realism," *NA/NL,* p. 20.

34. Mondrian, "Art and Life" (n. 1 above), p. 222.

35. Mondrian seems also to believe that curves are essentially natural. It is hard to know exactly what that means. But if it means that curves cannot occur in contexts which abstract them from the natural, then this is also false. Curves are often highly abstracted from nature—in topological description or even in abstract paintings (see the constructivist abstractions of Max Bill, or the op art of Victor Vasarely for example).

36. See Jaffé, *De Stijl* (n. 1 above), pp. 79–81. Jaffé's idea that De Stijl's painting and design is a natural projection into art of the severe rectangular spaces of Belgium and Holland which these artists have grown up in and internalized seems to me very astute. In spite of every attempt to do so, these artists cannot escape from the natural, since their naturalized senses of space are inherently structured by their experience. Dutch painting has always responded to (projected) its landscapes and cityscapes. Think of how deep the rectangle is in Dutch painting of the seventeenth and eighteenth centuries in Vermeer, the Ruisdaels, etc.

I believe that all painting is far closer to the actual fact and look of the world than many think—and in many different ways. One way, related to Jaffé's observation, is that artists internalize a landscape, a sense of color and geography, a sense of the rhythm of space. They internalize from their history of experience a sense of how space is filled, of how densely it is filled, of how sensuously and with what colors it is composed. The spatial continuum which an artist internalizes is partly derived from the space of nature itself (of forests, mountains, the sky, and fields of flowers), and partly derived from the spaces of cities and towns. One could say that this internalization of the forms of space is the internalization of a world. It serves as a kind of spatial schema, which an artist must consciously try not to project into paint in order to avoid it. The case of Mondrian shows how hard it is for an artist not to paint out of his experience of nature (and his naturalized internalization of the spaces of culture). In this sense spatial representation is naturalized ("natural," in Mondrian's sense of the term).

37. Nina Kandinsky's little story is taken from from Donald Hall and Pat Wykes, *Anecdotes of Modern Art,* (Oxford: Oxford University Press, 1990), p. 72.

38. Mondrian, "Plastic Art" (n. 26 above), p. 58.

39. Threlfall (n. 2 above) makes this point.

40. The phrase *white metaphor* is Derrida's, whose work on the relations between metaphor and philosophy's goal of presence has influenced me in both the chapters on constructivism and in this chapter. See Derrida, "White Mythology" (chap. 2, n. 23).

41. This mention of existence perfected is meant to make a connection with recent work of Stanley Cavell's on the idea of moral perfectionism. In the light of Cavell's work, Mondrian can be seen to be part of the history of the idea (and ideal) of a perfected moral existence whose dramatic exemplar is, for Mondrian, avant-garde art's representations of the possibilities of the perfected viewer. Cavell's book has helped me to think about the moral perfectionism of the avant-garde. See Stanley Cavell, *Conditions Handsome and Unhandsome: The Constitution of Emersonian Perfectionism,* Carus Lectures, 1988 (Chicago and London: University of Chicago Press, 1990).

42. Mondrian, "Towards the True Vision" (n. 11 above), p. 15. The resonances of Plato's *Phaedo* in these remarks is profound.

43. Switzerland, was just a spot on the map of Europe, but how much more it meant to those amid the unbalanced nationalist chaos of World War II! Not all nations were equal as Mondrian penned these essentialist thoughts.

44. The idea of a Keynesian world continuously out of balance or of a cyclical one or of a complex and partly contradictory international scene whose progress consists in political conversation, mutual conversion, or the resolution of ambivalence to an acceptable level, these ideas about the nature of internationalism (or anything else) are precluded from Mondrian's conceptual picture.

45. Mondrian's optimism about the applicability of abstract principles in the face of the complexity and diversity of particular things, cries out for a Montaigne or a Wittgenstein, the ones who say, "Look and see how much politics is like art before you speak about either's possibilities of perfection, much less about their essences." Aristotle's *Topics* will concur; it will claim against Plato's (and by extension Mondrian's) position that the fundamental concepts relied upon in a given topic of investigation (e.g., an investigation into the nature of art) cannot be assumed to be transferrable from that topic to another (e.g., an inquiry into international politics). Different topics require different kinds of thinking, different expectations about how clear the concepts will be, etc. For an excellent discussion of the topic of the topical in Aristotle and Montaigne, see Toulmin, *Cosmopolis* (intro., n. 20), chaps. 2, 5.

46. Mondrian, "Art and Life" (n. 1 above), p. 243.

47. Mondrian's investment of the terms of art with paradigmatic value turns art into the venue for fantasy. Art is many things, among them, it is a place in which psychological, political, social, or conceptual fantasies are given free reign, a place in which diaphanous voices are merged, contradictions are magically dissolved, and conflicts symbolically worked out. In the case of constructivism the fantasy played out in art is that the requirements of transparency in life and revolution will silently converge. Constructivism is the expression in art of a wish, the wish for convergence of opposites, both of which are required in the production of the future. Psychoanalytic insights about art as a place in which wishes are given privileged domain are apt; it is just that such insights do not go far enough or look to a wide enough pool

of fantasies. Art is a place in which every variety of wish at every level of breadth and depth is potentially allowed expression. Art is polymorphously fantastical. One could get a good working picture through the study of art alone (taking a diverse enough sample of art) of what a large range of human wishes have been throughout history. (Not all wishes, as the wishes of some have been excluded from socially dominant styles of representation.) What Mondrian's art in fact demonstrates is a wish, not a truth. His art is the deepest possible expression of the modernist wish to attain perfection and moreover to confirm it by demonstrating that the rest of the world can catch up.

48. Leibnitz believed in the principle of political resolution of conflict through a philosophical search for universal beliefs held by all nations. Leibnitz aimed to secure universal peace through the creation of a universal language. Nations would then, having been shown what they believe in common, possess a universal basis for more perfected interaction (internationalism of a sort without chaos). I owe these remarks about the political interpretation of Leibnitzian universalism to Stephen Toulmin's *Cosmopolis* (intro., n. 20), pp. 98–105.

49. I adopt the idea of art as conversation and marriage from Stanley Cavell, *Pursuits of Happiness: The Hollywood Comedy of Remarriage,* (Cambridge, MA: Harvard University Press, 1981). Cavell takes a group of Hollywood screwball comedies to be, in effect, philosophical explorations of the concept of marriage and of the idea of happiness that lies deep in (the idea of) America. Cavell believes these film comedies treat marriage as a kind of conversation. These films, with their representations of marriages under the threat of divorce, explore, according to Cavell, the fact that the terms of marriage and its prospects for mutual happiness cannot be set in advance of the persons who would inhabit those spaces of happiness, since happiness is their unique task and their unique space. Cavell takes the idea of America to be born in recognition of the role of uniqueness in life. The conversation of marriage is, on his reading, a mutual pleasure taken in the absence of any general concept, for the terms of the individual conversation (marriage) show us how the concept of marriage has been reinvented (rather than reinscribed) in each particular case.

It seems to me that Cavell's metaphor of marriage, especially regarding issues of power, resistance, and equality, also extends to the interplay of a painting's visual elements with the theory behind it. Neither partner—theory or the visual—if the marriage works, annihilates the other. Yet both resist the rule of the other as well as welcoming it. Can either term absolutely rule? Rather, it is only through a conversation worked out between theory and the visual that theory has the possibility of speaking for the art object at all, and it is only because the visual fits with our concepts that it can make artistic sense at all. In a particular case, the visual is typically to some degree out of sync with its companion interpretive text, and that fact is of crucial note for the nature of the art. The avant-garde is an attempt at domination, prefigurement of the visual by theory. Yet theory applies at all to the visual object only because of the extended marriages (correspondences) worked out by avant-garde artists between their theories and their visual objects. Even within the terms of those marriages, there are complex vicissitudes of resistance on both sides, as we have witnessed.

As to the issue of deciding questions of signification, recent work by Claudine Verheggen suggests a similar indecisiveness obtains in the field of language. It is less important to expect that one can decide every case of a conflict between a speaker's *intention* to mean something by his words and how we take his words than it is to understand why the problem arises in the particular case, what is at stake in each party's position, and how to agree to agree, or how to agree to understand each other as disagreeing over how to interpret a particular case. Therefore the question of what the speaker's words mean in a particular case need not be decided or decidable; what needs to happen is communication, which is to say, the achievement of mutual understanding about who wishes to mean what. Thus the marriage between an individual speaker and a community of speech is also one in which (some) difference is tolerable and perhaps unresolvable. See Claudine Verheggen, *The Social Character of Language and Thought* (Ph.D. diss., Department of Philosophy, University of California, Berkeley, May 1992).

Chapter Five

1. Cage studied composition with Adolph Weiss (a pupil of Schoenberg's living in Cage's home town of Los Angeles), followed by studies in harmony and counterpoint with Arnold Schoenberg (at UCLA) during the 1930s. The remarks by Robert Morgan quoted at the beginning of this chapter are in his article, "Musical Time/Musical Space," *Critical Inquiry* 6, no. 3 (Spring 1980): 538.

2. His mesostics, begun in the 1960s, are poetic texts based on compositional principles in which source texts are subject to chance operations. They are the culmination of this blurring of words and music. Cage composes his mesostics in the following way. First, a computer program generates from the source texts he chooses, according to chance operations, a vertical column of words in uppercase letters. Cage then composes the wing words, those words which will fill out the horizontal rows of the poem, according to a compositional stricture. The horizontal rows of lowercase letters that sit between any two successive uppercase letters in the vertical column must not use the second of the two capital letters. This principle of composition, reminiscent of Schoenberg's twelve-tone rules, along with the homogeneous rhythm of the jangled words, allows for a music to emerge from the reading of Cage's mesostics. As the listener hears repetitions of sounds, her ear picks up the constant suggestion of meaning in this chance play of signs whose source texts are already meaningful, while her ear is also lulled by the sounds of the letters of the words, which have been structured according to the principle of variety within repetition. Music and meaning converge to create a calming ambience in which the semantic suggestion of multiple meanings seems to appear and disappear haphazardly, as if the complexity of the contemporary world is being exhibited to the ear. In this play of signs which defeats all clear conceptualization, Cage's mesostics are, dare one say it, postmodern.

3. John Cage, *I/VI*, Charles Eliot Norton Lectures (Cambridge, MA: Harvard University Press, 1990). For my review of these lectures, see *Journal of Aesthetics and Art Criticism* 49, no. 4 (fall 1991): 384–86.

4. Cf. Ted Cohen, "A Critique of the Institutional Theory of Art: The Possibility

of Art," in *Aesthetics, A Critical Anthology*, ed. G. Dickie and R. Sclafani (New York: St. Martin's Press, 1977.).

5. John Cage, "Happy New Ears," *A Year from Monday: New Lectures and Writings* (Middletown, CT: Wesleyan University Press, 1963), p. 33.

6. John Cage, quoted in Calvin Tomkins, *The Bride and the Bachelors: The Heretical Courtship in Modern Art* (New York: Viking, 1965), p. 73.

7. John Cage, "Julliard Lecture," in *A Year from Monday*, p. 105.

8. *Ibid*, pp. 96–97. Cage's actual text is composed in four distinct columns and is meant to be read rhythmically. I have not reproduced that graphic presentation here.

9. Ted Cohen helped me to glean the importance of associations between works of art and persons for our acts of construing things as works of art. For a discussion specifically directed to how expression in music is related to expression by people, I have been stimulated by Peter Kivy, *The Chorded Shell: Reflections on Musical Expression* (Princeton, NJ: Princeton University Press, 1980).

10. In thinking about the importance of a concept of musical space I have relied on the work of Robert Morgan, whose quotation begins this chapter. See Morgan (n. 1 above), esp. the opening sections.

11. Cf. Paul Grice's account of "meaning" in terms of the notion of reflexive intention in his essay "Utterer's Meaning, Sentence Meaning, and Word Meaning," in *The Philosophy of Language,* ed. J. R. Searle (London: Oxford University Press, 1971), pp. 54–70.

12. While the issue of the identity of music, specifically of how anthropomorphic in quality music is, has represented an ongoing debate since the late eighteenth century, even formalism has viewed music as inherently symbolic of people. The debate has been about the way in which best to construe this symbolic capacity of music. Like Cage, musical formalists from Eduard Hanslick to Leonard Meyer have declared that most of what we ordinarily think of as the expression of emotion in music is not part of the music itself. Formalism's restricted conception of what the music itself is, is defended on the basis of a theory of beauty which identifies uniquely musical beauty with the disinterested contemplation of musical form. But according to formalism, form consists in structural relationships between sounds (harmonic, contrapuntal, elaborative, etc.), and musical structure matters to us in virtue of its symbolic likeness to persons. These musical formalists value musical abstraction in the way Mondrian values pictorial abstraction. As we have seen (chap. 4), Mondrian identifies the representational and emotional particulars of a painting with merely individual human interests, the point being to make painting universally expressive (an object of universal contemplation) by purging it of all such signifiers of particularity. Similarly, the formalist wishes to divest music of all traces of emotional (and representational) particularity which correlate with particular interests. The musical work, divested of these things, will shine through with universal formal relations, in which each of us will be able to take pleasure in the bare facts of our shared humanity. And what are these facts? To focus on the free play of formal ideas in sound is for formalists of a Kantian bent to acknowledge symbolically a specific and essential human capacity: the capacity for morality resident in the good will. The idea is that such a capacity lies concealed by ordinary life and thus needs a

symbolic entity—call it an art form—in which we can recognize it and take delight in it. Since that capacity is for Kant essential to our moral and rational nature, taking delight in its representation is our way of taking delight in the basis of our humanity as such, in what makes us human. Indeed, the formalist's reason for resisting our ordinary notion that expression is part of the music is that, for him or her, to project ordinary expression onto music is simply to conceal that symbolic representation yet once again.

Other formalists anthropomorphize the free play of form by taking it to be the expression of that magnificent human capacity called "genius." Either way, form purged of ordinary expression yields special access to some inner dimension of the human

Cf. E. Hanslick, *The Beautiful in Music,* trans. G. Cohen (Indianapolis: Bobbs-Merrill, 1957); and L. Meyer, "Some Remarks on Value and Greatness in Music," in *Aesthetics Today,* ed. M. Phillipson (Cleveland: Meridian, 1961).

13. John Cage, "Eric Satie," in *Silence: Lectures and Writings,* (Middletown, CT: Wesleyan University Press, 1961), p. 81.

14. My thinking about Cage in terms of classical skepticism was stimulated by an essay by Miles Burnyeat ("Can The Skeptic Live His Skepticism?" in *The Skeptical Tradition,* ed. M. Burnyeat, [Berkeley and Los Angeles: University of California Press, 1983], pp. 117–48). It has also been influenced by conversation with Stephen Toulmin, who views the later Wittgenstein as a classical skeptic.

15. Nietzsche, with an analytical eye worthy of Freud's, will later elaborate the urge to philosophical knowledge as a kind of psychological compulsion. See Friedrich W. Nietzsche, "The Problem of Socrates," in *Twilight of the Idols and The Anti-Christ,* trans. R. J. Hollingdale, (Harmondsworth: Penguin, 1968).

16. This is Burnyeat's point. See Burnyeat.

17. Ibid.

18. Pyrrho's response to the claim of knowledge, the style of reasoning he develops to disenfranchise the mind from its claims of perceptual knowledge, has represented a doppelgänger element in the history of philosophy. It has been a constant (and problematic) counterpart to the setting forth of heightened conceptions of knowledge, idealized notions of reality, plans for better proofs of existence, assurances of one's control over things through the mind's eye, as well as to the search for stringent philosophical truths, valid arguments, and the overadulation of the mind in general (as if your body were an ongoing problem you have to come to terms with rather than a source of mentality itself—not to mention of happiness). Pyrrho's skeptical tradition, his philosophy to end all philosophy, has become interwoven into the history of philosophy; one can mention the writings of Sixtus Empiricus, Montaigne, Nietzsche, and Wittgenstein (every one of whom has, paradoxically, done nothing less than rejuvenate the subject they aim to overcome, as if the urge to dissolve philosophy has continued to make it palatable and to humanize it).

On the role of skepticism in rejuvenating and humanizing the subject of philosophy and the philosophical subject, see the entire corpus of Stanley Cavell's writings, esp. *The Claim of Reason* (chap. 2, n. 26 above). See also Barry Stroud, *The Significance of Philosophical Skepticism* (Oxford: Clarendon Press, 1984).

19. John Cage, "Jasper Johns: Stories and Ideas," in *A Year From Monday* (n. 5

above), p. 79. According to Carolyn Jones, the phrase "avoid a polar situation" is John's own.

20. Wittgenstein, *Philosophical Investigations (PI)*, pt. 1, no. 122 (chap. 2, n. 20).

21. Amid the barrage of purportedly musical objects that have been produced throughout history, across cultures, and in this modernist century, listeners we trust can and do disagree about whether to consider individual examples of these music or not. Indeed, they are meant to—for example by the contemporary composer La Monte Young (a former student of Cage's). La Monte Young has produced a purportedly musical work consisting solely of one pitch sounded with varying timbre and dynamics. Some will refuse to call it music because they do not believe it can be taken seriously in any way. Others will take it seriously but not as a work of music. These might hear it as a meditative exercise distinct from music. Still others will take it to be music, hearing it as a meditative extension of what music is. All these alternatives are rational. We lack, in my view, a neutral vantage point from which to arbitrate this and other such disputes, since what we rely on in arbitrating are our own norms and preferences, and these can be contested by others. Our obsession with deciding every such case seems to me to represent an inability to acknowledge that what makes something music is nothing other than how people treat it (hear it and react to what they hear against the background of everything else they have heard), and no one can expect that their own ears—like their own selves—can be brought into complete harmony with those of others.

22. Michael Dummett, "Wittgenstein's Philosophy of Mathematics," *Philosophical Review* 68 (1959): 324–48.

23. In order to mean something by one's words when one speaks of a human possibility (a possibility for persons), one's words must be about beings who share our form of life in broad contours and sufficient numbers of details. The idea is that speaking of a being one imagines to live out a skeptical situation as a *person* involves being prepared to treat that being in a certain kind of serious way and to expect the possibility of similarly serious response from it: "My attitude towards him is an attitude towards a soul. I am not of the *opinion* that he has a soul" (Wittgenstein, *PI*, p. 2, p. 178). When we call a being a person we are disposing ourselves to deploy a web of beliefs, desires, feelings, interests, and practices toward the being, and that only makes sense under the presupposition that the being bears the possibility of responding, by and large, to our deployment of sensibility in the ways we expect, which in turn means that the being is more or less like us in conceptual and emotional resources. Indeed, what sense could it make to say that some tribe has thoughts, practices, feelings, beliefs, and attachments and views the physical environment totally differently from us, and that this tribe consists of persons? Why not simply say it is some other being related to the lion or the martian?

24. Stanley Cavell, "The Availability of Wittgenstein's Later Philosophy," in *Must We Mean What We Say? A Book of Essays* (Cambridge, MA: Cambridge University Press, 1976), p. 52.

25. Moreover, the cultural variety and plasticity of resources to our form of life preclude our ever outlining in a completely definitive way what the limits to our own form of life are.

26. Cf. Jonathan Lear, "Leaving the World Alone," *Journal of Philosophy* 79, no. 7 (July 1982): 382–403. I have found Lear's critical, Kantian approach to Wittgenstein very useful.

27. I have been helped here by the words of Arthur Danto, especially by his word "transfiguration" as he discusses it in his book, *The Transfiguration of the Commonplace* (intro., n. 13). I will have much to say about Danto's book in the next two chapters.

28. Or the idea that opacity and clarity can absolutely converge in a revolutionary epiphany of constructivist art.

29. For the idea of thinking about nonlinguistic objects as part of the figurative analogues of metaphor (what I gloss as a kind of metaphor) I am indebted to Ted Cohen's paper "Figurative Speech and Figurative Acts," *Journal of Philosophy* 72, no. 6 (November 1975): 669–84.

30. This favored word of the philosopher J. L. Austin has been adopted by Ted Cohen in speaking of Duchamp's "Fountain." It is meant to connect ideas of Cohen's (and, by transmission, Austin's) to my own. Cf. Ted Cohen, "The Very Idea of Art," Ted Randall Lecture, delivered at the National Council on Education for the Ceramic Arts (NCECA) conference in Portland, OR, *NCECA Journal* 9, no. 1 (1988): 7.

31. John Cage, "Composition as Process," in *Silence* (n. 13 above), p. 47.

32. Cage, "Eric Satie," ibid., p. 81.

33. Cage's recent performances have done nothing less than invent a musical space in which one really does feel as if any sound that might happen to happen is beautiful in its own right. This heightening of our ears occurs through Cage's skillful blending of structure and chance and his equally skillful sense of scale. He imposes enough of a score on his musicians to allow the audience gradually to become familiar with certain repeated sound structures, but he also allows his musicians enough freedom in what and when to play to make us realize that whatever happens, happens in part freely and spontaneously. Scale is crucial in the design of these performances. Usually for the first forty-five minutes or so everything sounds chaotic, but then, almost suddenly, if audience and work successfully commingle, a shift in perspective occurs. Each sound that happens becomes an adventure in its own right, as interesting as it seems inexplicable. One feels ready for any sound whatever—call that the feeling of at-oneness with whatever. However, only when there is the right blending of sounds by a composer with the subtlety of Cage's ears (the sounds of ambulances, too much percussion might disturb the growing effect) and the right amount of repetition in terms of which sounds are familiarized does the ear sufficiently internalize an acoustical background to open up its powers of focus. Elements of repetition, sound choice, and familiarity define a kind of musical structure internal to the Cage work. Thus the state of at-oneness is a state of partial structure.

Furthermore, the magical effects of these works are also dependent on a dimension of personification. (For an especially effective example of this, see Cage's *Soundspace,* created for the Cage celebration as part of the Los Angeles Festival of the Arts, September, 1987.) It is the integration of structure and chance which procures their effects. It is because one knows that each sound is (to a degree) freely offered by a musician (or because each is there for no other reason than that it happens to be there, as opposed to its being intentionally placed there by some

composer) that each becomes identified with that musician's freedom or with its own freedom. Because each is perceived as free, each becomes worthy of respect in its own right. It is as if a community of sounds is being created similar to a community of persons—a community in which sounds are related to each other—independent but simultaneously existing, related and in mutual conversation, each capable of dropping out if it wants. Music is, to use Cage's term, "identified with life" by becoming the likeness of persons. As in *4.33*, the line between sounds and people remains magnificently obscure. (I will connect Cage's anarchism to his respect for each "personified" sound in its own right, below.) It takes what Schoenberg called an "inventor of genius" to dream up such a situation and to make such a situation work.

34. Marjorie Perloff has suggested this word to me in conversation. I am grateful to her for many other cogent remarks about Cage.

35. It is worth noting that what we admire about Cage's project also depends on our conception of it as cast in imperfect, human terms, that is, in terms of him. Skeptical projects need to inspire conviction, and who should one look to for the payoff of skeptical practice other than Cage himself? Cage, Saint Francis, and other such masters actually define for us our expectations of what it is possible to do within a discipline. We measure its difficulty, interest, and profundity against what they have done. To adopt a phrase from Protagoras, "Man is the measure of man." Cage's virtue is to have mastered a task, set its terms. It is crucial to Cage's practice that one follow along and feel one's way into the hang of what he does—call that the Suzuki method of music discomposition in the interests of Buddhist at-oneness. Like all music, Cage's is not a matter of explanation but of getting the hang of a way of hearing, feeling, and treating the world. It is his intention and his voice that must guide us at every point in our engagement with his practice. His virtuosity makes it appear natural and easy when we know it to be difficult. We admire that just as we admire his natural serenity. These qualities of character set the terms of his project: it is the prospect of achieving them (of relating to the world with that ease and generosity) that makes the project of achieving Cagean ears desirable. Ironically, once we take seriously the idea that total detachment is possible, his terms (or mine, or yours) no longer seem to be *the* terms. Human mastery becomes little or nothing, comparatively speaking.

Then Cage wants to abolish all individuality and voice in music, but his, like all art, is ineluctably personal. Cage's practice of chance operations is motivated by his noninterventionist attempt to remove his own likes and dislikes from his art. His claim of a relation to sound independent of his own tastes demands the same questioning that we have already given Mondrian. How is one to decide whether Cage's practice, a practice which depends on his own example for guidance, is not, in fact, a project which imposes his idiosyncratic, if endearing, personality on us? Cage himself abhors projection of self: he most especially abhors the exhibitionist tendency in art and the place of aggression and violence in human communication. Cage can stomach neither Emerson's intensity of speech nor Beethoven's aggressive linking of sounds. Is that not a matter of Cage's own taste? He is entitled to it, but then his practice of disruption through chance should be understood in terms of his own hatred of self-exhibition. Similarly, Cage studiously avoids the erotic in music.

Is that not to his own taste? Ironically, while his practice claims to remove Cage himself, he reappears as the central focus of the entire activity, for it is he to whom we must pay attention.

This is not to say that his practice is nothing but the imposition of his tastes. Art is multiply determined, and the authenticity of Cagean practice is to be measured in what it does for us, not simply by whether he does it because it is to his taste. (And how could it not be, in some sense, to his taste? Is he a masochist? Then saying he does what is to his taste is saying nothing other than that he does what he must. And what serious person doesn't?) This is to say, however, that Cage makes the same modernist claim of universality that Mondrian makes.

36. For a more extended discussion of Cage's global art practices, specifically of how his turn to the global is played out in his mesostics, see my essay, "John Cage's Approach to the Global," in a forthcoming anthology edited by Marjorie Perloff and Charles Junkerman, *The Language of Changes: John Cage and the Making of Americans* (Chicago and London: University of Chicago Press).

37. In this he is like Derrida and certain feminists.

38. John Cage, "Preface to *Lecture on the Weather*," in *Empty Words: Writings, 1973–1978* (Middletown, CT: Wesleyan University Press, 1979), pp. 4–5.

39. Carl Schorske, "Mahler and Ives: Populism and Musical Innovation" (Three lectures given under the auspices of the Stanford Humanities Center and the Department of History, Stanford University, January 1991).

40. Originally scored for piano with flute and viola accompaniment but normally performed in its solo piano arrangement.

41. Ives, a musician Schoenberg described as a composer of genius, proposes an idea of musical variation as far from Schoenberg's own Brahmsian, linear principle of the "developing variation" as one can imagine; Ives's principle is, rather, that of elaborating motific material (the Beethoven motif—da da da, *dum*—from Symphony no. 5) in a variety of distinct ways which, rather than following each other in dramatic development, relate to each other as in a mosaic.

42. This interpretation of Cage has its sources in an unpublished address Cage gave to the Cage Symposium (Strathmore Hall, Washington, DC, May 1989). I am grateful to Marjorie Perloff and to Marilyn DeReggi for having invited me to present a paper, "4.33" at that event.

43. I owe this connection between Ives's simultaneity and the moment of epiphany in Cage's music of life to Carl Schorske's second lecture, "Vienna and New York: Creating a Theatrum Mundi" (Stanford, CA, January 1991).

44. The concept of moksha, taken from India, shows another sense in which Cage's musical discipline amalgamates East and West. This amalgamation of East and West has its geographical sources in the America of Cage's youth, a youth lived in the displaced deserts and palm trees of Southern California. There the past can appear as fabrication and the possibilities of the future matters of mere invention. Cage is fond of repeating that his father, an inventor of huge submarines and machines of all kinds, used to say, "When people say something is impossible, then I begin." That utterance is remindful of Edison's telephone, Hearst's castle, Hollywood, Andrew Carnegie, and Walt Whitman. For Cage this climate of invention has a geography capacious enough to leave room for all sounds. It is a climate in which

the great traditions of European music seemed essentially no closer than the chants of Southwest Indians or of Buddhist priests. (Cage studied relatively little classical music until his year in Paris; at that time he was already a young man. It was only after that year that Cage took up composition seriously with Adolph Weiss.) Therefore it is a climate in which self-construction is everything and all things can appear possible. (Cage himself dates his interest in an art embracing all sounds to his brief period of study with the animator Oscar Fischinger, whose avant-garde animations explore the total range of colors and objects with interest in everything that might appear. Fischinger had been brought to Los Angeles to work on Disney's *Fantasia;* that collaboration did not work out, but fortuitously, it brought him into Cage's world.)

45. Not so for Ives, who resists, in my view, judgment about whose voice in concord is most important.

46. It is, both in Indian philosophy and for Cage, a state conditioned by a feeling or belief in the illusion of all differences (paradoxically, Mondrian will come at this conception from the opposite direction; he will try, like Plato, to think his way into the illusion of essential sameness: spiritualists will be spiritualists).

Chapter Six

1. Danto, "Andy Warhol" (chap. 1, n. 4), p. 458. The epigraph is quoted from ibid.; Wittgenstein's quote can be found in *PI,* pt. 1, no. 593. The very idea that Picasso and Braque were theoretical painters has been challenged by a number of recent art historians. The locus classicus of such challenges is Leo Steinberg's essay, "The Philosophical Brothel" (chap. 4, n. 12 above).

2. Is that because he claimed credit for discovering a universal truth of nature, or because scientific theory is itself partly a creative art?

3. I will discuss Warhol's art of words in chap. 8.

4. Danto, *Transfiguration of the Commonplace* (Intro., n. 13), p. 113.

5. Arthur Danto, "The Artistic Enfranchisement of Real Objects: The Artworld," in *Aesthetics, A Critical Anthology,* ed. George Dickie, Richard Sclafani, and Ronald Roblin (New York: St. Martin's, 1989), pp. 171–82.

6. The locus classicus of Quine's discussion is in W. V. Quine, *Word and Object* (Cambridge, MA: MIT Press, 1960), chap. 2; see also D. Davidson, *Inquiries into Truth and Meaning,* (Oxford: Clarendon Press, 1984).

7. Quine, *Word and Object,* p. 29.

8. One must have beliefs about factories, soaps, cleanliness, kitchens, males and females (who does the work when), pots and pans, etc. to understand what the term means. By extension, one must have deeper beliefs about objects, production, metal, etc.

9. Holism is a feature of art interpretation both in the sense that (1) overall account must be taken of the object's visual features to (completely) interpret any single one, and (2) because a wide background context of belief, historical evidence, and society are potentially relevant in shaping even the interpretation of simple visual elements. This thought—that what makes an artwork an artwork is a holistic pattern of meanings, identifications, and beliefs undetermined by the object—regis-

ters various powerful intuitions about art and art criticism, e.g., that some amount of underdetermination always obtains at any point in the interpretive process. There is always more than one route of reading to take which will account for the evidence of the object, and which will be internally consistent. The art of choosing a path into reading is to take the most incisive path: the most effective, simplified, tasteful, or provocative, the most suggestive, risky, or secure one. Holism also invites the individual to think about how much of the totality of human belief (and participation in society) must be brought to bear on even the simplest reading of a painting. Danto invites us to consider how much of a theory of mimesis is at work in descrying the simplest picture of Churchill and his dogs: how many internalized scientific beliefs, beliefs about nature, about the role of a dog in an Englishman's life, about Churchill's face as a dog's face, about the bulldog character of the Edwardian English, about their admixture of integrity and aggression, about dress, landscape, class, gender, etc. Holism invites us to think of art criticism in the broadest possible terms, to think about the relations between Mondrian's painting and much of the history of painting and culture, to think about how much socially constructed knowledge goes into even a drop of painting.

10. For Quine's style of theorizing and for Danto's, identification and interpretation are themselves interconnected processes. For Quine, the initial assumption that the being one is going to interpret is a person (a speaker of language) is a primary identification which becomes the assumption of further interpretation. It is an immediate assumption based on habit and theory (if the being looks like a person and immediately sounds like one, assume he or she is one). That assumption may be, in practice, immediate and intuitive, but it is, in fact, the product of habit and theory and is as such potentially revisable. One's initial identification of some being as a speaker is subject to confirmation or suspicion vis-à-vis the ongoing interpretive process. If the putative speaker were to begin to utter things which absolutely did not compute, or which lacked the linguistic characteristics of variety and repetition in speech, we might gradually wonder if (1) she had gone mad, (2) she had switched languages on us, (3) her language was quite a bit different from ours, more different than we had initially thought, or (4) she were really speaking at all, as opposed to mimicking, warbling, or something else. We might not know what to think.

Similarly for Danto, to identify some object as a work of art is to have already given it partial interpretive structure, since identification of an object as an artwork is identification of it as something of a certain kind. Identification of examples of well-worn genres of art (landscape paintings, figurative sculptures, clay pots) proceeds as immediately in the case of art identification as the identification of speakers in linguistic interpretation. Similarly, such identifications may be revised in the course of further interpretation (as in the case of fakes, copies, monkeys at the typewriter, etc.).

11. Danto could have opted for the anthropologist's example of the art of a distant community; he chooses the avant-garde because of his connection to it, because it is important to him that he be part of his dialectic.

12. Peter Galison, "History, Philosophy and the Central Metaphor," *Science in Context* 2, no. 1 (1988): 197–212.

13. There is a curious disjunction between Danto the philosopher and Danto the

critic. When he reads the avant-garde as support for his philosophical theories, his reading is highly theoretical and quite removed from the visual evidence. When he reads art, including the avant-garde, as a critic for the *Nation* magazine, his style of reading shifts into a marvelous postmodern bricolage of close attention to visual detail, sensitivity to the poetic mood of the work, a capacity to feel this way into the artist's position, and a facility with introducing some stray bit of theory or philosophy which ends up illuminating the ambience of the artwork. Danto writes like Ruskin transposed into the streets of Soho and Los Angeles with a copy of that fictitious book of Ruskin's called the (*Rolling*) *Stones of Venice* (*California*) in his pocket. In short, he writes like Danto, like the individual he is. Danto believes his criticism is extraordinarily free. Is it therefore free of theory? If so, does that mean it does not interpret/define the artworks it responds to in the way a theoretical style of criticism (i.e., Danto on Warhol) would?

14. We may perhaps supplement these factors by reference to what Foucault would call the history of social concepts, practices, and institutions generally.

15. Wittgenstein introduces the concept of "seeing-as" in part 2 of the *Philosophical Investigations*. It is the concept of a type of seeing which is half perceptual, half semantic. The concept is of great importance for art. For an excellent discussion and emendation of its role in art, see Richard Wollheim, *Painting as An Art,* A. W. Mellon Lectures in the Fine Arts, Bollingen Series XXXV, no. 33, (Princeton, NJ: Princeton University Press, 1987), chaps. 1, 2.

16. Danto, "Artistic Enfranchisement" (n. 5 above), p. 33.

17. Danto admits that Warhol's boxes look different from ordinary ones but quickly elides the point. So for him the upshot is that nothing in the visual character of the works serves to define them as art since nothing in the visual character of the works is, in essence, different than what you would see in an ordinary Brillo box. I will return to this elision.

18. A topic related to the topic of theory is that of interpretation as reading. Avant-garde art has, I have said, illustrated the need for supplying an interpretation to make the art comprehensible. It is often not enough to receive a Tatlin visually. A Tatlin *Wood Construction* struggles with gravity in its material labor of making itself. One can receive these things about it visually but only with an appropriately prepared eye. The eye needs the background mind to make sense of what is shown: a reading is required. Sometimes the raw power of the sculpture seems to force the reading on one, at other times one must read the pages of *LEF* to prepare one's eye to receive and appreciate the power in the event. Danto's weaker claim suggests that this need for a reading be thought of as a need for theory-laden eyes. To see is to need to read, which means to need to have a theory. Only when one reads a work, makes sense of it, can one appreciate it. And only when one sees that it has a sense, when one appreciates its force, expression, intention, urge, and sensibility can one truly call it serious art. Thus theory precedes identification of a thing as an artwork because reading precedes identification (or, better, reading is dialectically intertwined with identification).

Diagnosis of the crucial role of reading in art seems accurate, especially with respect to the pulse of our most incomprehensible twentieth century, a century so explicitly difficult to read in its flirtations with incomprehensibility. But is reading

to be so easily glossed as theorizing or applying a theory? Danto's reading of Warhol is to be glossed in this way, but is his style of reading typical? My readings have, by contrast, suggested that making sense of an avant-garde artwork is not simply a matter of finding an explanatory key to the work but, rather, of finding a way to engage it as a whole. The avant-garde intends to force the viewer into a position of full engagement with its acts of philosophy and lunacy. Engagement is a matter of the viewer's realignment of her perceptions, concepts, feelings, and paths of intimacy, a realignment of the pattern of expectations which she projects into her involvement with an artwork. Her realignment of that pattern of expectations is not merely a realignment of her theories, but in some sense is a partial reshuffling of her whole viewing self or person. That is certainly what Cage intends to have happen in her. Similarly, the constructivists have complex aims. They wish to to turn the viewer into a revolutionary, a self-reflective philosopher, a scientist, and a lunatic. They also wish to raise her level of spirituality (Gabo). The avant-garde elicits a conceptual response, but more pervasively a realignment of the person that goes beyond theory. Reading a work is not simply theoretical, engaging it is not simply a matter of reading it—have it either way.

Again, one can gloss all of these factors which jointly comprise engagement as "theoretical" if one wants to. And one is right if all one means is that theory permeates both seeing and reading. But the gloss is, let it be said, a gloss on many different experiential factors.

19. Wittgenstein, *PI* (chap. 2, n. 20 above), pt. 2, p. 197.

20. Consider also his radical example of Neolithic art. According to Danto, Neolithic art is not art until a theory comes along to make it art. The power of the Neolithic image is not sufficient to make that image art until we come along and supply a further concept. The Neolithic concept certainly was not ours. We tend to read those images through the lens of their modernist appropriators—Jean Dubuffet, Henry Moore, *Arte Povera,* and the like. So in some sense Danto is right. To call Neolithic images "art" without further qualification is to project our post-eighteenth-century concept of art onto that world. It is precisely to make the modernist move Heidegger makes when he assumes that the essential definitions of our words reside in their ancient sources.

Yet the Neolithic painter was consumed by the power of his or her images, and thus had some concept of their power and use. Her concept was certainly not the same as ours. But why not trust the power in her images to tell us that (1) they had a use, and (2) the use bears significant family resemblance to ours? Both Neolithic images and ours connect (1) the raw power in incanting a visual image on a surface (a cave wall, a canvas) with (2) some further pattern of beliefs and expectations about its role in the stream of life (Neolithic or twentieth century). The Neolithic image is part of the family of related things called "art" on account of its visual power and because that power was harnessed to a use. Neolithic aestheticians need not tell us this, their images speak louder than words. Were the Neolithic painter not visually consumed by his or her images, that would be a different story. But then it would not be the absence of theory which would cause us to deny that those objects on the wall of the cave were of the realm of art but the absence of our trust in their visual power.

21. This is more or less Ernst Gombrich's position in *Art and Illusion,* Bollingen Series XXXV, no. 5 (Princeton, NJ: Princeton University Press, 1960).

22. See Danto, *Transfiguration of the Commonplace* (Intro., n. 13), chap. 1.

23. That our identifications or interpretations of art may be wrong or incomplete is a skeptical problem we must live with. We have our ways of resolving some such problems and these ways are not merely theoretical. They have to do with questions of connoisseurship, education, vision, and cultural change. And they have to do with the hard facts of history (like where a painting was found, in what shape, and by whom).

24. Richard Wollheim has pointed out that the very idea of claiming to imagine five identical Rembrandts is inimical to our concept of what a Rembrandt is and, by extension, to our concept of what great art is. (Wollheim, "Criticism as Retrieval," in *Art and Its Objects,* 2d ed. (Cambridge: Cambridge University Press, 1980), pp. 196–97. According to Wollheim, we conceive a Rembrandt to be an object of such complexity, depth, and virtuosity that it is hard to imagine another person, or even Rembrandt himself, being able to come up with another work exactly identical to it, especially given the role of what Wollheim will later refer to as "thematization", the artist's capacity to exploit any number of small accidental results which occur during the act of painting. Try to imagine all of these chaotic micro-events which take place during the act of painting being repeatable in another situation of painting; or try to imagine an artist's being able to duplicate their result by other (equally chaos-ridden) means. (For his discussion of thematization, see Wollheim, *Painting as an Art,* chap. 1). The role of accidents in art, of changes in the canvas which are then exploited by an artist, of differential color pigments, of slight slips of the hand which are retained, of the specific mood, light, and weather under which an artist paints, of how the paint is dried and how the artist responds to that make it harder and harder to imagine the kind of controlled situation required for repetition or duplication. It is rather like, let me add, someone saying, "Imagine someone else living exactly your life." What does one have to do to get in control of that task, to conceptualize it clearly, to fully imagine what it would take to do that in detail so that you could go about doing it? What kind of genius would that take? It is not obvious, the details of life being too overwhelming and too chaotically arranged. What Arnaud Du Tihl, the brilliant protagonist of that piece of history called *The Return of Martin Guerre* (Natalie Zemon Davis, *The Return of Martin Guerre* [Cambridge, MA: Harvard University Press, 1983]), manages to do in taking over Martin's life and "living" it for a time is not to duplicate the life of Martin—although his replication of Martin's life is amazing in the details of its success—but rather to appropriate that life in his own terms, to recast it as his own in a way that makes Martin's wife happier. It takes genius to do that, and it would take a similar kind of genius even to make the style of Rembrandt one's own. Making the style one's own would be hard enough; completely replicating an extant Rembrandt would, in a sense, be harder.

25. Paradoxically, Danto's strategy of opening up a world of readings without constraint aligns with Derrida's strategy of exploding the canons of reading by presenting a near infinity of possible alternative readings of a picture (or of a text generally). Thus in his reading of Van Gogh's shoes, Derrida generates an indefinite number of psychoanalytic, social, and representational interpretations. The shoes are under the virtuosity of his inventiveness, bisexual, homoerotic, a pair, not a pair,

a shoe and its mirror image, etc. Derrida's execution is brilliant, and his postmodern rhetoric of challenging all canonizations of reading, all principles of how to read, and all assertions of meaning has its own good reasons. But Derrida, too, dispenses with the questions of visual constraints on these readings, with questions about their relative degrees of their plausibility, about—granted how the pictures look—how far we must go in accepting one reading as opposed to the other. There are no easy answers to such questions, yet few are prepared to accept the equal plausibility of all his readings in the light of the evidence from their eyes, which means that the eye matters decisively, if not definitively (cf. Jacques Derrida, *The Truth in Painting*, pt. 4, trans. Geoff Bennington and Ian McCleod [Chicago: University of Chicago Press, 1987]).

26. Wittgenstein, *PI*, pt. 1, no. 201.

27. Cf. *Ibid.*, no. 86.

28. Danto, *Transfiguration of the Commonplace*, p. 125.

29. Wittgenstein, *PI*, pt. 1, no. 85.

30. The way out of the desire to define art in terms of a theory held by the artworld may look to one as though one should retain the claim to define art in terms of an essential fact about the artworld, but the fact should be the artworld's practices, not its theories (as if one can fully distinguish these). Then it will look as though it is place in the artworld rather than a theory held by it which defines things as art. That skeptical solution to skepticism about theories, remarkably in the spirit of Saul Kripke (*Wittgenstein on Rules and Private Language*, [Oxford: Blackwell, 1982]), is the position of the institutional theory of art (see George Dickie, "The New Institutional Theory of Art," in Dickie, Sclafani, and Roblin, eds., *Aesthetics* (n. 5 above), pp. 196–205). What defines art, according to the institutional account, is an institutional practice (itself probably historically evolving). But then one has the problem of identifying what this practice is, who exemplifies it, why it changes, etc. The practice is no more decisive and no easier to pin down than Danto's theory.

The thrust of Wittgenstein's position would be to say that no one thing can serve as the definition of art. Art is not defined by a mere theory or by a mere practice or by mere observation. It is in the joint interplay of all of these conditions, themselves structured by history, society, gender, politics, the history of technology, and whatever else, that the definition resides. Indeed, it takes all of these factors to define the very idea of the artworld. Art is made possible by the organicist interconnection of various factors (in competition, in harmony, in tandem) of a form of life. For a further discussion of this point, see my article, "Wollheim on Manet: The Work of Art as Psychoanalytic Object," *Journal of Aesthetics and Art Criticism* 49, no. 2 (Spring 1991): 137–53.

31. See Philip Fisher, *Making and Effacing Art: Modern American Art in a Culture of Museums* (New York: Oxford University Press, 1991); and Lewis Mumford, *Art and Technics* (New York: Columbia University Press, 1952).

Chapter Seven

1. I owe this remark to Ted Cohen (cf. Cohen, "The Very Idea of Art" [chap. 5, n. 30], pp. 7–14).

2. What in French philosophy is often glossed as the play of differences.

3. Stanley Cavell, *Conditions Handsome and Unhandsome* (chap. 4, n. 41), p. 20.

4. Warhol's collapsing of the distinction between the aesthetic realm and the realm of commerce is but the latest assault on the eighteenth century's distinction between fine and useful art. The distinction between fine and useful art itself has various useful contexts of application, most of which depend on some specific idea of the kind of use which fine art should not have. However, as a general distinction, it has produced or augmented such abuses of art as (1) the removal of Indian temple carvings from their sites to some European museum where the temple carvings are interpreted independent of their context in the stream of Indian life, which is to say, the turning of on-site art (art whose use is profound and clear) into the status of fine art. From site to *sight,* art has been turned by the ethos of the museum into a sight to be gazed at by viewers and cited in their museum guides. Indian carvings became in Western eyes mere objects to be "transfigured" by the sensuous viewer. (2) The distinction has led to the need to separate the functions of the fine arts from their aspects of sensuous beauty, thus reducing sensuous beauty *es-sensually* to formalism. Eugène Delacroix's celebration of the French Revolution cannot, according to eighteenth-century formalism, be part of what makes his images so profound, immediate, and sensuously absorbing. (Then how is Delacroix's *formal* structure to be explained, if not partly by reference to the power of design in the nonformal symbols of Delacroix's torches which play against Delacroix shapes and colors? Formal balances, on close inspection, depend on nonformal elements which strike the eye and mind and therein acquire a central place in a pictorial form.) (3) The distinction has led to the devaluing of the "useful" arts, as if the only worth in useful arts is typified by the uselessness of the hairpins of a Madame de Pompadour, the usefulness of a person's galoshes, or by what you do with an ordinary urinal when you are not thinking about whether it is art.

5. The eighteenth century's distinction is between (1) things and (2) the way our interest in things transfigures them into art. Aesthetic interest, or pleasure, functions for the eighteenth century in the way theory functions for Danto. It adds a new kind of relation to the thing which transports it into a new experiential realm, making it into something else. The eighteenth century's distinction went through a succession of recastings in the subsequent history of aesthetics. Thus, e.g., Collingwood remade it as a distinction between the art object and the true work of art, which is an ideal object defined as the artist's own act of expression (cf. R. G. *Collingwood, The Principles of Art* (Oxford and London: Oxford University Press, 1938).

6. Since existence is not a predicate, that says nothing about the thing other than to register that we must be able to acknowledge that an "I know not what" could exist independent of our ever having lived and achieved powers of conceptualization.

7. Caroline Jones has pointed out to me in private conversation that the Brillo box is not Warhol's medium; it is, rather, his subject or model. Rauschenberg, she points out, did, by contrast, really use boxes as his medium, cutting them out and pasting them onto his canvases. One might say that the Brillo box is Warhol's medium in a looser sense, but then one is required to say what that sense is, other than as subject or model or article of mimicry.

8. For brilliant discussions of the interpenetrating nature of genre members, see Cavell, *Pursuits of Happiness* (chap. 4, n. 49), intro., pp. 1–44; and Charles Rosen, *Classical Style* (chap. 2, n. 6), pt 1.

9. Perloff, *Futurist Moment* (Intro., n. 24), p. 69.

10. *Ibid.,* p. 75.

11. Fisher, *Making and Effacing Art* (chap. 6, n. 31), chap. 9.

12. For Fisher, the humanization of objects occurs partly through the artist's mode of production itself, which has become in this century a mixture of mechanization and craft. The artist's act of making—whose traces are borne by the object—is an act which retrieves the object from its alienated state by showing that the features of mass production, craft, and individual expression can be reconciled. The art object becomes a symbol of this reconciliation between people and objects (cf. Fisher).

Of course, the threat in the increasing mechanization of the studio is that, before one knows it, art objects will simply become another kind of fetishized commodity in the world, rather than symbols of the reconciliation between commodities and the older values of art. For a discussion of the way the artist's studio has, from Warhol to Stella, become increasingly mechanized in various respects, see Caroline Jones, "Machine in the Studio" (Ph.D. diss., Stanford University, 1992).

13. Cf. Michel Foucault, *The Order of Things: An Archeology of the Human Sciences* (New York: Vintage Books, 1973).

Chapter Eight

1. I allude, of course, to Milan Kundera's book (*The Unbearable Lightness of Being,* trans. Michael Heim [New York: Harper & Row, 1984]), which has much to say about the postmodern. The Danto quote in the epigraph is taken from his article in the *Nation* (chap. 1, n. 4), p. 461; the Carl Andre quote is taken from the exhibition catalog, an excellent resource document, *Andy Warhol: A Retrospective,* 6 February–3 May 1989 (New York: Museum of Modern Art, 1989), p. 436.

2. I have used some of what follows to different purposes in my article, "The *Journal of Aesthetics*" (Intro., n. 22). There my question concerns the relation between Danto's art criticism and his aesthetics.

3. Andy Warhol and Pat Hackett, *POPism: The Warhol '60s* (New York: Harcourt Brace Jovanovich, 1980), pp. 39–40.

4. Thomas Crow, "Saturday Disasters: Trace and Reference in Early Warhol," *Art in America* (May 1987), p. 129.

5. For an extended discussion of the way Warhol's Factory repeated industrial relations from the 1950s, with Warhol as the big boss, the star of it all, and others doing the manual labor without adequate recompense; for a discussion of the complex gender relations in that closet of a place where sexuality was liberated and concealed; for a discussion of the Factory as a closet; see the work of Caroline Jones (*Machine in the Studio* [chap. 7, n. 12], chap. 4), from which I have benefited.

6. Cf. Charles Stuckey, "Warhol in Context," in *The Work of Andy Warhol,* ed. Gary Garrels, Dia Art Foundation, no. 3 (Seattle: Bay Press, 1989), pp. 3–33.

7. Cage, "Jasper Johns" (chap. 5, n. 19), p. 79; the first sentence in the quote is Cage's; the second is Cage's quotation of Johns.

8. Walter Benjamin, "The Work of Art in an Age of Mechanical Reproduction," reprinted in *Illuminations,* trans. Harry Zohn (New York: Harcourt Brace & World, 1968), pp. 217–52.

9. Erwin Panofsky, "Style and Medium in the Moving Pictures," in *Film,* ed. D. Talbot (New York: Simon & Schuster, 1959).

10. Stanley Cavell, *The World Viewed* (New York: Viking, 1971), pp. 25–27.

11. This is what makes the film actor, but especially, in our gendered world, the film actress, so easily fetishizable. The film medium has already made her into a kind of material by making her into an eternally replayable icon to be gazed at from the safe position of the viewer (who is absent from her as she is present to him). This in itself is not yet to fetishize her but it is to make it easy to do so, for she is there on screen to be gazed at perpetually. In a culture like ours, where women are defined by the gaze of men, the screen must resist participation in this vamping. The tendency of film to fetishize the actress is explored in the films of Hitchcock, especially in his *Rear Window.* It is a theme introduced into the literature on film by Laura Mulvey's classic essay, "Visual Pleasure and Narrative Cinema" (reprinted in *Movies and Methods,* vol. 2, ed. Bill Nichols [Berkeley and Los Angeles: University of California Press, 1985], pp. 303–14).

12. I refer to Cavell's idea that movies are pieces of the past replayed (Cavell, *World Viewed,* p. 23).

13. The supervenience of an aura on a thing is another connection between romanticism and surrealism, whose techniques of *assemblage* and (semi-)automatic writing generate mysteriously irrational dreams out of words and things which appear to be their inner auras.

14. I believe that only when this is understood can we appreciate the importance of film as a medium today. For film has made it possible to retain the old, auric (and many other) values of art in a global, mechanical world. No wonder painting feels it cannot compete with film for the attention of the world. This is not because film has replaced the old values of auric art with new and potentially revolutionary ones; it is, rather, because film has recast the old idea of the aura in a way that makes *it* mass-producible. Film has delivered the possibility of the aura to the gaze of millions.

15. Cavell; *World Viewed,* pp. 25–27.

16. Benjamin, Bürger, and Jürgen Habermas would all, I think, call Warhol's practice reactionary or fascist in its reliance on film to idolatrize, and in its easy accommodation to capitalist commodification procedures.

17. I owe this point to Lucia Saks.

18. Thomas Hess, *Art News* (November 1963), p. 23.

19. Patrick Smith, [Interview with] "Gerald Malanga," in *Warhol: Conversations about the Artist,* (Ann Arbor, MI, and London: UMI Research Press, 1988), p. 23. Malanga is a poet and Warhol associate.

20. Benjamin Buchloh, "The Andy Warhol Line," in Garrels, ed. (n. 6 above), p. 64.

21. Smith, p. 224. One can ask whether Warhol ever did leave commercial art or whether, having made enough money working for clients in the 1950s, Warhol then

decided to continue doing commercial art without clients. I find this too simple. Warhol makes a game out of commercial art which depends on a certain distance from it (call that the distance of fine art, except that Warhol is creating a new style of art that is distant both from fine art, traditionally construed, and from commercial art, taken strictly). Similarly, he makes a game out of Brillo boxes through enough visual distance from the originals (and enough likeness).

22. I am, of course, referring here to the concept of Jean-Francois Lyotard (*The Postmodern Condition: A Report on Knowledge,* trans. G. Bennington and B. Massumi (Minneapolis: University of Minnesota Press, 1984). I will discuss Lyotard briefly in chap. 9.

23. Rainer Crone, *Andy Warhol* (New York: Praeger, 1970).

24. G. R. Swenson, "What is Pop Art?" *Art News* (November 1963), p. 29.

25. Gretchen Berg, "Andy: My True Story," *Los Angeles Free Press* (17 March 1967), p. 3.

26. Ibid.

27. Andy Warhol, *America* (New York: Harper & Row, 1985), p. 8.

28. Turner's history of America claims the open American frontier has been the crucial stimulant to American history (Frederick Jackson Turner, *The Frontier in American History* (New York: Henry Holt, 1920).

29. I learned this from Caroline Jones.

30. [Conversation with] "Ronne Cutrone," in Smith (n. 19 above), p. 348.

31. Warhol and Hackett, *POPism* (n. 3 above), p. 50, quoted in *Andy Warhol, a Retrospective* (n. 1 above), p. 457.

32. I have always felt that the 1960s TV show *Bonanza* represents the Kennedy years. The Cartrights: Ben, Adam, Hoss, and Little Joe, are fair, just, good, high-minded, and liberal; but they are also absolutely in control of the land and the guns, which they will use if they have to. They always prefer to talk to bad guys, to give them a fairer deal than the bad guys would give them. But if a bad guy refuses to come around, because of his essential orneriness, the Cartrights will wield the firm arm of their command. Their combination of fairness and strength is unbeatable, like Kennedy's America.

33. *On Photography* S. Sontag, (New York: Delta, 1977).

34. I refer to *Shoah,* Claude Lanzmann's 1985 film.

35. I refer, of course, to the line from Alfred Hitchcock's *Psycho* (screenplay by Robert Bloch). I will shortly pursue some Hitchcockian aspects of Warhol.

36. Smith, p. 183.

37. Ibid., p. 239.

38. I refer to George Cukor's remake of *A Star is Born.* Esther Blodgett is a self-made, hardworking star who is, with the right guidance from her otherwise destructive husband "Norman Maine," made over into a star. The idea of her arrival from nowhere is reinforced in the film by the fact that she has come from some undiscussed place in the midwest of America to Hollywood. There is in Cukor's remake absolutely no discussion in the film of Esther's parents or of her background other than to say she came from a typical American place, that she had no money, that she had to work hard at her career, and that she endured a long struggle in the theater (probably in New York) before arriving in Hollywood. Like an immigrant, she beat

the pavements, threatened by the casting couches of unseemly men, before she got her chance.

I am saying that there is an equivalence set up in the American mind and exploited both by Warhol and by this film, between (1) immigration from the other world to America, from humble beginnings to success (Horatio Alger) and (2) the movement from ordinary humble American cities and towns to the bright lights of Hollywood. Both Esther Blodgett and Horatio Alger make it through hard work, talent, and economic luck (not to mention through the luck of having the right skin color and the right religion). *A Star is Born* acknowledges the hard work behind the success (not, however, the issues of differential treatment in America on the basis of race and other characteristics which make Esther's success possible in a way that no success is possible for others). But Cukor's film also shows how the fact of work is recast as a kind of Whig history once the star is born. Esther Blodgett's early life is shown to us in a film within Cukor's film, as the birth of the actress Vicki Lester, and it is shown as a roaring musical, a roaring piece of theater. Her life is therefore rewritten as art. This is Cukor's way of showing that stardom mythologizes and glamorizes the past of a person by presenting it as fiction. Vicki's whole life is film now—from the point of view of the public. Not from her point of view; she is a person of flesh and blood who must live through hard knocks to come before emerging as a person in possession of her human identity, which means her identity both as an actress and as a wife/widow. Cukor, always empathic to the plight of the human in a way Warhol is not, only takes this woman to be truly born at the end of the film, when she has emerged from a melancholia brought about by the suicide of her destructive husband to claim her public persona under the name of "Mrs. Norman Maine." It is this claiming of her new name which makes her both a real person (the widow Mrs. Norman Maine) and a film star (the created character Vicki Lester). This claiming of her person had to be done on her very own and in private, not through the star-gazing public eye which is only interested in the mythos of her appearance on screen. This is Cukor's humanization of the star, his portrayal of what must happen in this person's life for her not to be killed by the mythology surrounding stardom.

Of interest to me here is how the star's past is shown (1) to arise from nowhere and (2) to be rewritten as myth, not as real history. These are features the American writing of history—the Horatio Alger myth—shares with American film.

39. The close connection in the American imagination between film stardom and Horatio Algerism is a running theme from the movies of the 1950s. Such movies, which often take place in the world of New York business or advertising, call on the zany, frenetic, and unreal medium of film comedy to project the rise to stardom of a 1950s executive. *Will Success Spoil Rock Hunter?* is a brilliant spoof on this state of affairs. In it, a young ad man on the make, Rockwell P. Hunter (played by Tony Randall, himself a spoof on Rock Hudson, superlover of 1950s melodramas) climbs up the ladder through a crazy adventure with Jayne Mansfield (by the way, was she born "Jayne" or "Jane"? Does it matter?). Frank Tashlin, the film's director, uses his experience in film animation to spoof Rockwell P.'s superanimated rise to success (and relinquishment of success in favor of a ridiculous return to "nature," specifically, to pig farming). His spoof is on the world of TV, which advertises

through overstimulation and can lift up grape pickers from places like Cucamonga into the world of stardom. Tashlin's film, while it lambastes television, is a comment about the crazy medium he himself works in, the medium of film, which projects nobodies—whether grape pickers or ad men—as successes if they can only play opposite a Jayne Mansfield before the eyes of millions. It is a premise of the film that the overstimulating, oversexed, and over-the-rainbow media of film and TV are of a piece with the zaniness of corporate Madison Avenue. Both project the spoils of success like the golden arches (the "big W") of *Its a Mad, Mad, Mad, Mad World.*

40. Andy Warhol, *The Philosophy of Andy Warhol (from A to B and Back Again)* (San Diego and New York: Harvest, 1975), p. 117.

41. Swenson (n. 24 above), p. 60.

42. Nicholas Love, Warhol memorial service, St. Patrick's Cathedral, New York (1 April 1987), quoted in *Warhol: A Retrospective* (n. 1 above), p. 459.

43. See Caroline Jones (chap. 7, n. 12).

44. Swenson, p. 60.

45. Warhol, in ibid.

46. See Jones, who says that Ken Silver also arrived at this idea.

Chapter Nine

1. And from Hegel and from the history of philosophy.

2. Lyotard *Postmodern Condition* (chap. 8, n. 22), p. xxiv.

3. I am, of course, referring to Derrida's critique of the metaphors of illumination here. Cf. Derrida, "White Mythology" (chap. 2, n. 23), tr. Bass, pp. 207–72.

4. Related to me in private conversation by Marjorie Perloff.

5. By claiming this, Lyotard takes issue with Habermas's notion that the project of modernity is as yet incomplete and that legitimation in terms of the universal, humanist concepts of the Enlightenment is still crucial for the integrity of culture (cf. Jürgen Habermas, *The Philosophical Discourse of Modernity,* trans. F. Lawrence, Cambridge, MA: MIT Press, 1987).

6. Lyotard's idea is close to Fredric Jameson's, who claims that what late capitalism has done is to destroy the semiautonomy of the cultural sphere. For Jameson, the one kind of art which can best resist that sphere is the art made by marginalized social groups: women, Afro-Americans, Native Americans, Chicago Americans, Third World artists, etc. These artists still participate, according to Jameson, in the incomplete project of modernity. They have their narratives and their commitments, which empower their art with a purpose and value à la the halcyon days of modernism.

7. See Lyotard; *Peregrinations: Law, Form Event,* Wellek Library Lectures, University of California, Irvine, (New York: Columbia University Press, 1988), chap. 2.

8. Danto, "Warhol" (chap. 1, n. 4), 459.

9. Danto thinks of his art criticism as essentially free of all philosophical perspective (except when he is writing as a philosopher-critic about the avant-garde). He believes his art criticism must be consistent with his philosophy, but it is not in any further way motivated by it. I take issue with his own self-description, in that I believe his criticism exists in more than a relationship of consistency with his philos-

ophy; it exists in correspondence with it. Danto the critic inhabits, in my view, that free postmodern space he attributes to Warhol. Danto's criticism is a warm, playful, original, and subtle form of bricolage. When writing for the *Nation*, Danto will bring to bear an admixture of close attention to visual detail, art-historical context, and theory, all in the interest of his subject. His subject may be the world of an individual artist, it may be an artwork in its times, it may have to do with the reception of an artist in the present, or his subject may be some quirk in that world of buying, selling, making, reading, and exhibiting glossed as the artworld. Danto's criticism avoids all generality as strongly as his philosophy seeks it; instead, it seeks to focus on whatever strikes that writer as worthy of attention in the temple of interest, pleasure, and exasperation called art. The individuality of voice in Danto's criticism harks back to the days of Ruskin, even to Charles Baudelaire, as does Danto's openness to the flow of whatever happens to happen in the world of art. Danto's is the critical space of polymorphous freedom: a space in which everything is used in the free play of reading, seeing, and response. His is that very postmodern space that art now occupies. From my perspective, then, Danto exemplifies the thought that writing is now as free to become its own form of art, as free to play with art from a million prismatic and contextual perspectives, as painting and sculpture themselves are. No one occupies this space better than Danto himself.

10. For an extended discussion of this point, see my contribution, "The Beginning of the End: Danto on Postmodernism," in *Arthur Danto and His Critics,* ed. T. Rollins (Oxford: Blackwell, fall 1993).

11. Jean Baudrillard, *Simulations,* trans. Paul Foss, Paul Patton, and Philip Beitchman (New York: Semiotext(e), 1983), p. 83.

12. Especially in Fredric Jameson, *Postmodernism, or the Cultural Logic of Late Capitalism* (Durham, NC: Duke University Press, 1991).

13. John Berger, *Ways of Seeing* (London: BBC Books; Penguin, 1972).

14. For a different but extremely interesting discussion of Olympia as a prostitute, see T. J. Clark, *The Painting of Modern Life: Paris in the Art of Manet and His Followers* (New York: Knopf, 1984), chap. 2.

15. Wollheim, *Painting* (chap. 6, n. 15), chap. 6.

16. Including, in more recent times, performance art.

17. I speak, e.g., of the Derrida of *The Truth in Painting* (chap. 6, n. 25), pt. 4, pp. 255–382.

18. Let it be noted that not all theoretically minded art uses theory as a social weapon. The turn to theory in conceptual art can simply represent a philosophical turn, a turn toward self-exploration, self-understanding, and the raising of philosophical questions about art through visual means. Joseph Kosuth, deeply influenced by Wittgenstein, is an example of such a philosophically minded artist—proving that Danto's claims about art merging with philosophy do capture some range of examples of art being done now in our multifaceted postmodern age.

19. "A Forest of Signs: Art in the Crisis of Representation," exhibition at the Museum of Contemporary Art, Los Angeles (7 May–13 August 1989). I reviewed this exhibition for *Modern Painters,* a London art journal founded and edited at that time by the late Peter Fuller, a maverick intelligence whom the artworld will miss.

His independence of mind, alternative voice, integrity bordering on tenaciousness, and dedication of spirit were rare in that or in any world.

20. Ibid.

21. I do not wish to be construed as impugning these writers. My topic here is the reception of their writing by the artworld.

22. Arthur Danto, "Bad Aesthetic Times," in *Encounters and Reflections: Art in the Historical Present* (New York: Farrar, Straus, & Giroux, Noonday Press, 1991), esp. pp. 306–7.

23. See chaps. 2–5, where I work out this idea.

24. On the idea of originality as a myth, see Rosalind Krauss, *The Originality of the Avant-garde and Other Modernist Myths* (Cambridge, MA: MIT Press, 1989).

It should be pointed out that, from the perspective of my story, abstract expressionism was received under equivalent forms of mythologizing. From the perspective of this mythologizing, it is Pollock's breakthrough which justifies his use of paint. It is the Greenbergian thought that abstract expressionism is philosophical because it has revealed the essence of painting (flatness and two-dimensionality), which justifies the color-field painters. I do not mean to say that these myths of reception provide anything approaching a complete explanation of the paintings. Like Mondrian, color-field painters wish simply to paint; the importance of Greenberg's ideas for their intentions vary. Theory did help them to paint, but it is not clear that such theory was required. All I mean to say is that these same modernist myths were in play (up to a point) in the reception of abstract expressionism as well.

25. Those who have found a way to engage in a theoretical project (like Holzer) or make original objects (like Sandro Chia) have reinvested these norms with new value by reinventing them.

26. The term is Fredric Jameson's (cf. Jameson [n. 12 above]).

27. Two of the various books documenting this art are Tony Godfrey, *The New Image: Painting in the 1980s,* (New York: Abbeville, 1986); and Howard Fox, *A New Romanticism: Sixteen Artists from Italy,* companion catalog to Hirshhorn Museum and Sculpture Garden exhibition (3 October 1985–5 January 1986) (Washington, DC: Smithsonian Institution Press, 1985).

28. Proust, *Time Regained,* trans. C. K. Scott Moncrieff and Terence Kilmartin (New York: Vintage, 1982), p. 916.

29. Ibid.

30. Ibid.

31. And, of course, others.

32. Stated many times in his classes and in his private conversations during his Brandeis University days in the 1970s.

33. I think of my interpretation of Proust as making a connection between Proust's approach to theory and the "perspectivism" of Nietzsche. I have learned about Nietzsche's perspectivism through the writings of Alexander Nehamas, esp. *Nietzsche, Life as Literature* (Cambridge, MA: Harvard University Press, 1985). The idea of a pattern of quasi theories, registering dimensions to human life, some of which may take their place only for a moment in Marcel's fleeting life, is an idea in accord with Baudelaire's famous temporal definition of the modern as "the

ephemeral, the fugitive, the contingent" (Charles Baudelaire, "The Painter of Modern Life," in *The Painter of Modern Life and Other Essays,* trans. J. Mayne (New York: Phaidon Press, Da Capo Paperback, 1964), p. 13. What Proust shows is that that part of experience called "theory" is similarly contingent.

34. As we have seen an ideology never entirely followed in practice.

Index

Abstract painting, 99, 321 n. 7
Adorno, Theodor, 273, 277, 301
Aesthetics: discipline of, 12–14; its tradi-
tional concepts of art and beauty, 342 nn.
4, 5
Aiken, Henry, 305–6
Alloway, Lawrence, 248
Avant-garde: its aim of embodiment, 5, 8,
35, 127, 310 n. 8; contemporary inheri-
tance of its theoretical practices, 17, 234,
271–73, 298–301; its game with objects,
227–31; its game with theory, 4, 9, 33–5,
61, 137, 228–9; limits of its theories,
179–81; its mentality, 3–5, 126; its utopi-
anism, 8–9, 19, 33, 35, 71–2, 127, 228–9,
257; various senses of the term, 309–11 n.
8. See also Bauhaus; Bürger, Peter; Cage,
John; Cruz-Diez, Carlos; Constructivism;
Danto, Arthur; De Stijl; Gabo, Naum; Lis-
sitzky, El; Lyotard, Jean-François; Mayak-
ovsky, Valdimir; Moholy-Nagy, László;
Mondrian, Piet; Perloff, Marjorie; Soto, Je-
sús; Tatlin, Vladimir; Theory; Van Does-
burg, Theo; Warhol, Andy

Baudrillard, Jean, 272, 284–7
Bauhaus, the, 1, 56, 67–9. See also Galison,
Peter; Gropius, Walter
Baxandall, Michael, 2
Benjamin, Walter, 239, 240–3, 273, 344 n.
14
Berger, John, 288
Buchloh, Benjamin, 248
Bürger, Peter, 34, 310 n. 8

Cage, John, 6, 8, 140–73, 223, 230, 272–3,
277, 306; his anarchism, 166–8; 4.33,
150–2, 155, 162–3, 173, 230; his Mes-
ostics, 329 n. 2; his musical innovations,
143, 333–4 n. 33; his skepticism, 7, 142,
147–8, 152–4; his utopianism, 142, 154,
165; his Zen voice, 162–4

Cavell, Stanley, 157, 218, 240, 243, 327 n.
41, 328 n. 49
Constructivism, 33–92; its cartesianism, 44–
6, 51–3, 87; its general idea of the art-
work, 36, 38; as the laboratory for the
new, 8, 88–9; its scientific conception of
art, 64–76; its use of biological theory,
61–7; its utopianism, 46, 90–91. See also
Cruz-Diez, Carlos; Gabo, Naum; Lissitzky,
El; Luceña, Victor; Mayakovsky, Vladimir;
Moholy-Nagy, László; Soto, Jesús; Tatlin,
Vladimir
Cornell, Joseph, Fig. 228
Crone, Rainer, 249–50
Crow, Thomas, 236–7
Cruz-Diez, Carlos, 77, 81. Fig 80. See also
Constructivism
Cucchi, Enzo, 301. Fig. 302
Cukor, George, 345–6 n. 38
Curtis, Jackie, 256
Cutrone, Ronnie, 252

Danto, Arthur, 24–32, 177–231; his concept
of the artworld, 209–11; his concept of
theory, 5, 16, 28–9, 181–2, 184, 194–8; as
critic, 337–8 n. 13, 347–8 n. 9; his Hegeli-
anism, 11, 25–6, 31; influence of Quine
on, 186–92, 337 n. 10; his metaphysical
distinction between artworks and things,
213–26; his reading of the avant-garde,
14–15, 25–32, 189, 214, 226–31; his
reading of postmodernism, 17–18, 31–2,
281–4; his reading of Warhol, 12–14, 26,
29–30, 188, 190, 198–202, 232–4, 249,
267–9; as recipient of the avant-garde's
mentality, 11, 16, 32, 191–2, 269; his
thought experiments, 202–5; his utopian-
ism, 21–32; 281–2
Derrida, Jacques, 289, 340–1 n. 25
Descartes, René, 48–53
De Stijl, 6–7, 93, 108. See also Mondrian,
Piet; Van Doesburg, Theo
Dewey, John, 218, 224

351

17–18, 301–3. *See also* Avant-garde, contemporary inheritance of its theoretical practices; Baudrillard, Jean; Danto, Arthur, his reading of postmodernism; Lyotard, Jean-François; Museum of Contemporary Art, Los Angeles
Poststructuralism, 20. *See also* Avant-garde, contemporary inheritance of its theoretical practices; Derrida, Jacques; Lyotard, Jean-François; Postmodernism
Prina, Richard, 295. *Fig.* 295
Proust, Marcel, his conception of theory in art, 304–7
Pyrrho of Elis, 153–4. *See also* Cage, John, his skepticism

Quine, Willard Van Orman, 186–92, 195–7, 337 n. 10

Russell, Bertrand, 47, 49

Schoenberg, Arnold, 141
Schorske, Carl, 169
Seeing-as, in art, 195, 197
Sontag, Susan, 253–4
Soto, Jesús, 76–8. *Fig.* 79. *See also* Constructivism
Swenson, G. R., 250, 260–2
Syrop, Mitchell, 294

Tashlin, Frank, 346–7 n. 39
Tatlin, Valdimir, 41, 63. *See also* Constructivism
Theory, 16, 137–8, 178, 193, 348 n. 18; contemporary uses of it by the artworld, 17–19, 121, 213, 269–307; genealogy of, 3; as

interpreted through the artwork, 39; its relation to the visual artwork, 185–6, 54–9, 95–8; as repressive of the artwork, 303–4, 306–7. *See also* Avant-garde; Danto; Postmodernism; Poststructuralism
Thoreau, Henry David, 167–8, 171
Toulmin, Stephen, 313 n. 20, 318 n. 26, 327 n. 45, 328 n. 48

Utopianism. *See* Avant-garde, its aim of embodiment, its utopianism; Cage, John, his utopianism; Constructivism, its utopianism; Danto, Arthur, his utopianism; Mondrian, Piet, his utopianism

Van Doesburg, Theo, 93, 110. *See also* De Stijl; Mondrian, Piet
Venturi, Robert, 4
Verheggen, Claudine, 329 n. 49

Warhol, Andy, 232–68; and America, 234–6, 250–2, 257, 345–6 n. 38, 346–7 n. 39; his *Brillo Box*, 16–17, 31, 188, 190, 198–202, 267; his contributions to the avant-garde, 245–6; his *Death and Disaster* series, 260–5; and film, 239–46; his inheritance of avant-garde practices, 236–9, 249; the postmodern character of his art, 249, 272, 281–3; the underdetermined character of his art, 232–3, 247–50. *Figs.* 24, 241, 252, 259, 264. *See also* Danto, Arthur, his reading of Warhol
Williams, Bernard, 10
Wittgenstein, Ludwig, 6, 20, 47, 90, 155–8, 165, 197, 205–8, 221, 240, 301, 322 n. 10, 323–4 n. 22, 332 n. 23, 341 n. 30
Wollheim, Richard, 289, 340 n. 24